PLANKTONIUM
AN UNSEEN WORLD

JAN VAN IJKEN

TERRA

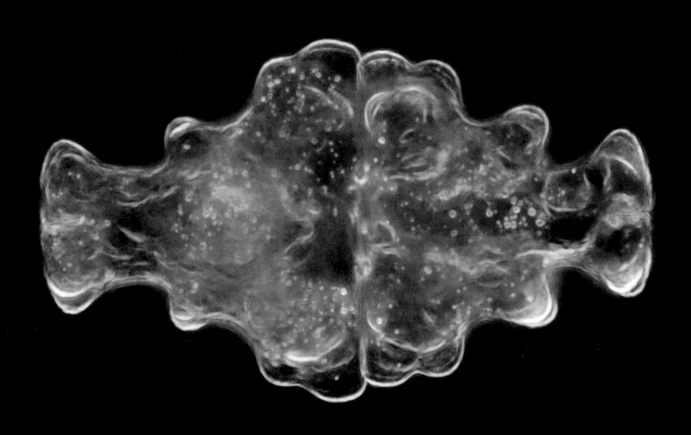

FOREWORD

Plankton. These microscopic critters are vital to nearly all life on Earth. They are the basis of nearly all aquatic food webs, supporting much of life under surface and a fair amount above – including us. Like plants, phytoplankton use the light of the sun for energy, releasing oxygen in the process. They do this on a truly astounding scale, producing more than 50% of the oxygen on Earth. Every other breath we take, is provided by the ocean. They even control our planet's climate. Without plankton we simply couldn't exist.

Plankton occurs in such huge numbers their blooms can change the colour of the ocean, visible from space. However, despite the importance and abundance, their microscopic size – some are half the diameter of a human hair - means they are all but invisible to us.

Jan van IJken's skill, patience and artistic touch reveal this unseen realm in an extraordinary way. Through his unique photo series, we are introduced to a world of intricate complexity and stunning beauty. A truly distinctive view of our 'inner space' so vital to all life on Earth.

Will Ridgeon
BBC Producer / Director
Blue Planet II and *Planet Earth III*

CONTENTS

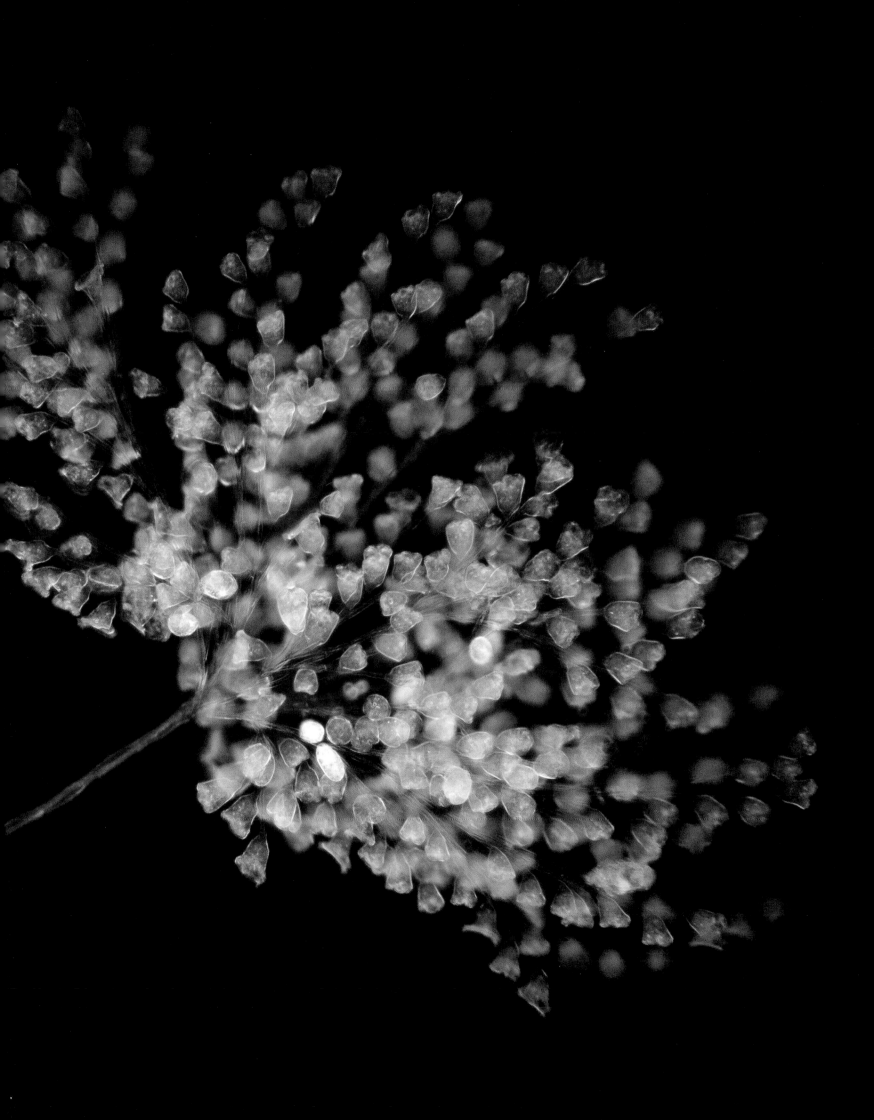

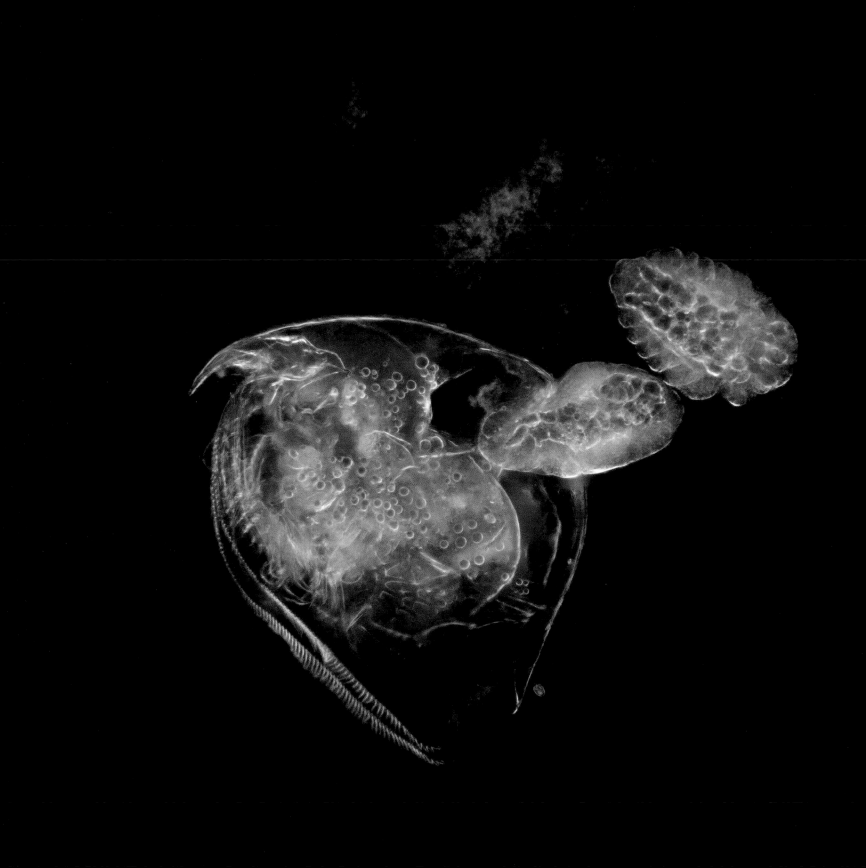

A TREASURE CHEST
OF BIODIVERSITY

Imagine lying on your back, being held and supported by a body of water, gently drifting along, going with the flow. Plankton do that. The term plankton is used to describe a wide range of free-living organisms who, either despite their small size, or lack of locomotory strength, are destined to drift, at the mercy of currents and streams.

Plankton inhabit the watery world: they live in transient pools and ponds, freshwater lakes and rivers, and the vastness of the deep blue ocean. Despite its name of Earth, our home planet is dominated by water, covering 71% of its surface. Water is the largest habitat on the planet, so it is hardly surprising that plankton make up the most abundant group of organisms on the globe.

Often unnoticed, sometimes unnoticeable, here is a treasure chest of biodiversity. Almost every group of organisms in what biologists call the "tree of life" is represented in the plankton. How can we even begin to study and understand these thousands of different species? We start by categorising them into groups – by size, physical similarity, feeding method or where they live, in fresh, brackish or marine waters.

The smallest and most abundant plankton, the femto- and picoplankton, are represented by viruses and bacteria. Although less than one-hundredth the width of a human hair, they play an important role in aquatic ecosystems. They break down organic matter, recycle nutrients and control the growth of the plant plankton.

The nano- and microplankton come next. About the width of a human hair, and visible using a light microscope, this group includes a wide variety of mostly single-celled organisms. Some are classed as animals, some as plants – and some sit curiously somewhere between what we think of as plant and ...animal. (Example in book: dinoflagellate (Tripos) and *Noctiluca scintillans*.)

Moving up the size spectrum again, we have meso- and macroplankton. Nearly all multicellular, these are classic examples of animal plankton – the zooplankton. We tend to think of plankton as microscopic, but much larger organisms, such as jellyfish, are plankton too, as they are also swept along with water currents.

Some types of zooplankton spend their entire life in the plankton and may never grow more than a few millimetres in size. These are the holoplankton, like the water flea, rotifer, appendicualria and copepod. (Examples in book: water flea, rotifer, appendicularia, copepod). In contrast, others, the meroplankton, spend only part of their lives as plankton. Typically, meroplankton are the larvae of much larger organisms, such as crabs, worms, starfish and even bony fish. These larval stages can look very different from what we recognise as the adult form, just as a caterpillar looks nothing like a

butterfly. We are still finding larval forms in the plankton and have no idea what the adult looks like!

The phytoplankton, what could be loosely thought of as plants, play a critical role in planetary health, helping complex life to exist. As primary producers, they lie at the base of most aquatic food webs, providing food for those higher up in the food chain. Just like plants on land, phytoplankton use sunlight and carbon dioxide, together with pigments such as chlorophyll, to produce sugars and life-giving oxygen. About half of all the oxygen in the world is produced by these tiny plants – Earth's second lung!

We higher animals owe our very evolution to phytoplankton, in particular to a group known as cyanobacteria or blue-green algae. These ancient microorganisms are a specialised type of bacteria that are able to photosynthesise and produce oxygen. Billions of years ago, the atmosphere was mostly carbon dioxide and methane, so most life on Earth was anaerobic and single-celled. Some two and a quarter billion years ago, as cyanobacteria evolved in harmony with various geological processes, the amount of oxygen in the atmosphere steadily began to rise. This Great Oxidation Event had a profound and lasting effect on the evolution of Earth and life. Higher oxygen concentrations allow for aerobic respiration, which in turn allows for larger metabolisms and the development of complex multicellular life.

Diatoms, members of another major phytoplankton group, have an external structure made up of silica. These glassy houses have a stunning array of shapes, sizes, textures and intricate structures which vary from species to species. (Examples in book: Coscinodiscus, Ditylum, Bacillaria, Licmophora.) So captivating are the geometric patterns found on the surface of diatoms, that the desire to resolve their microstructure helped drive the advancement of light microscopy in the 1800s.

Dinoflagellates also fall into the category of phytoplankton. Although many can photosynthesise, others prey on diatoms or small zooplankton and are thus classified as heterotrophs. Some dinoflagellates, the mixotrophs, demonstrate fantastic adaptation by combining both, using the sun for energy and "hunting" for food.

When conditions are right, several species of phytoplankton can produce blooms, dense populations sometimes hundreds of kilometres in length, so big that they can be seen from space. A notorious bloom forming species is the dinoflagellate *Noctiluca scintillans*. Looking like a tentacled balloon, this species lives up to its common name of sea sparkle. It contains an enzyme that creates a bluish flash of light when the organism is disturbed. If the background sky is dark enough, sea-swimmers can be treated to a spectacular bioluminescent show by *Noctiluca* blooms, which are common in coastal regions.

Not all algal blooms are good. Both diatoms and dinoflagellates can produce harmful ones, with some species producing powerful poisonous toxins, some deadly to other marine life and able to cause upset stomachs, amnesia and even paralysis in humans.

Almost every major group of aquatic animals has representatives that live in the plankton as larvae, adults or both. Zooplankton diversity is as great as that of a tropical rainforest, with herbivores, filter feeders, omnivores and ferocious predators. Zooplankton grazing helps keep phytoplankton populations in check. Unlike phytoplankton, zooplankton can thrive in the dark, living in cave systems as well as the deep ocean. Most, however, can be found in surface waters, the home of their food source. During daylight hours, the zooplankton stay hidden in the dark depths to avoid being eaten by larger visual predators such as fish. As the sun begins to set, the zooplankton rise to feast on the phytoplankton near the surface. This is the largest migration on the planet, and it occurs every day.

Zooplankton are food for larger organisms in the food web and nearly all life in the sea depends on them. Small crustaceans, such as water fleas or copepods, provide food for juvenile fish, themselves food for bigger fish, sharks, seals, birds and dolphins. Some large animals feed directly on zooplankton – some whale species, for instance, consume swarms of krill by the tonne. The leatherback turtle feeds almost exclusively on gelatinous plankton, like jellyfish and salps.

All these trillions of plankton play another essential role in the health of our planet, they regulate the carbon cycle. Their excretions and dying bodies contain carbon, just as the leaves and wood of a tree do. These carbon-rich particles fall gently down through the water column, a marine snow transferring carbon dioxide, once in the atmosphere, down to the sediment, where it can be locked away for hundreds of thousands of years.

Different types of plankton prefer different conditions, needing particular values of salinity, pH and temperature as well as specific nutrients. This makes them excellent indicators of change – indeed, on a planetary scale, plankton are the most sensitive group of organisms to environmental change. Scientists have noticed that certain species are responding to warming waters and climate change; abundances, seasonal timing and distributions are shifting. They are concerned about the effect of these changes on finely balanced food webs, oxygen production and the carbon cycle.

A cupful of water holds a hidden planktonic world. Under a microscope, the seemingly empty and uninteresting suddenly turns into an abundant, diverse ecosystem bursting with life. Without plankton, the world that we call home would be very different. There would be no fish, no penguins, no crabs, no barnacles, no whales – and not enough oxygen for us to have evolved. We, and many other species, owe our very survival to the humble plankton.

This book opens up and honours the often-unseen world of the plankton. Its spectacular photography will lead you to a deep appreciation of the beautiful array of shapes, forms and functions found in these life-giving organisms.

Marianne Wootton

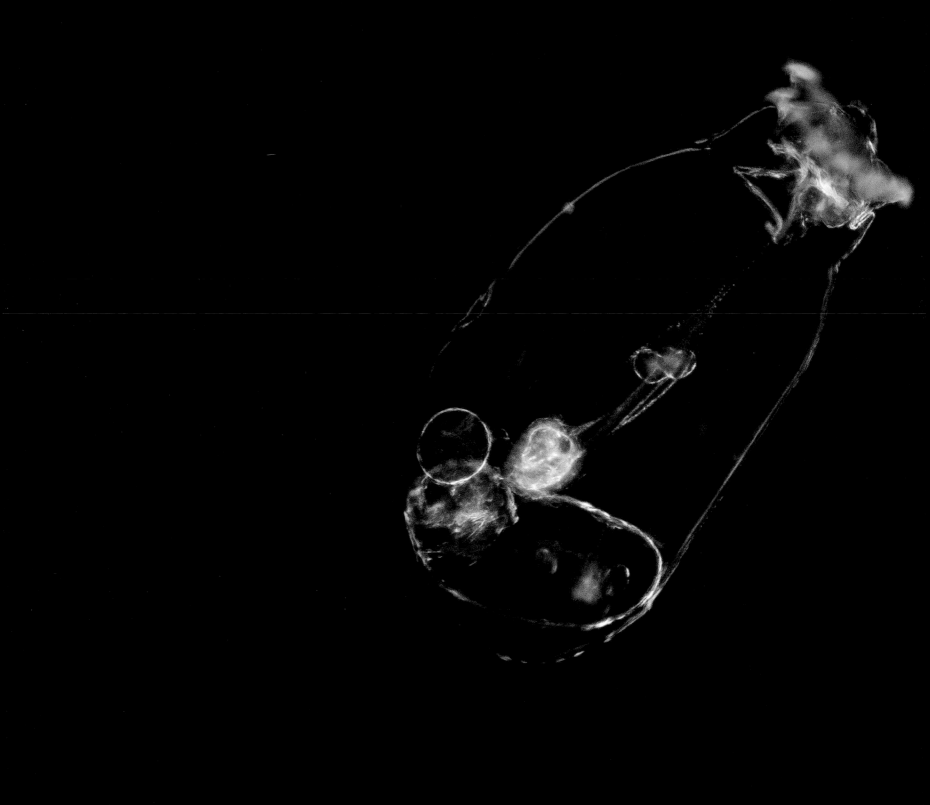

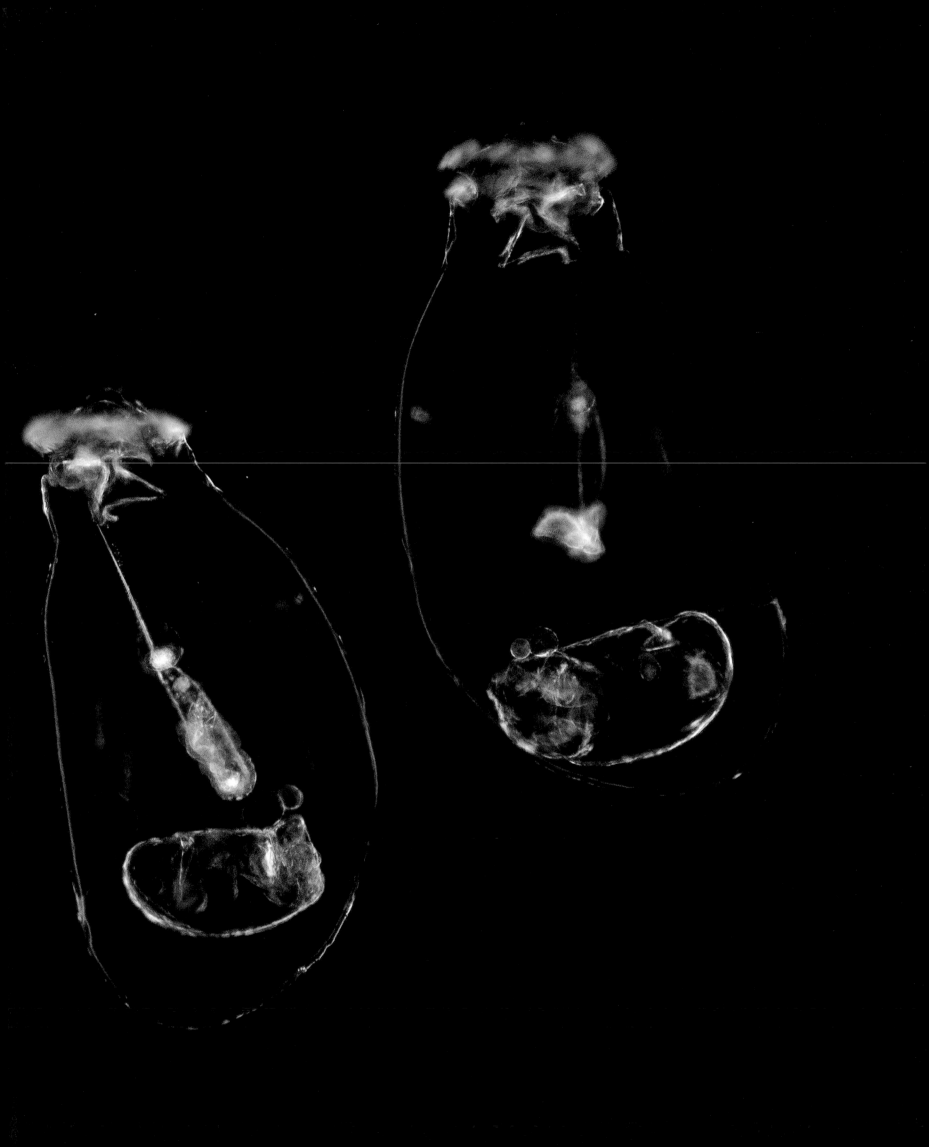

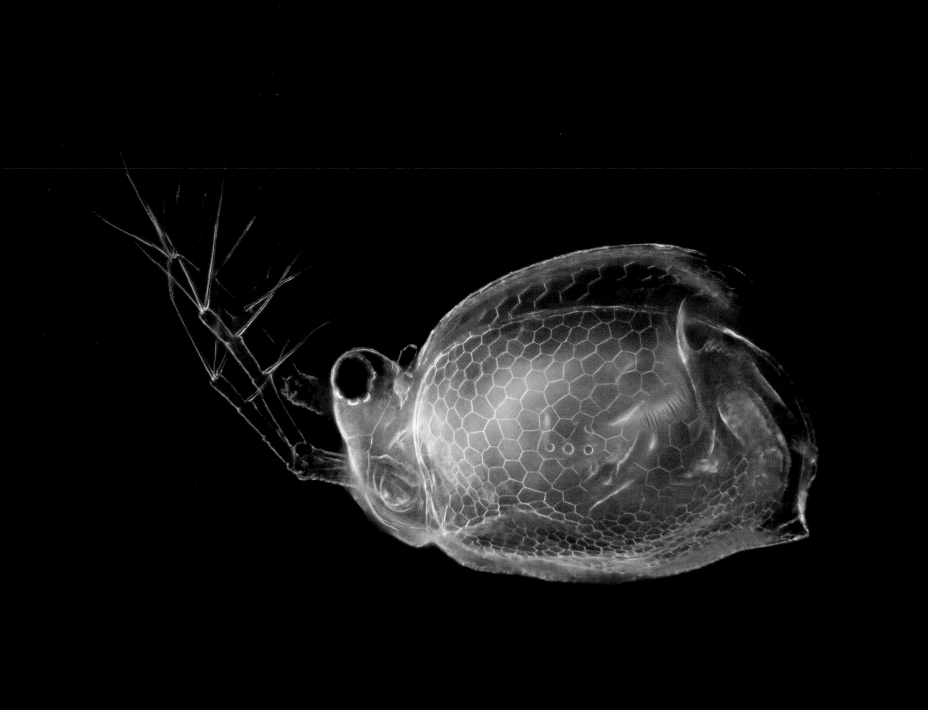

DANCING PLANKTON,
OR THE ART OF THE INVISIBLE

Flocks of starlings in flight, the nascence of a salamander, the birth of a water flea: everything Jan van IJken encounters in nature, records on film, and captures as a photograph is gradually decreasing in size, and *Planktonium* reveals his most recent results. But as he zooms in on the tiniest organisms, their importance only seems to increase. Without plankton, there would be no life on Earth, neither in the water nor on land. Van IJken's graphic research increasingly impresses upon you how vulnerable all natural processes are, right down to the smallest life forms existing alongside human beings who imagine themselves to be the central figures in nature.

Through his work, Van IJken resembles a contemporary Antoni van Leeuwenhoek, the 17th century scientist whose use of microscopes in Delft earned him the title of the father of microbiology. When he placed his own dental plaque and sperm under the microscope, he was amazed to see it teeming with all sorts of 'creatures'. Likewise, Van IJken's curiosity leads him to examine the simplest life forms in his immediate surroundings before capturing them on film, either statically or in motion. He fishes them out of Dutch ponds and ditches, or out of the Wadden Sea mud. His process involves something Van Leeuwenhoek was unable to do: capturing these images. Many developments had to take place before this was possible: early experiments with light-sensitive paper and metal in the 18th century (by the Germans Johann

Schulze and Johann Kniphof, and the Austrian Alois Auer), the 19th-century 'chronophotography' practised by the Frenchman Etienne-Jules Marey and the subsequent first time-lapse film by the Swiss Julius Ries in 1907 showing the fertilisation and birth of a sea urchin in a two-minute, 20 metre film. The role of these scientists is often overlooked in the development of photography as a visual art. Their techniques also had to be considerably simplified and made more affordable before artists such as Van IJken could capture images of the very tiniest organisms, how they move, how they multiply and finally, of the patterns they make when they live in groups.

Making visible what is invisible to the naked eye has fascinated many for centuries. But it was not until the 1960s that the general public was unavoidably confronted with such incredible images on a grand scale when they were circulated through new mass media. It happened in two ways, almost simultaneously. In 1965, *Life Magazine* in America published the first colour photographs of the development of the human foetus, taken by the Swedish photographer, Lennart Nilsson. Four years later, Neil Armstrong took the first colour photos of the moon, while he himself could be seen in black and white on TV as the first man to set foot on the moon. Two revolutionary photographic and cinematic moments in a short space of time thus made everyone aware of the vulnerability and the beauty of life on Earth. It was breathtaking,

astounding – and beautiful. The closer you get to nature, the more mysterious it becomes. The fact that the development of photographic and cinematic techniques at micro level has also progressively enabled doctors to view the entire body from the inside using miniscule cameras – and has even enabled robots to perform life-saving surgery – has only served to increase the mystique surrounding it.

From the first photos of plants taken by Henry Fox Talbot right through to the images of the coronavirus produced by means of an anonymous technique or those of the planet Jupiter taken by the new James Webb telescope, the formal beauty of the unknown – because invisible to the naked eye – is often the first to catch the attention. You see perfect circles and ellipses, identical halves, perfect multiplying patterns. The viewer cannot avoid the idea that there is 'a system' behind so much geometry. Some see this as the effect of growing scientific knowledge dating back to the Enlightenment which provides perceptions of beauty from biology, physics, chemistry to mathematics. Others attribute less cerebral, more religious emotions it to ('only the mastery of a God could devise such a thing').

Enter Jan van IJken, in the tradition of so many other contemporary artists who use science to demonstrate what humans' sublime experiences of nature can entail (such as in David Hockney's iPad work). Van IJken transforms it using a variety of techniques - employing light, colour and time - into a new ensemble. He not only captures images, as has been done in 'ordinary' science films to the fascination of many for

over a hundred years. He confronts the viewer not merely with forms, colours and movements – ranging from flocks of starlings to a drop of plankton – which are complex in themselves. From a wealth of material, he selects the shapes, movements and processes which intensify a one-time, fleeting introduction to such images in nature or through news media and makes them inescapable. They invite reflection.

Through the shapes Jan van IJken chooses for *Planktonium*, he strips the various organisms which make up plankton of their everyday, almost banal, contexts. He gives an idea of their dazzling variety of manifestations and colours. He shows different stages of development, demonstrates how they combine to create new shapes, and how the 'organisation' between all these shapes progresses. He does not make use of a narrative structure, however, as in an earlier project, *Becoming*, where he depicts the development of a salamander, from conception to 'birth'. Research is not the aim of this work of art. In the film made of the *Planktonium* project, we do not get to see or hear the names of the various organisms (these can only be read in the book). Neither do we discover which is more unique than the other, where we can find them and which is the most threatened (all of them in fact). Van IJken does something else: he beautifies the most invisible. By adding sound to the film images – a special composition by the Norwegian composer Jana Winderen, who includes the natural sounds of shells and whales – the plankton appears to dance (the sound and movement has to be imagined when reading the book). It is essentially an endless dance of unlike

organisms, which nonetheless form an ensemble from the beginning to the end of the film in which they appear – or from the first to the last page of the book. Nor is any order introduced: from simple to more complex organisms, for example. They are only classified to some extent by colour and shape. *Planktonium* is neither an encyclopaedia, nor a sampling – although the Latin-sounding fictional name might suggest otherwise. It is a collection of manifestations which are simultaneously intended to overwhelm.

Van IJken's projects can be compared to an image of natural phenomena which are intended to evoke a new sensation, rather than simple recognition or a discovery of something you have not yet seen (such as an image of a virus or an unknown constellation). Taken together, the images in *Planktonium* give rise to a sublime experience. This experience is not immediately connected to the recognisable, but to the experience of nature in its most 'exposed' form. Many of Van IJken's images in Planktonium recall the tradition of Absolute Film and photography from the 1920s, such as the visual compositions created by Ruttmann, Richter, Fischinger and Eggeling, the work of surrealists such as Man Ray, the most abstract images in works by post-war painters such as Pollock, Newman or Rothko, and of the Viennese Actionists, Arnulf Rainer and Günter Brus who rediscovered the work of their fellow Viennese artist, Auer. They demand silence, patience, attention and an open mind.

Furthermore, Van IJken's *Planktonium* certainly has activist potential. The project could definitely be used in a political discussion about the destruction of the earth's ecosystem by the burning of fossil fuels. Plankton is the first non-human victim of this, after which the rest of the food chain will follow. These images do not focus on what climate change or microplastics bring about, but the implication is obvious. The simple but effective posters which read 'Bye-bye fish, Bye-bye birds, Bye-bye flowers, Bye-bye people' distributed by the Dutch environmental organisation *Milieudefensie* in the early 1970s and hung up at many windows could be given a contemporary make-over with plankton. Every creature counts.

Pauline Terreehorst

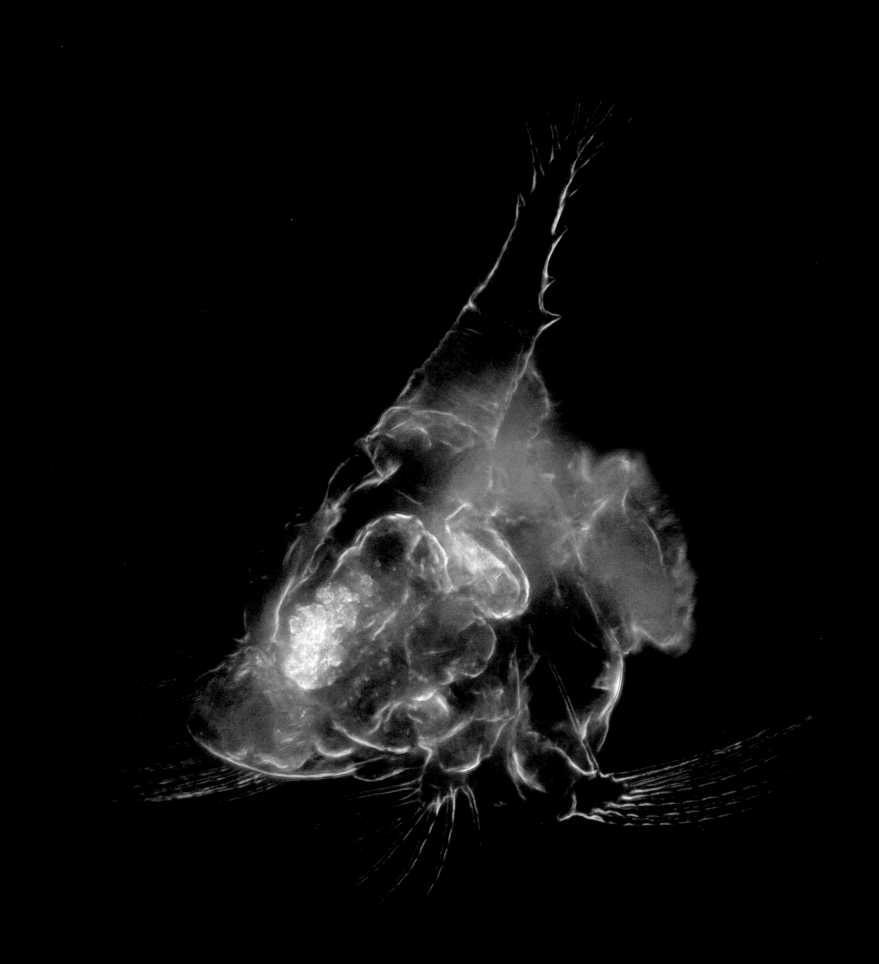

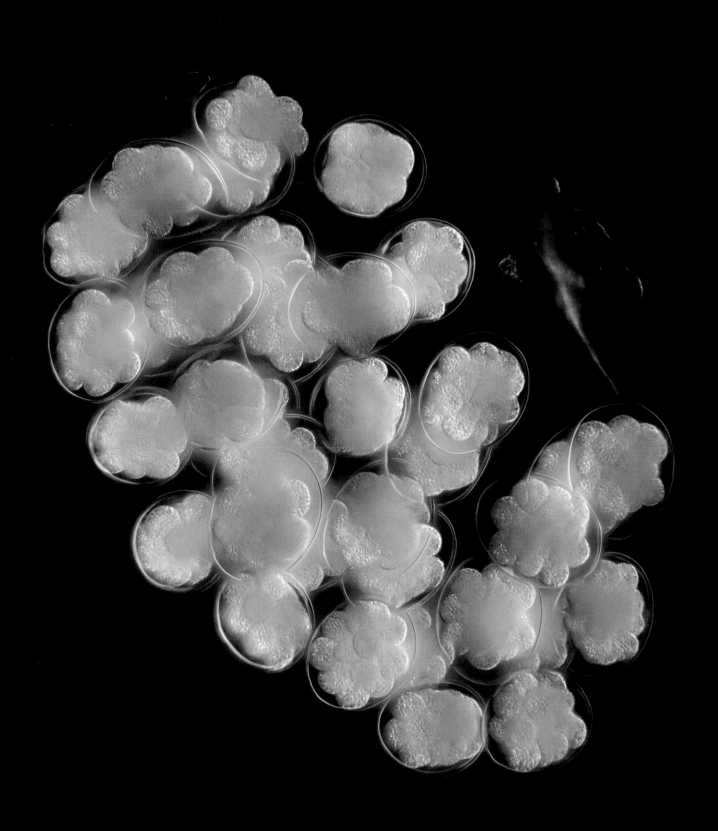

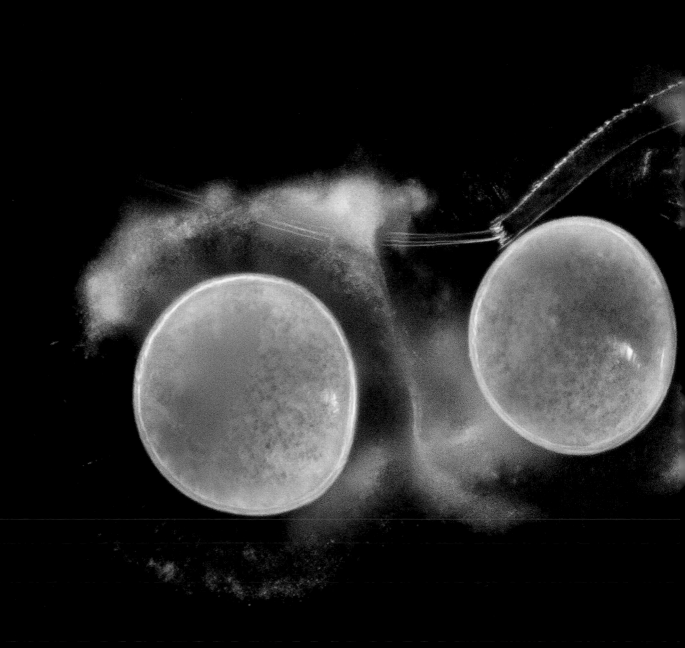

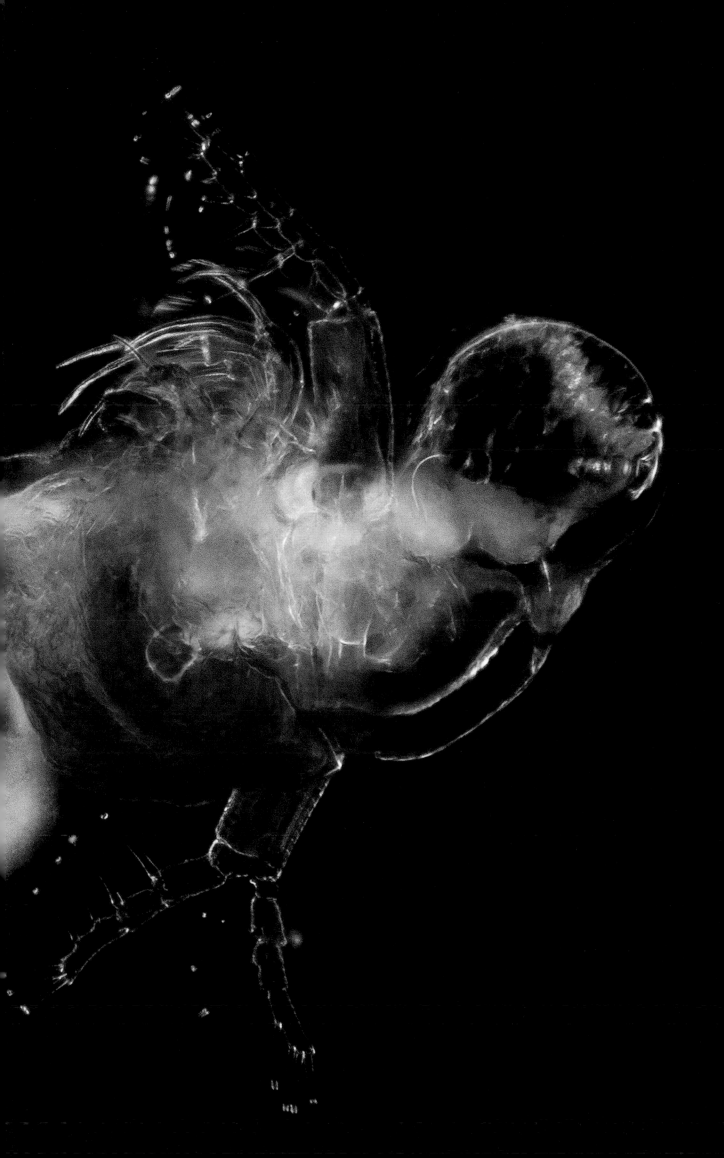

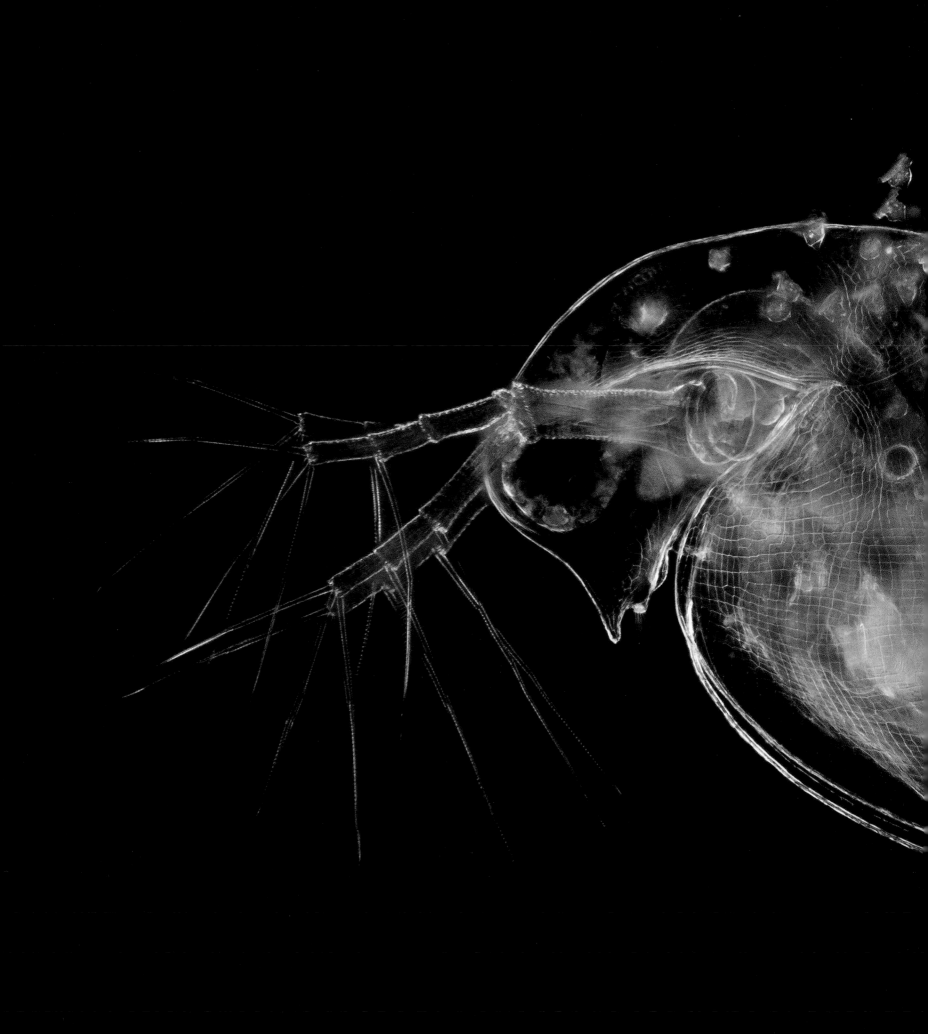

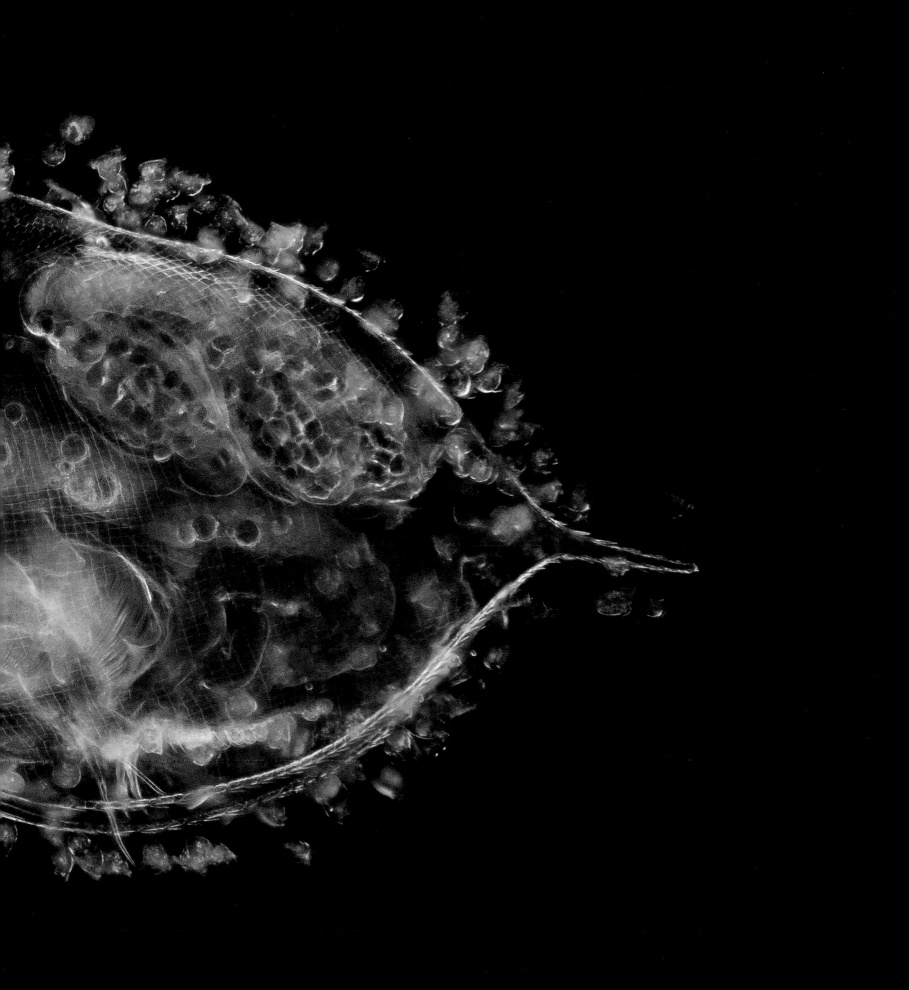

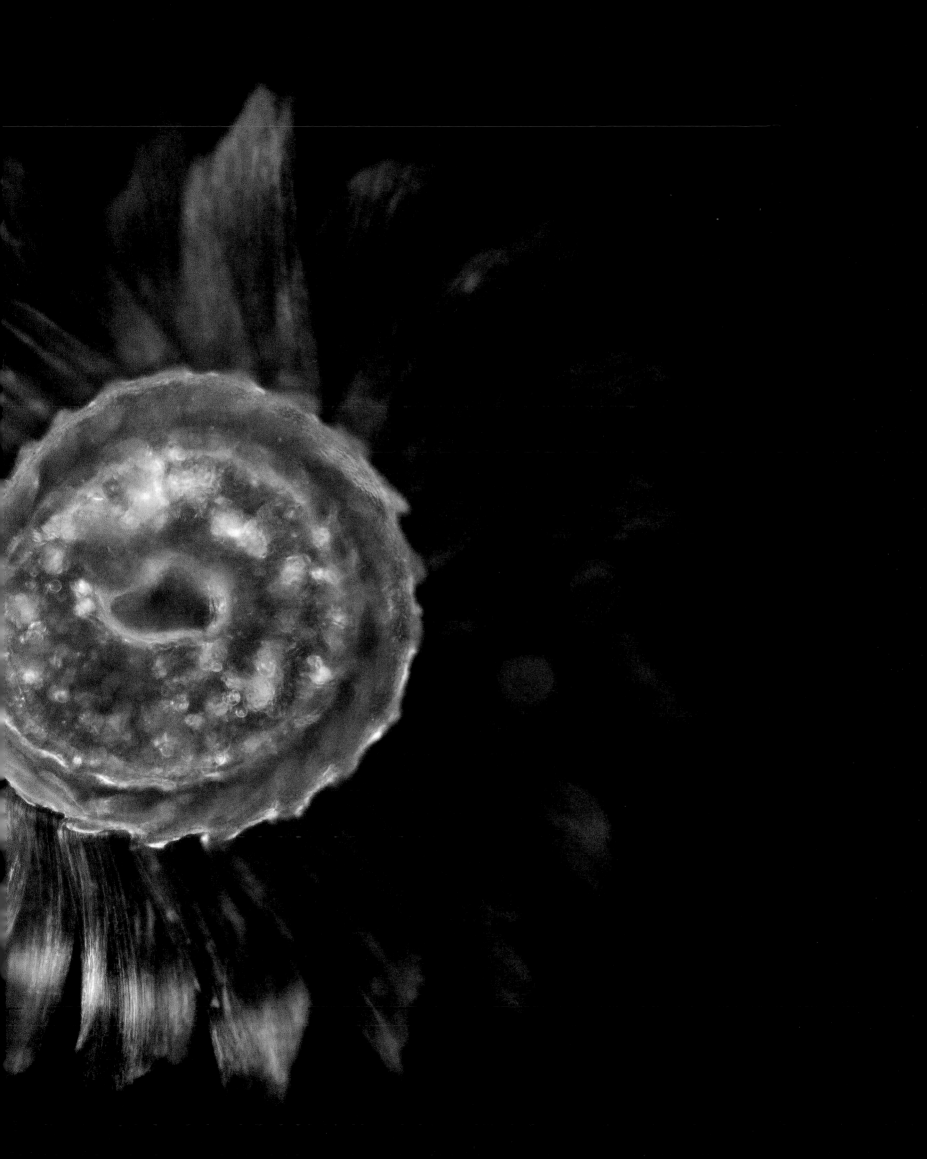

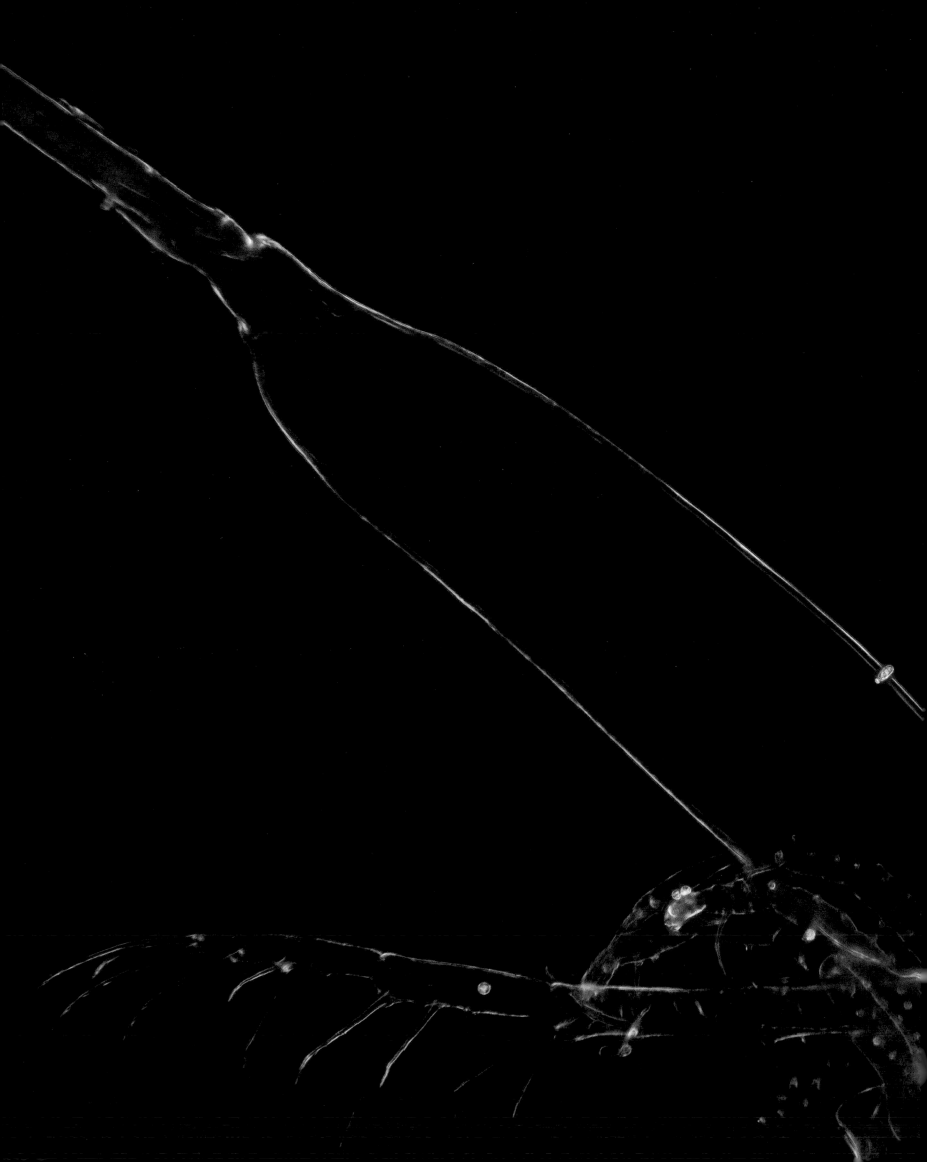

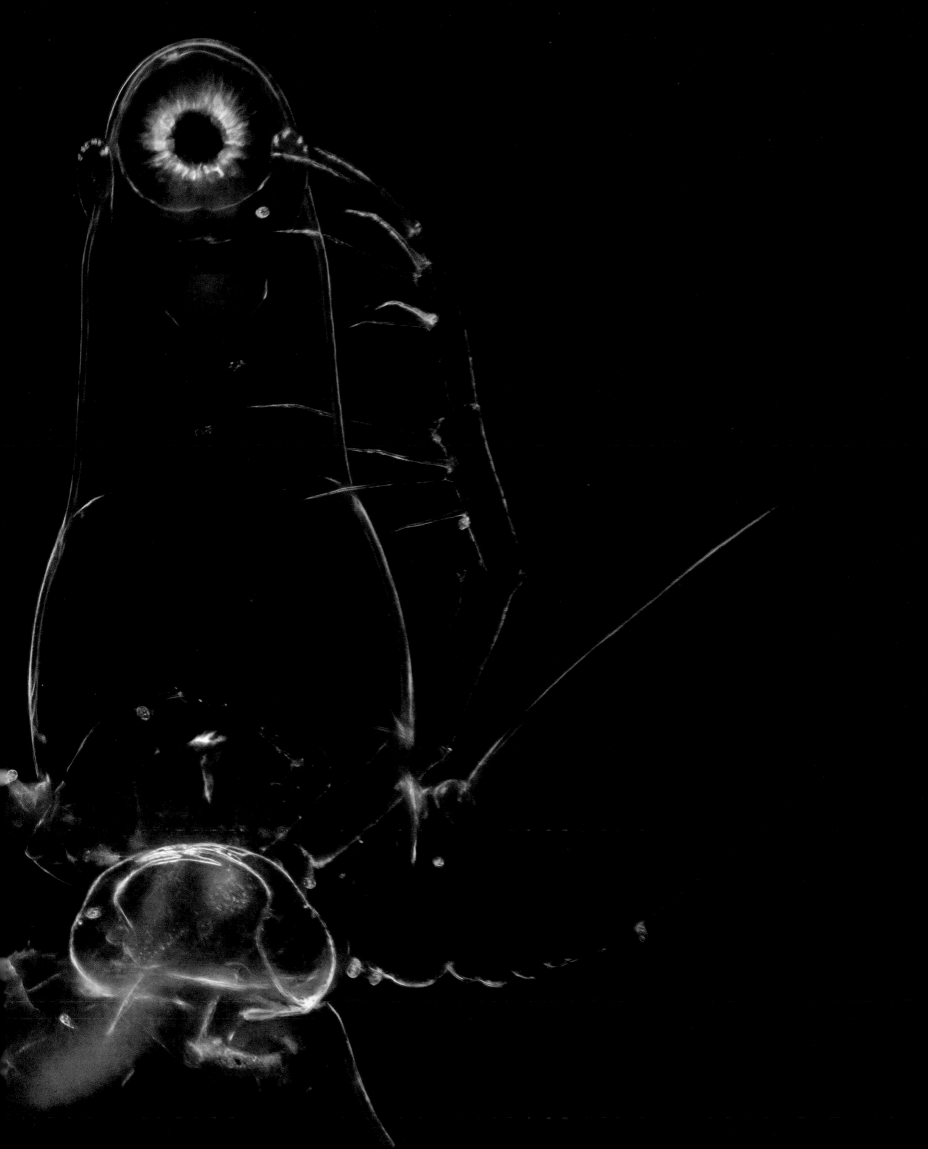

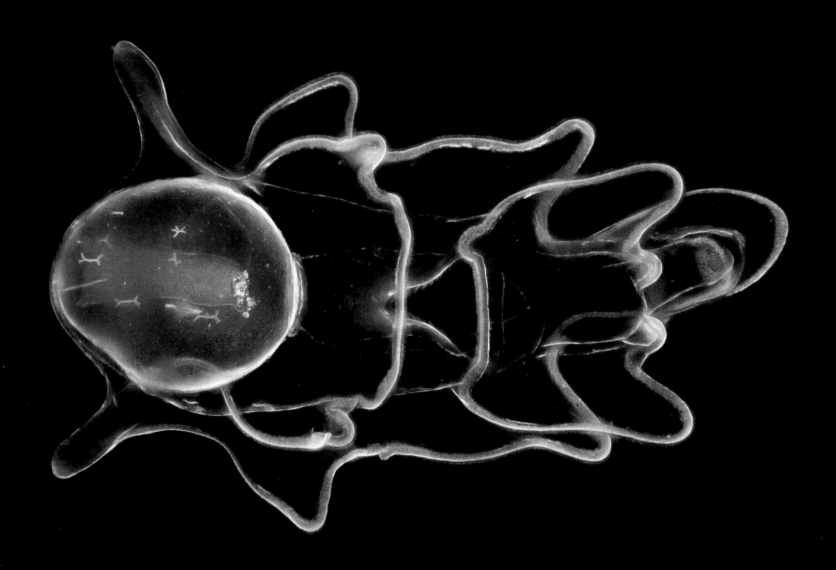

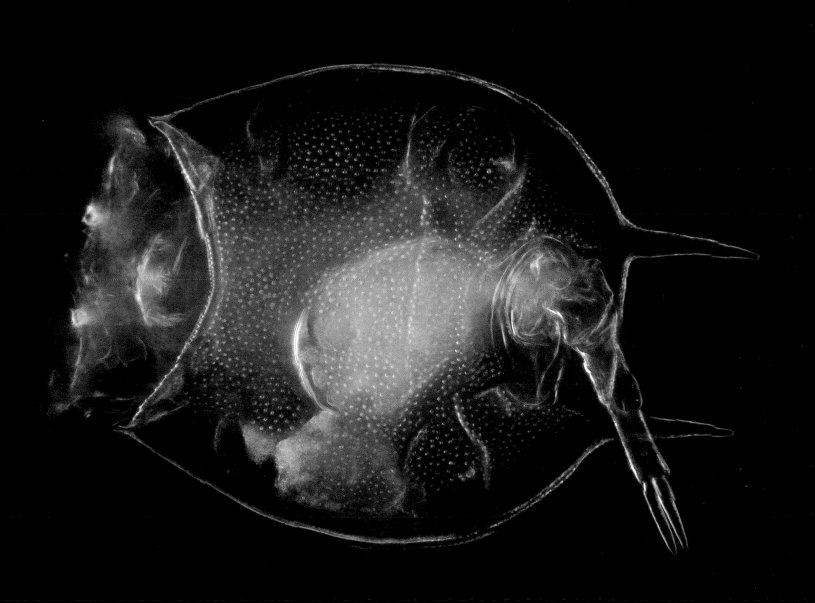

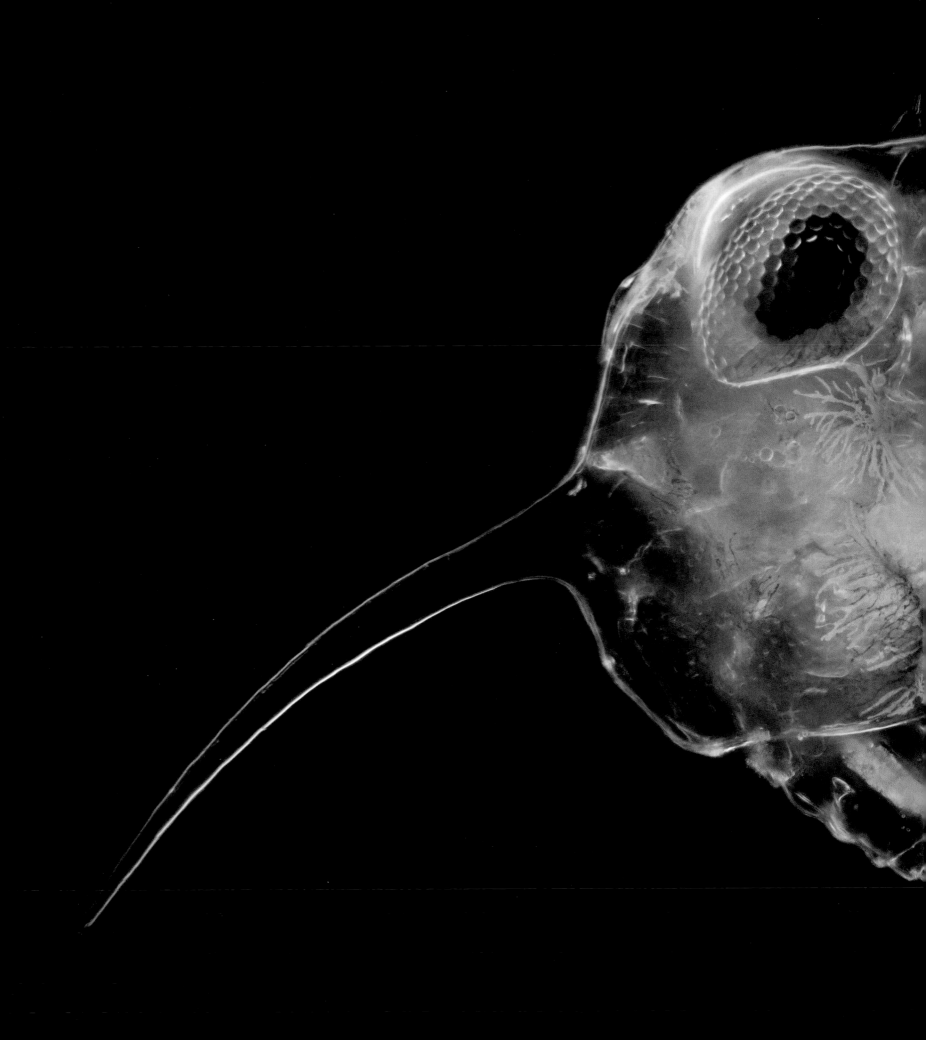

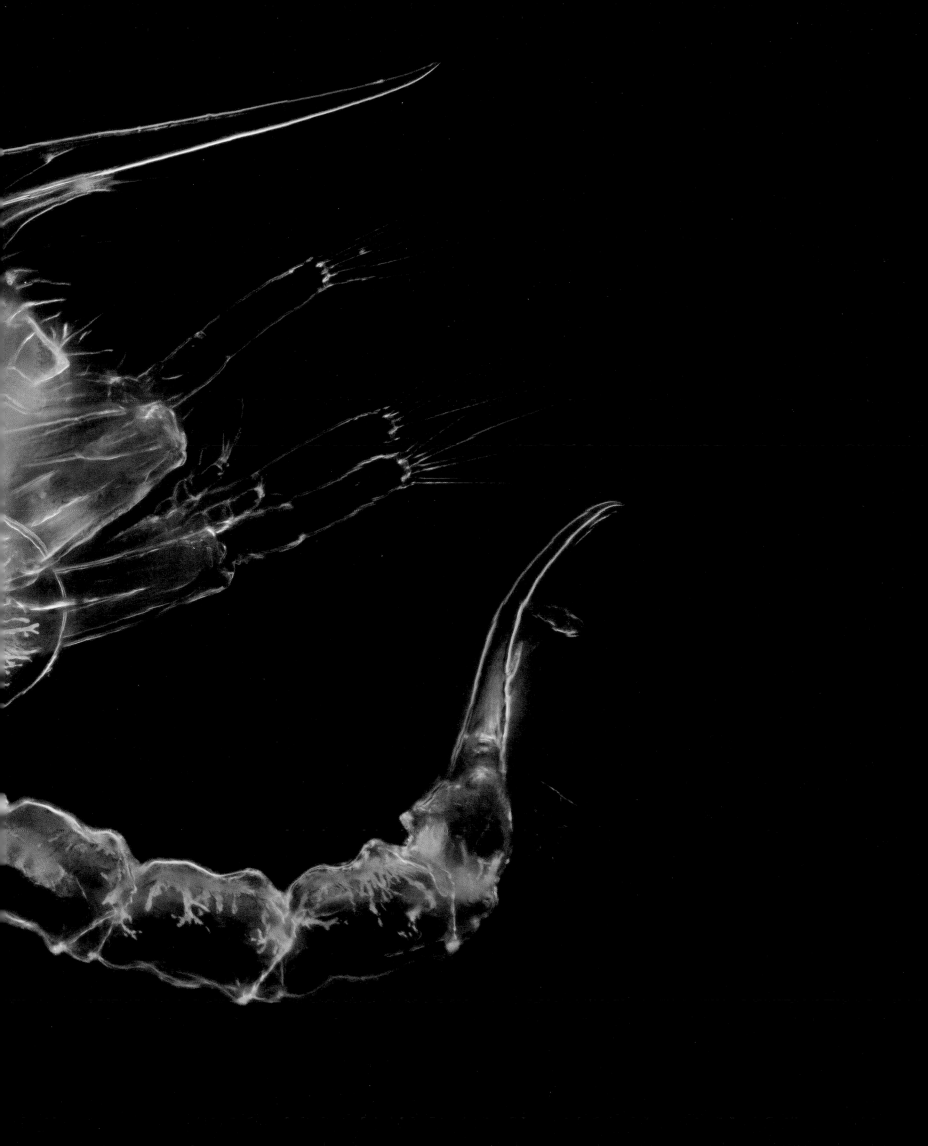

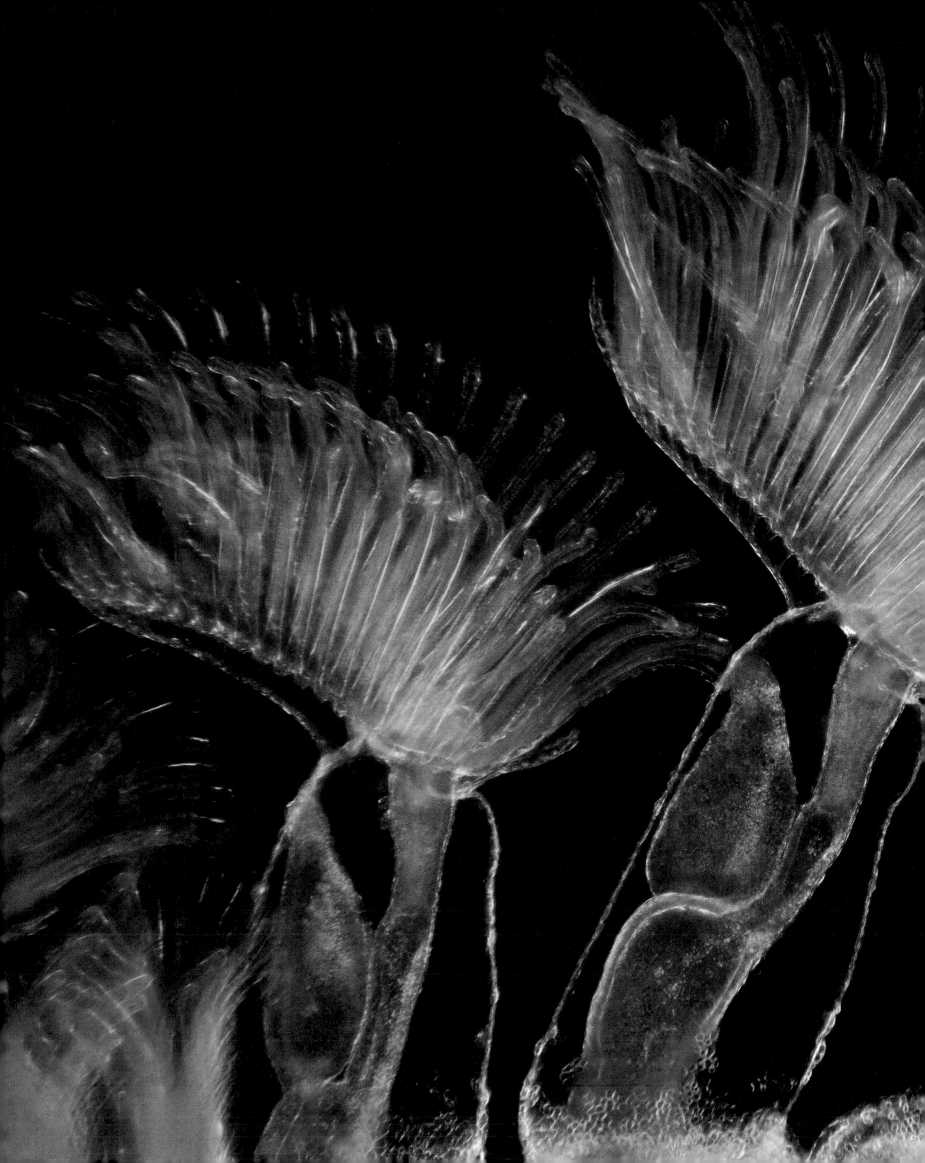

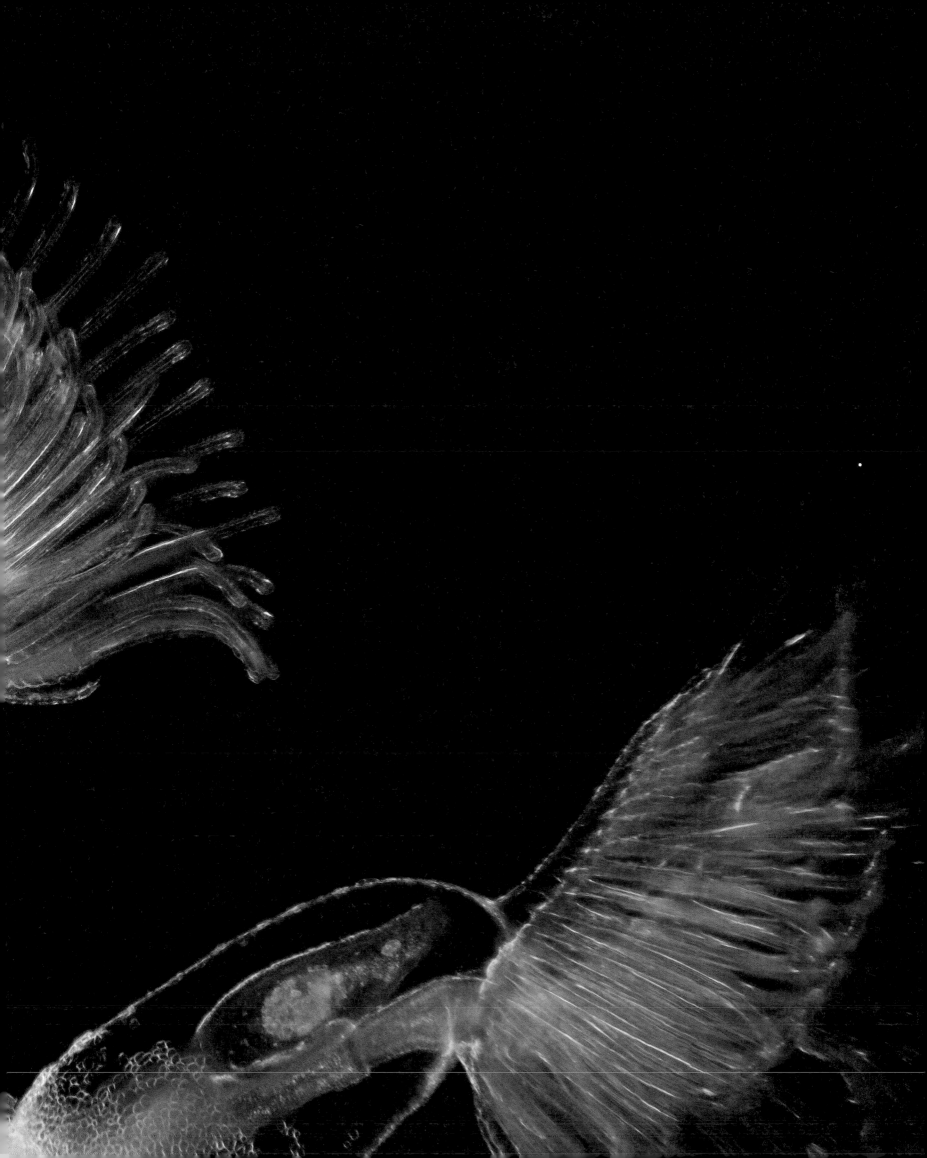

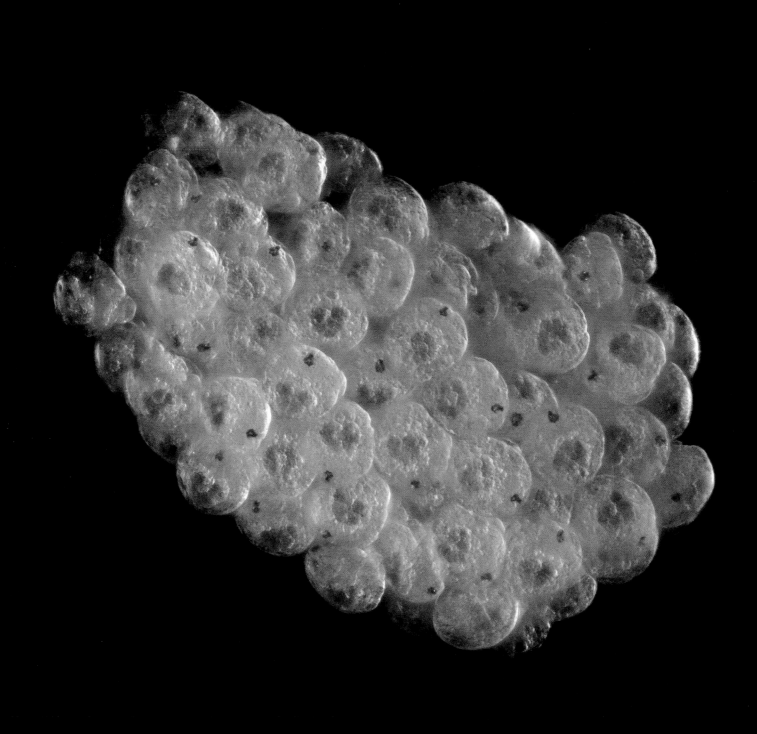

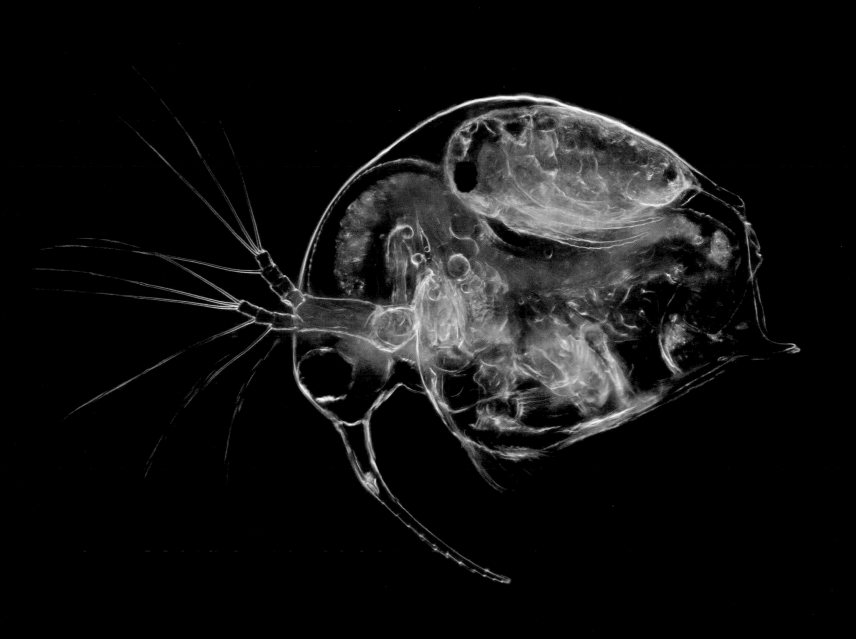

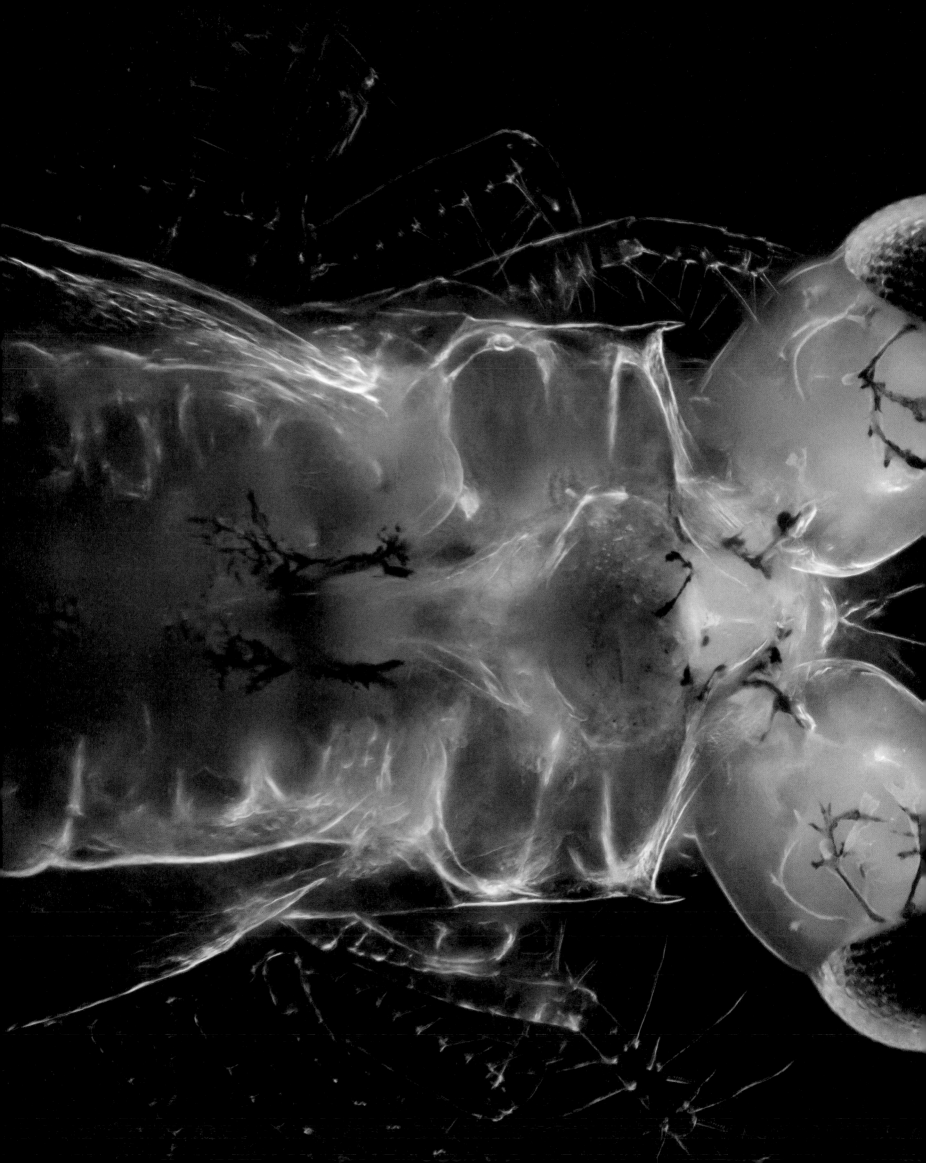

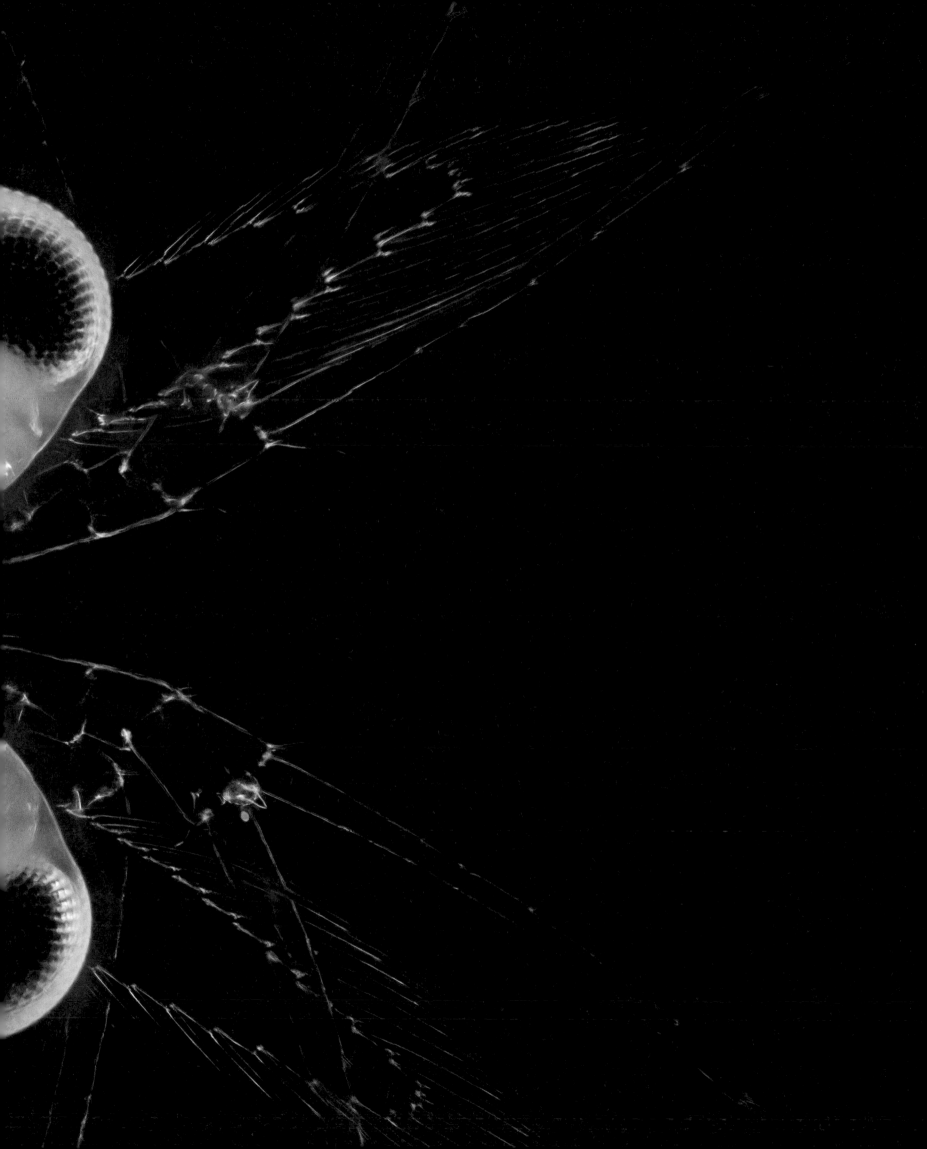

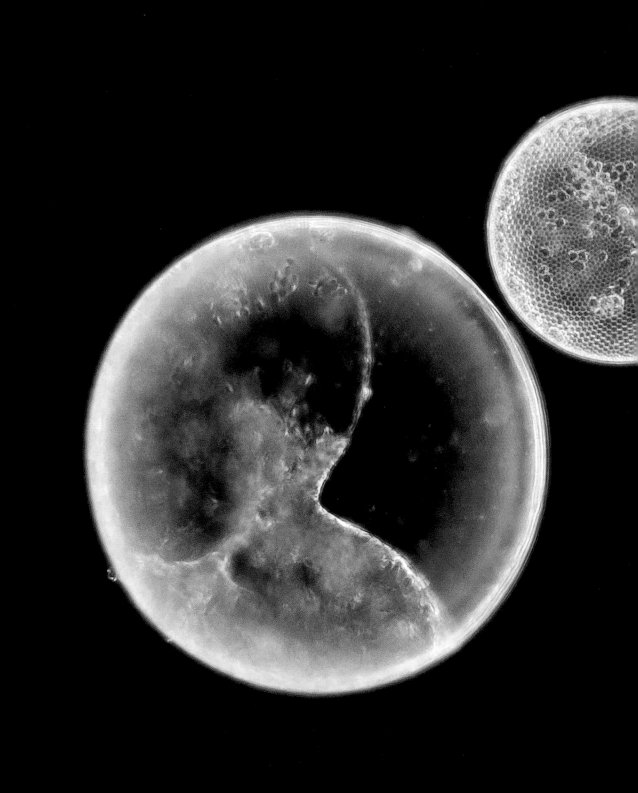

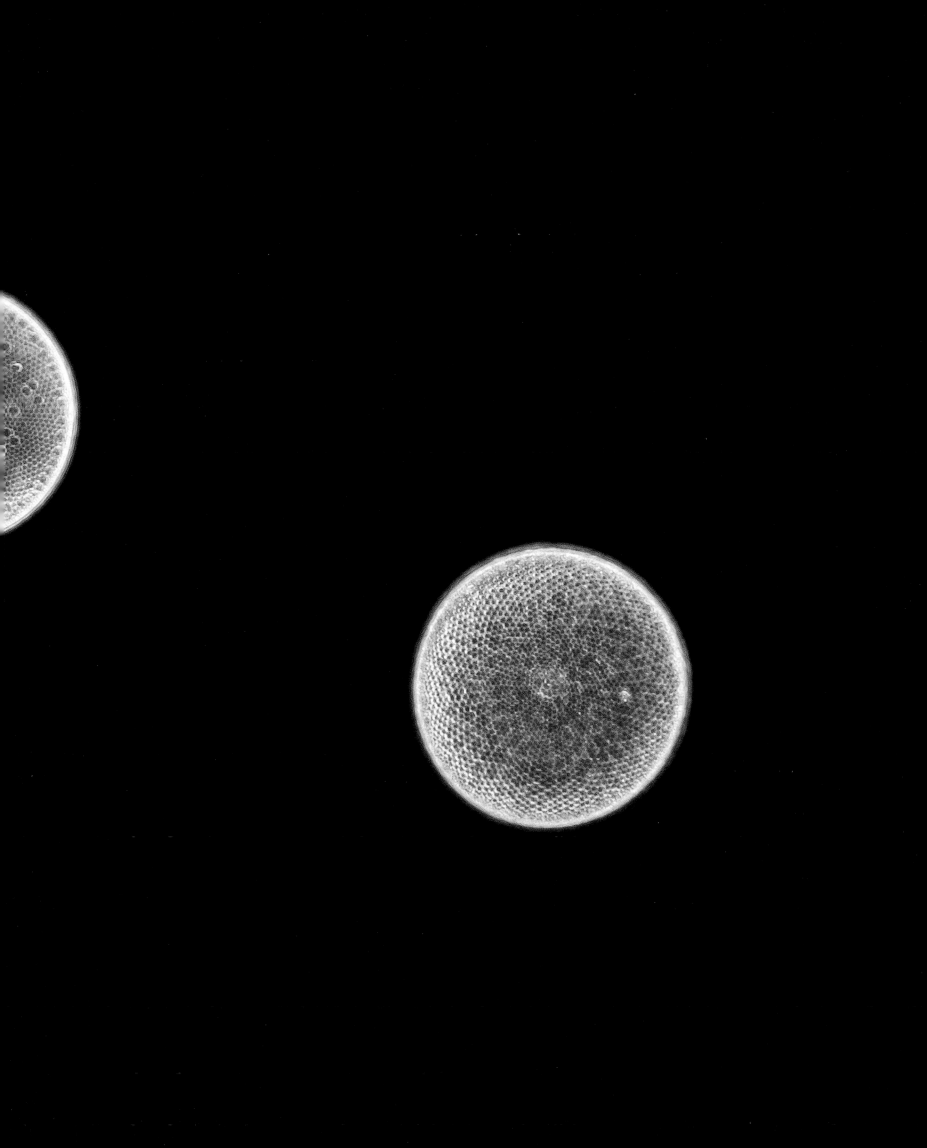

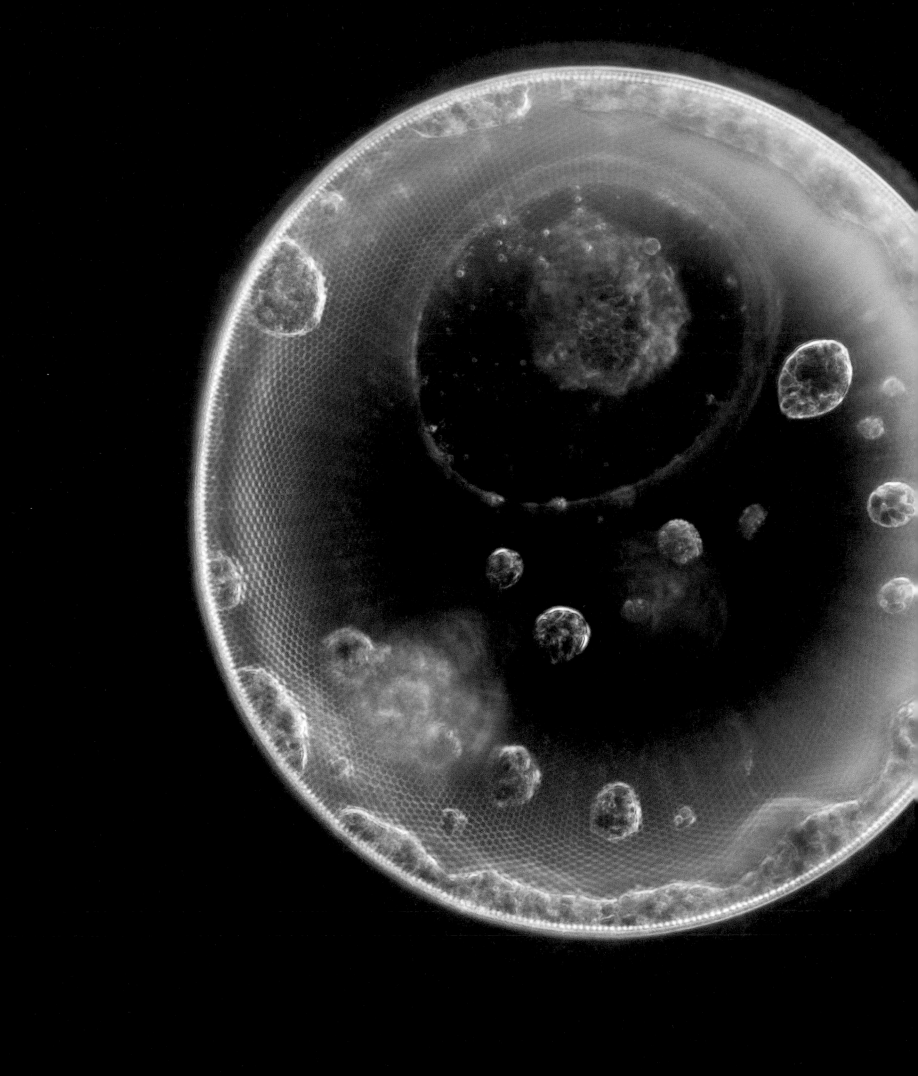

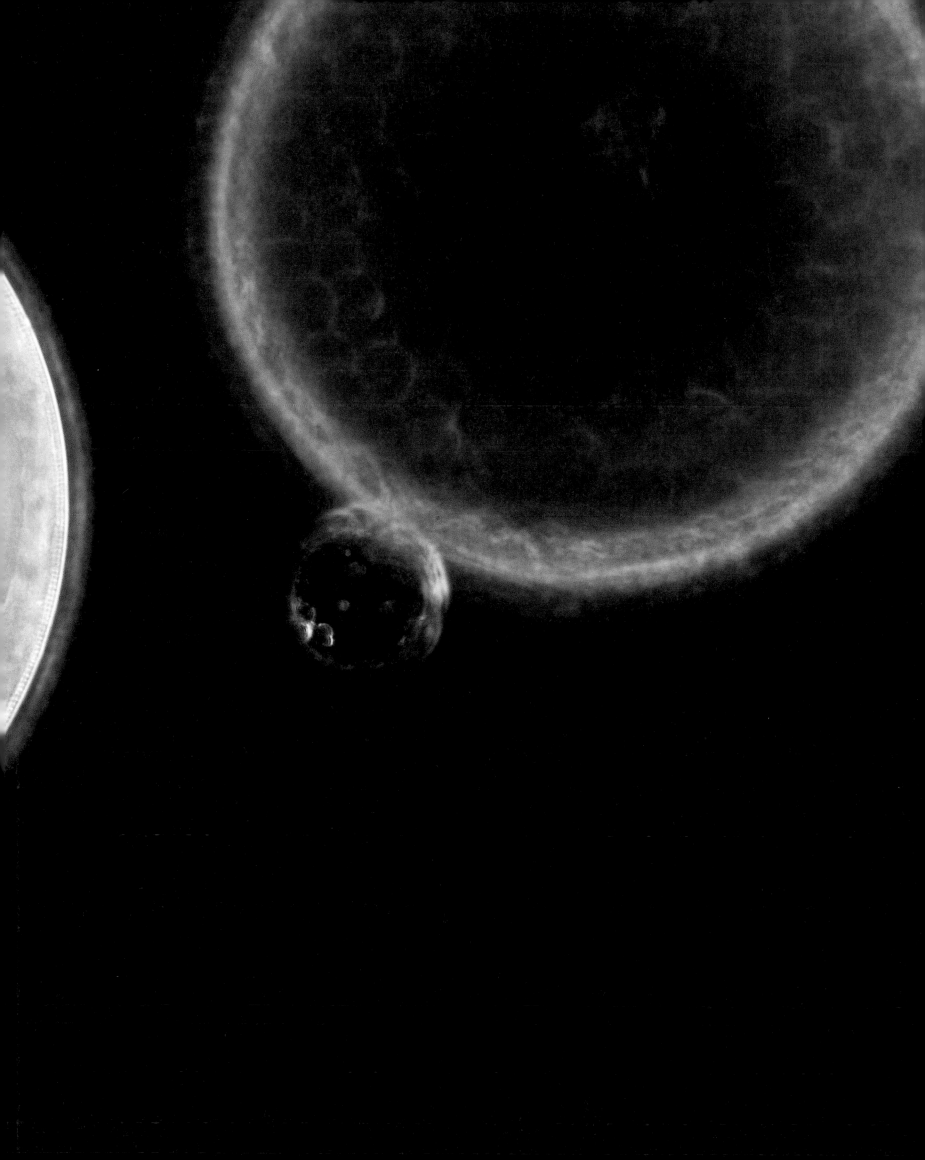

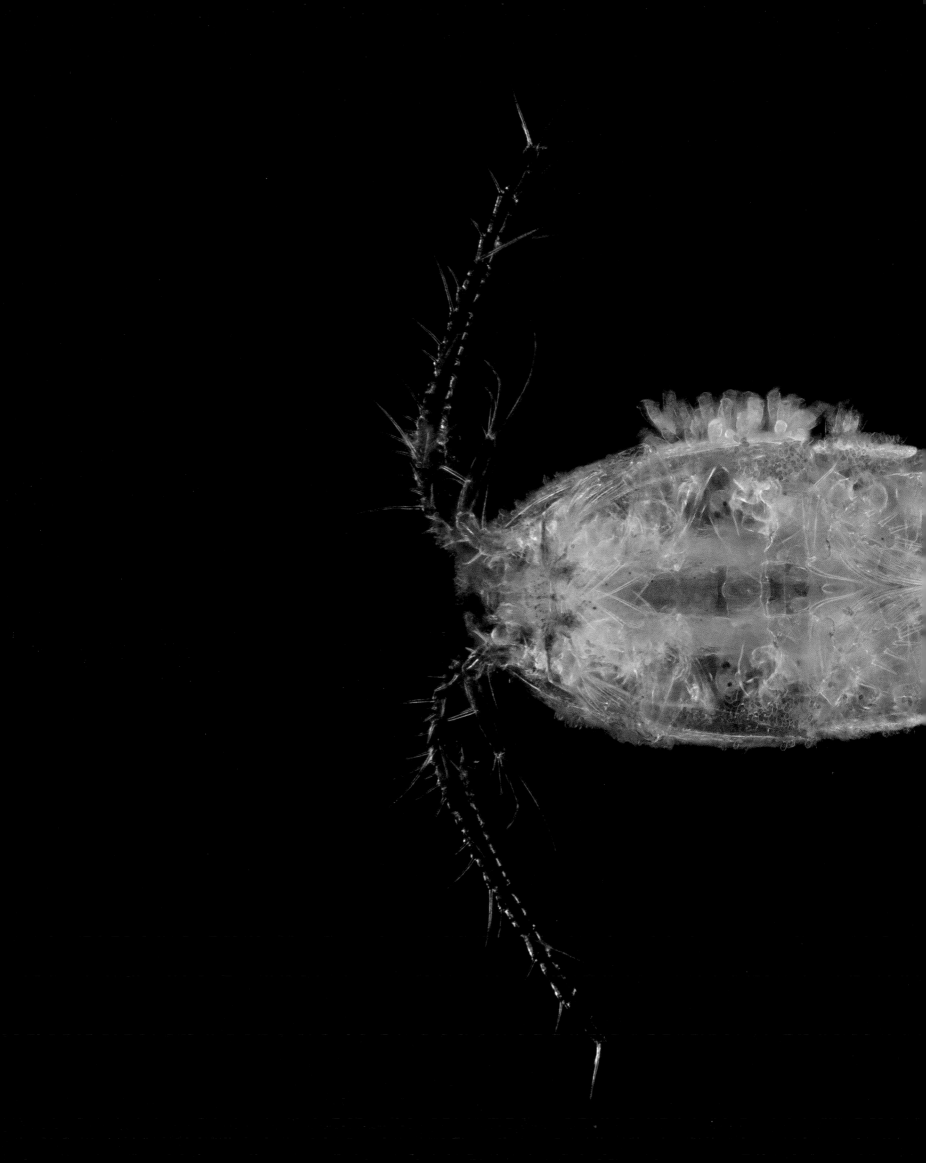

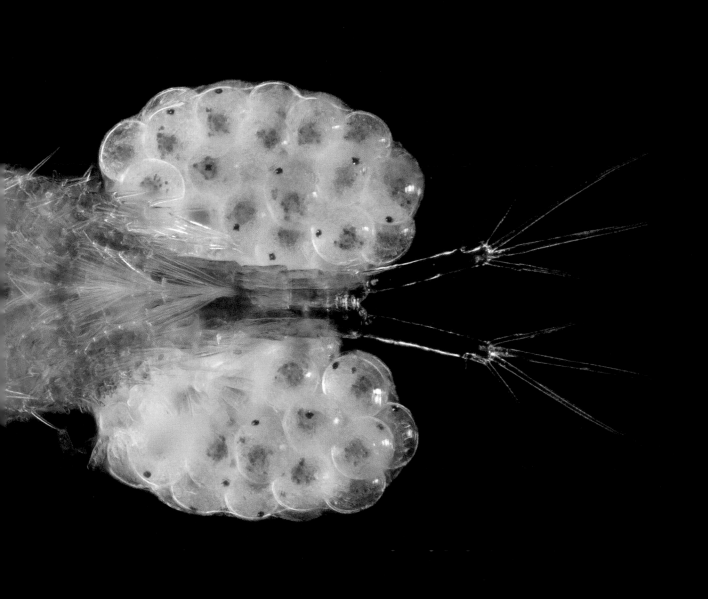

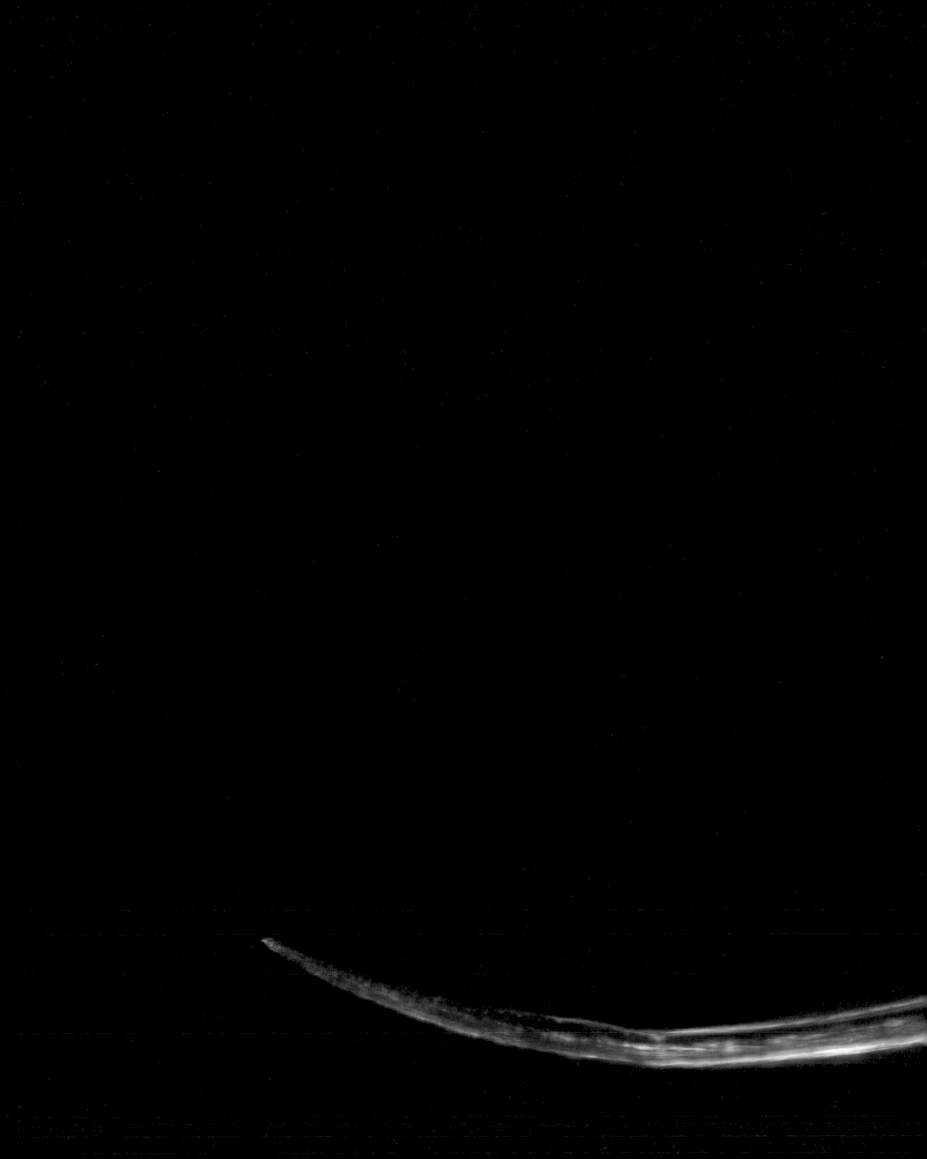

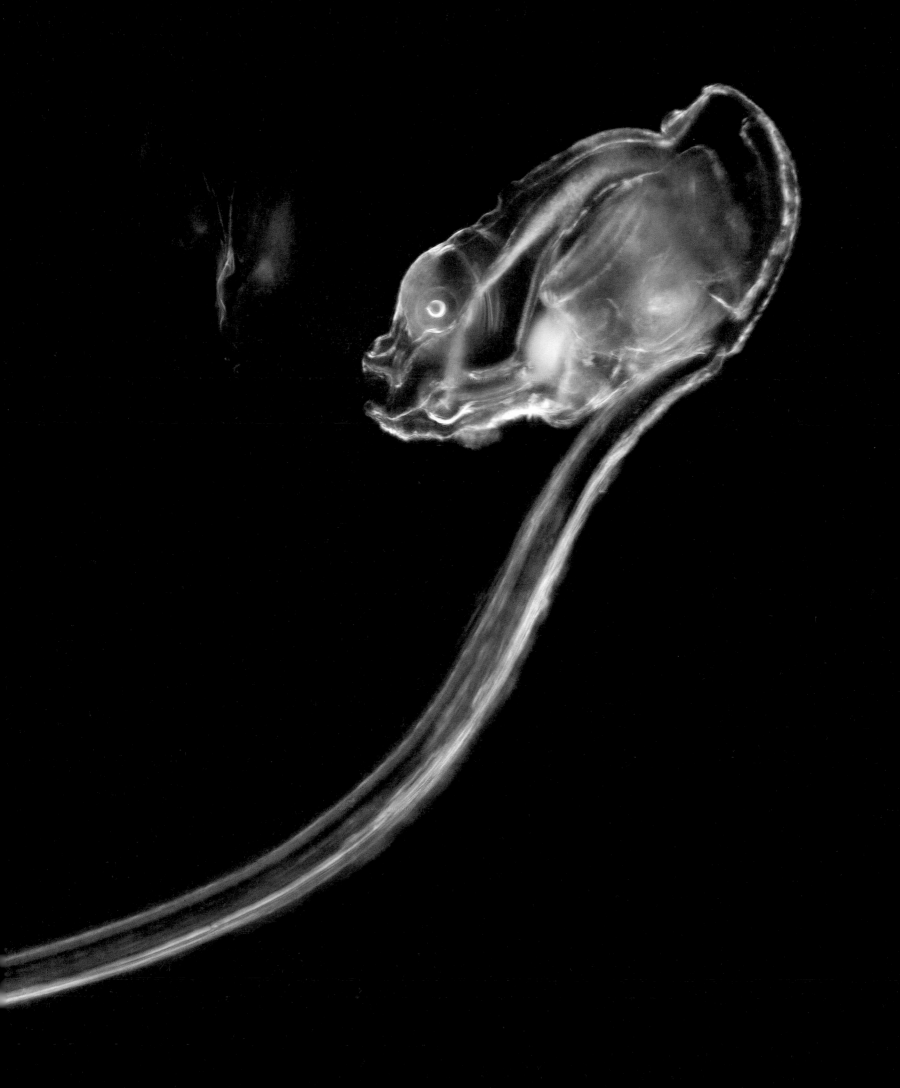

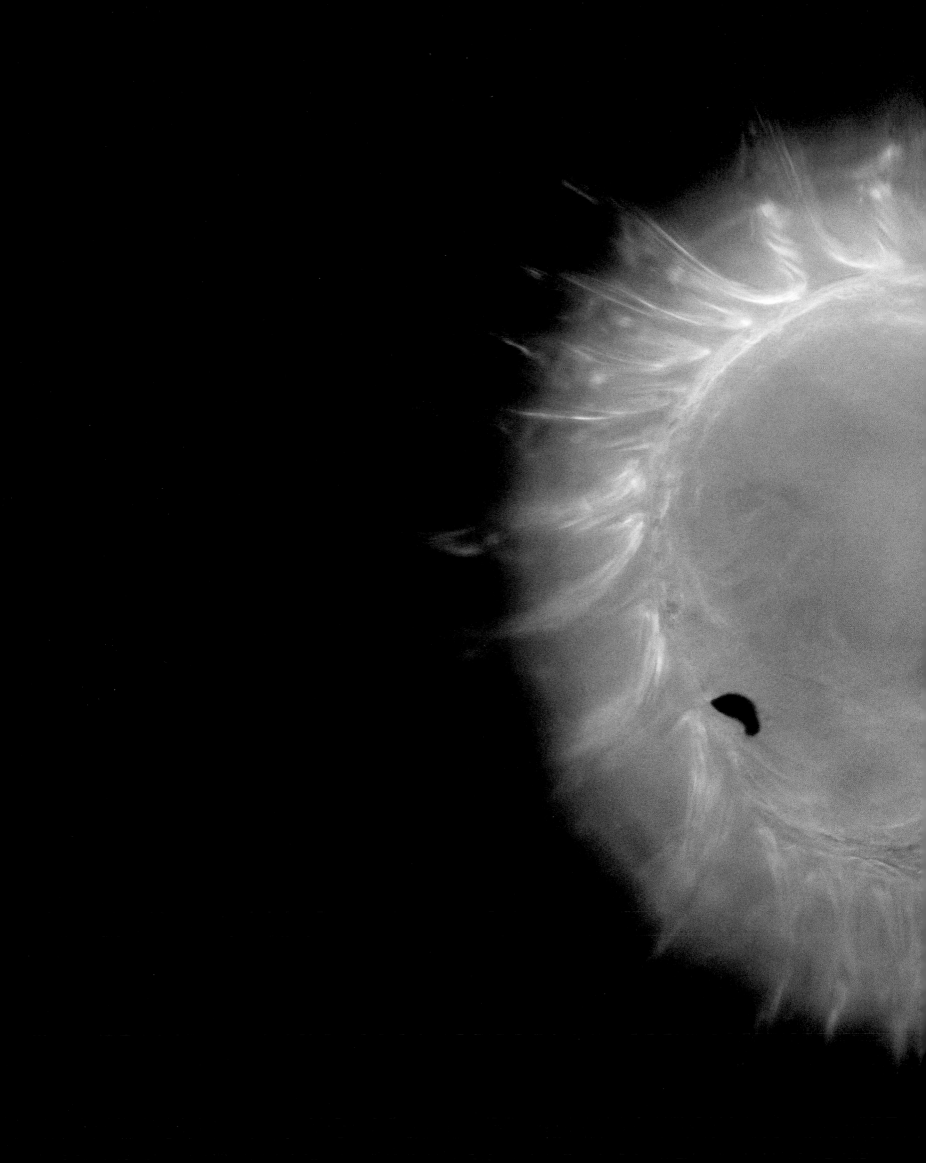

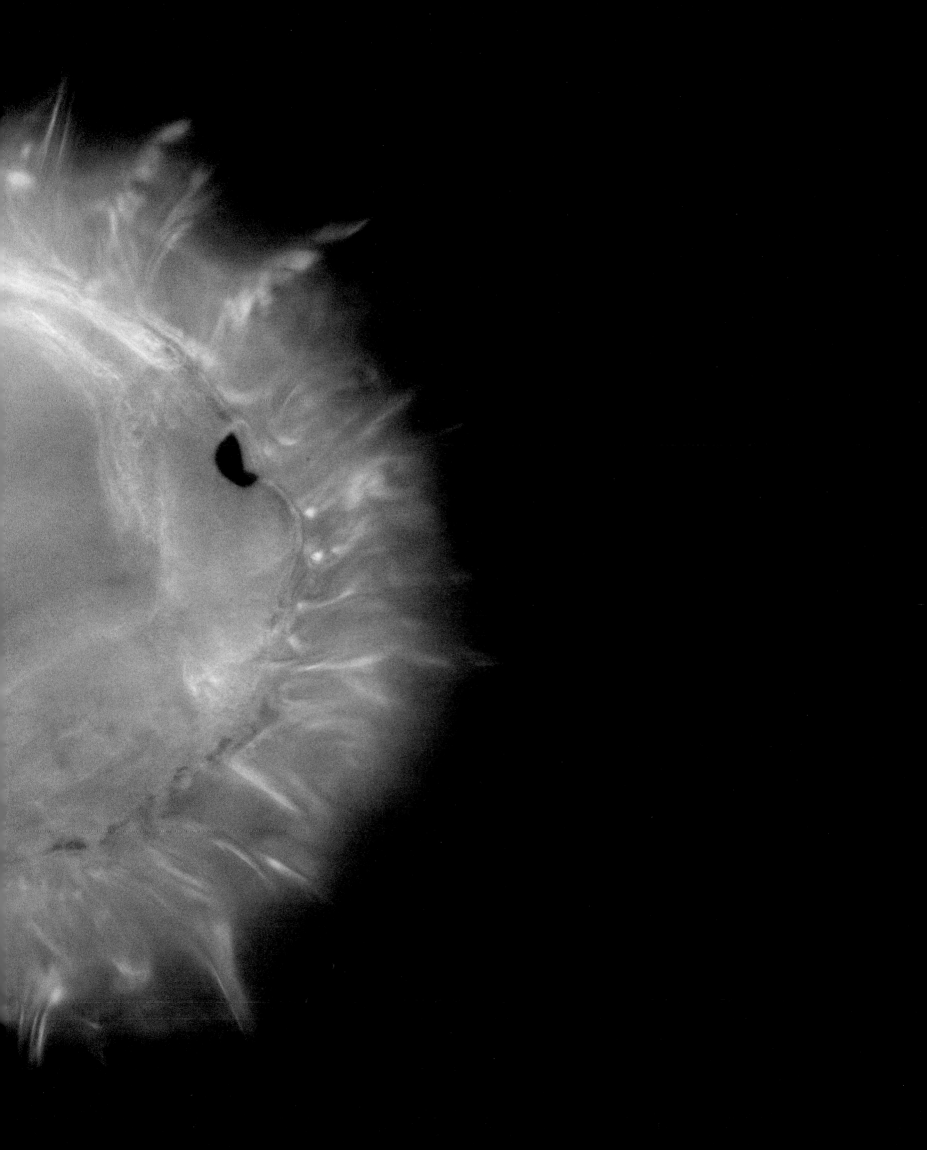

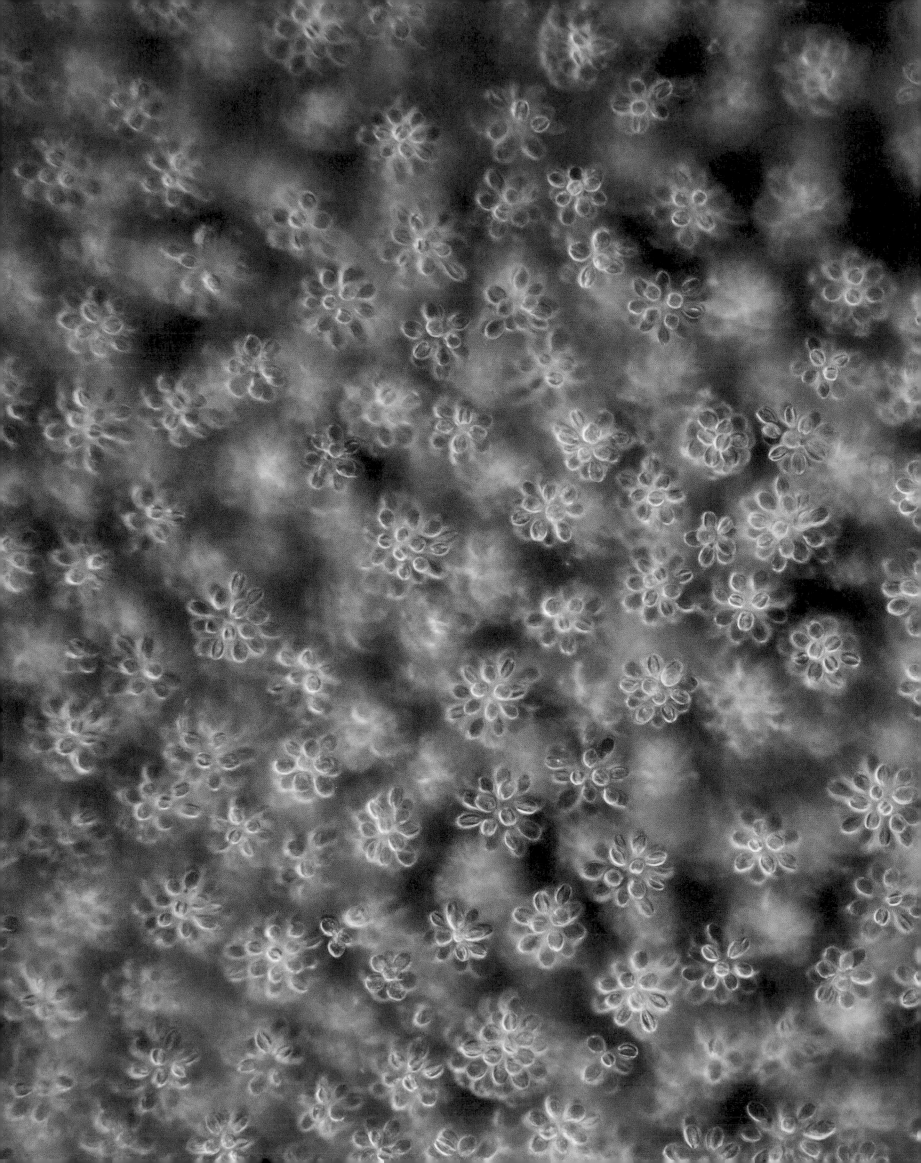

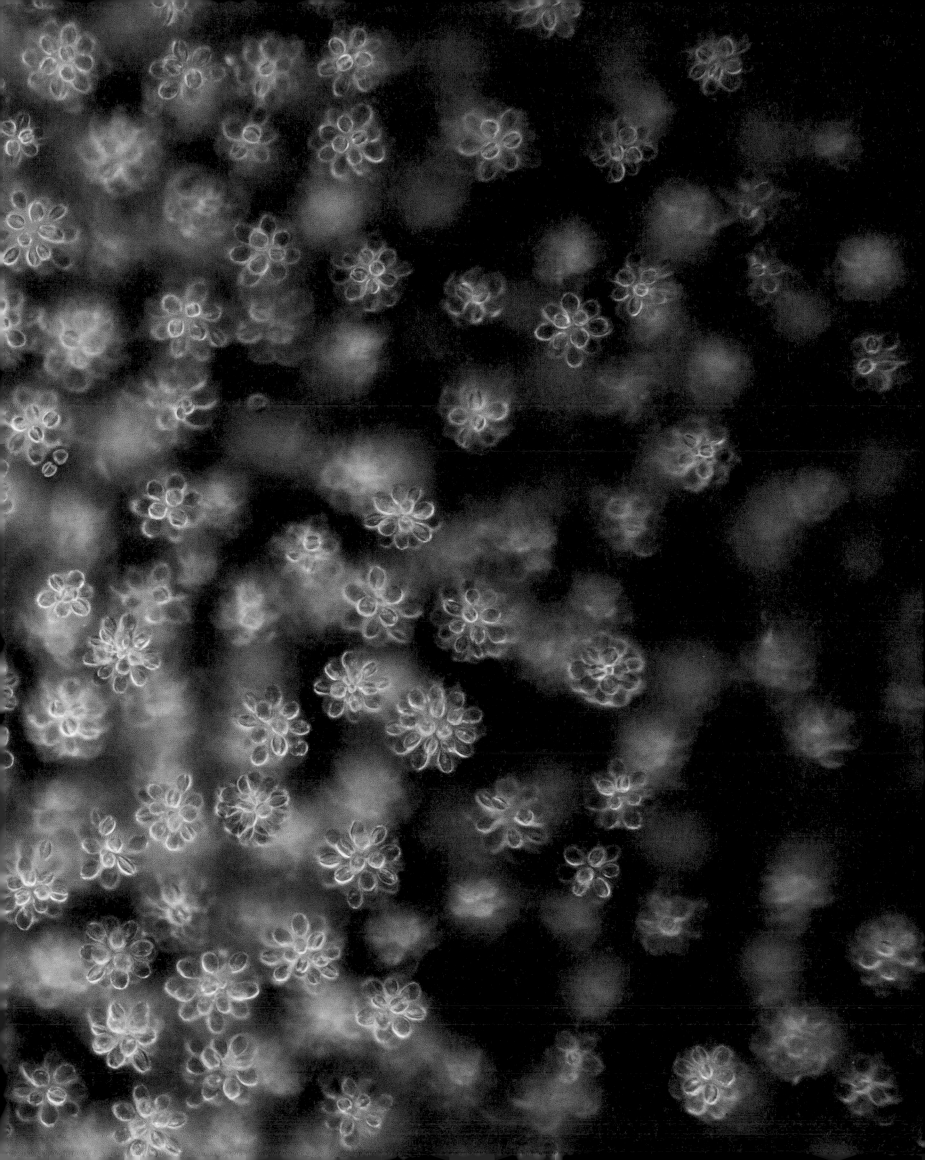

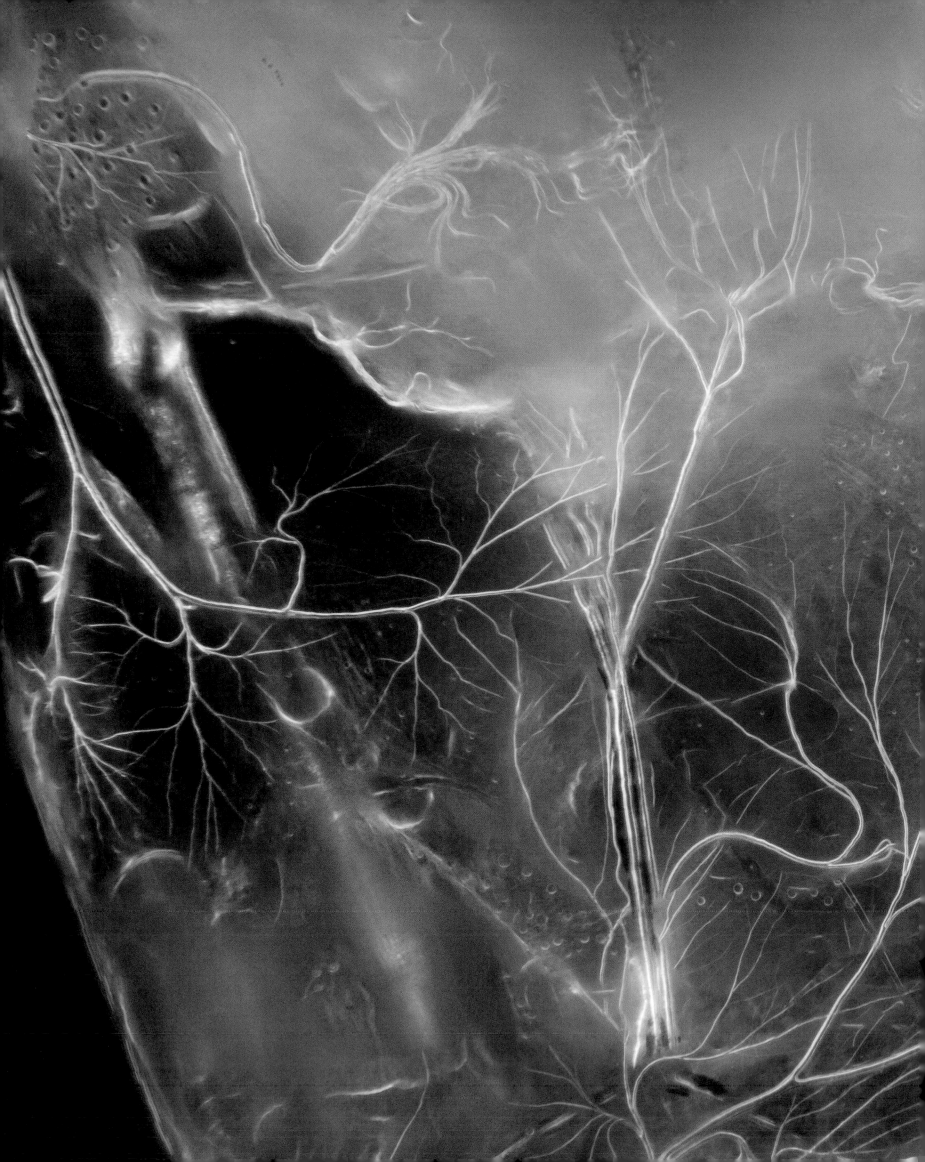

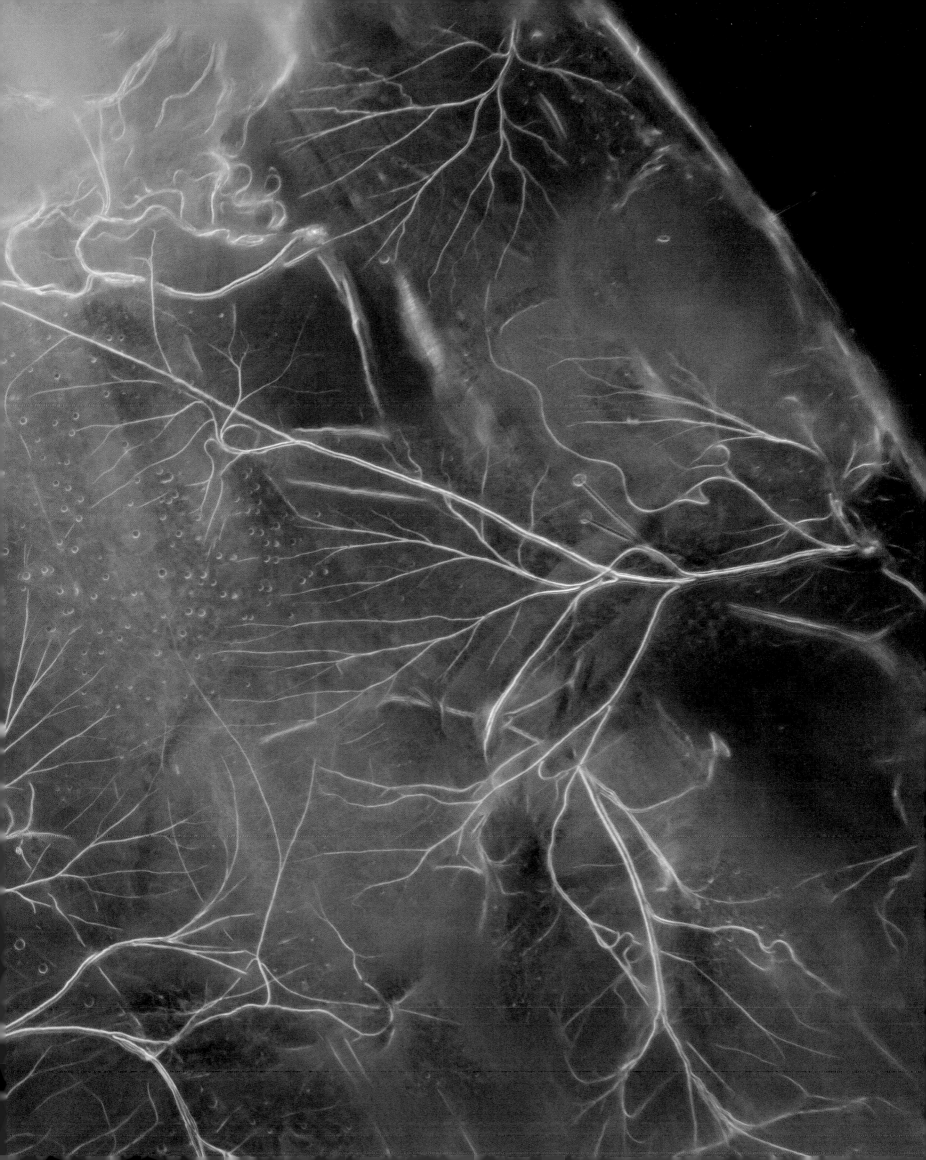

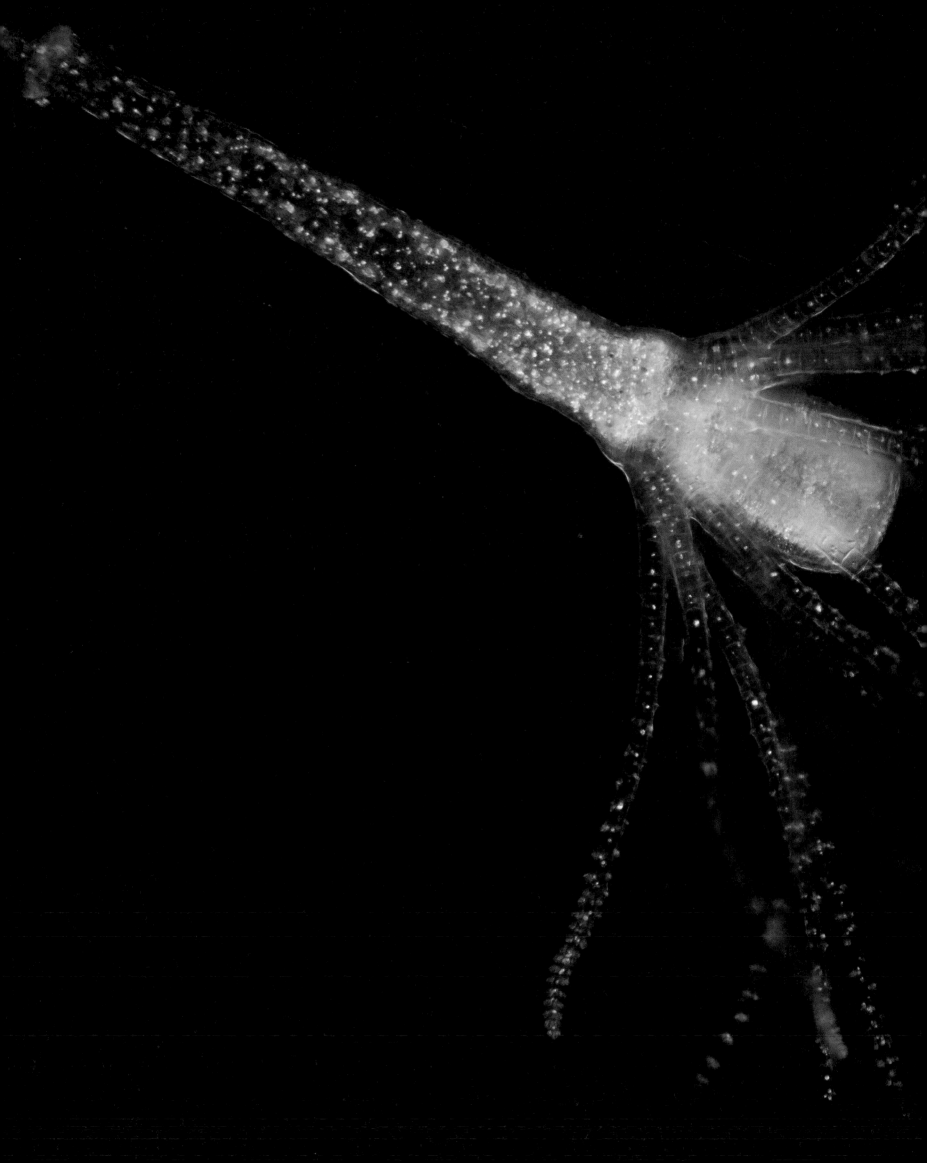

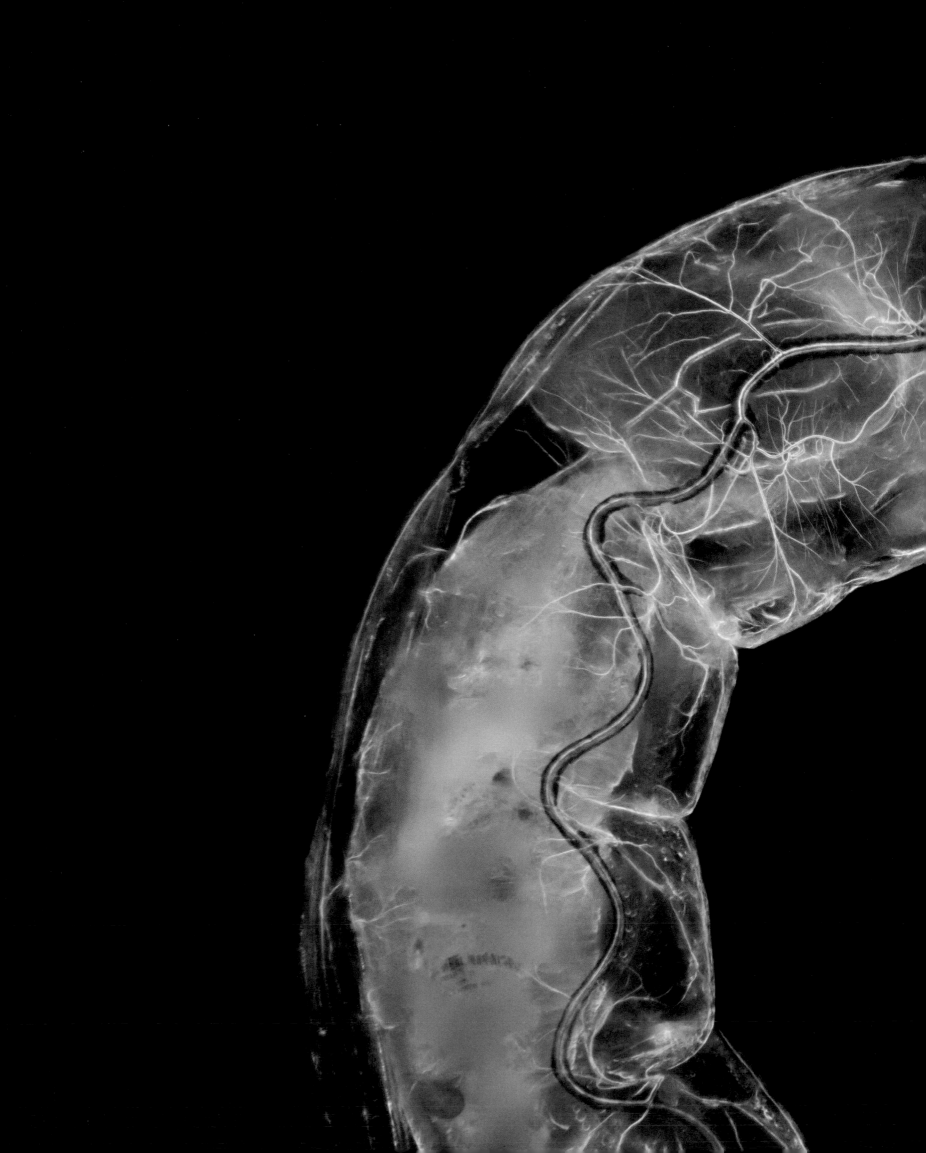

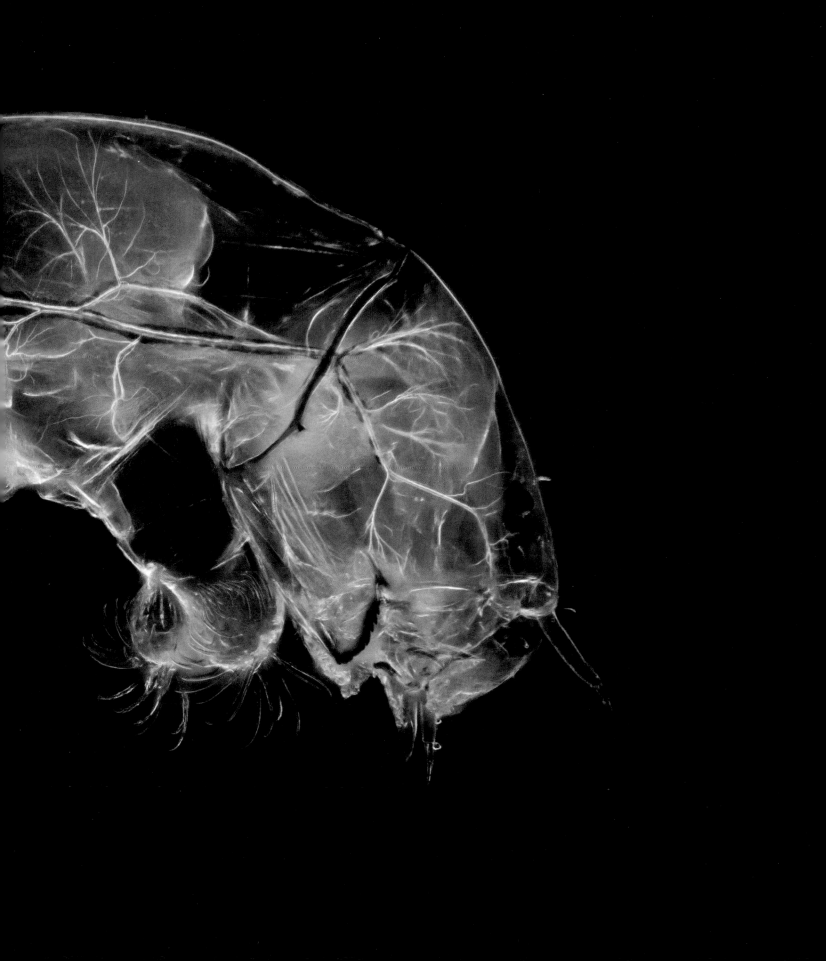

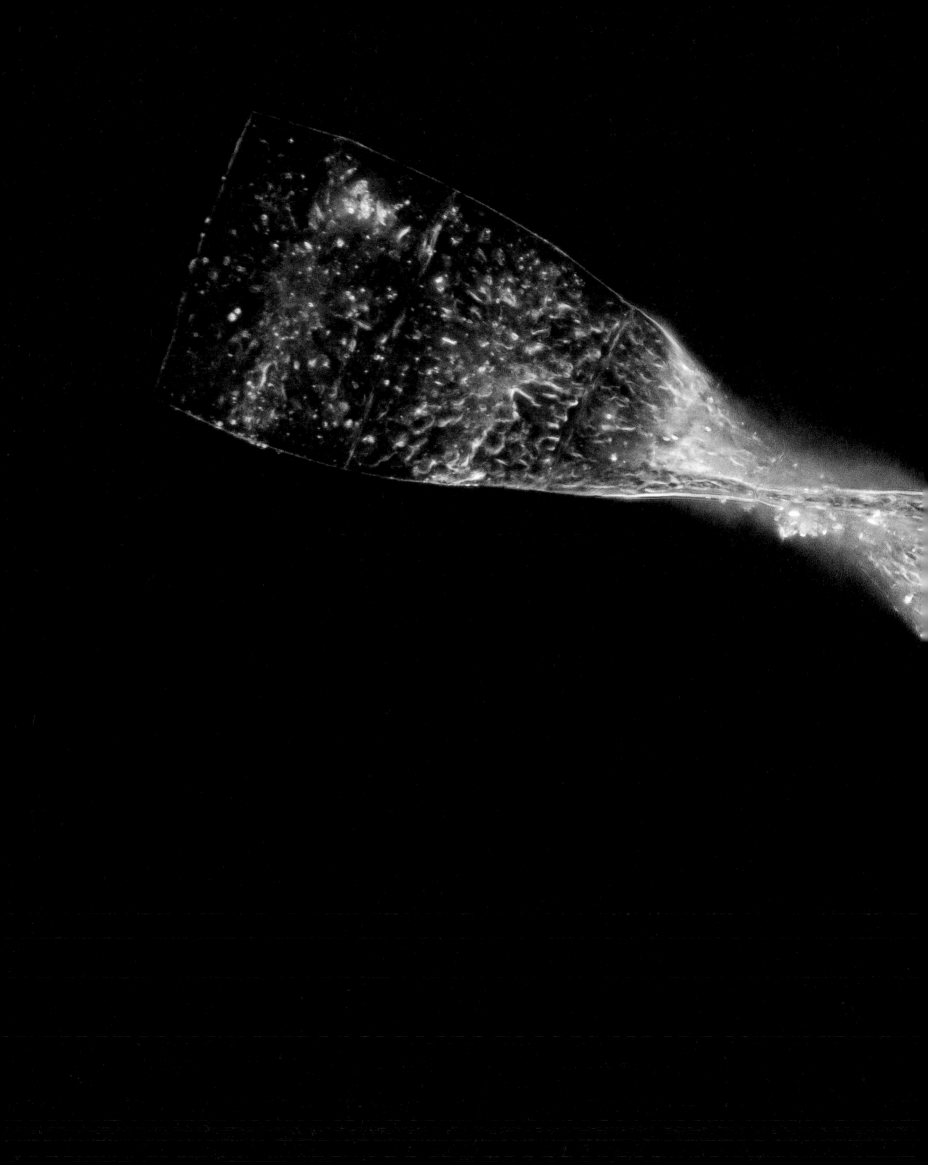

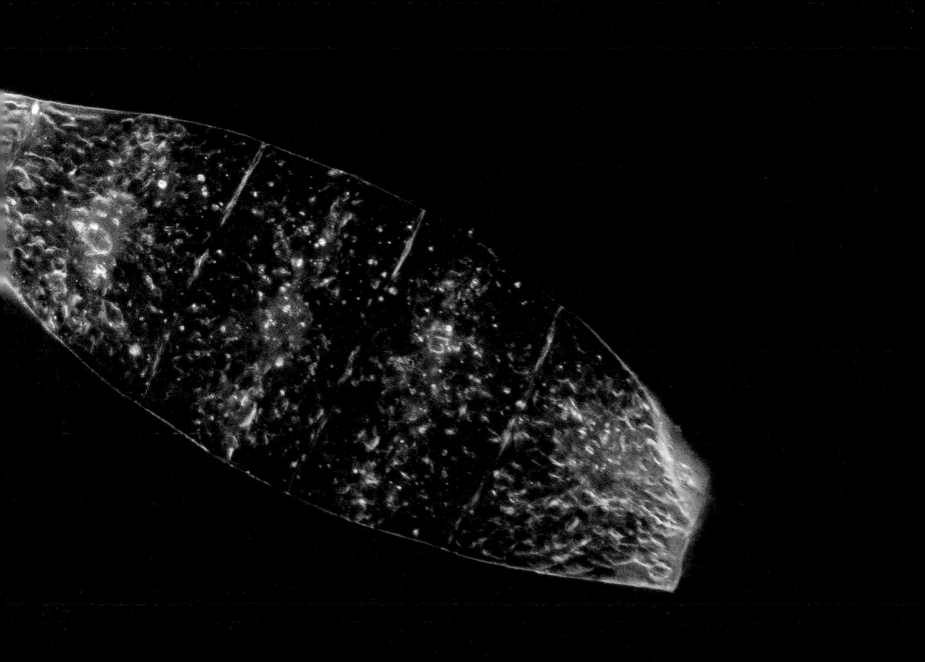

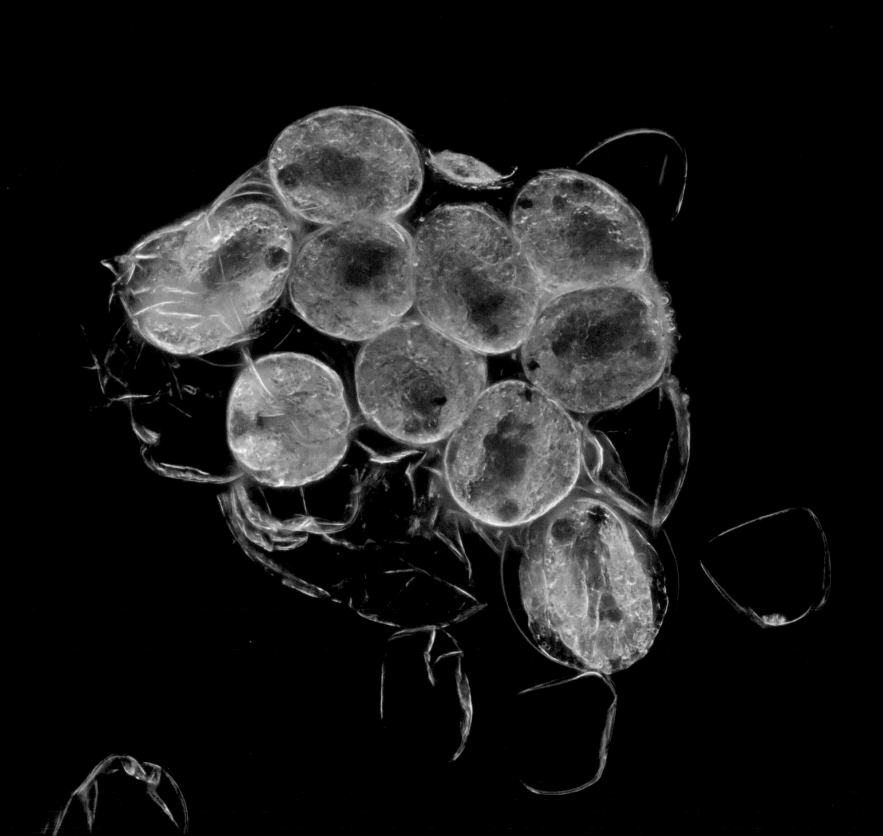

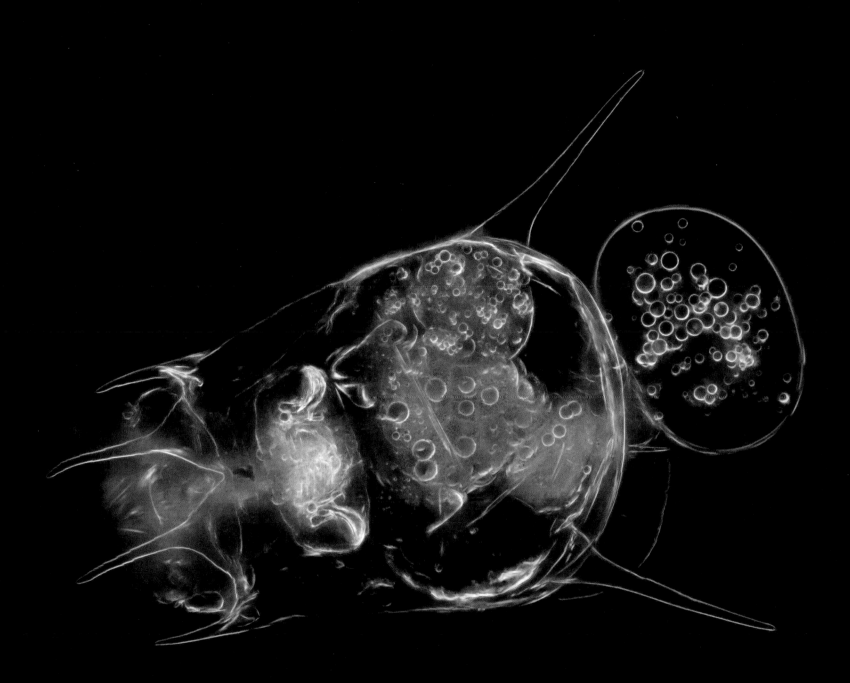

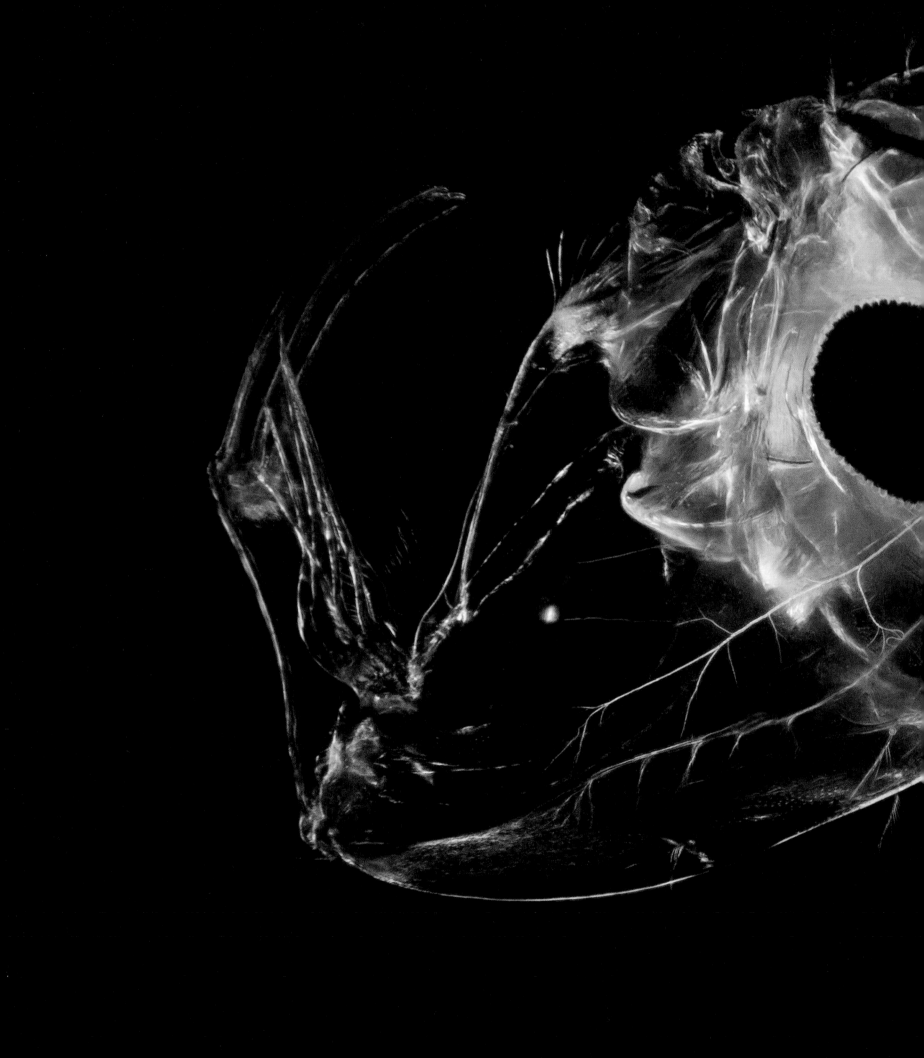

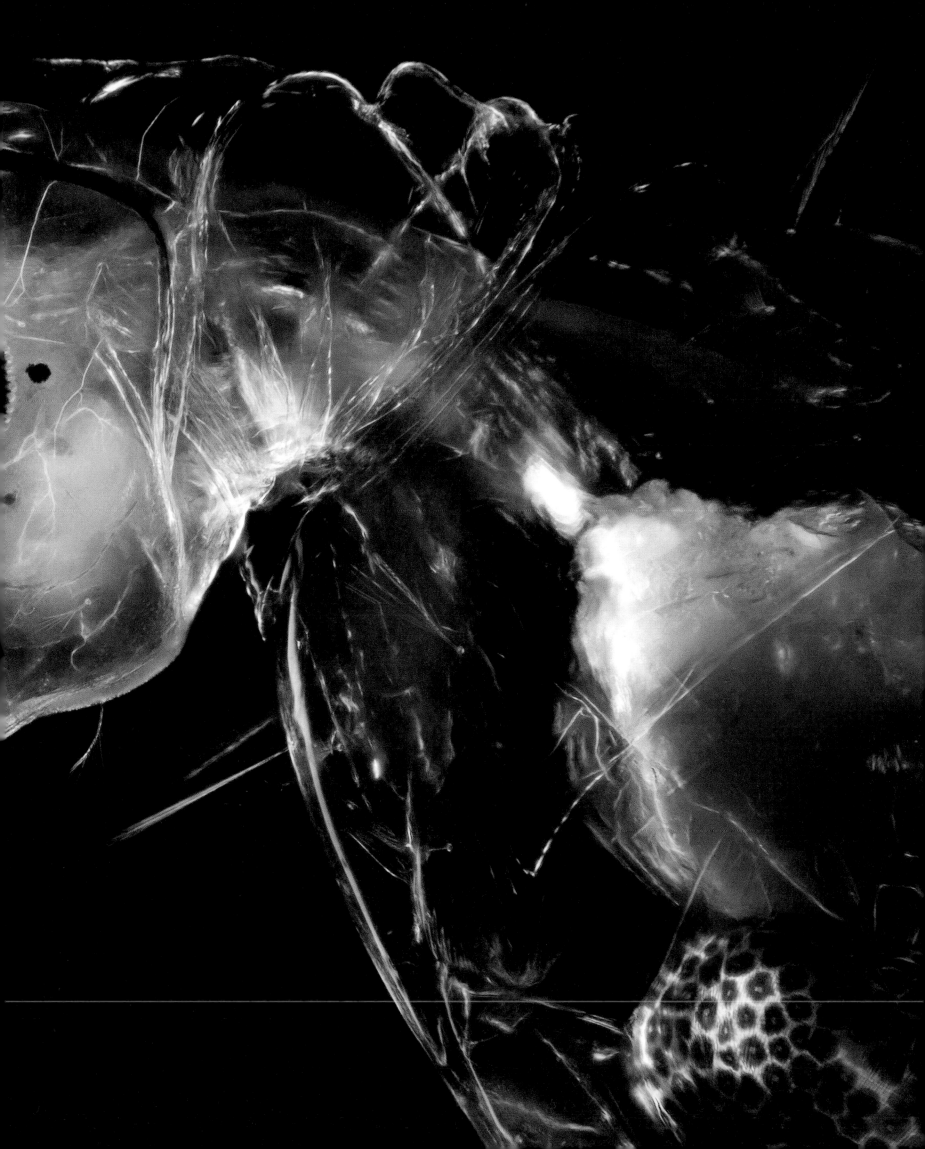

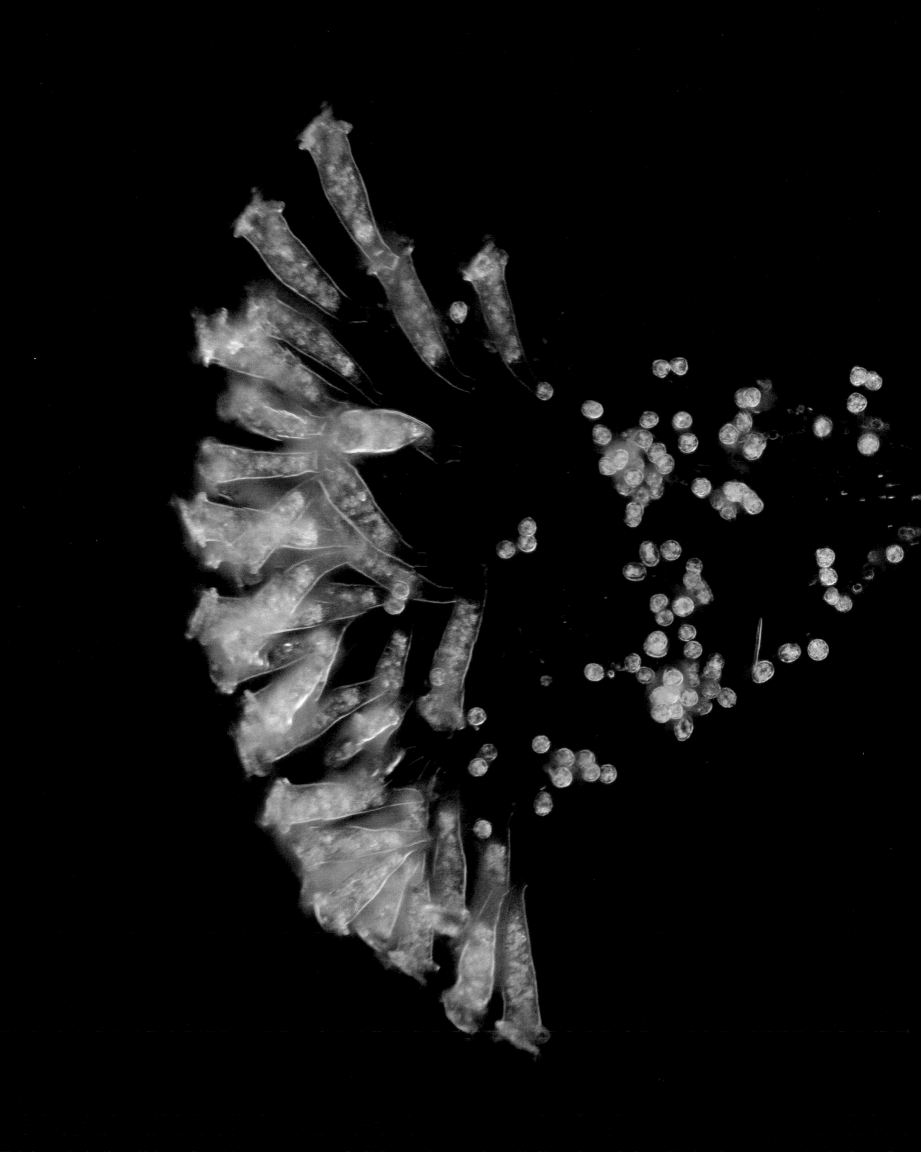

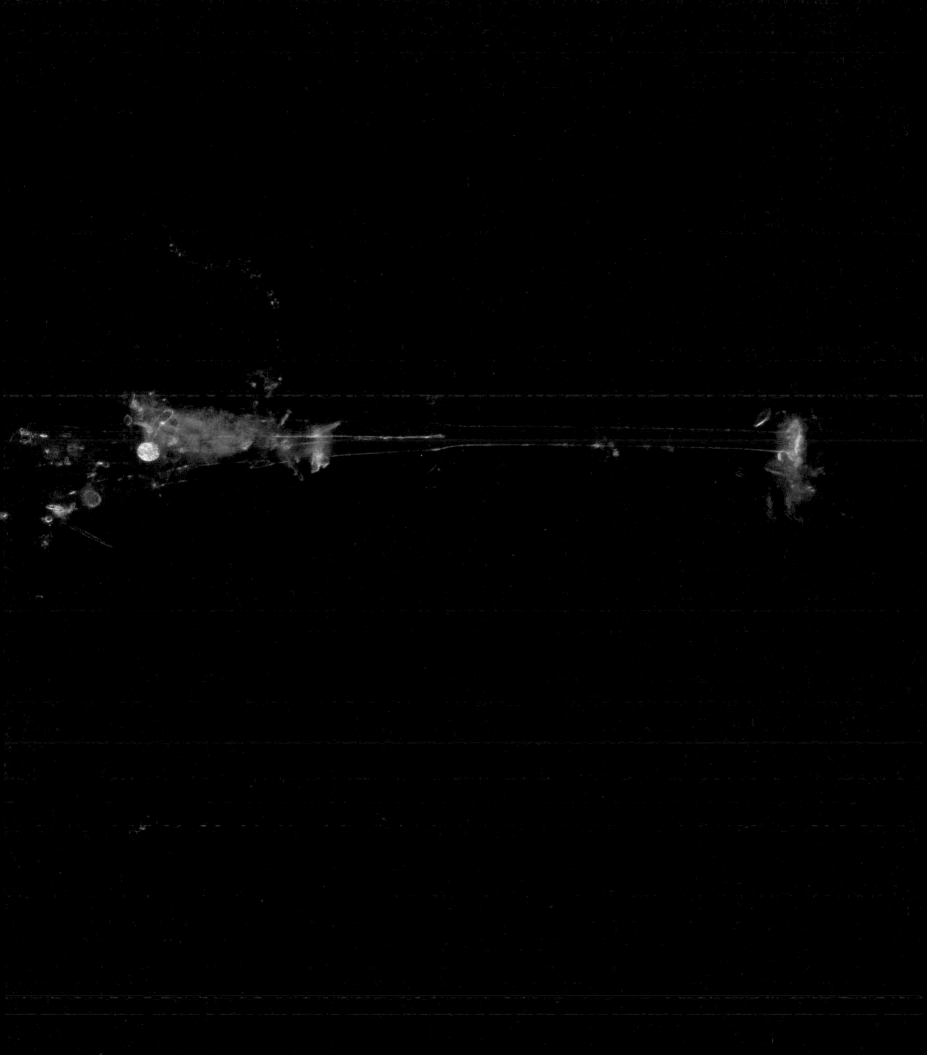

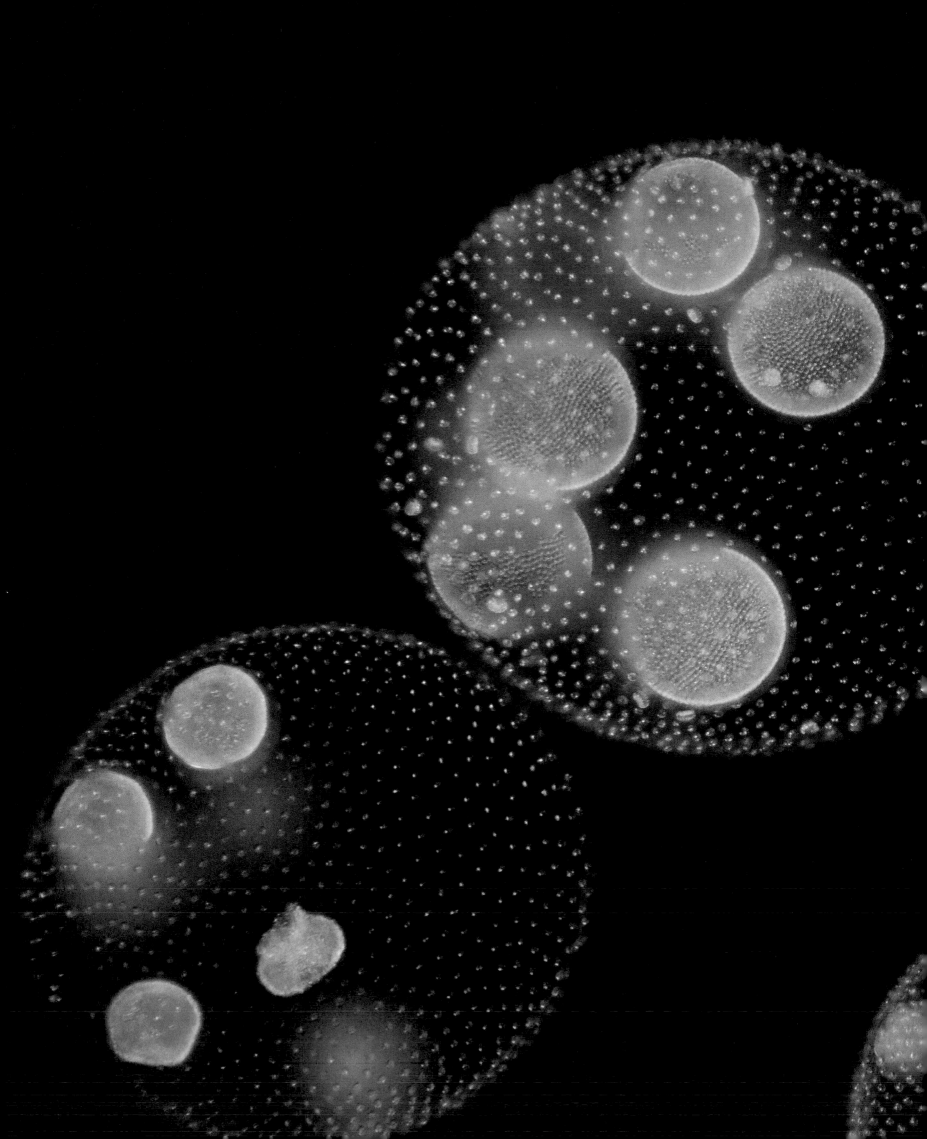

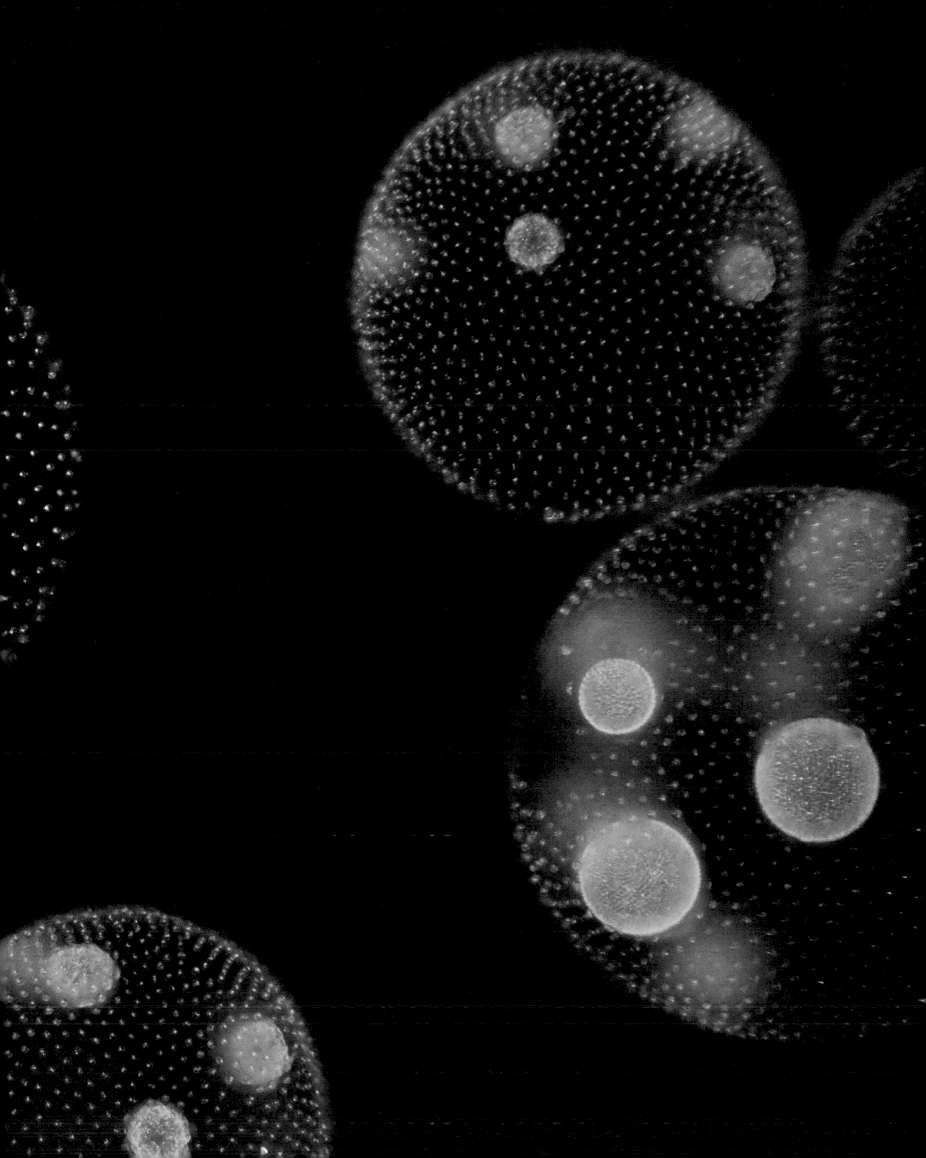

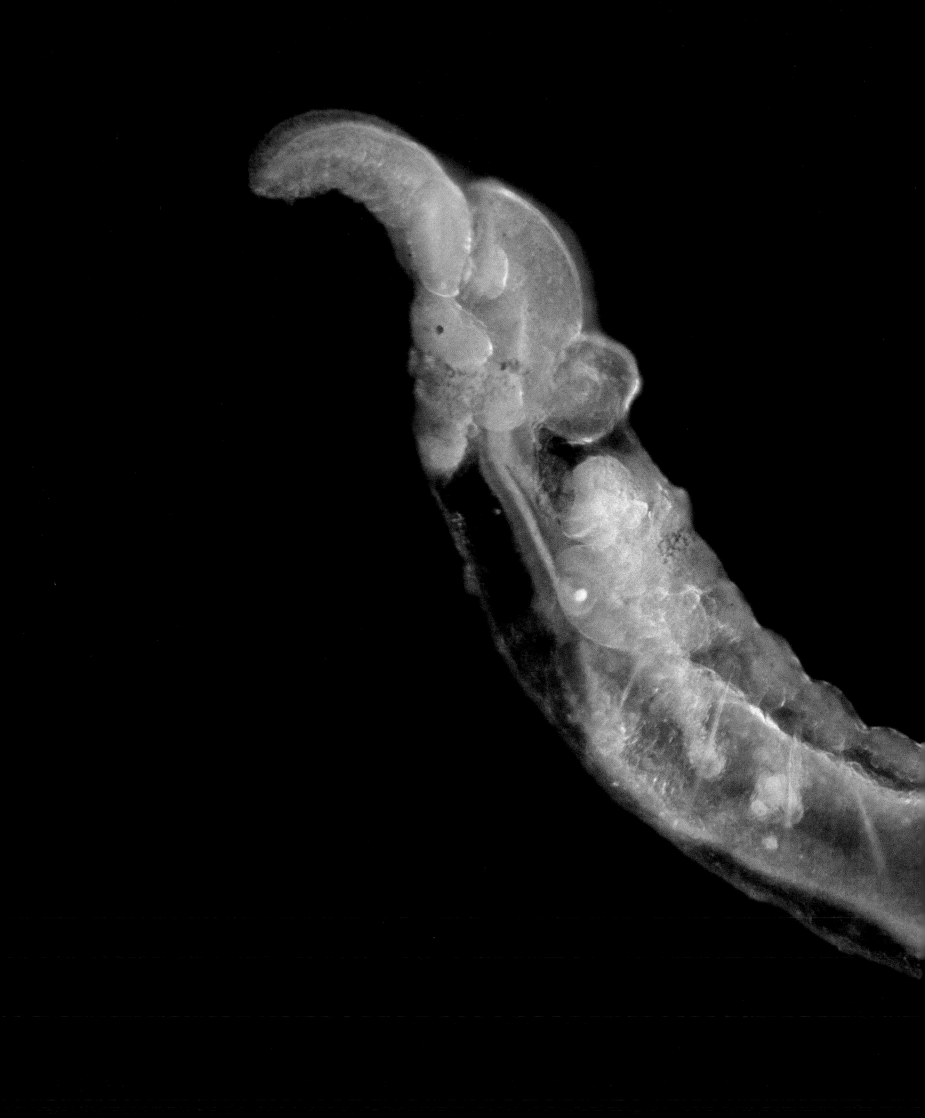

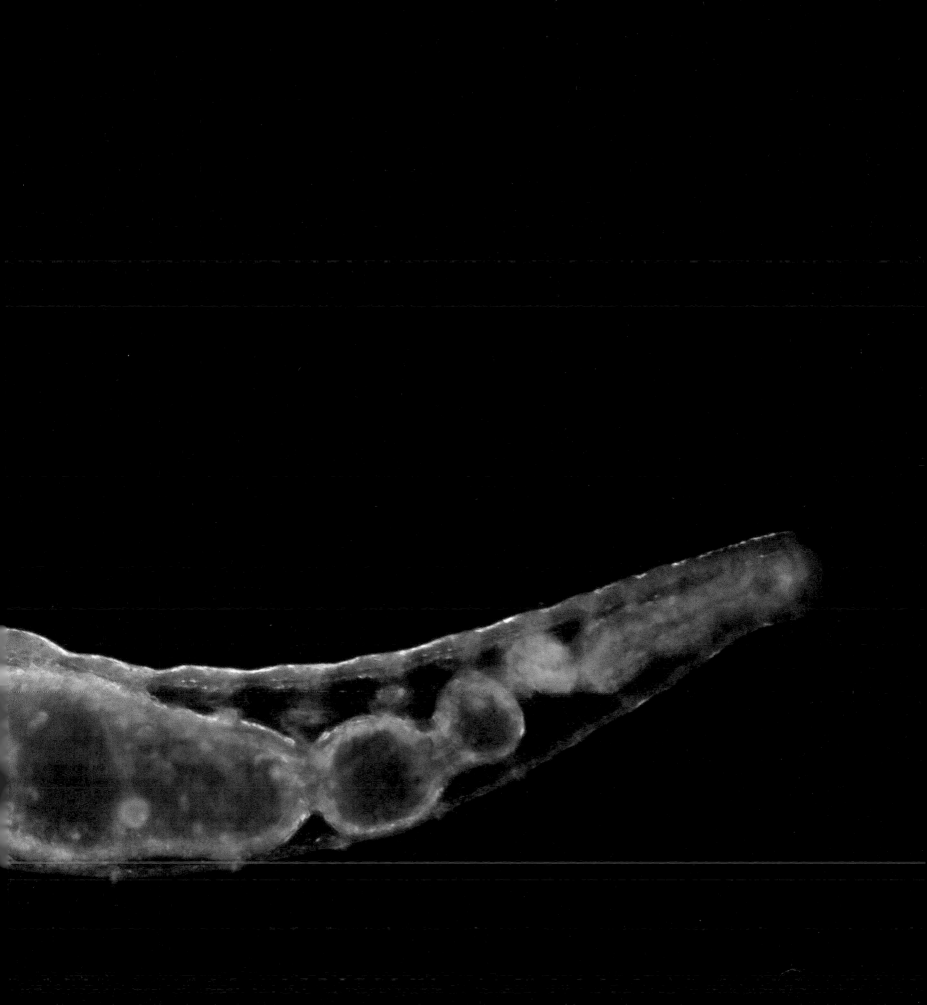

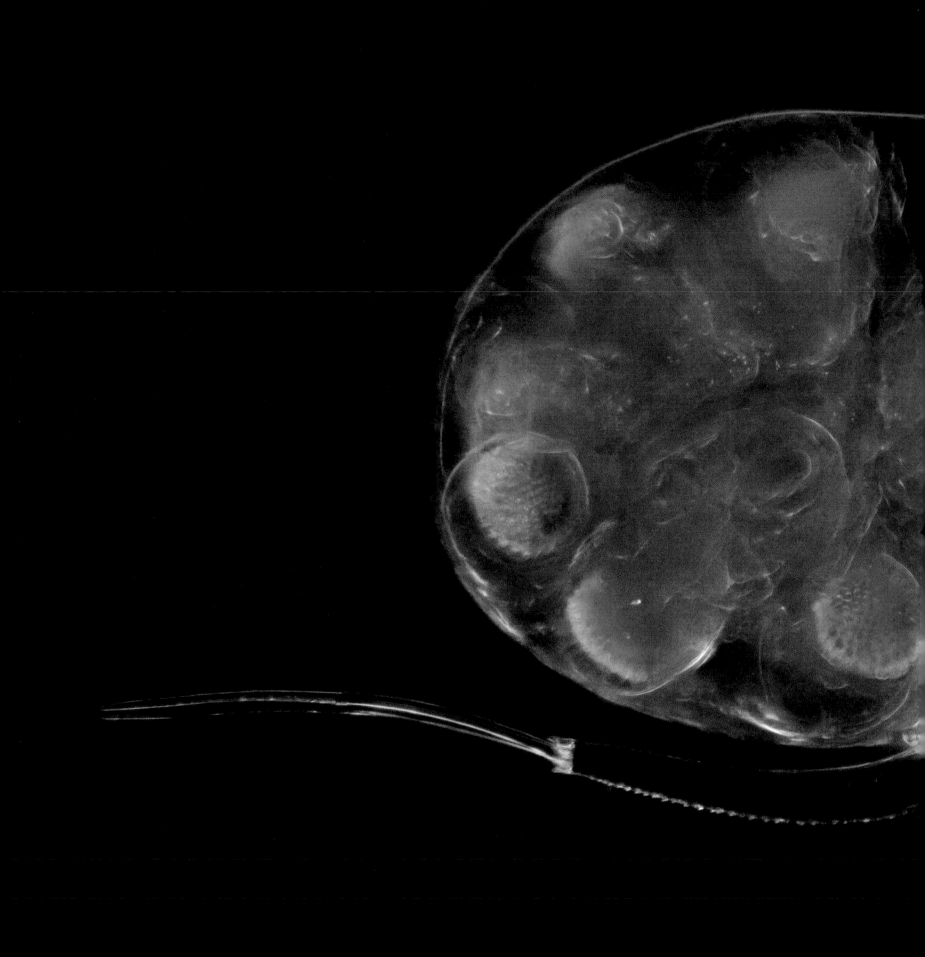

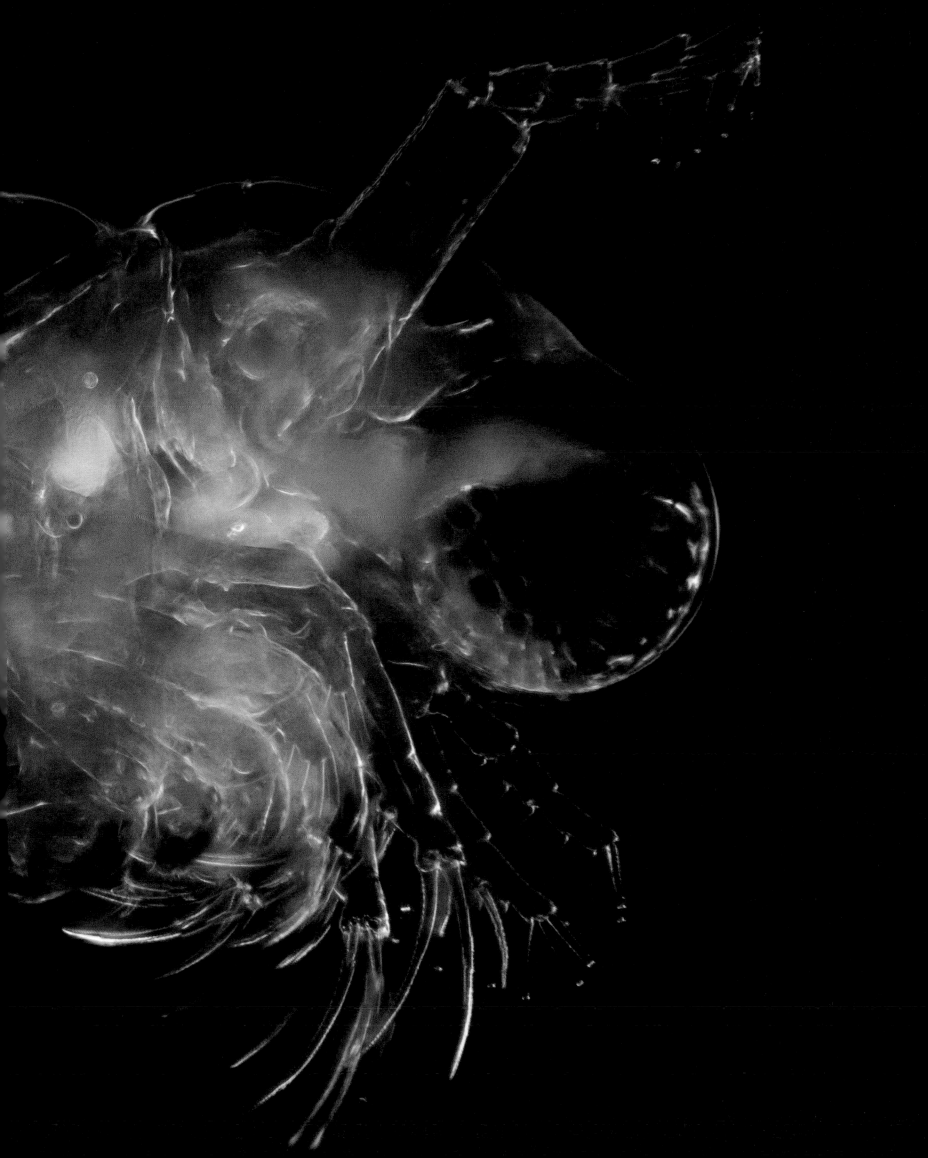

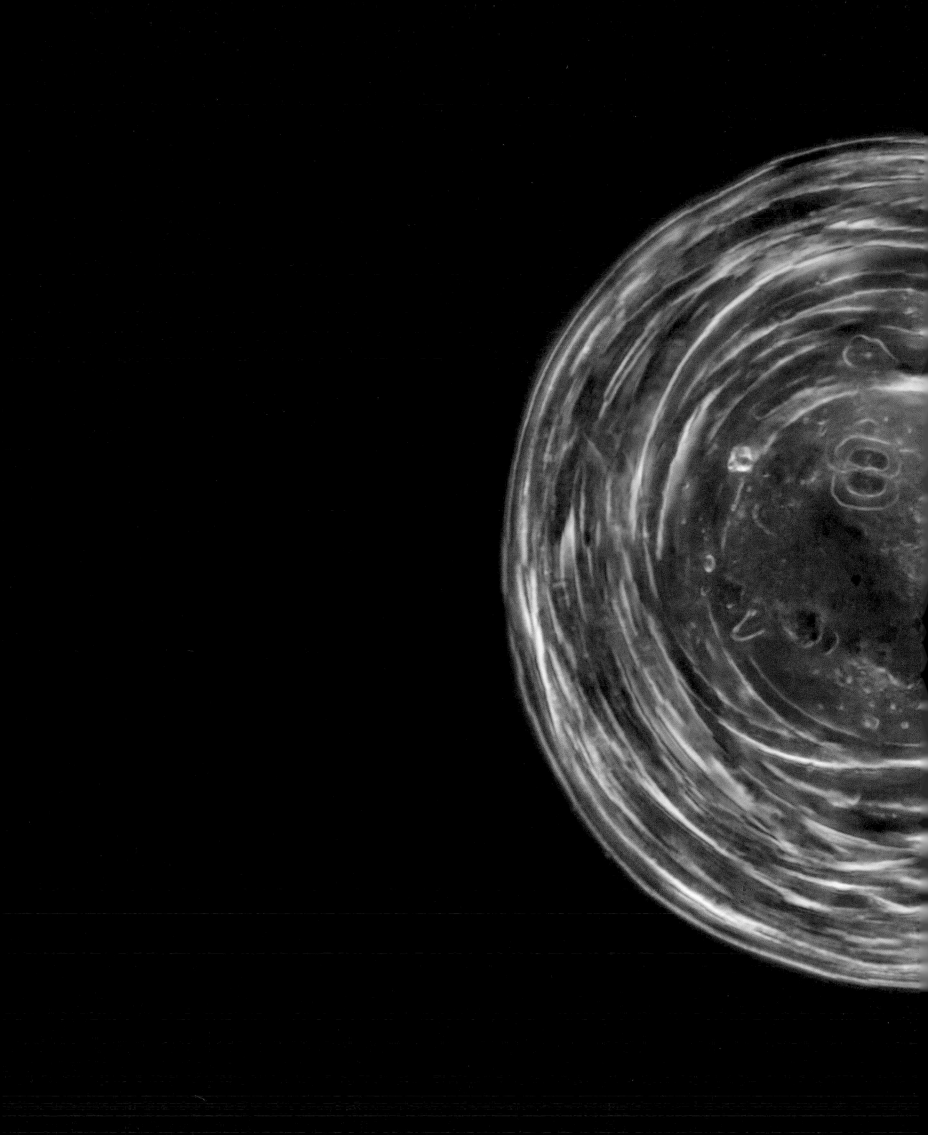

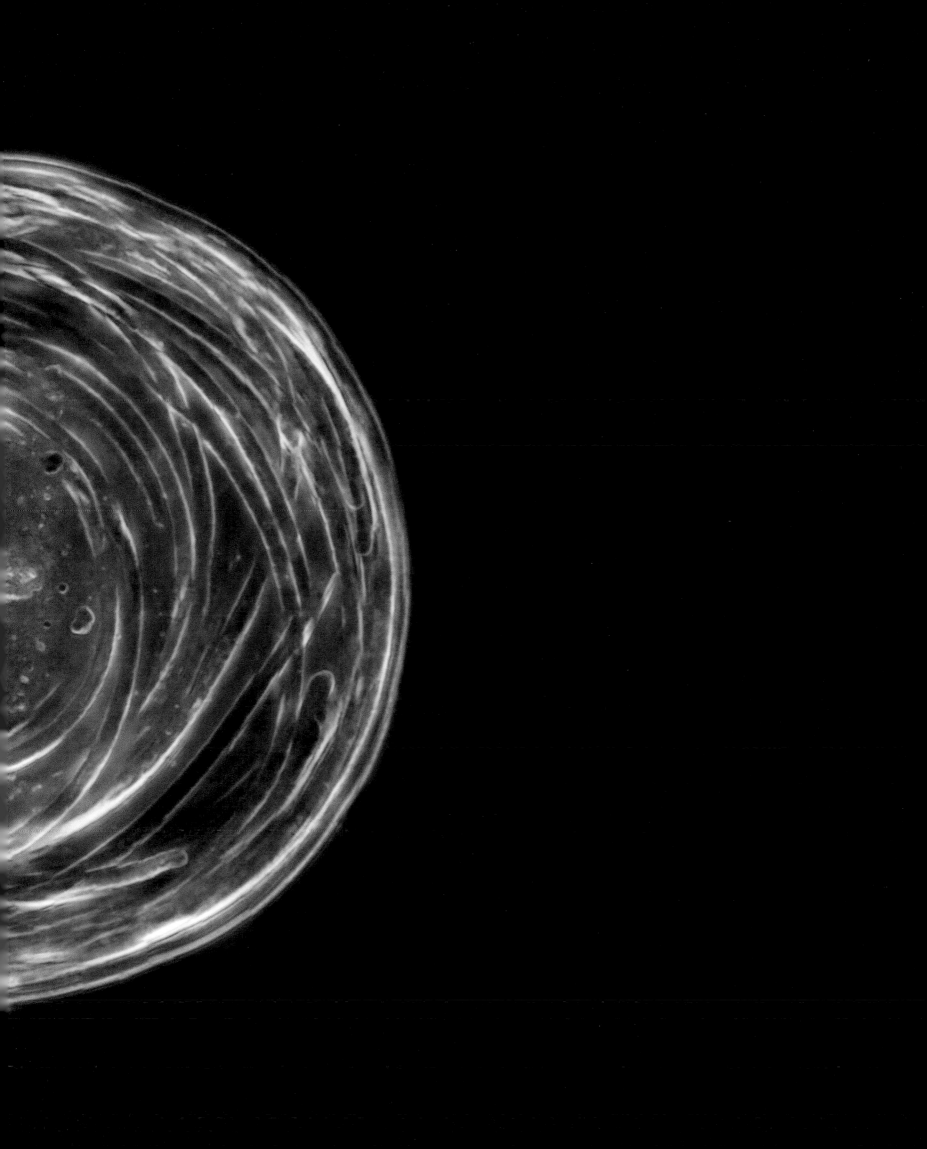

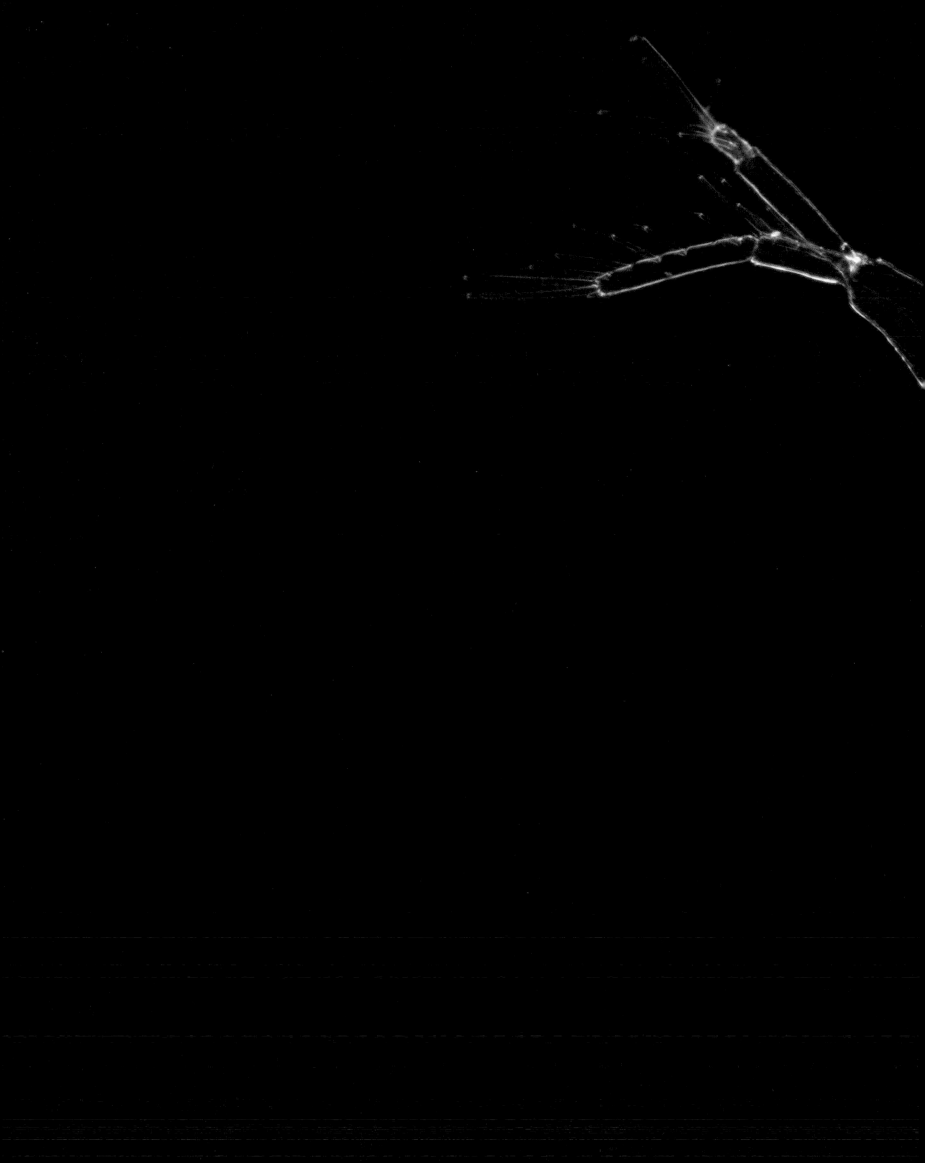

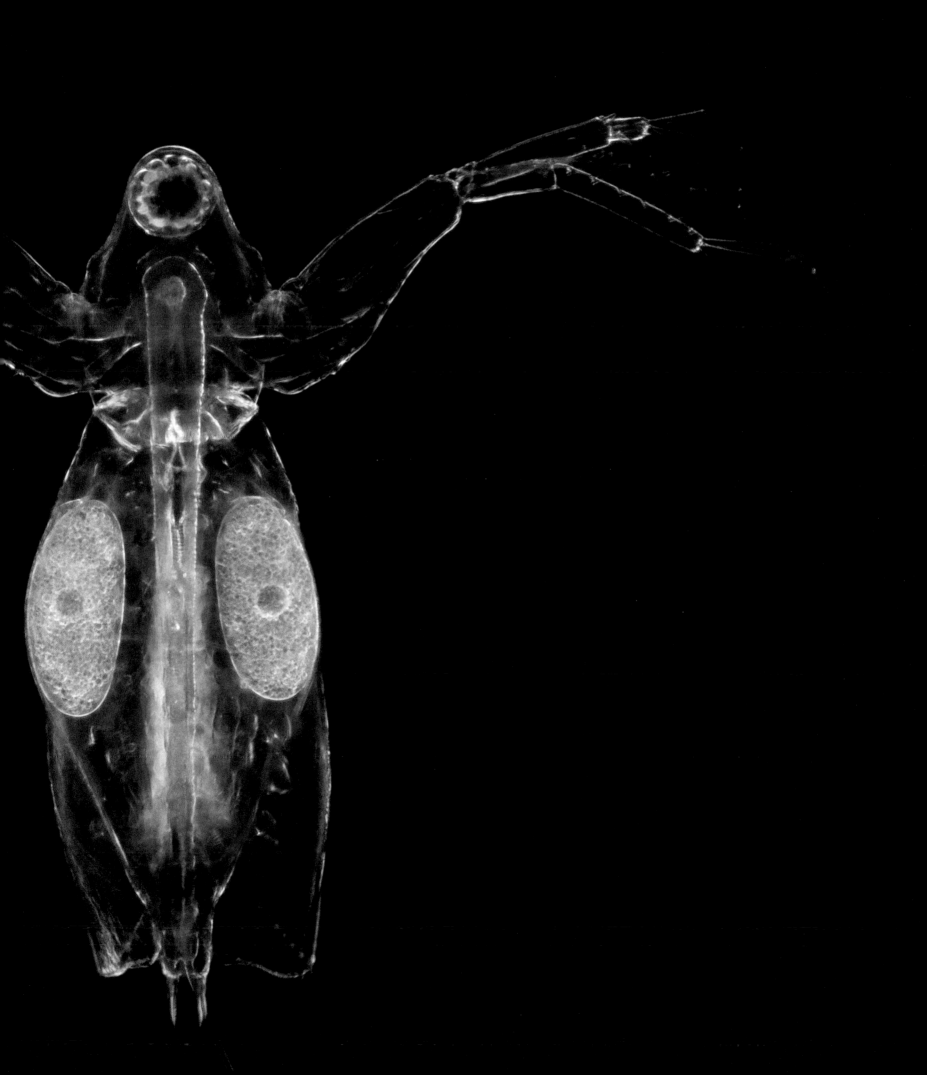

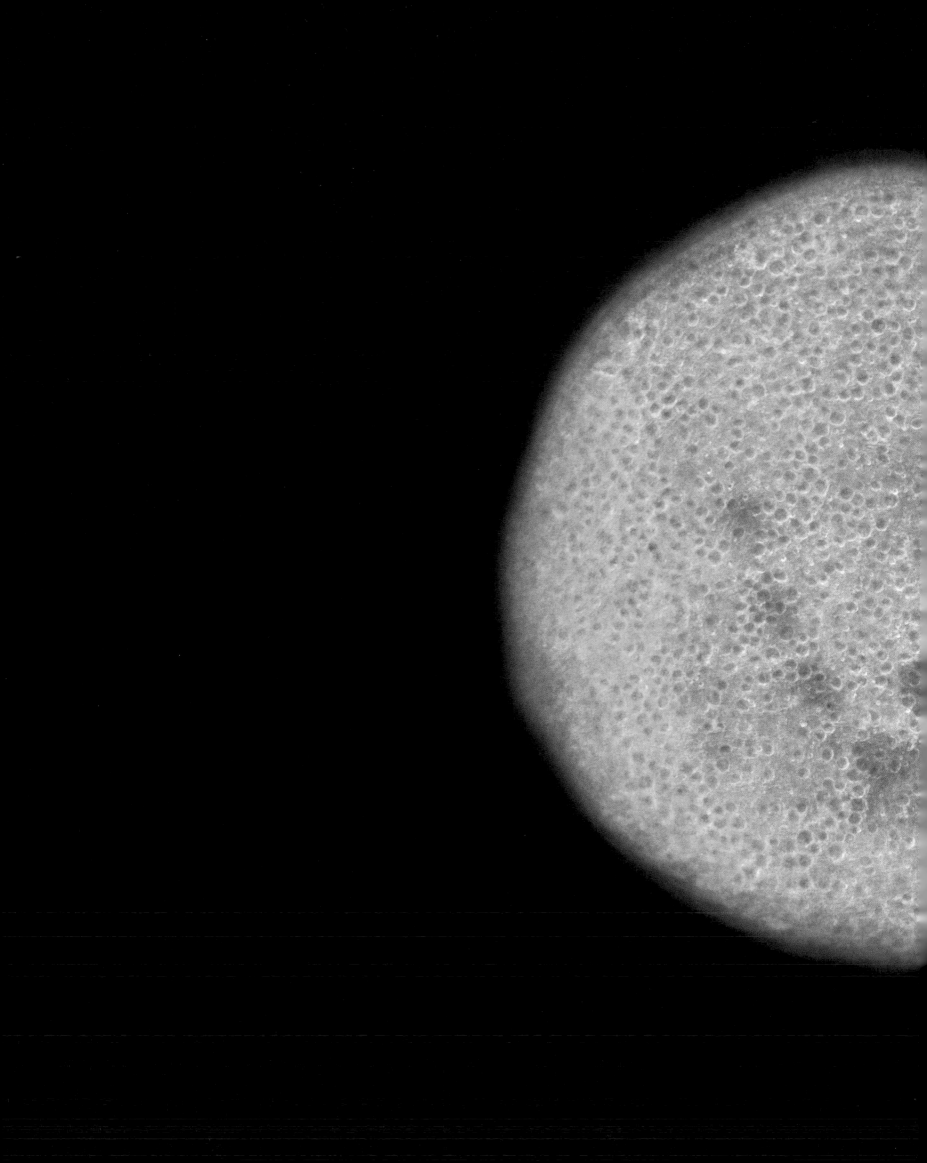

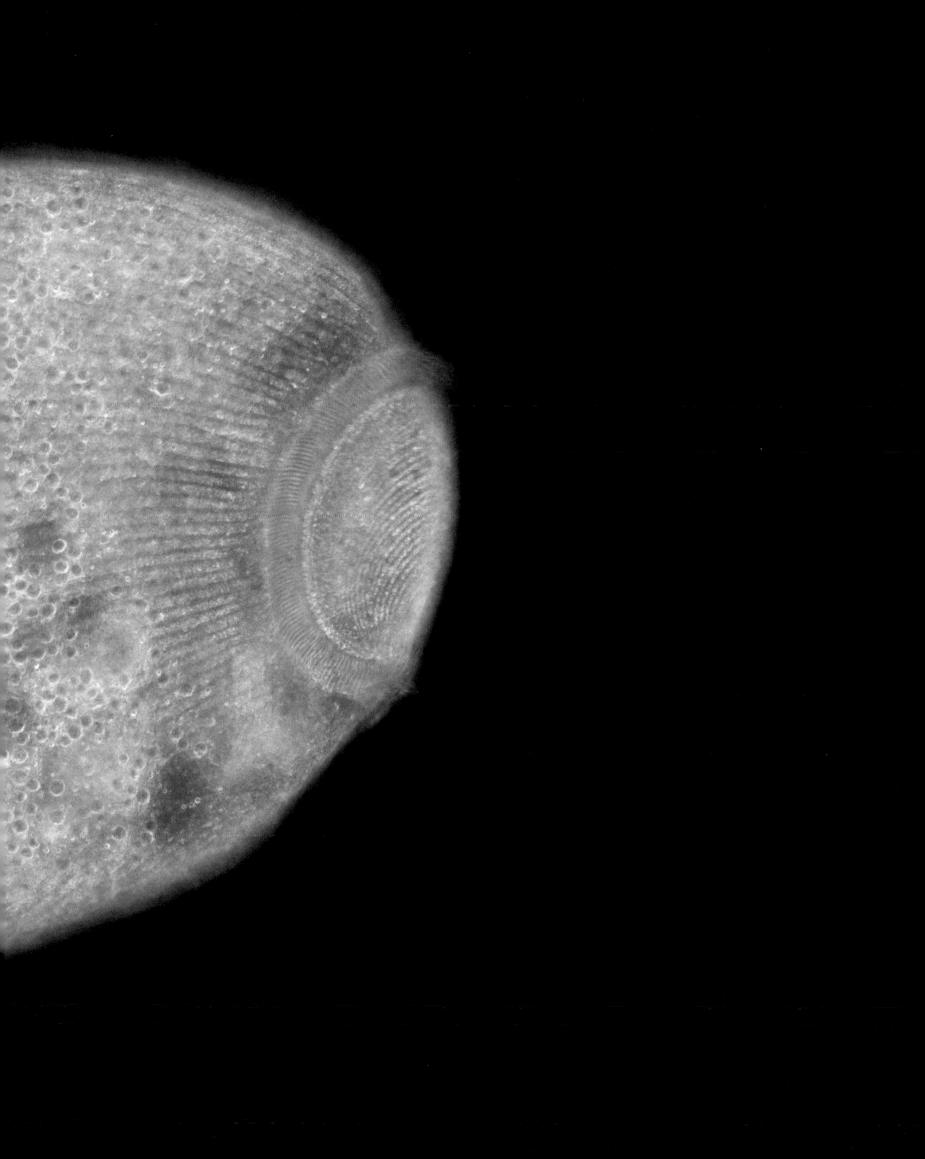

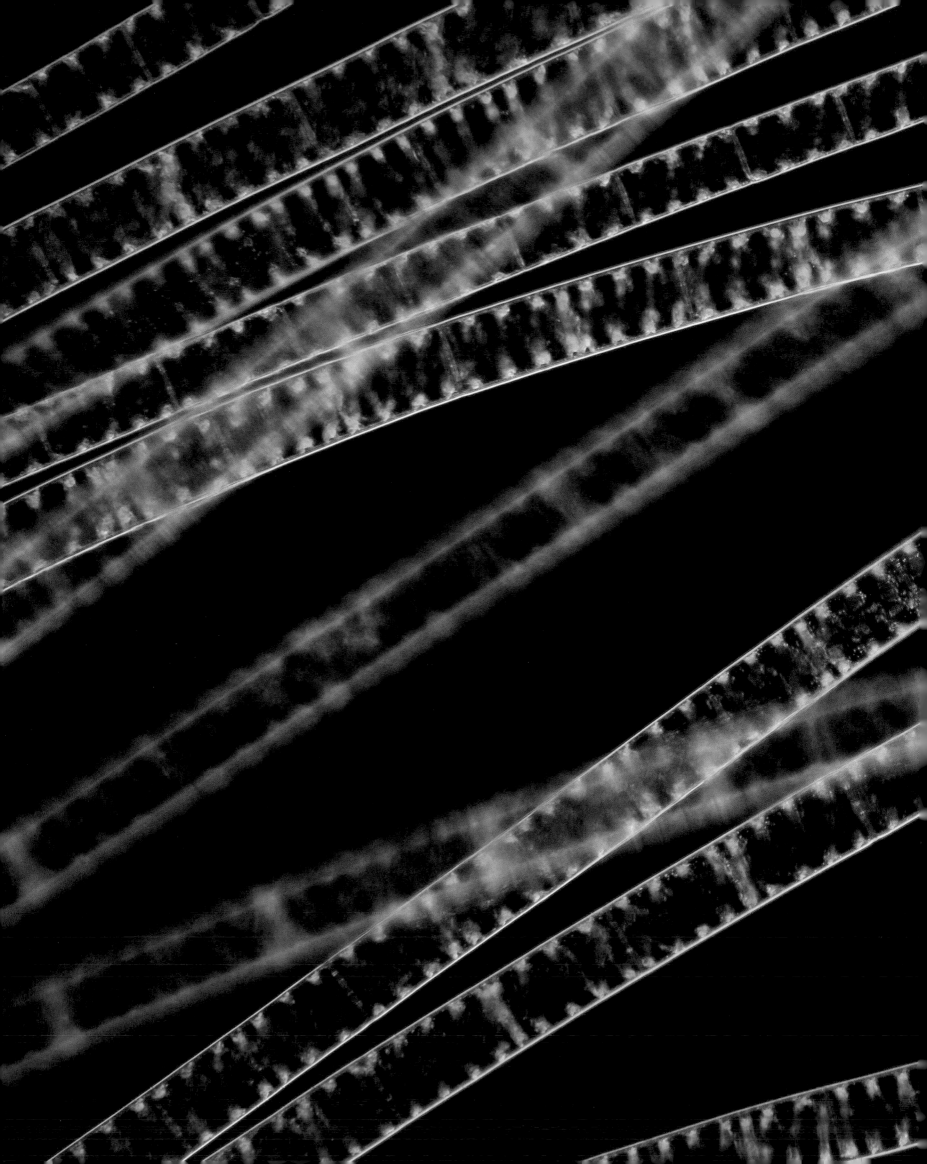

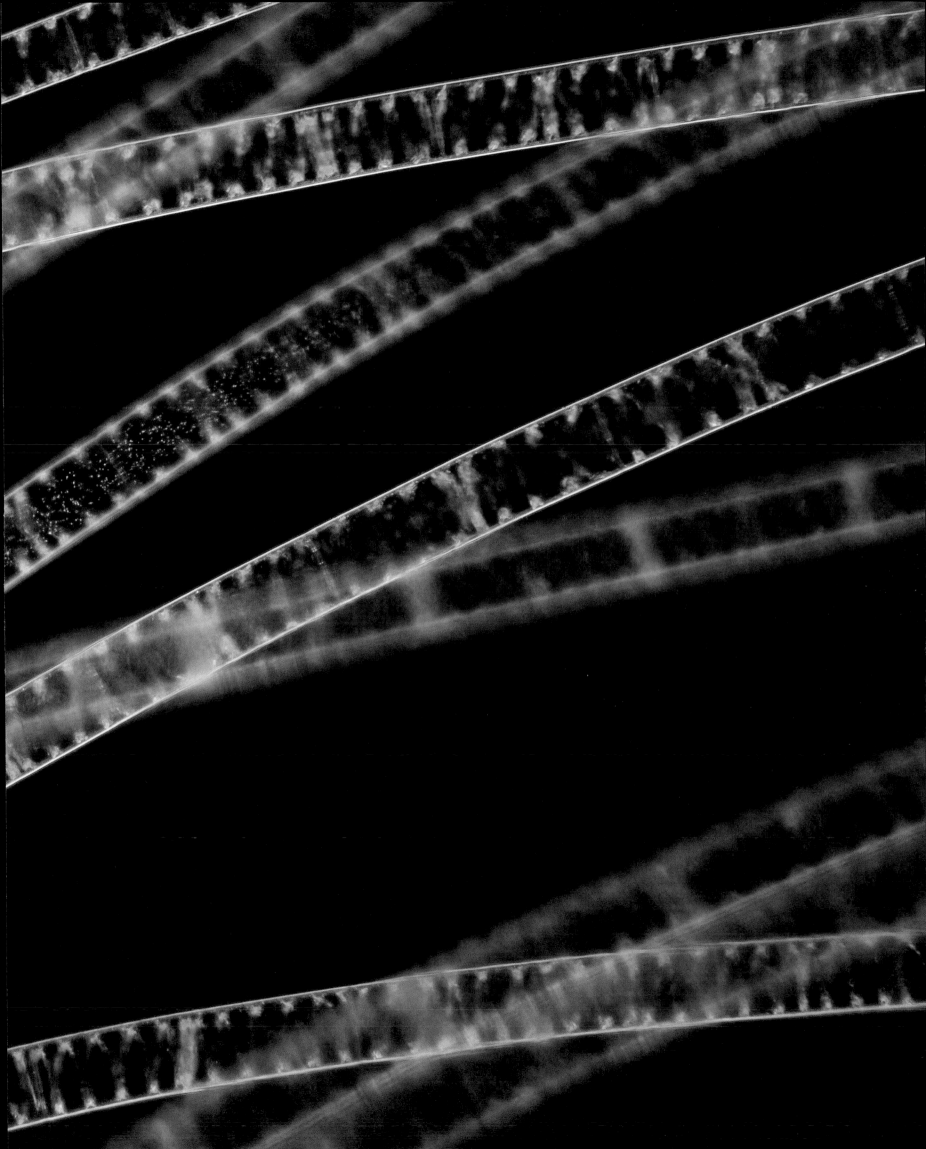

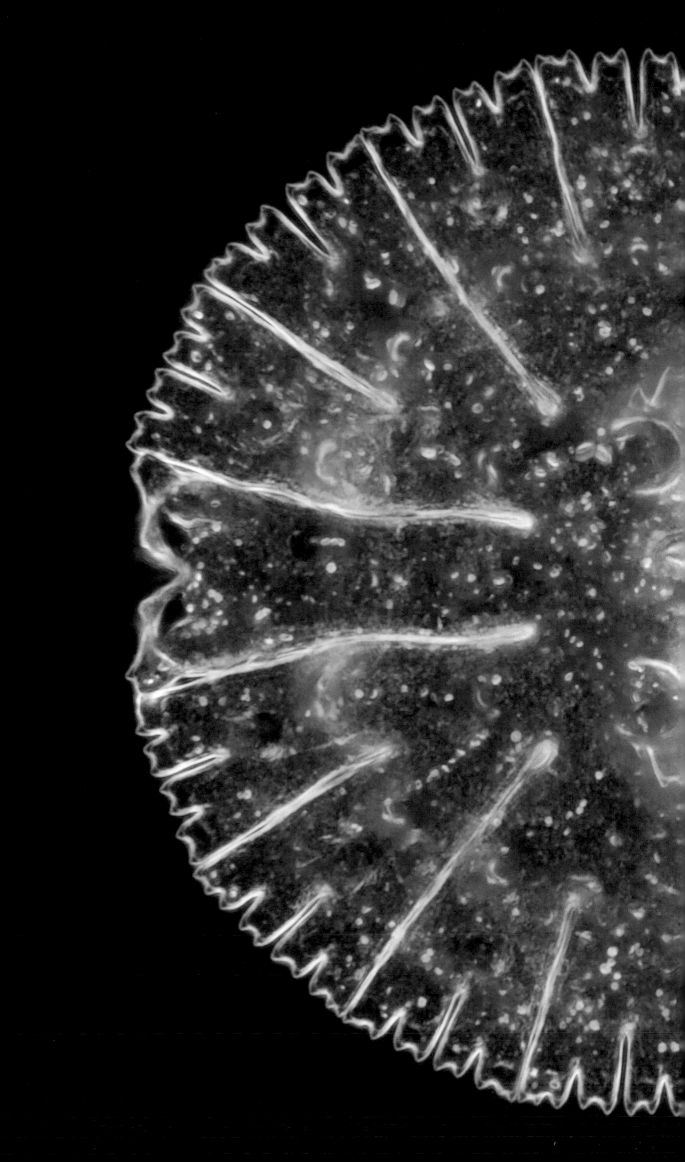

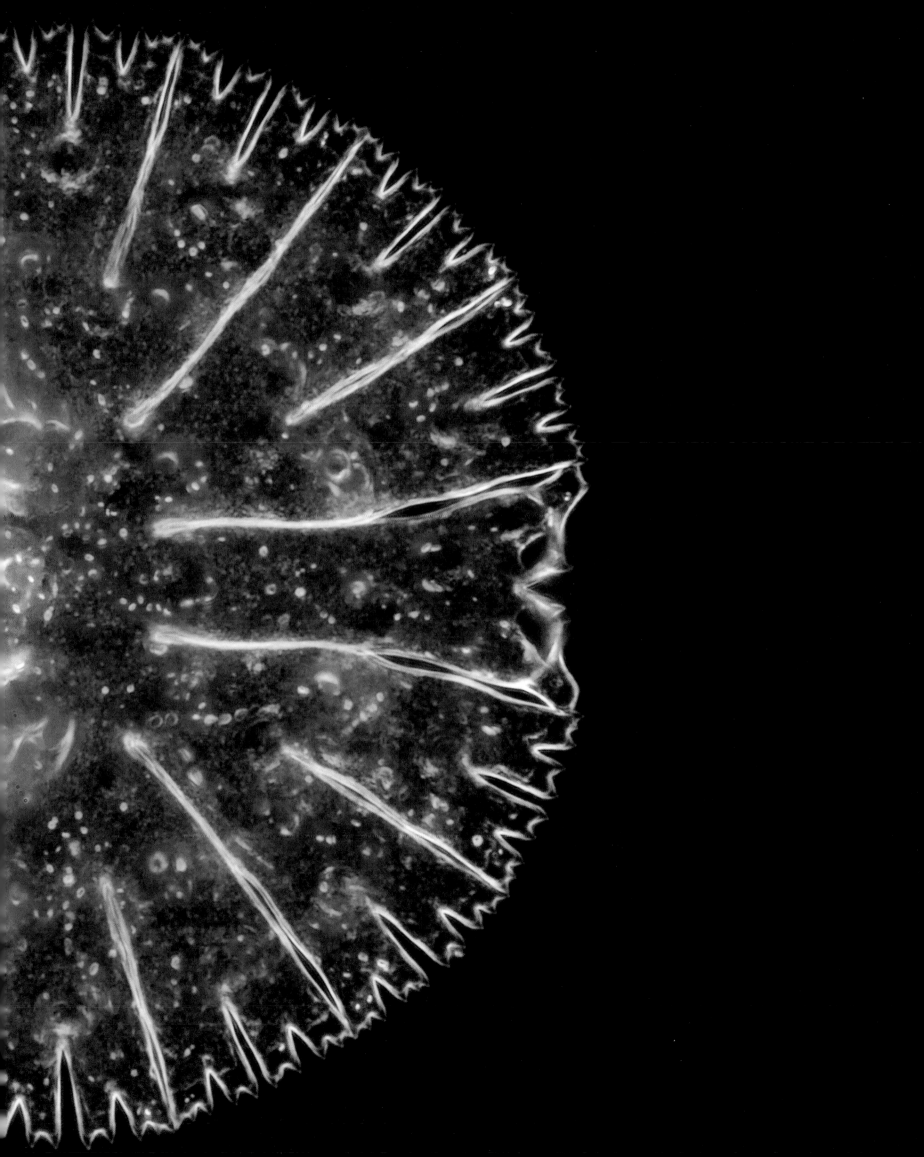

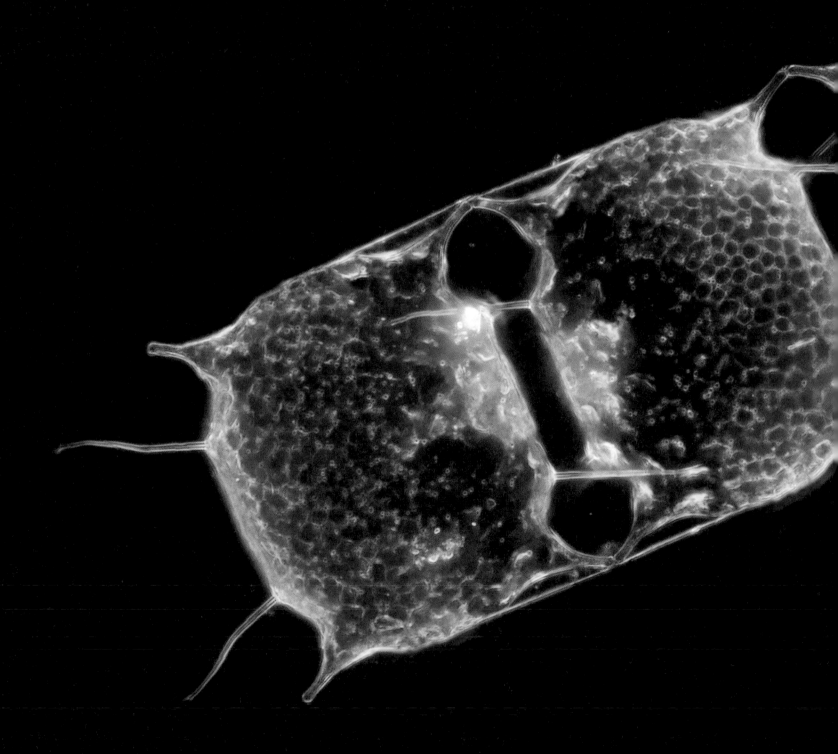

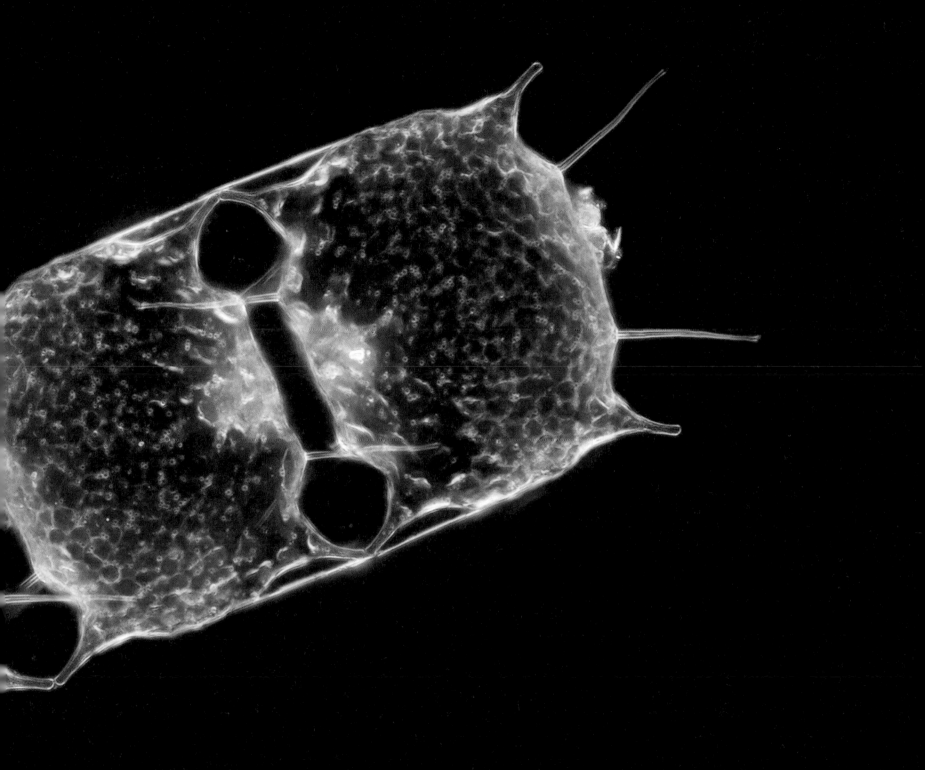

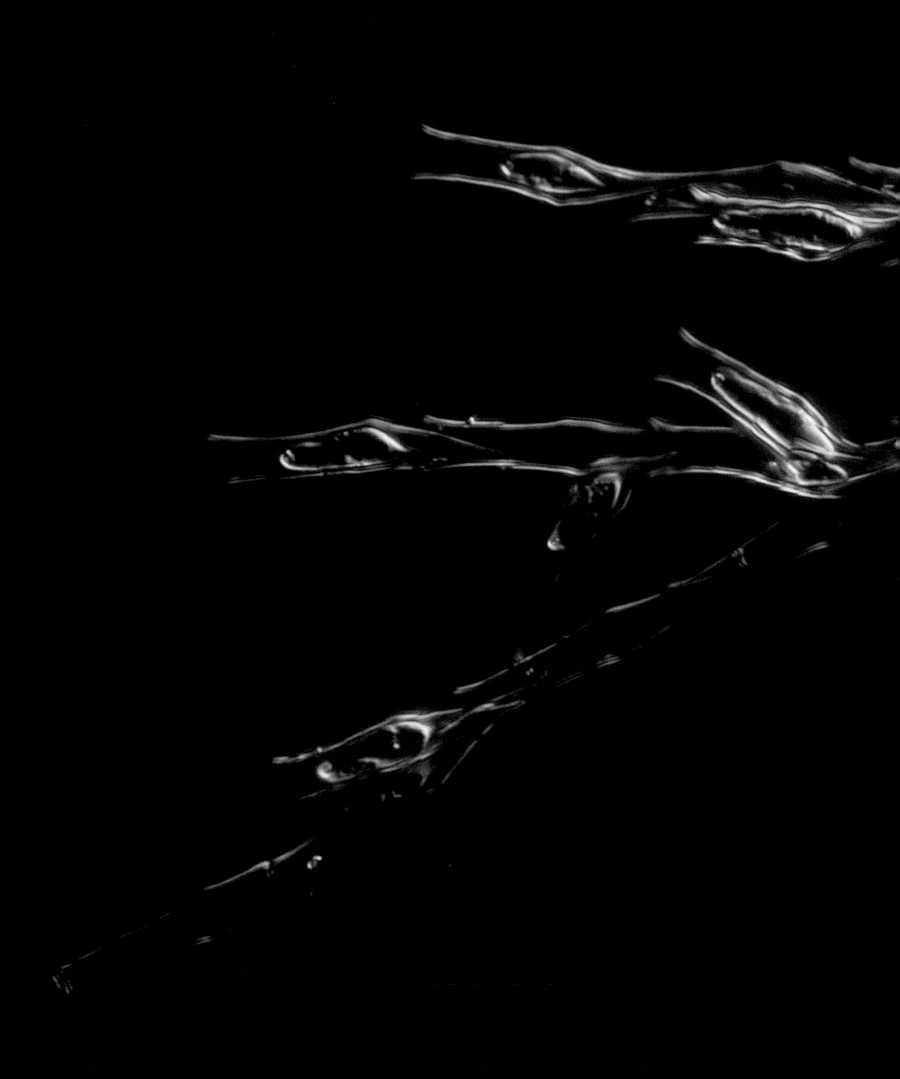

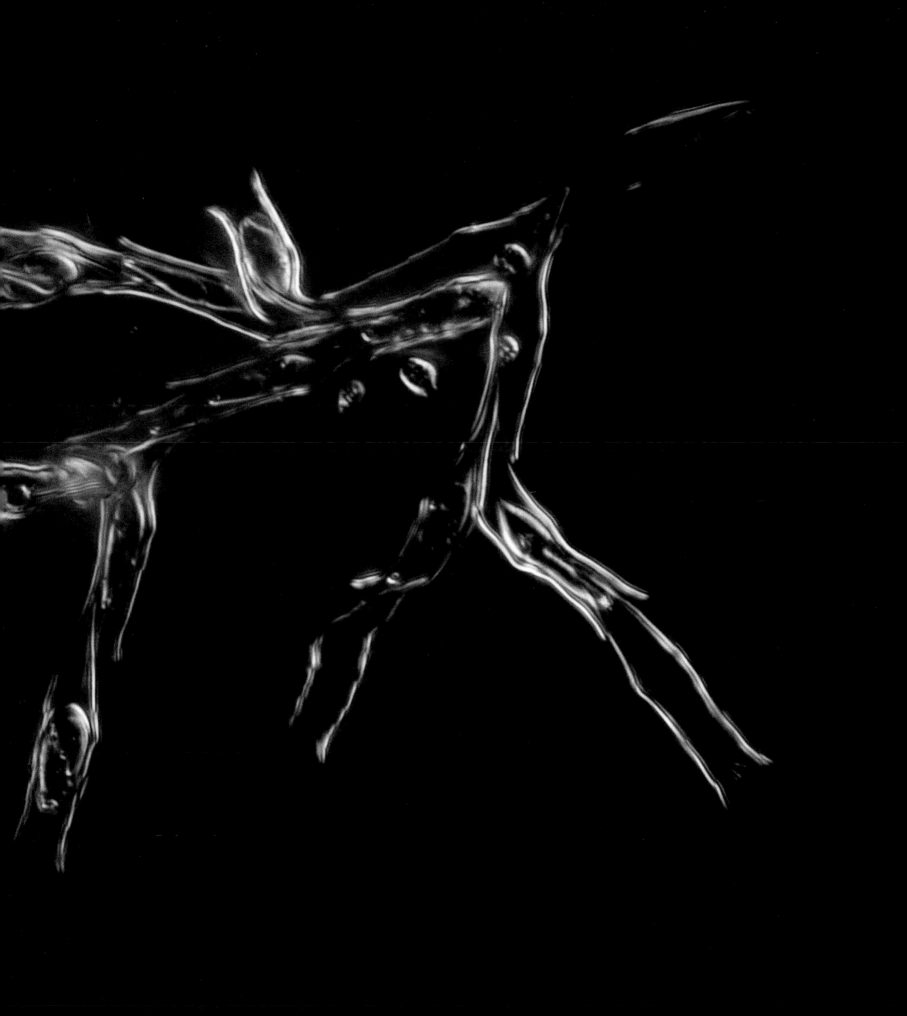

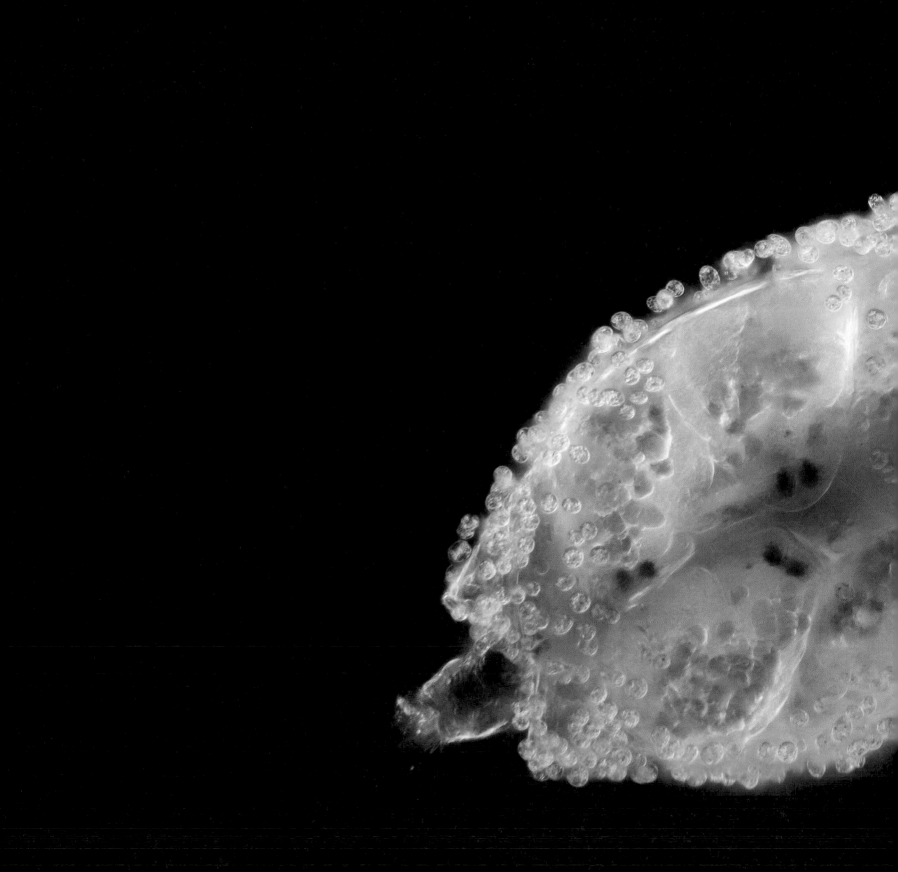

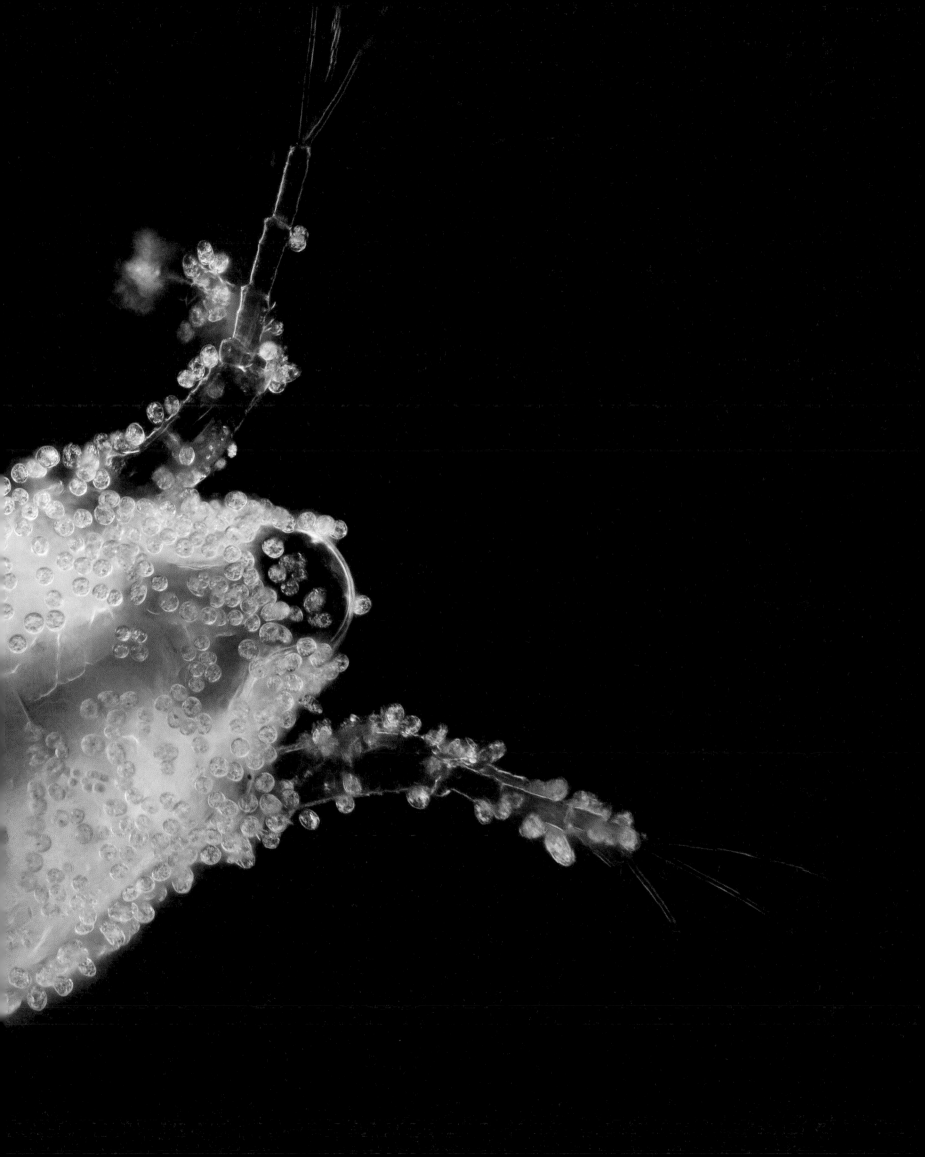

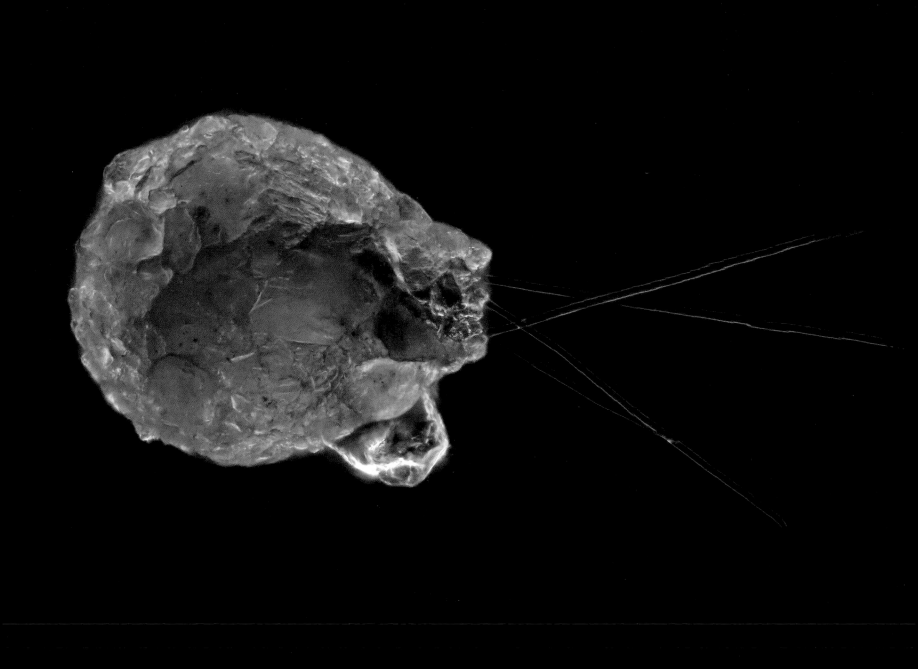

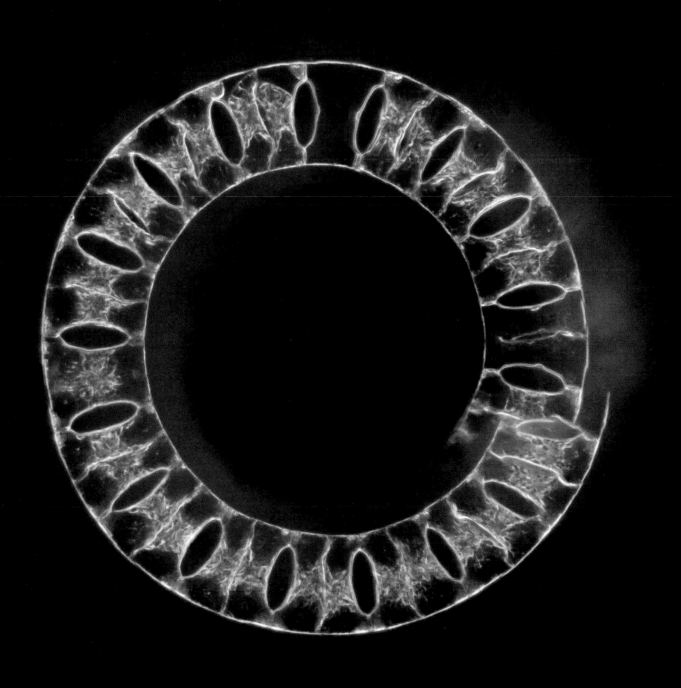

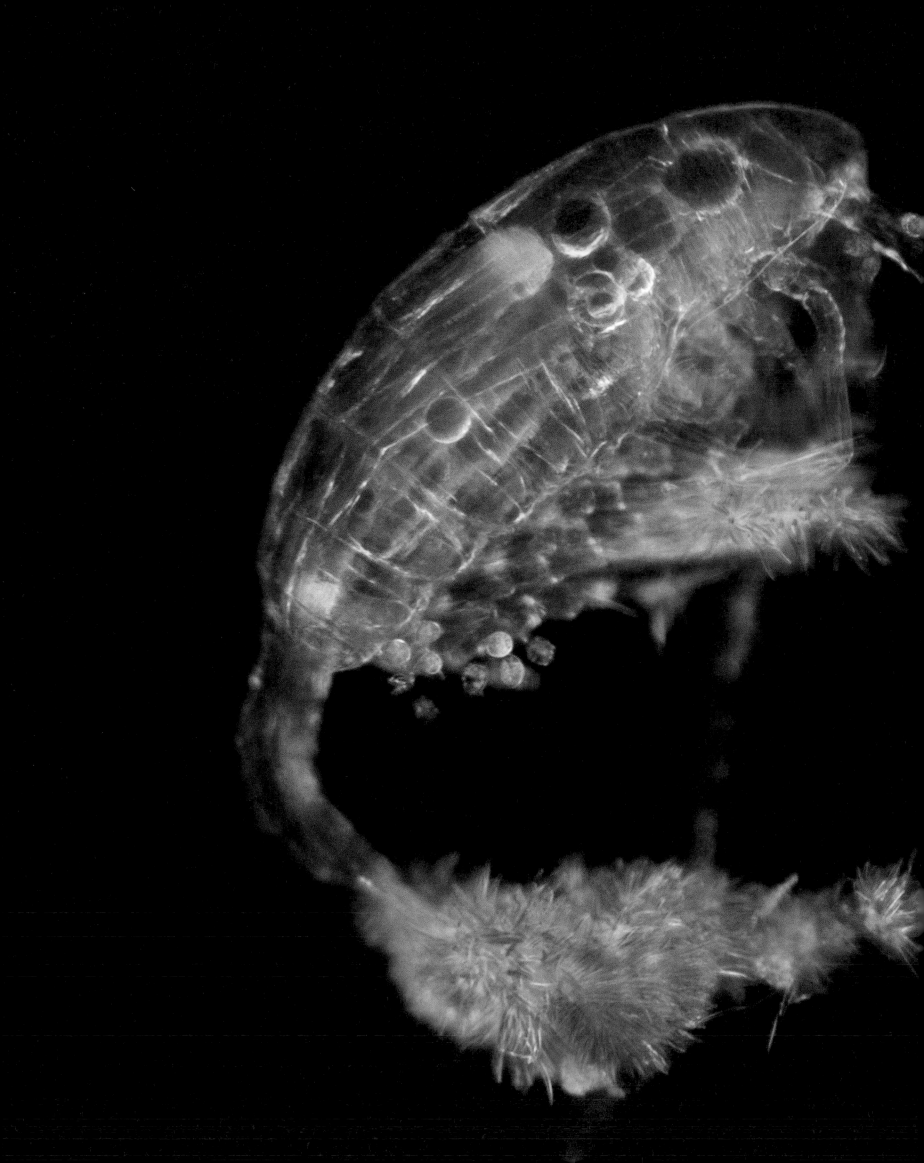

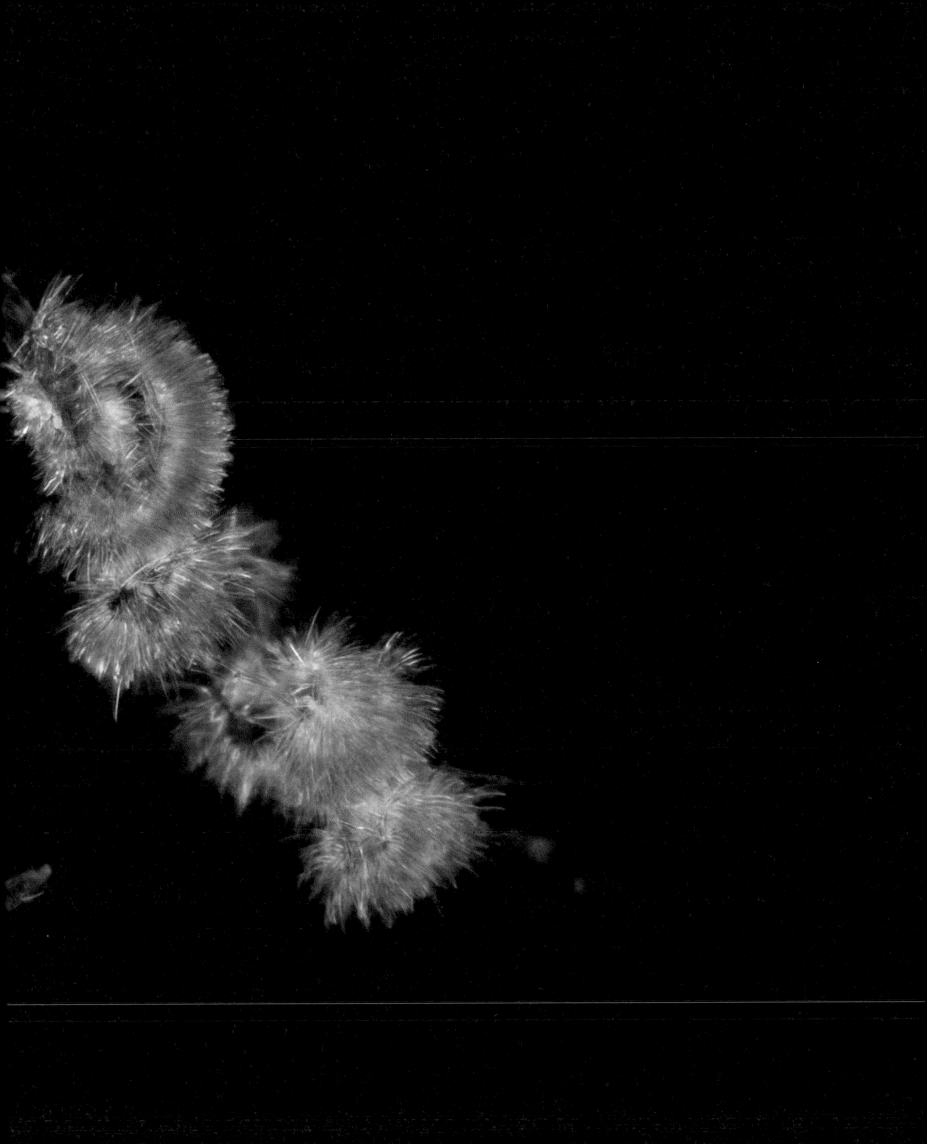

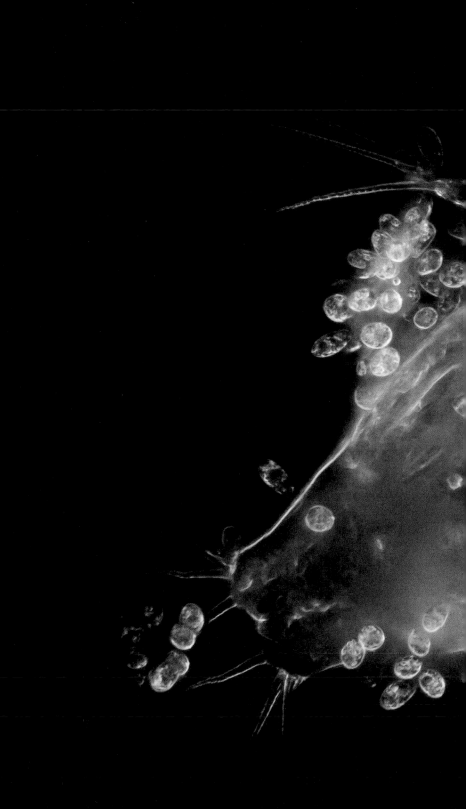

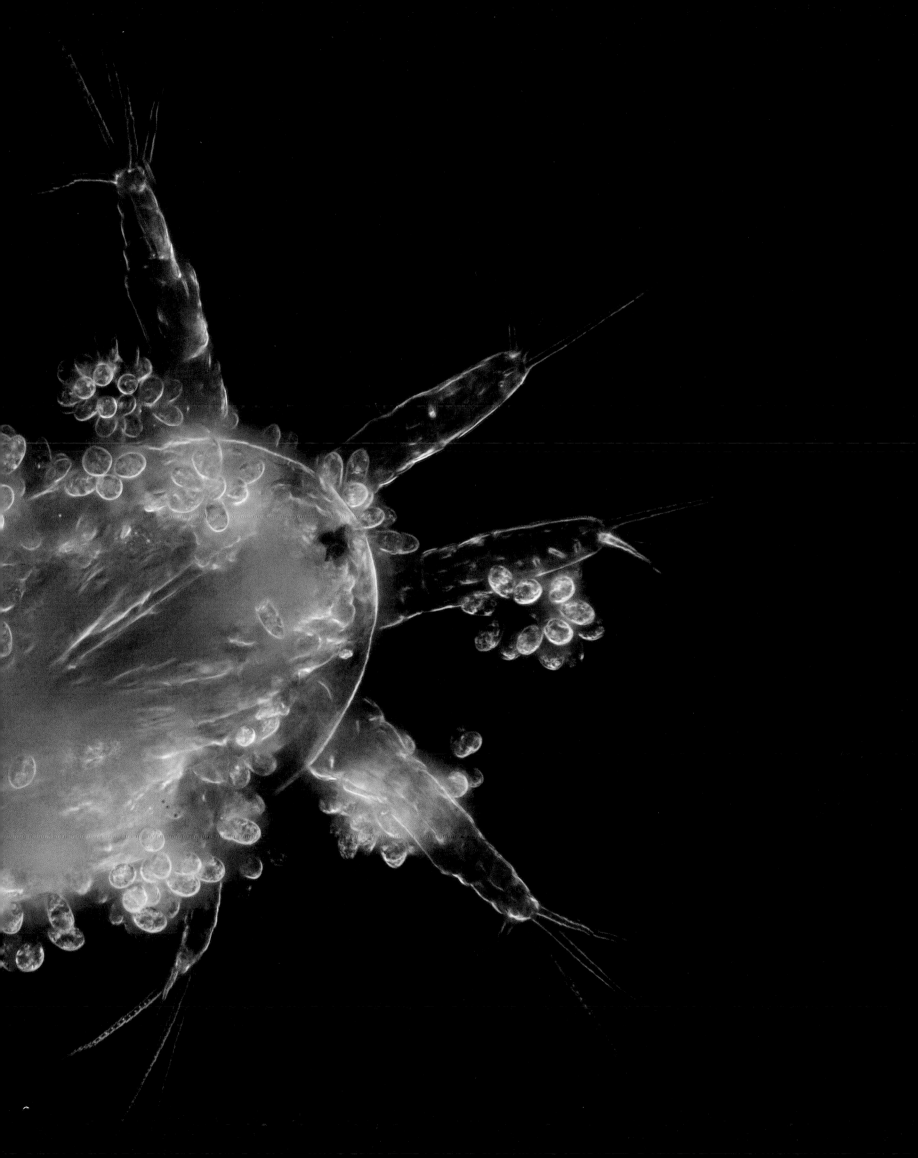

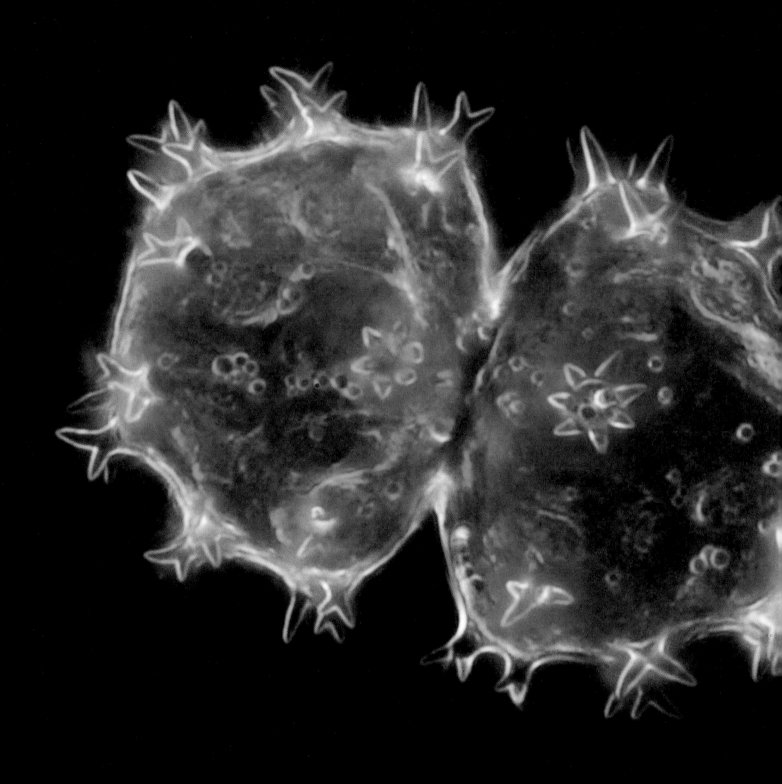

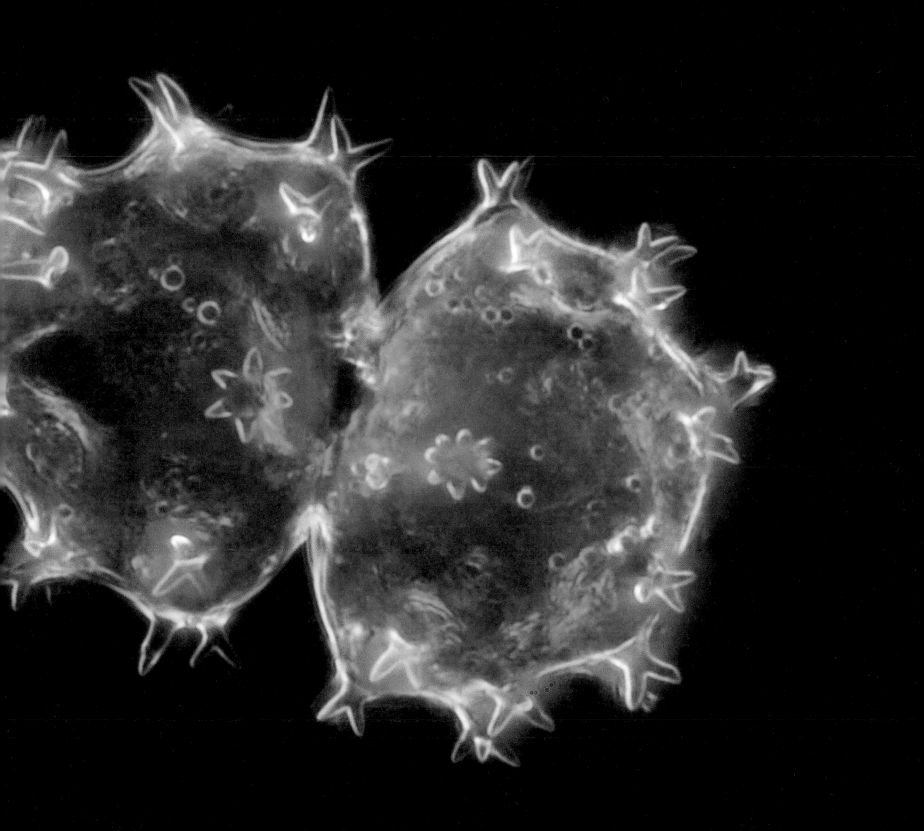

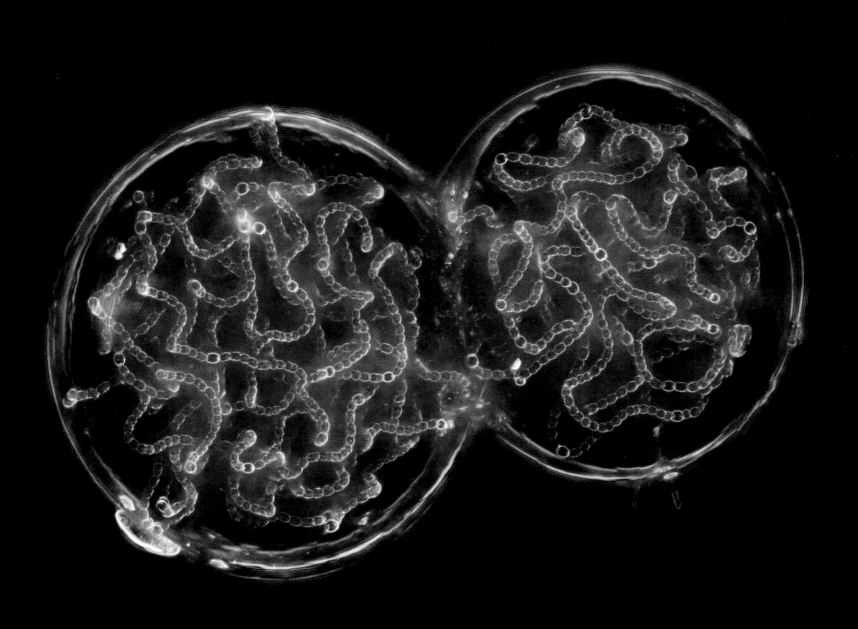

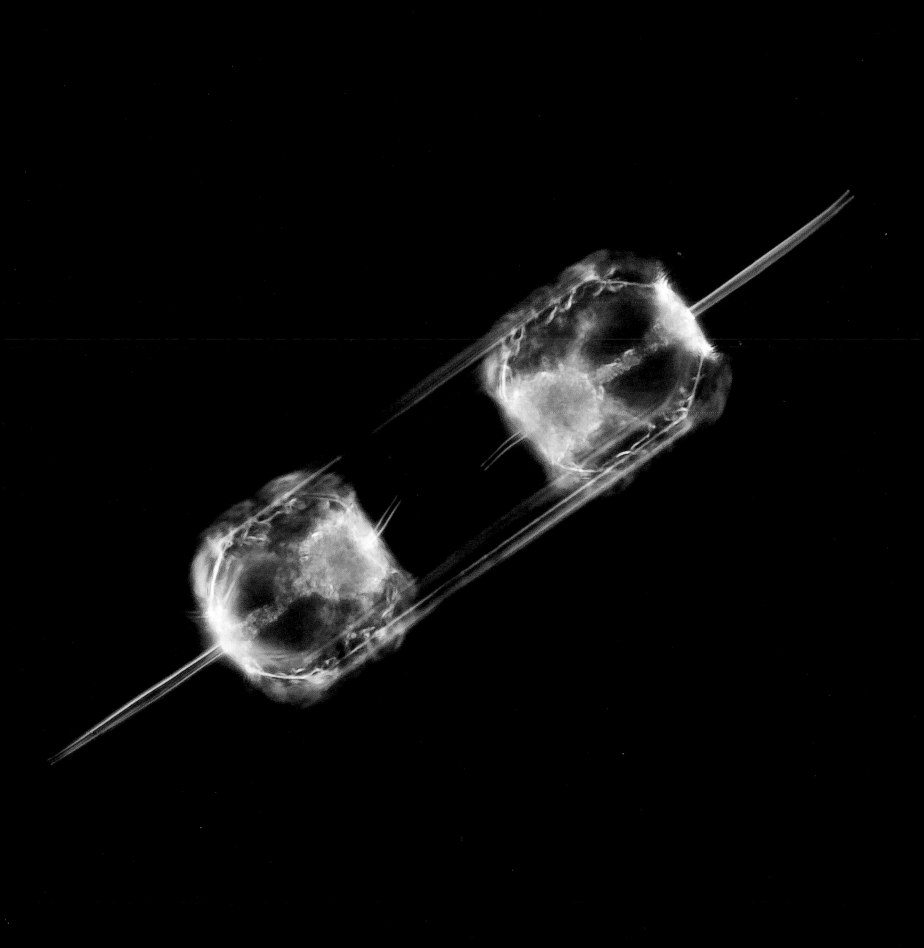

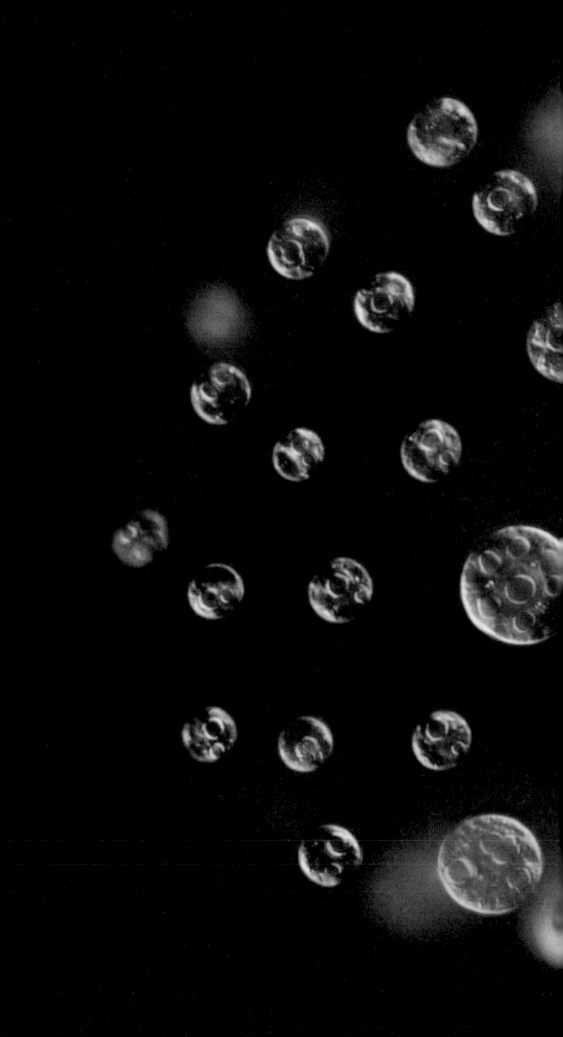

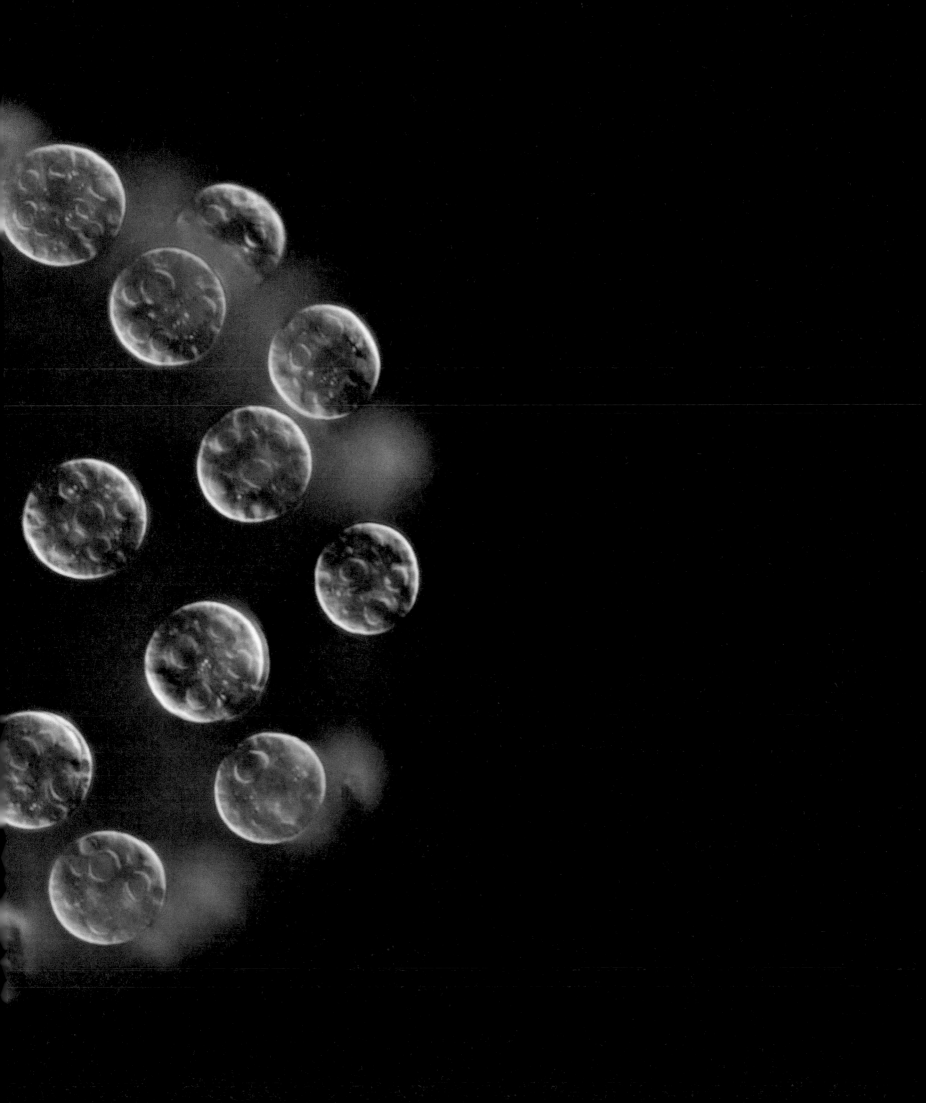

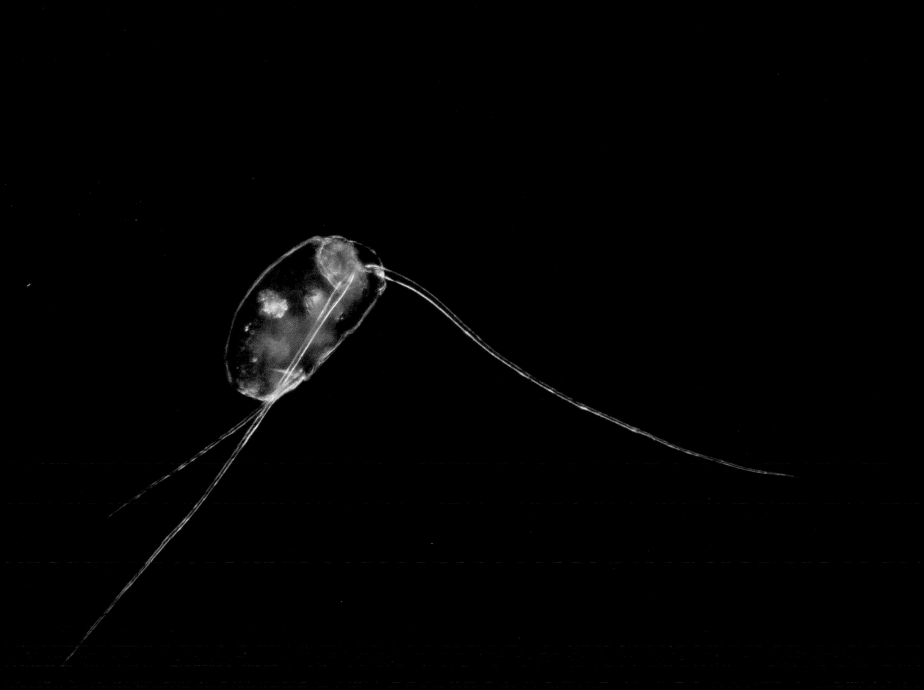

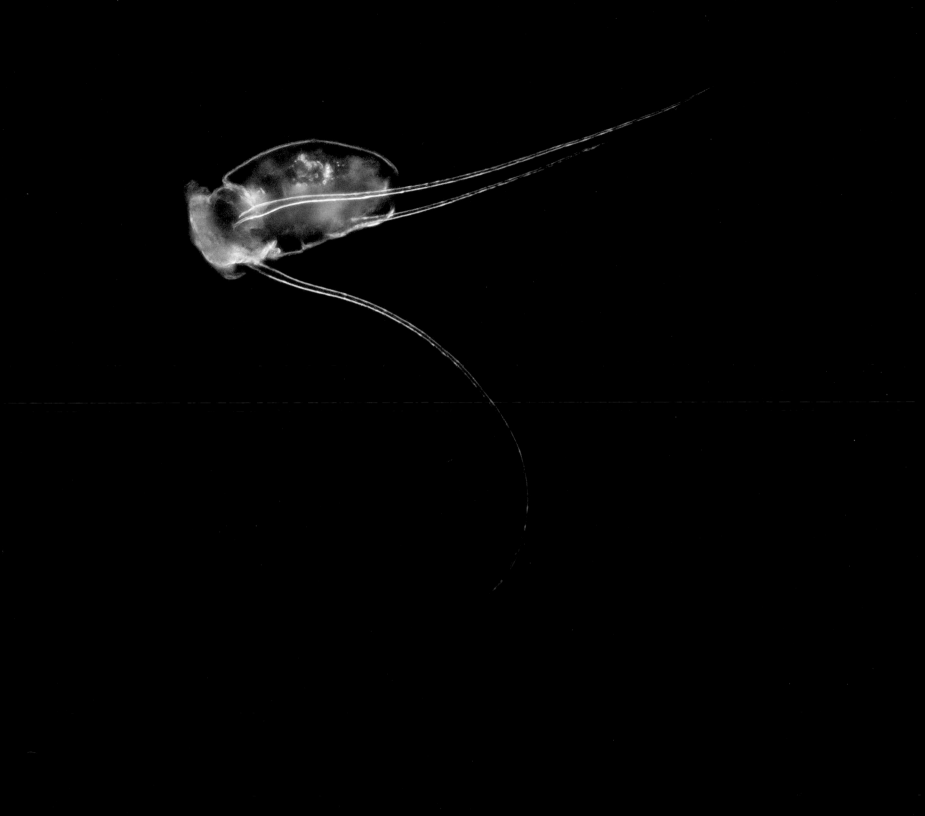

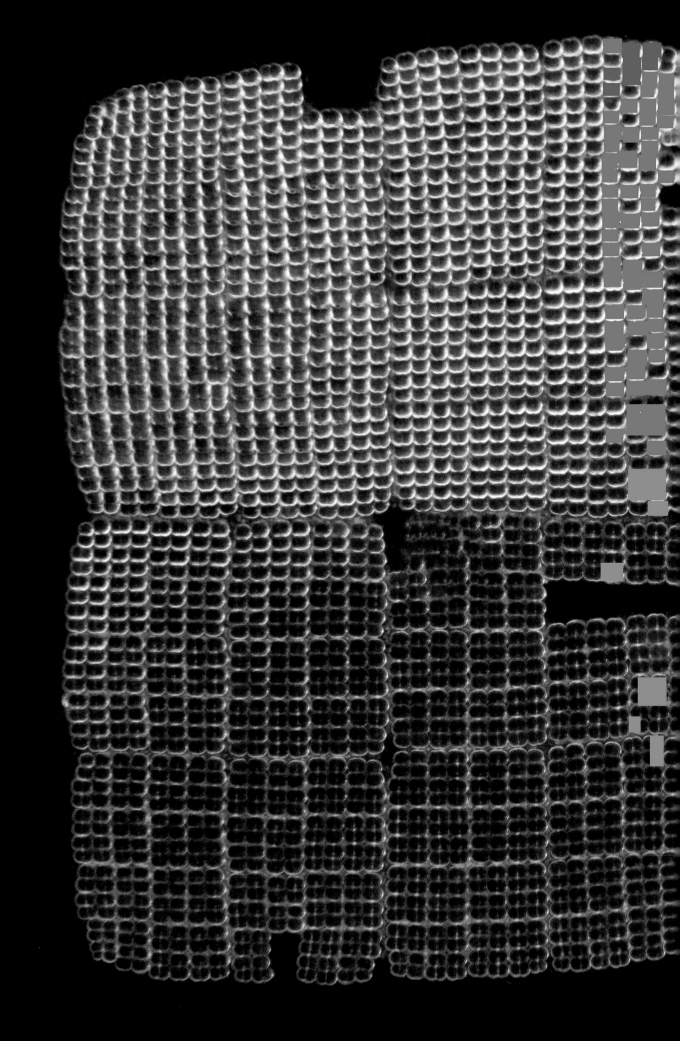

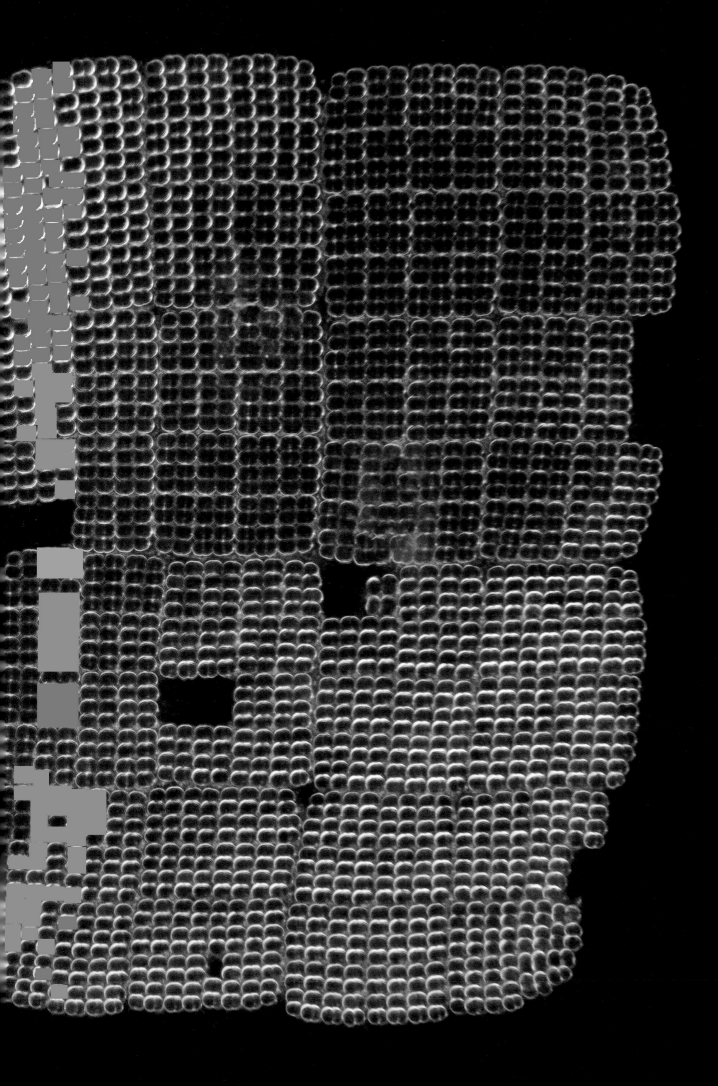

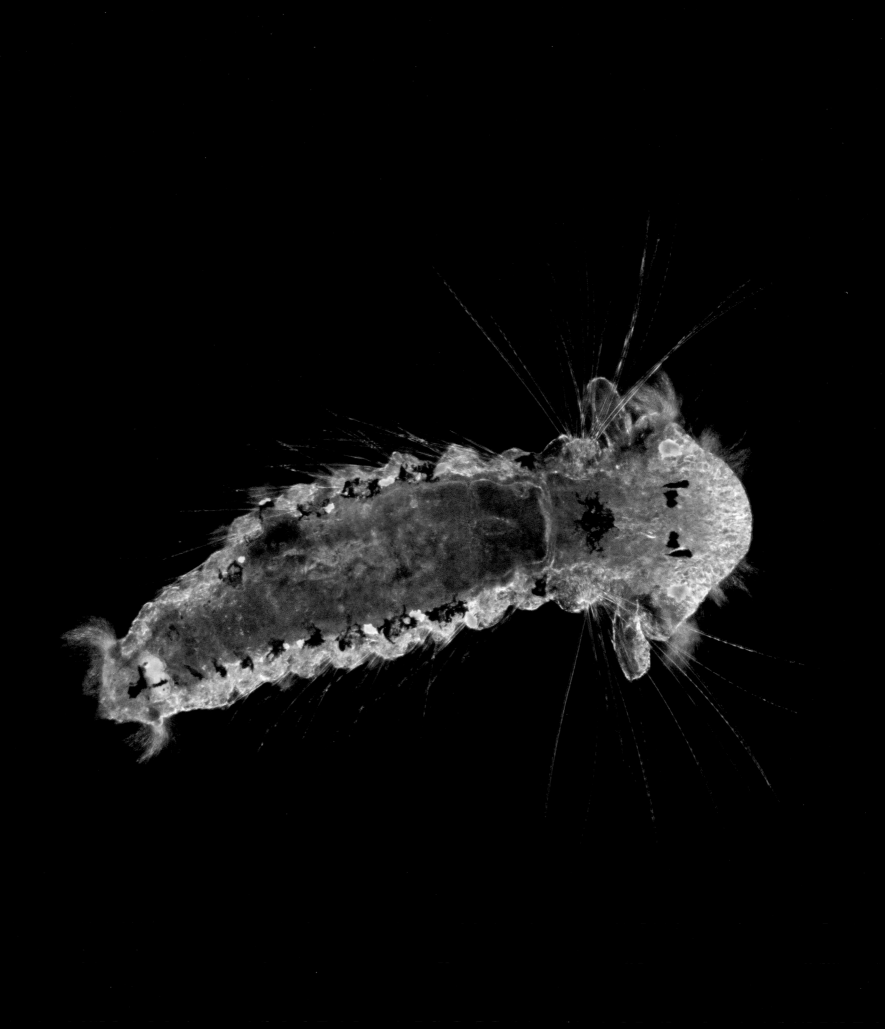

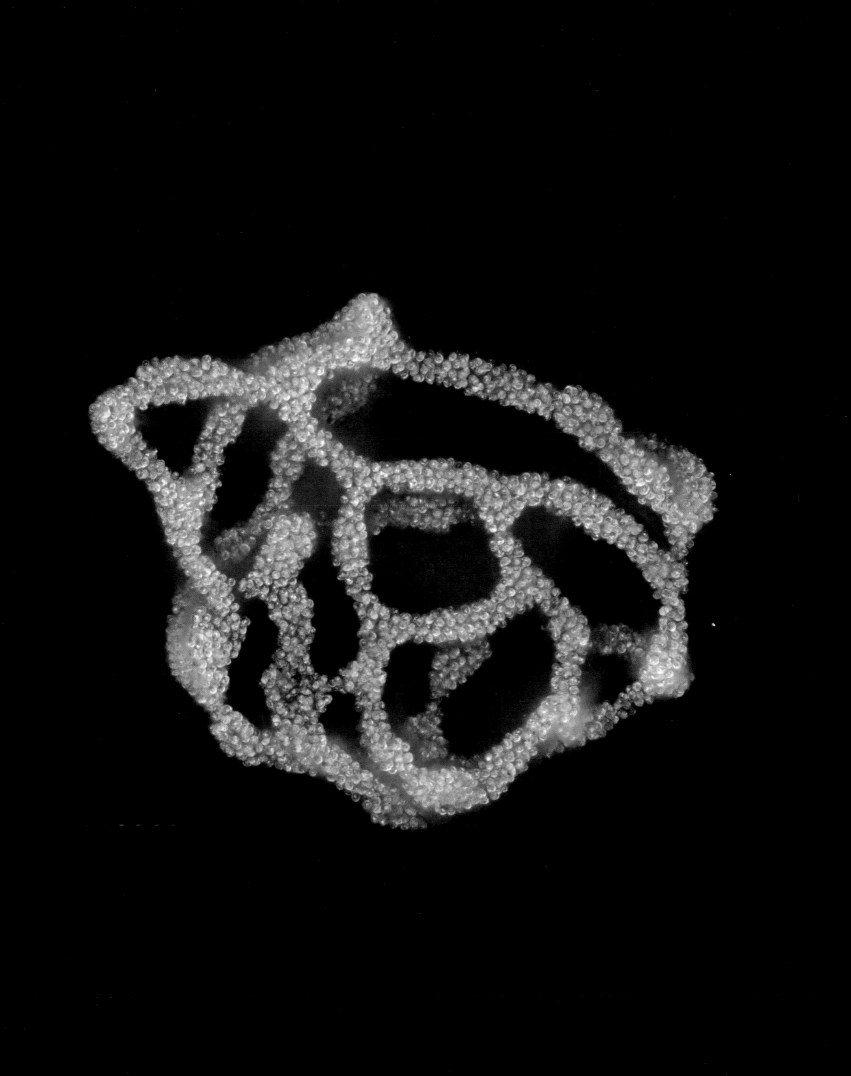

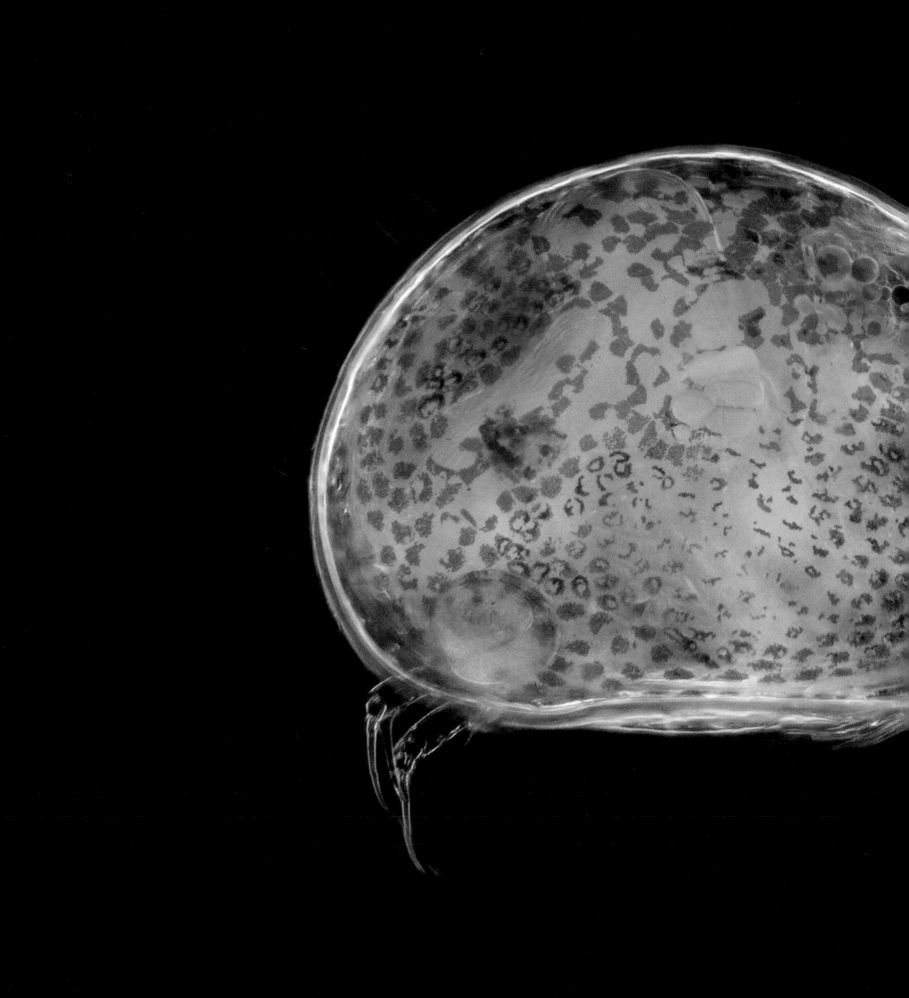

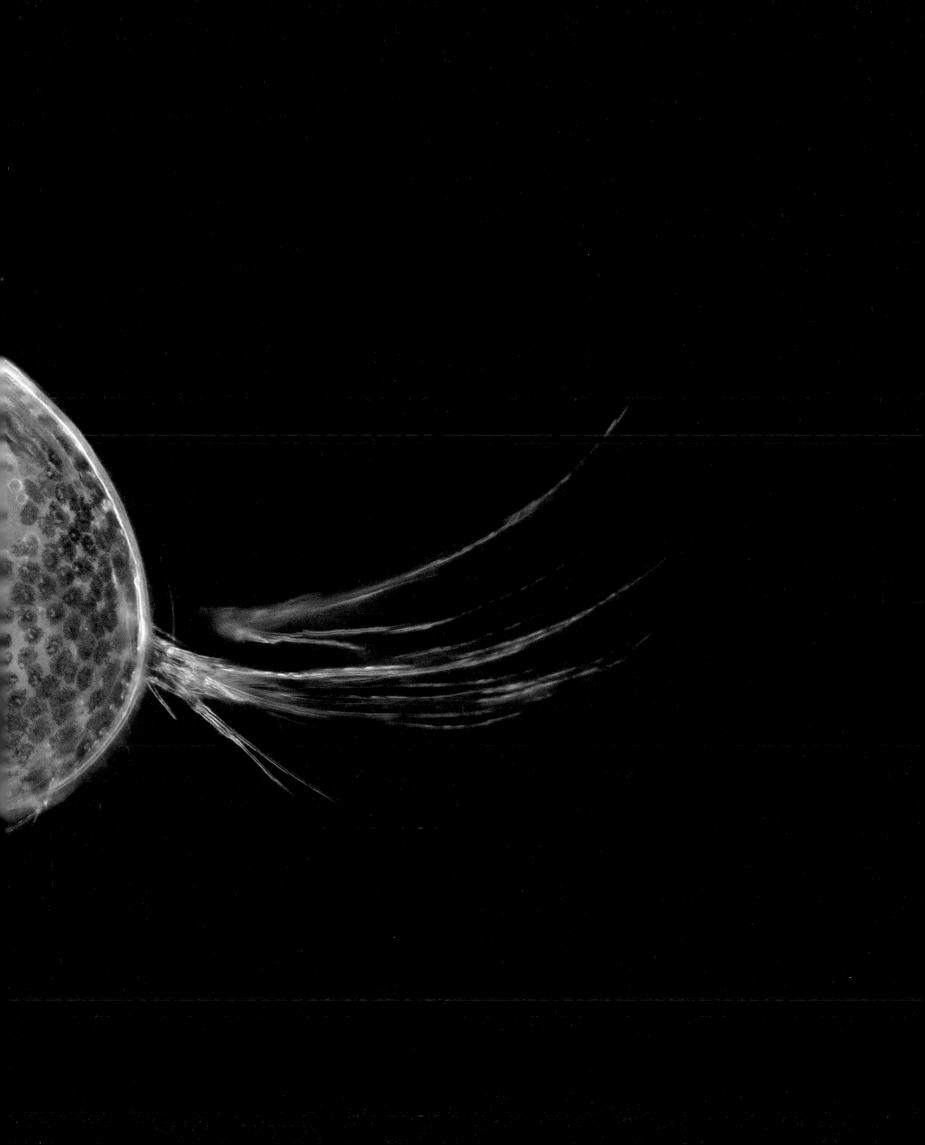

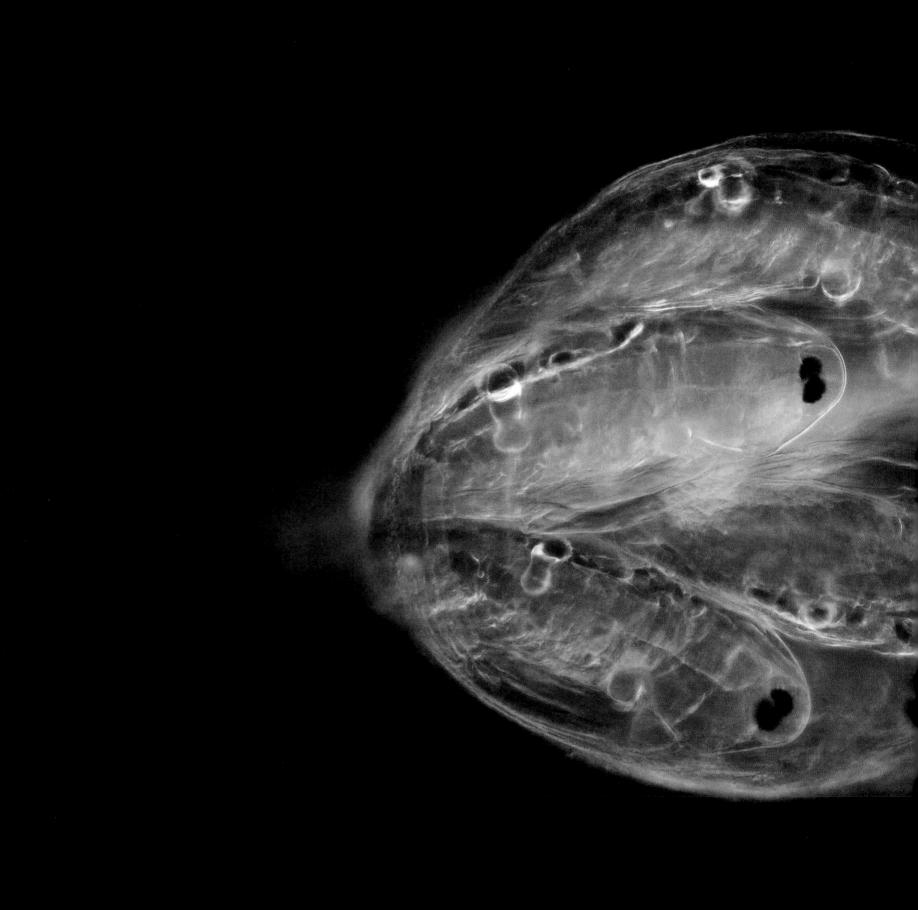

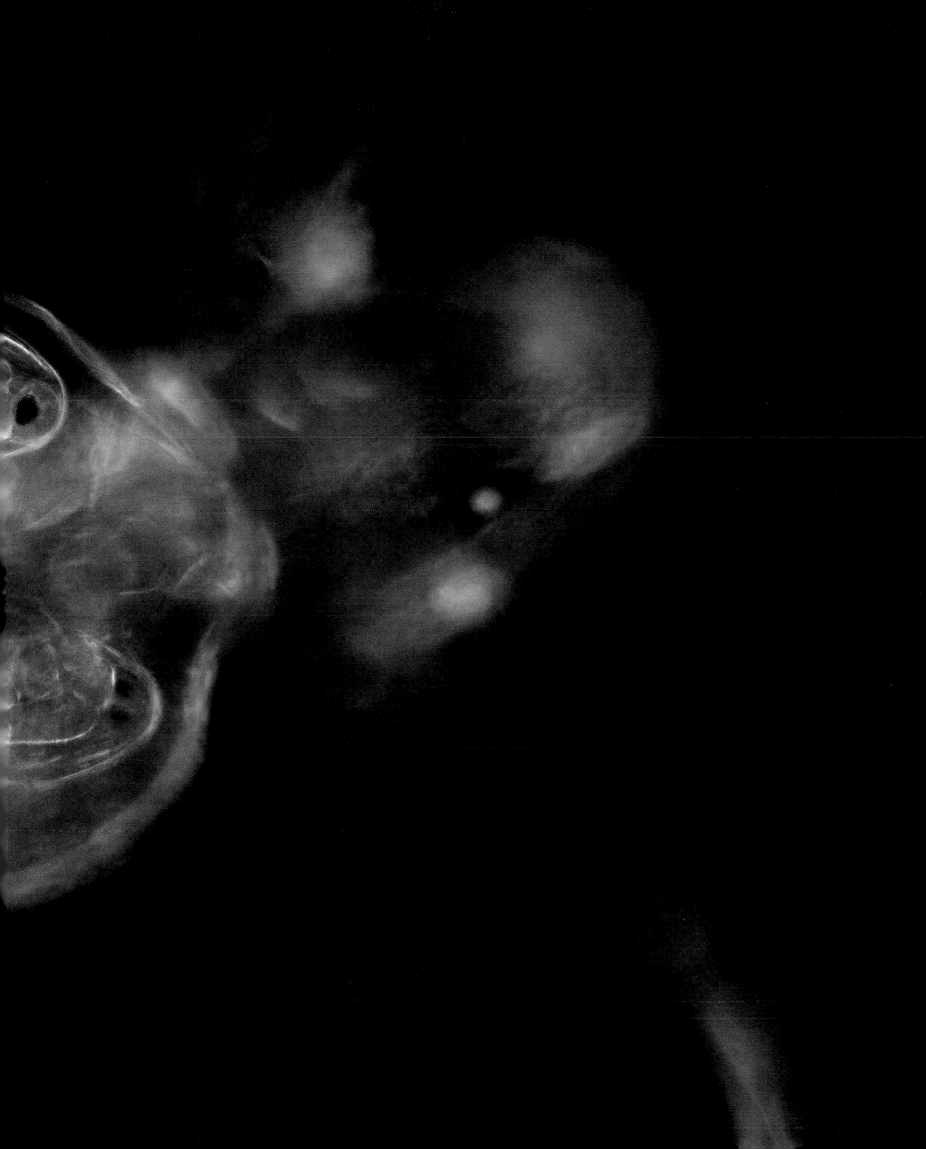

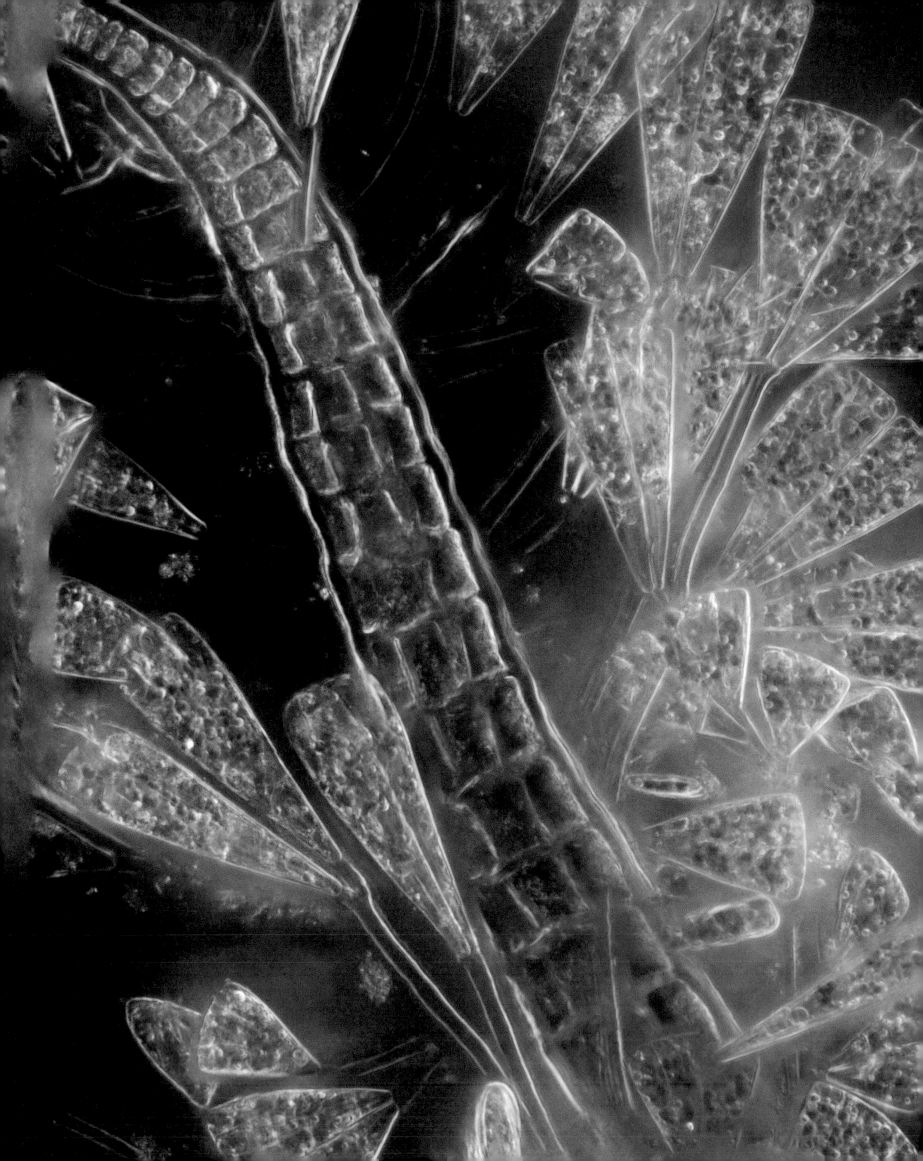

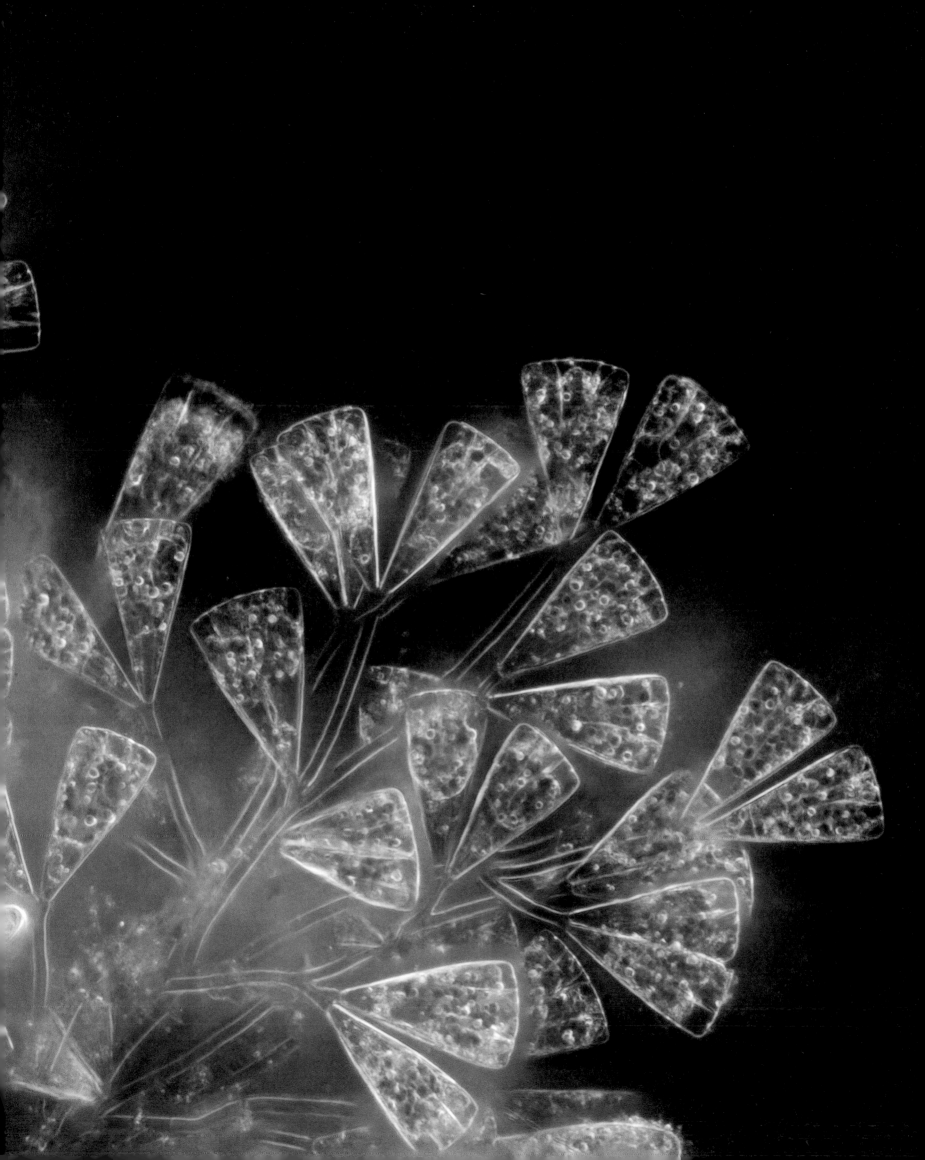

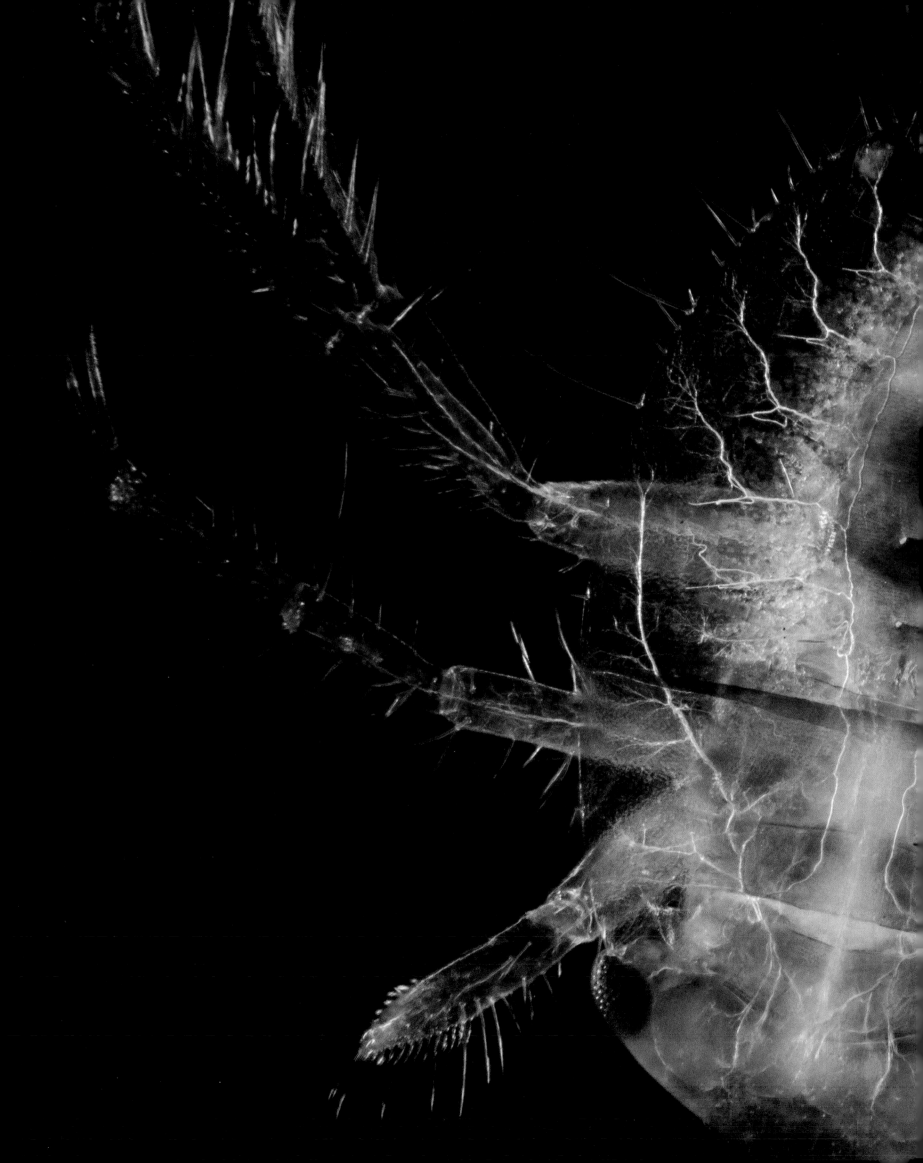

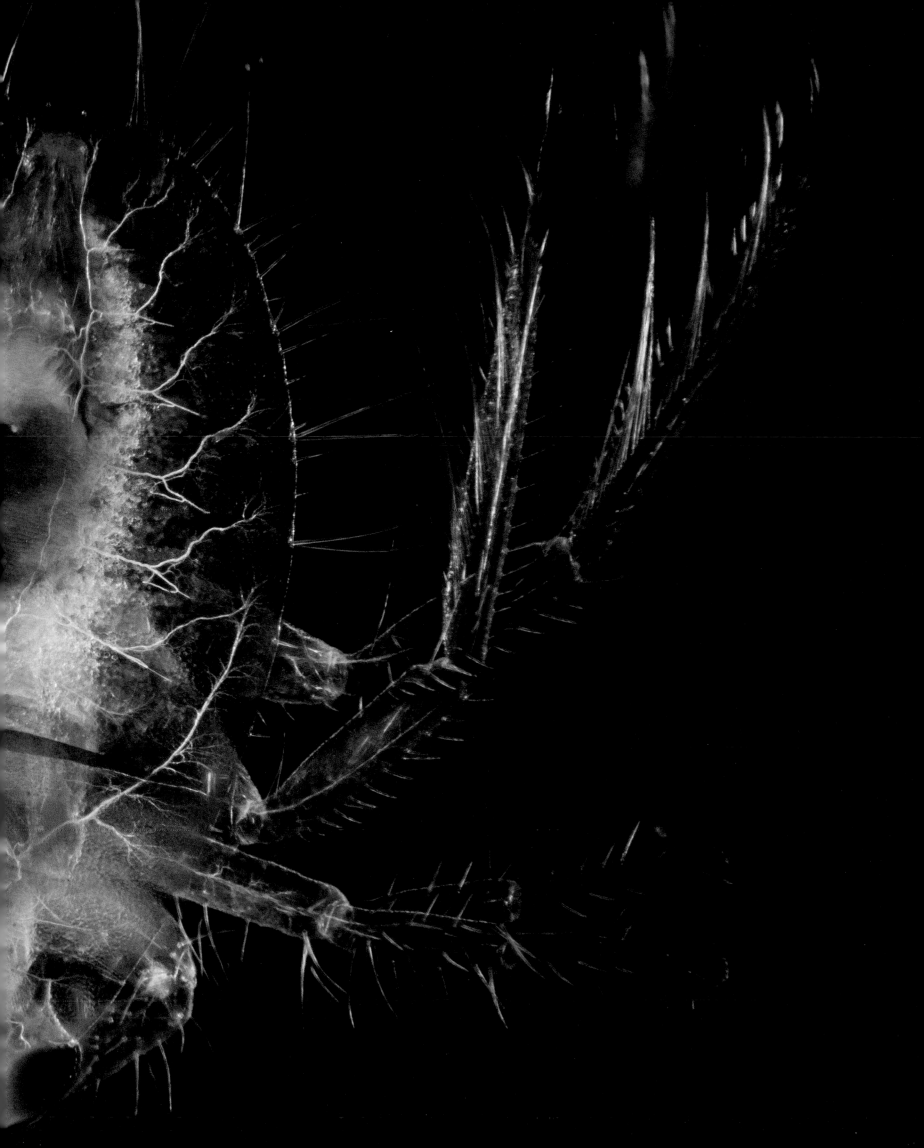

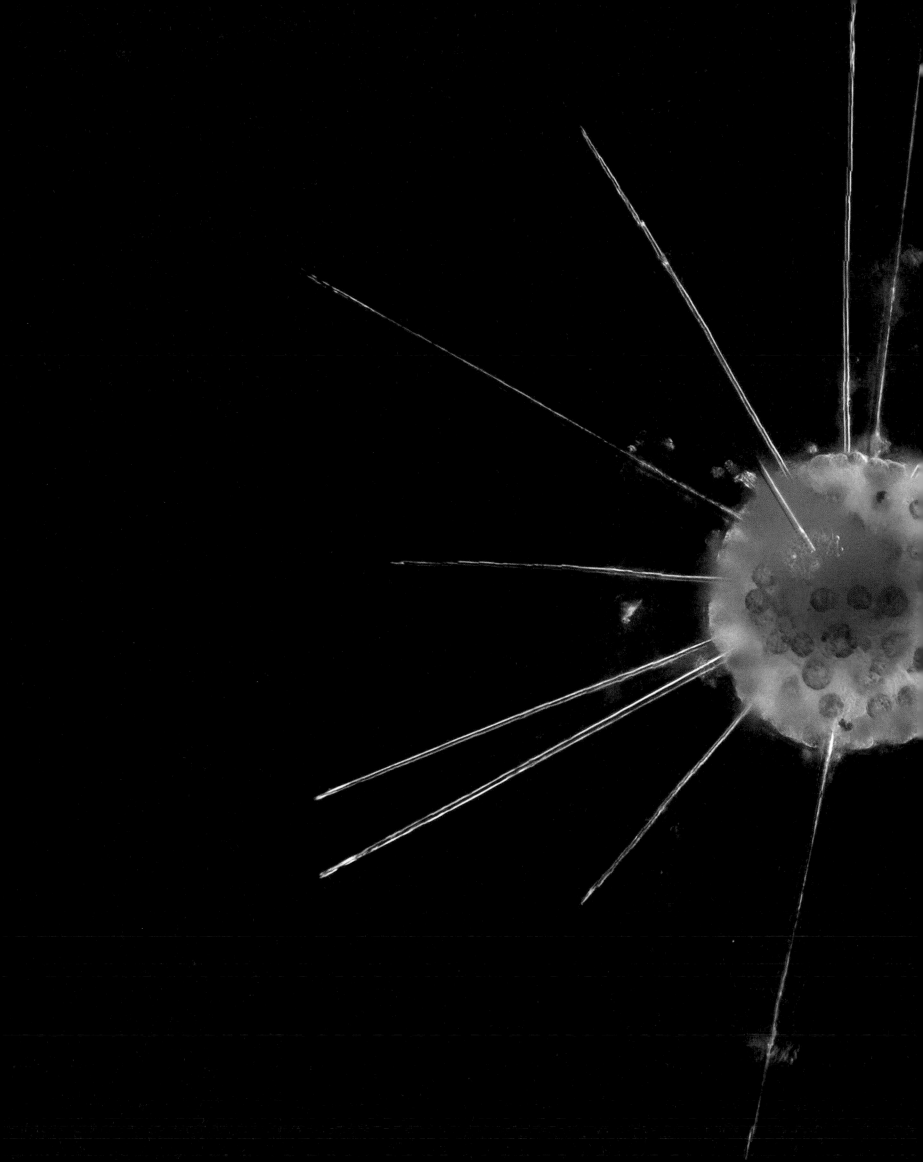

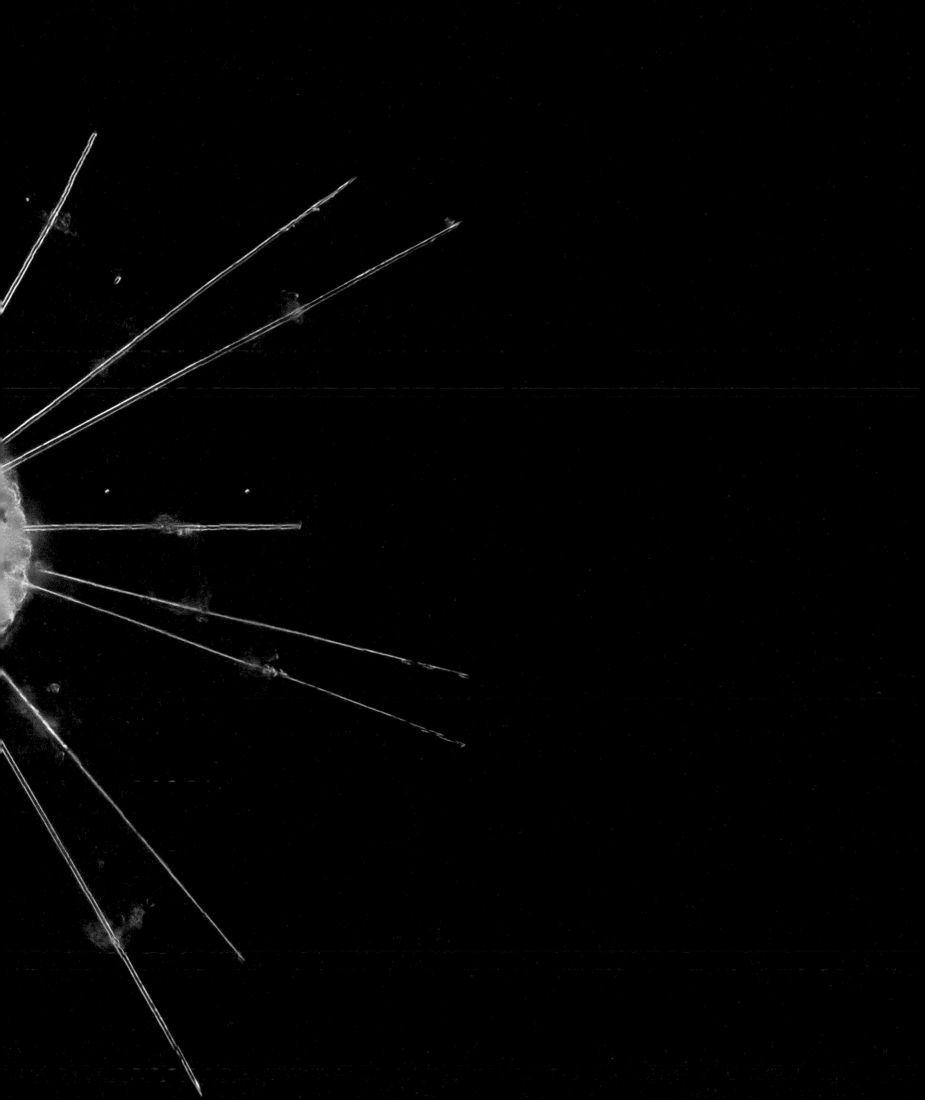

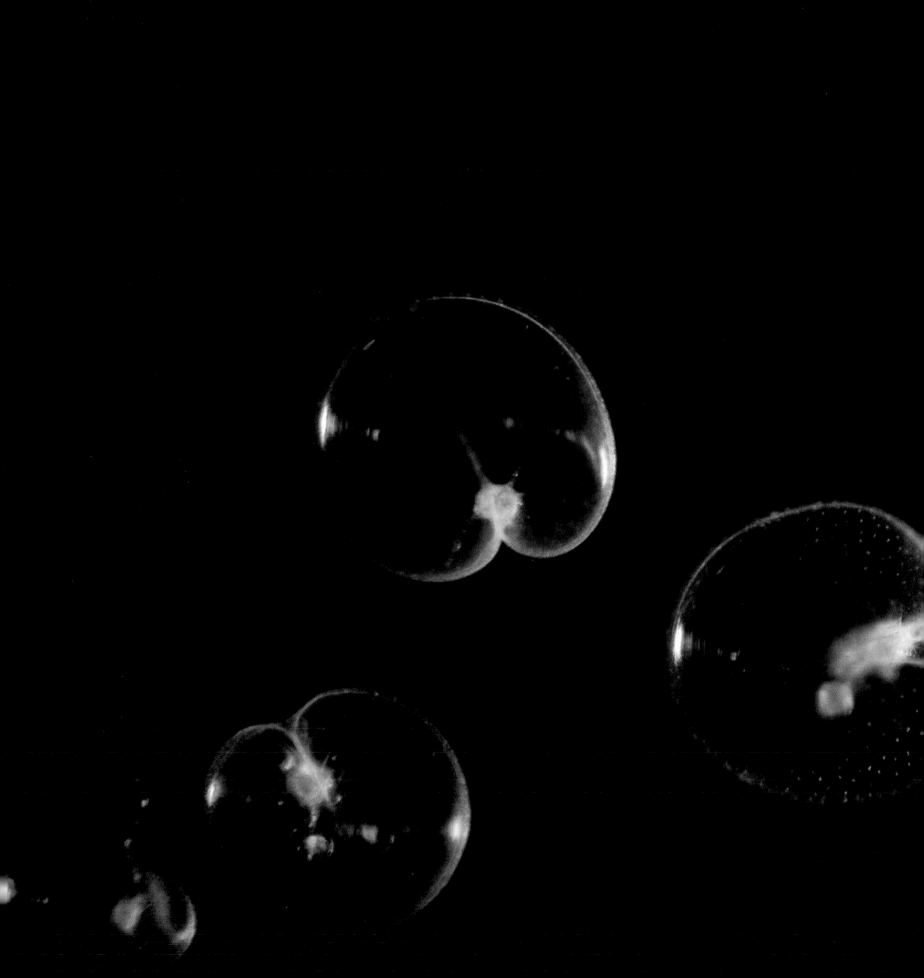

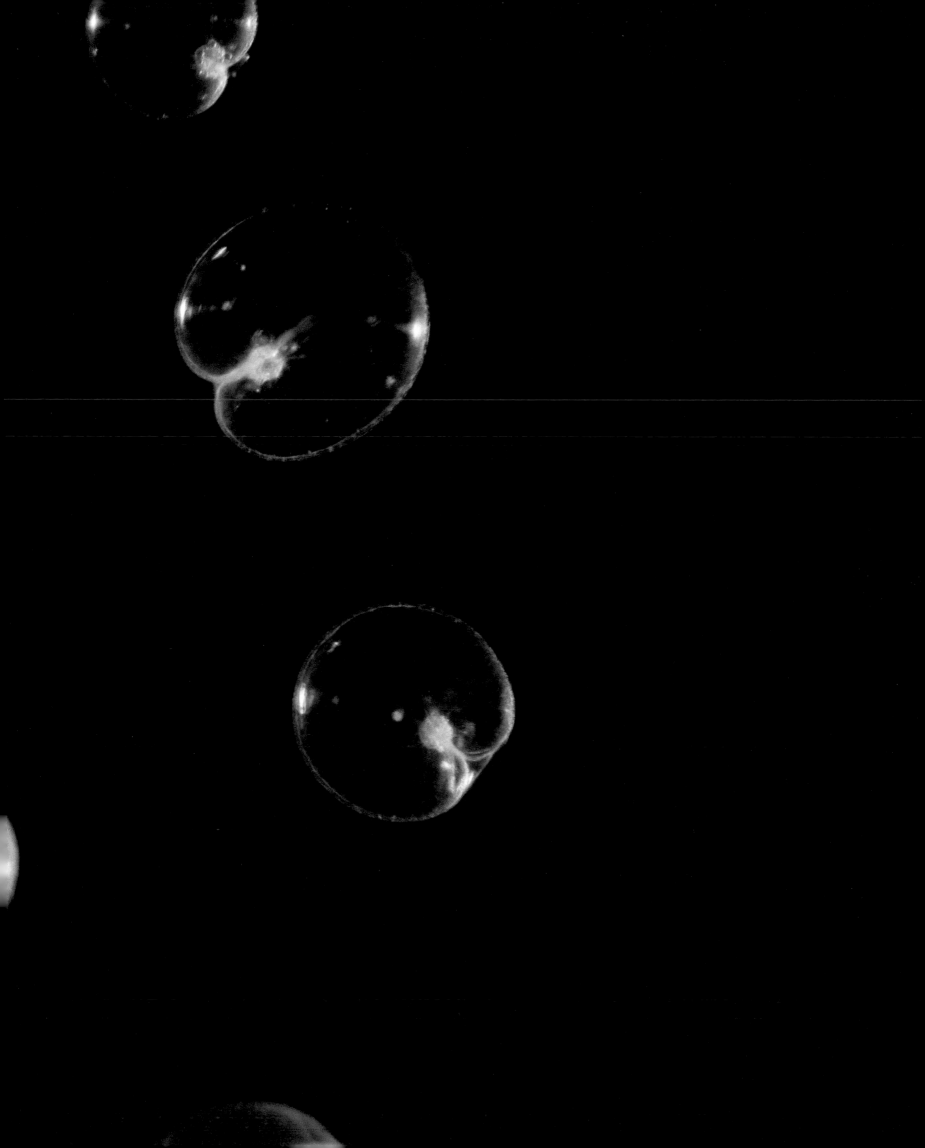

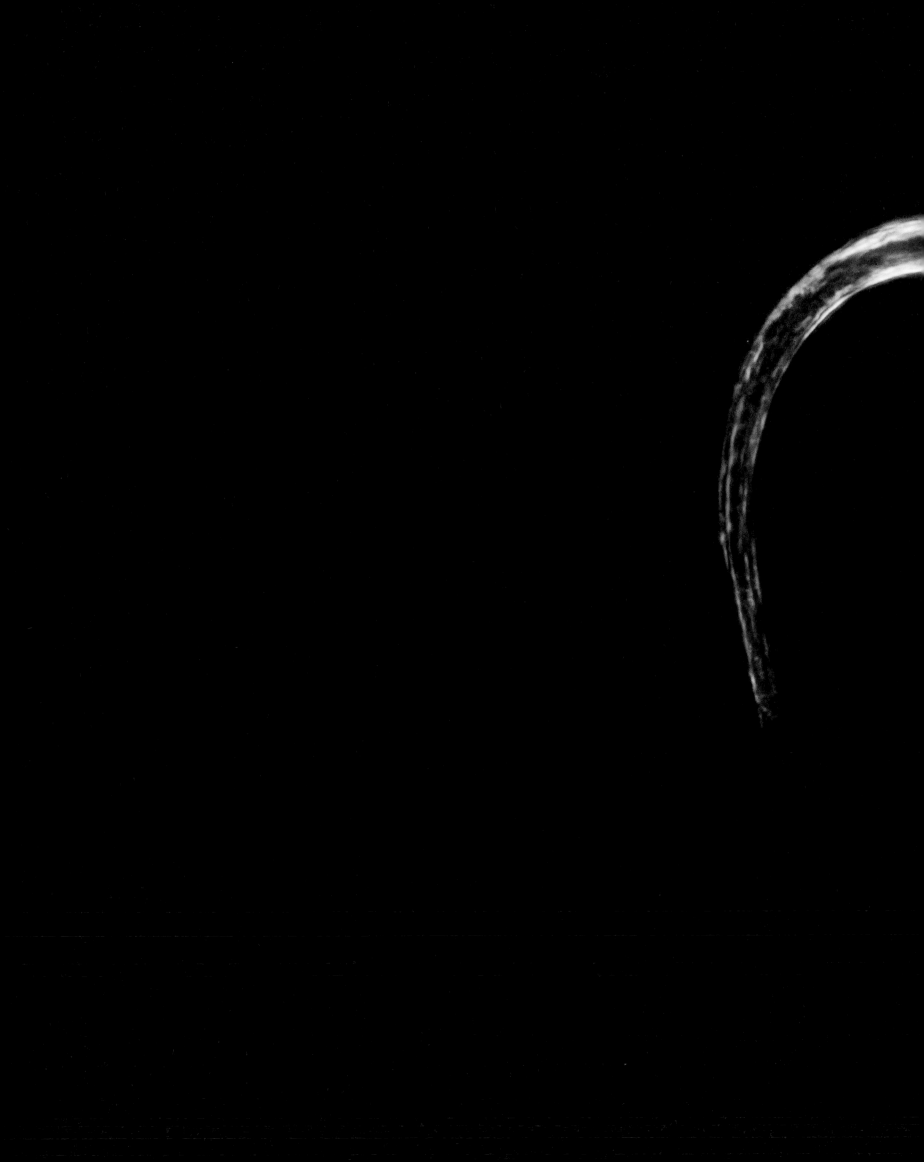

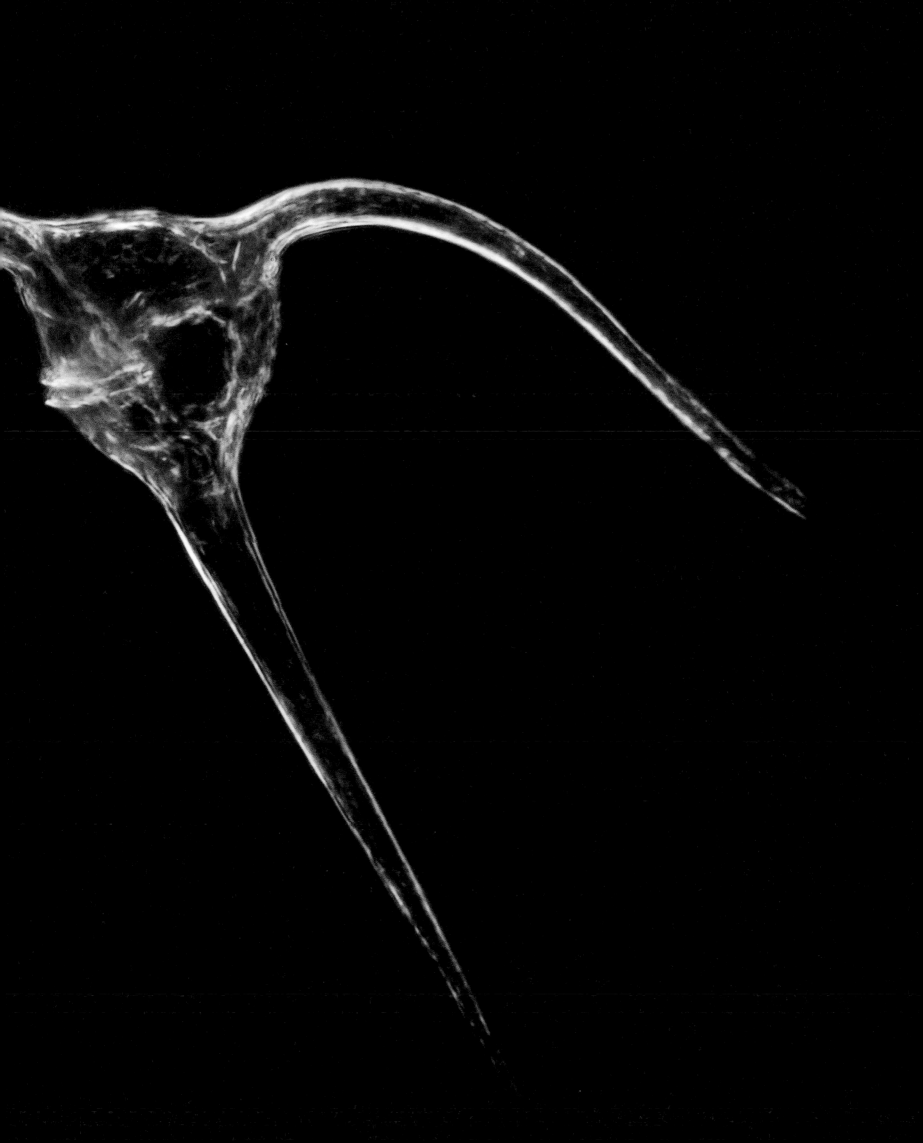

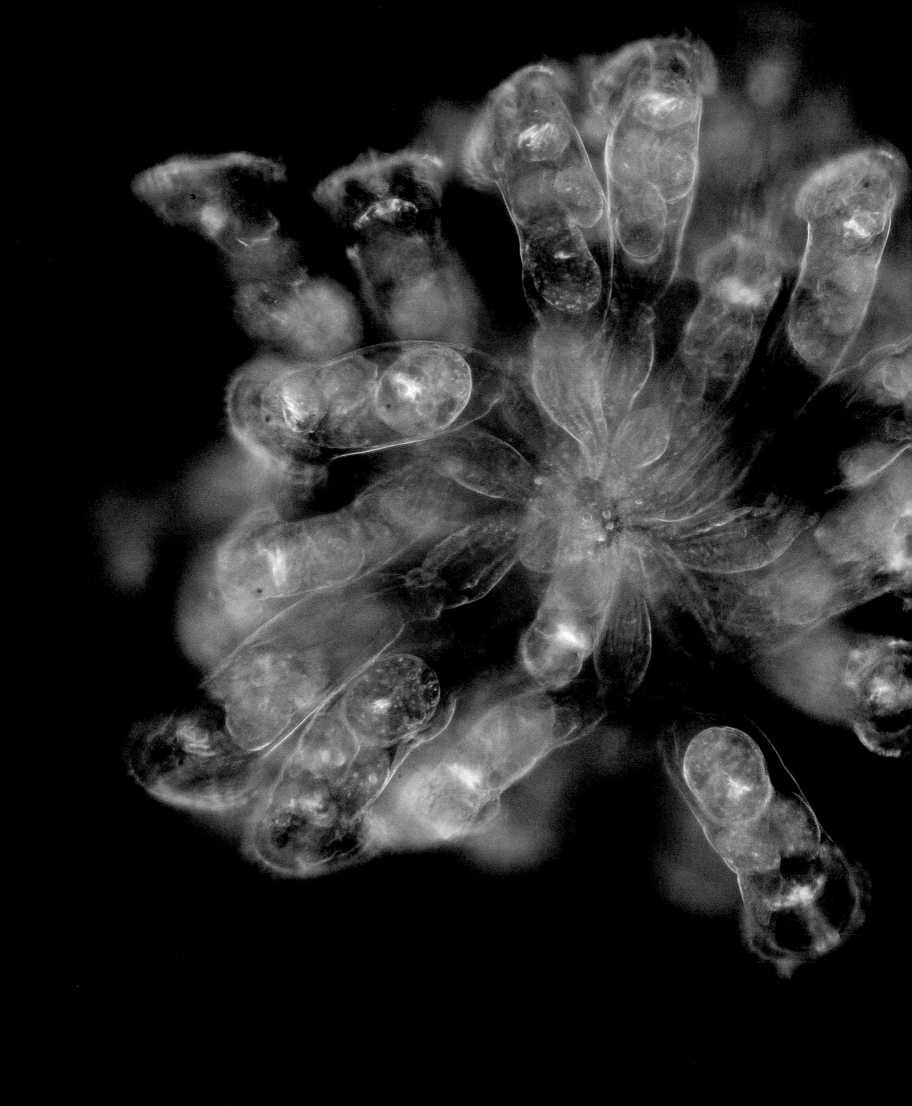

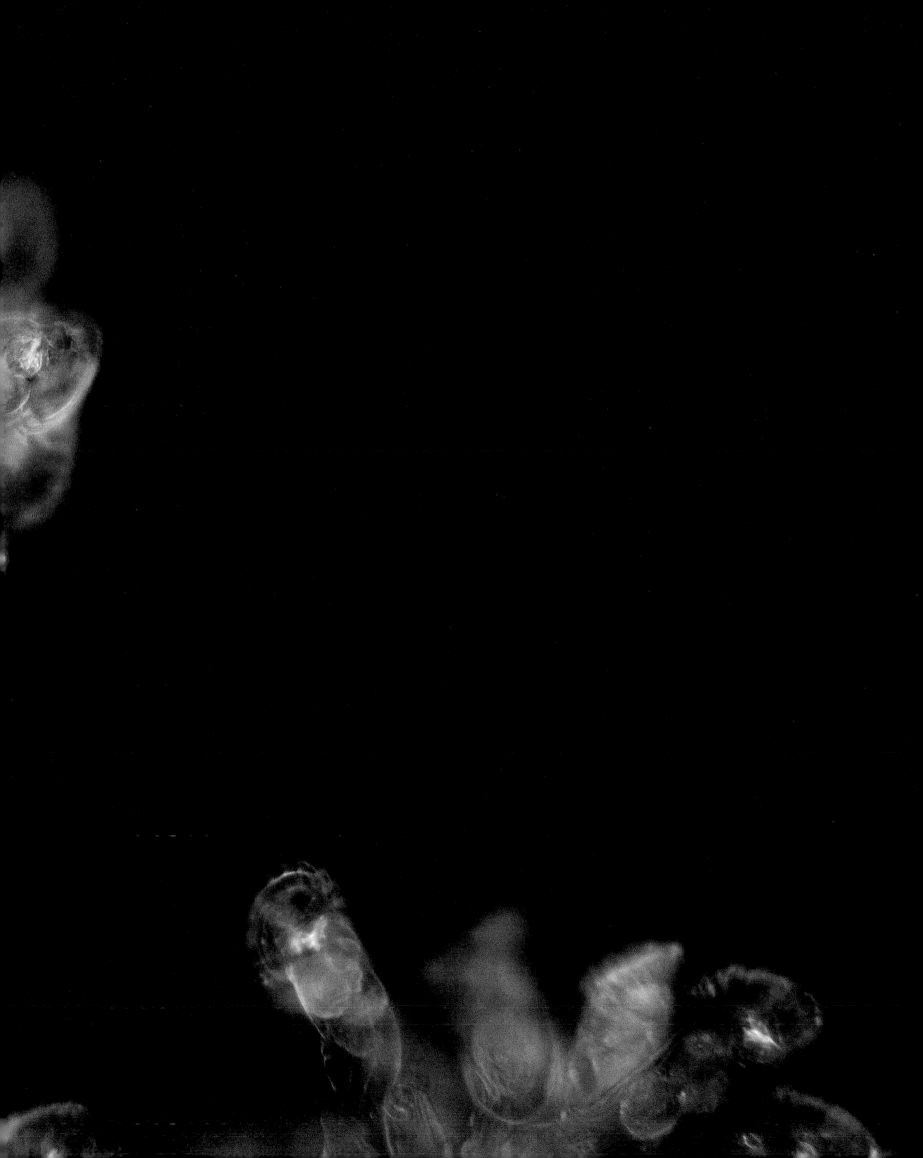

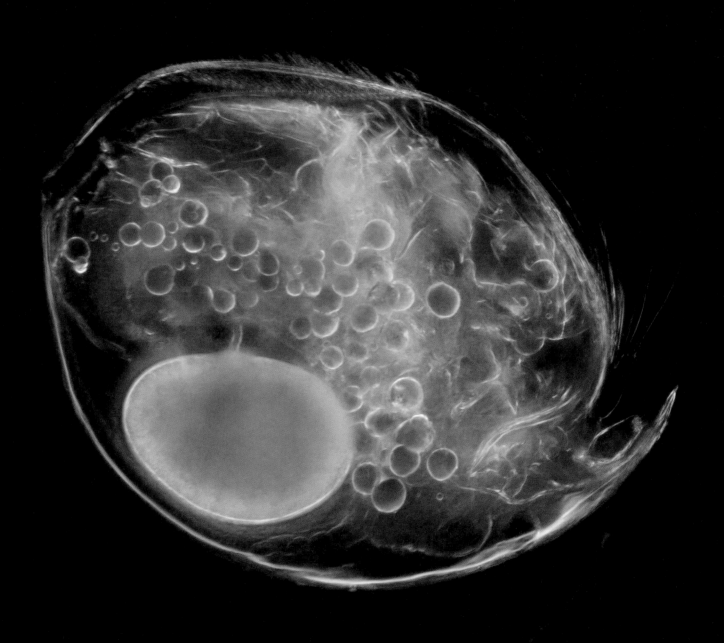

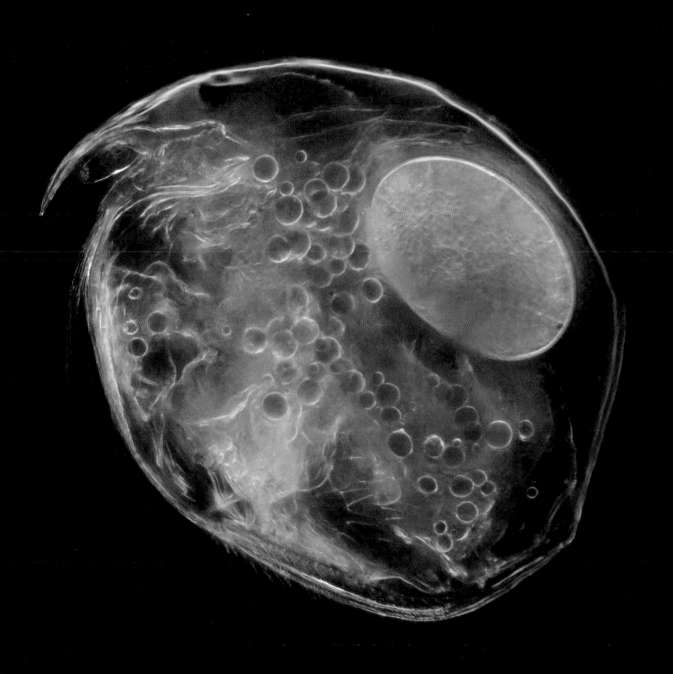

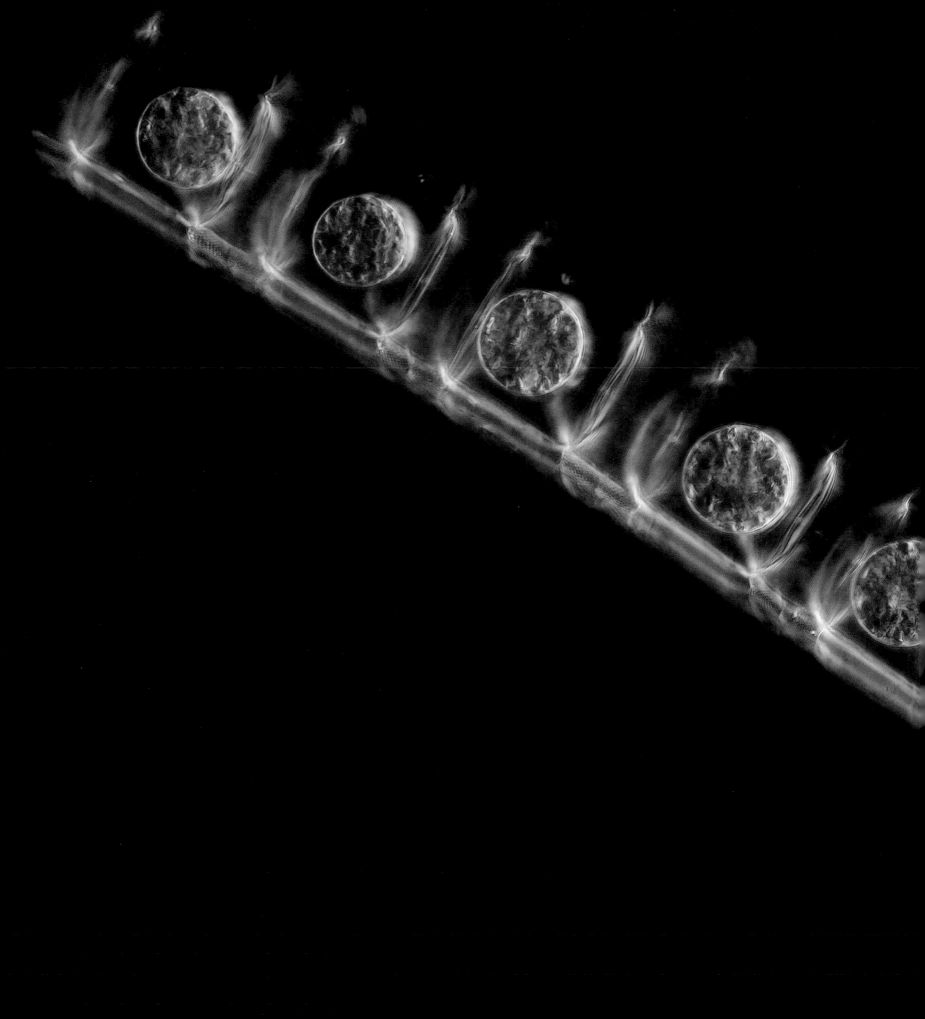

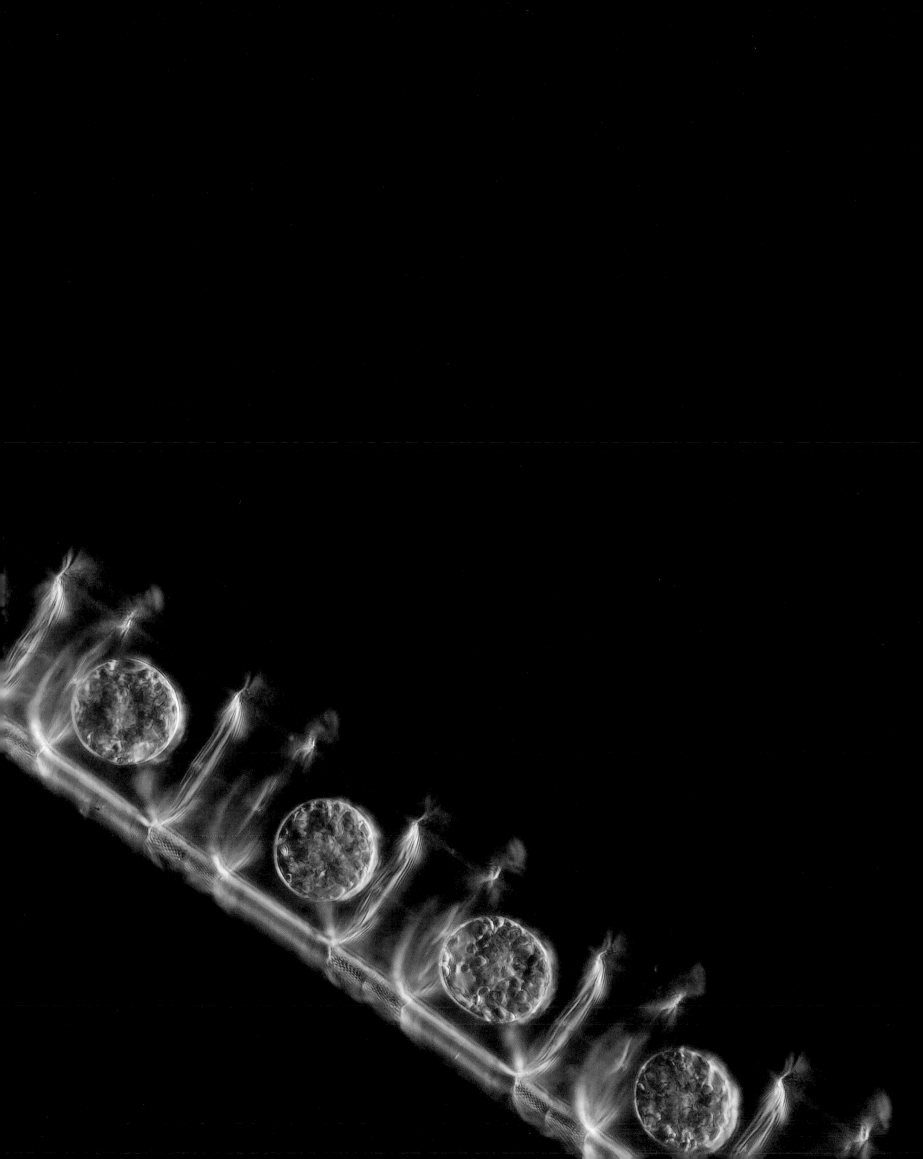

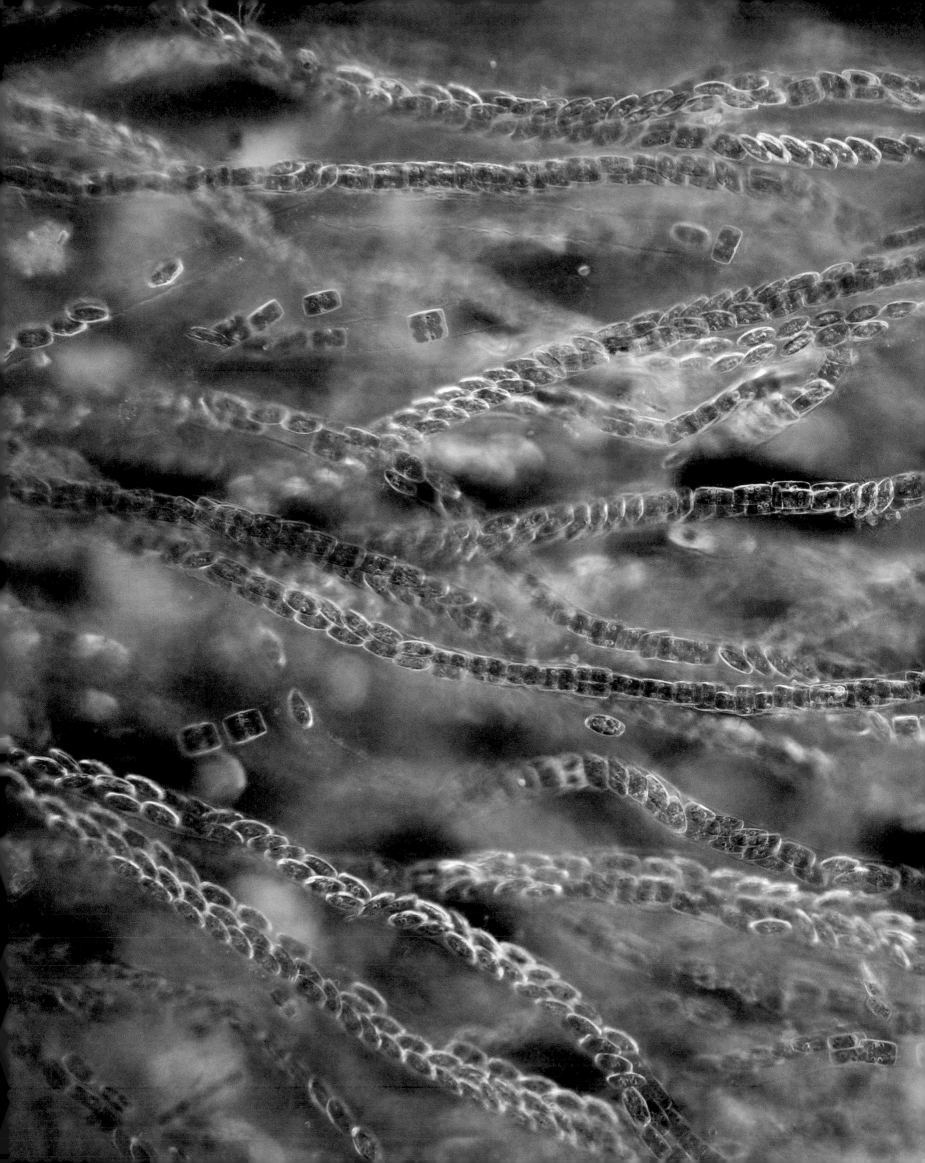

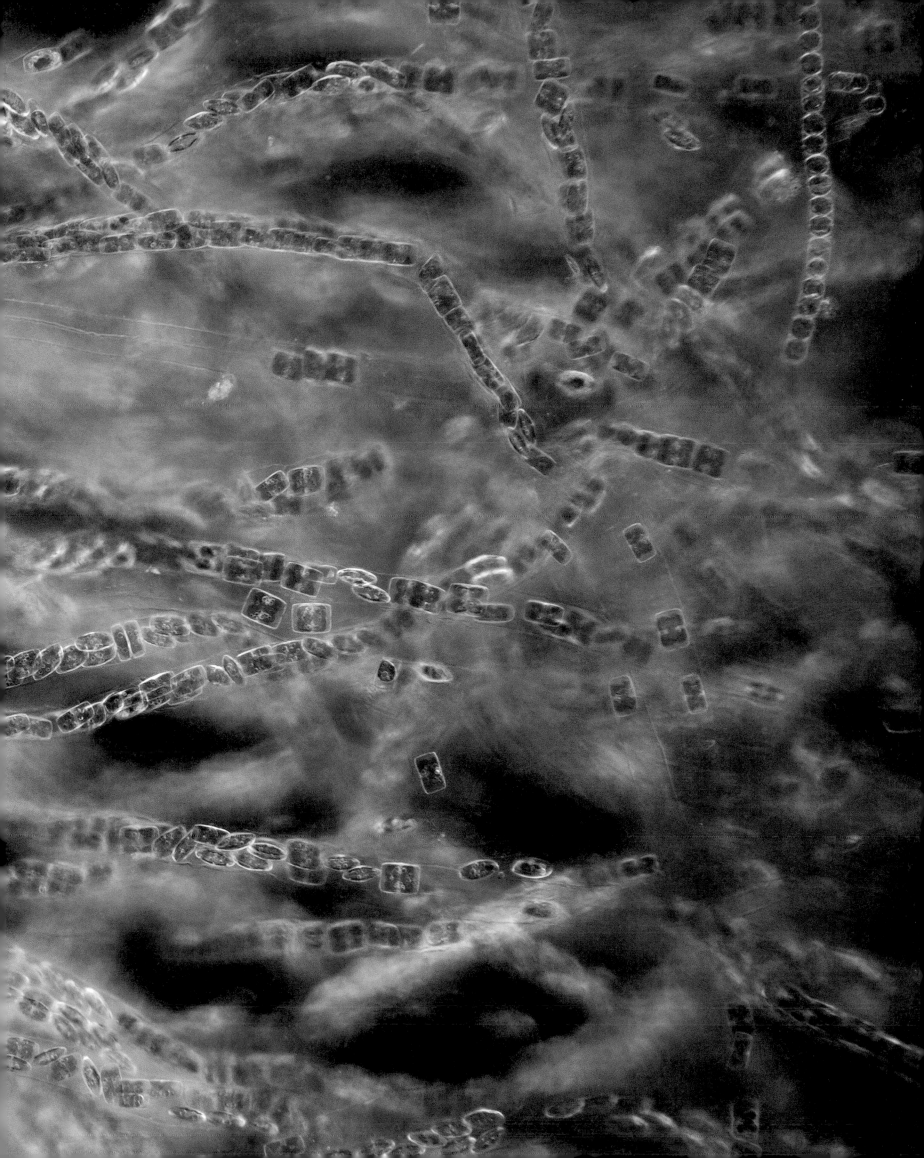

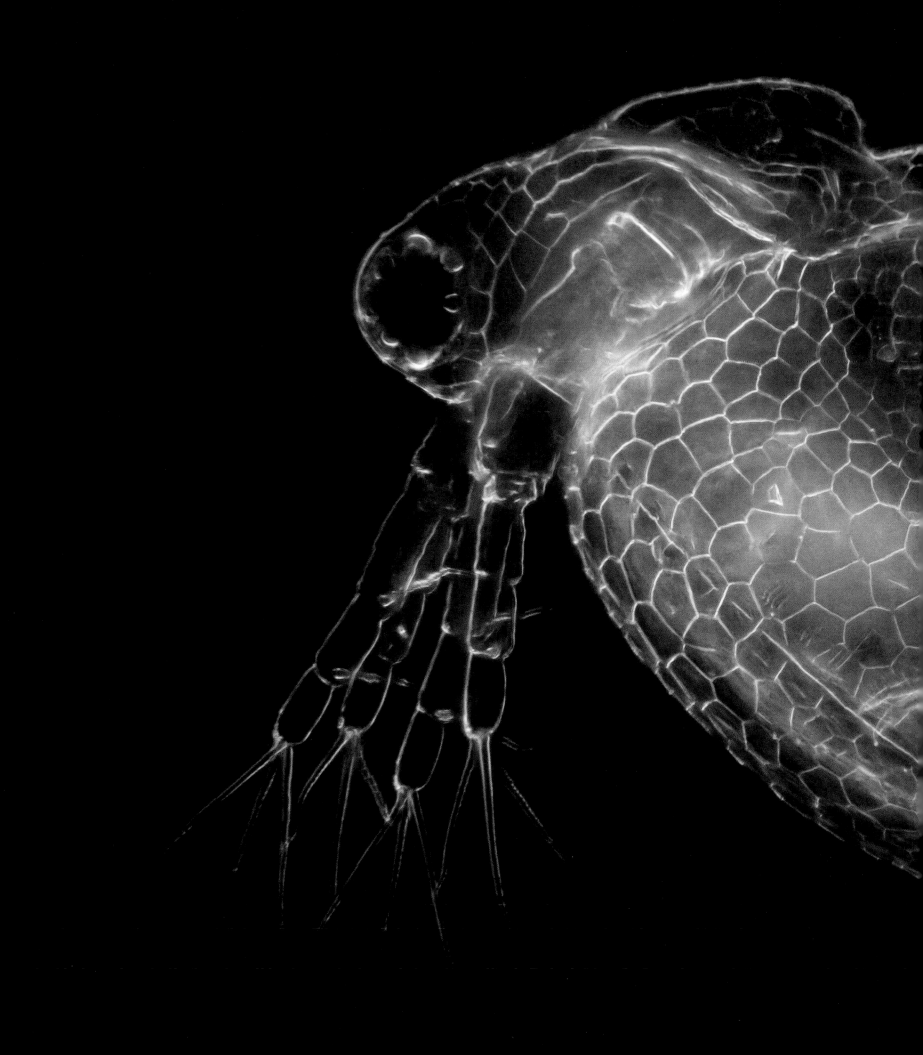

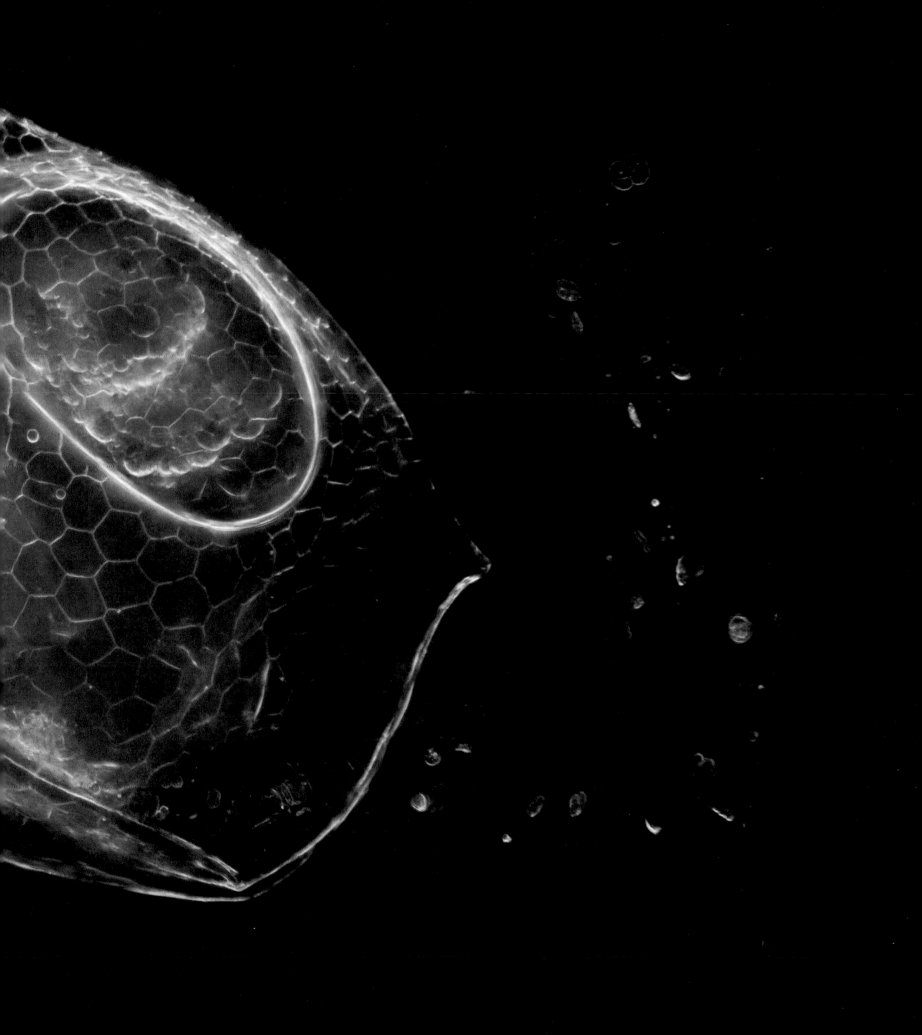

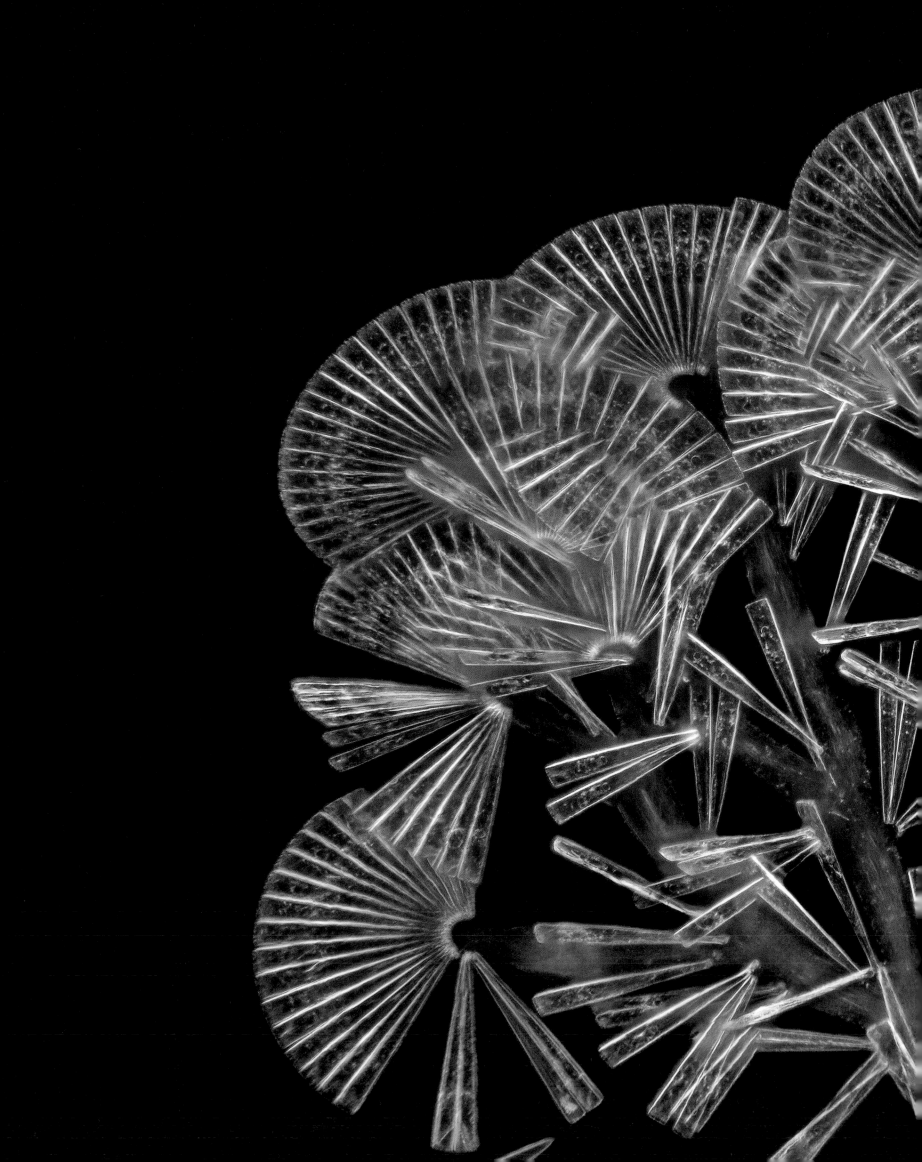

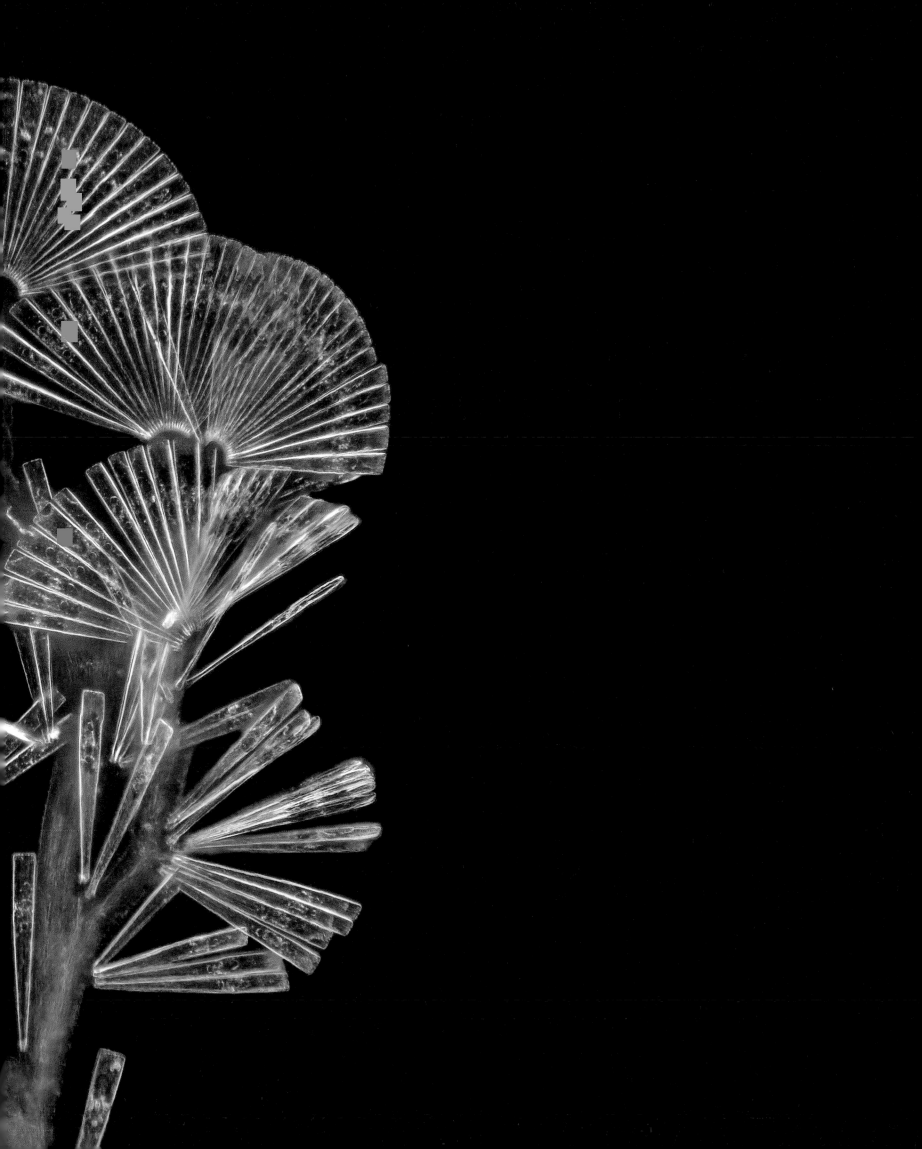

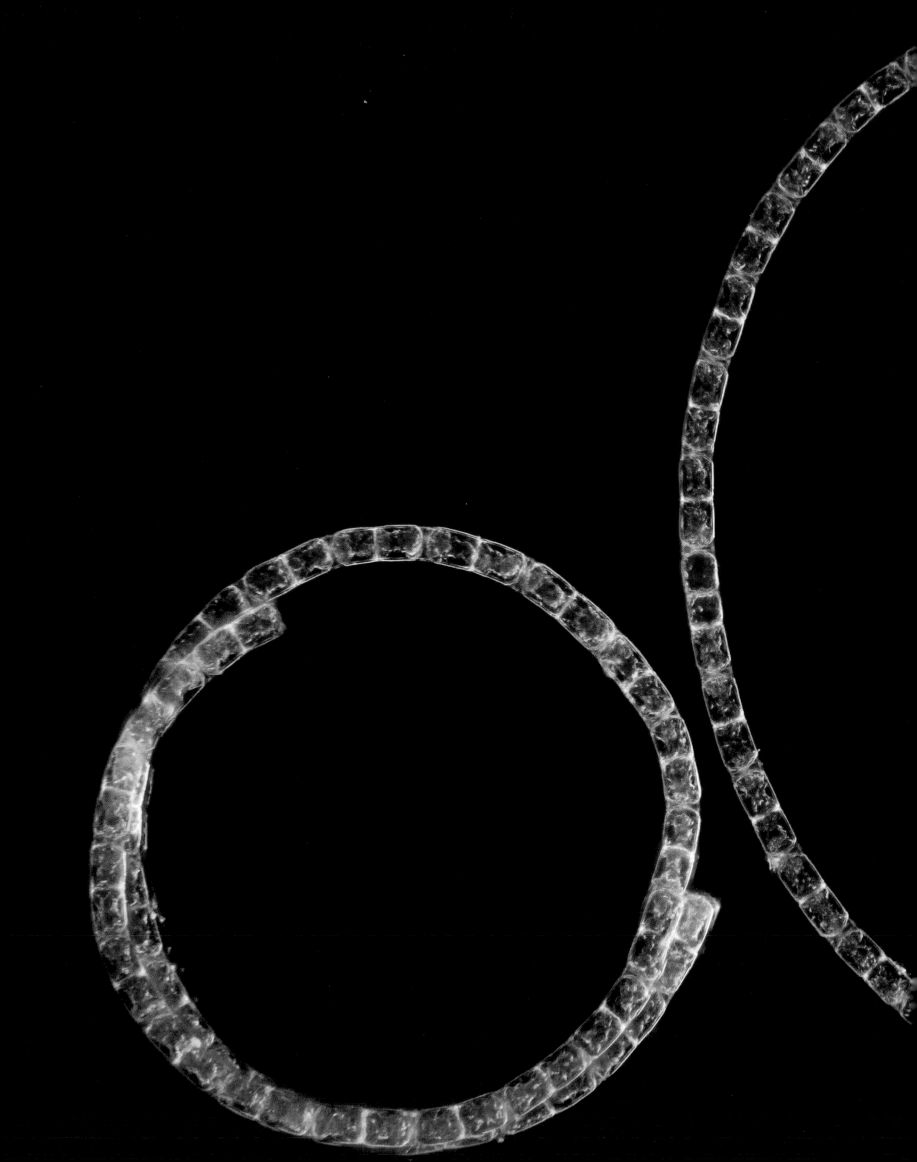

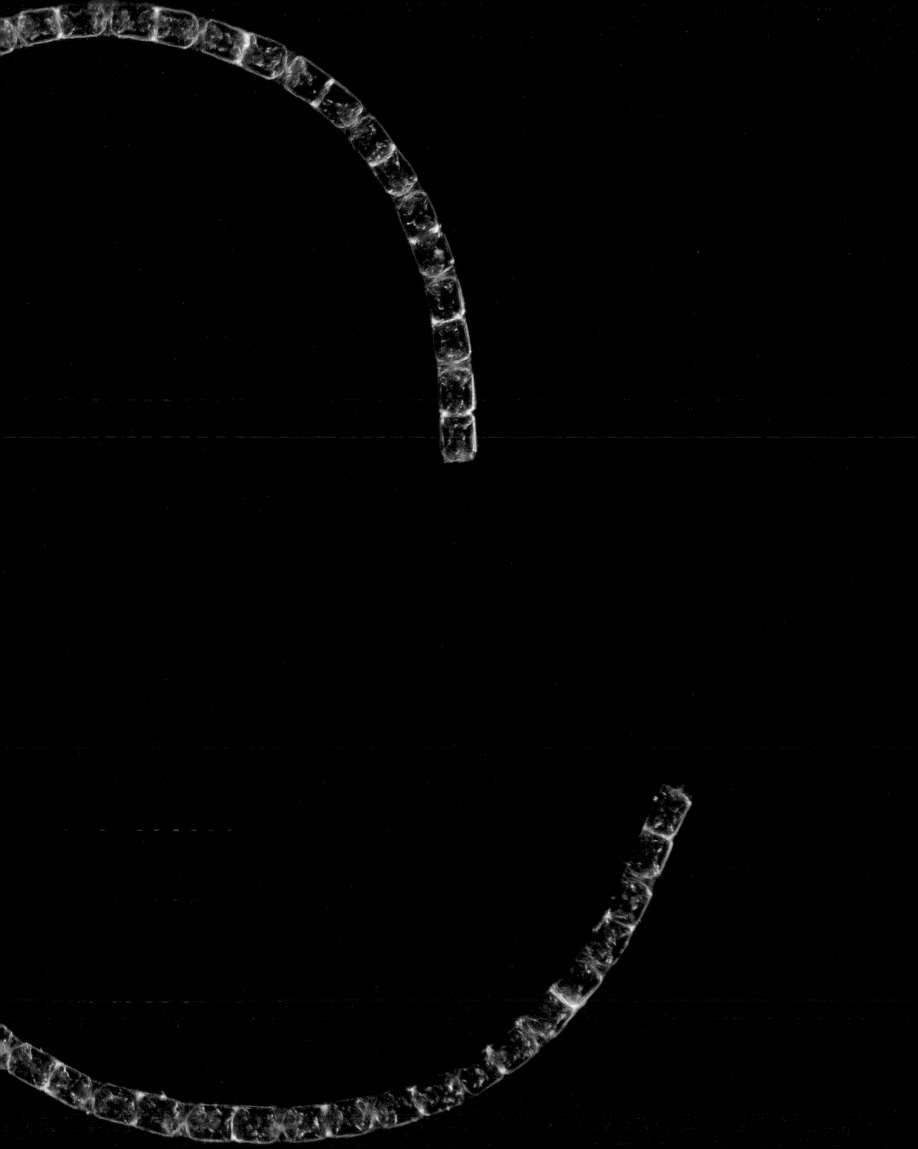

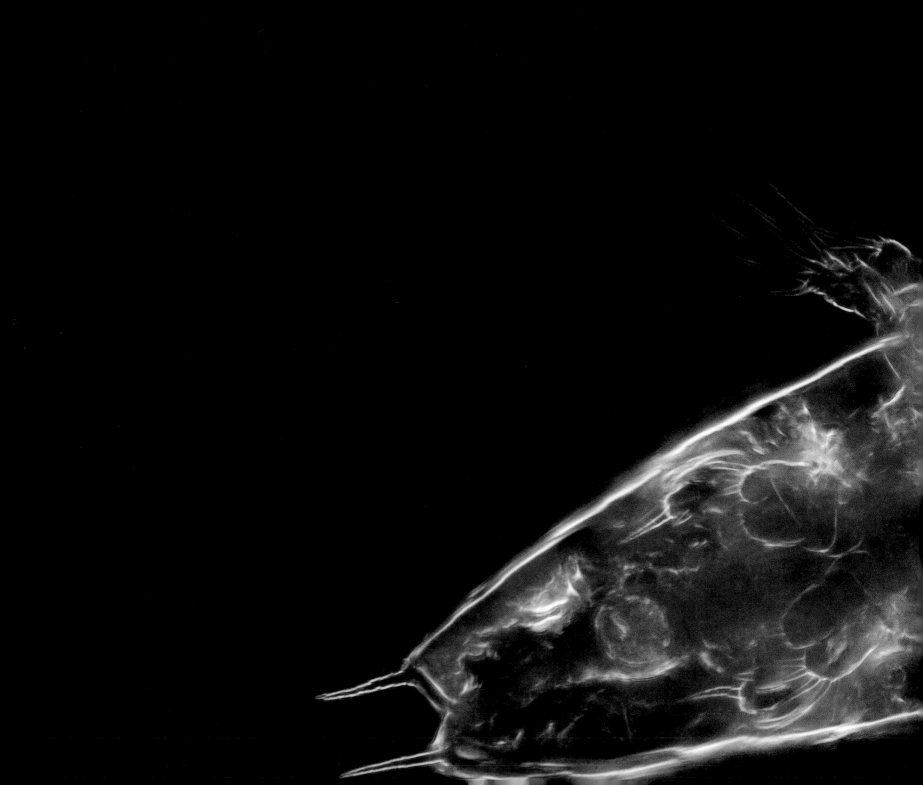

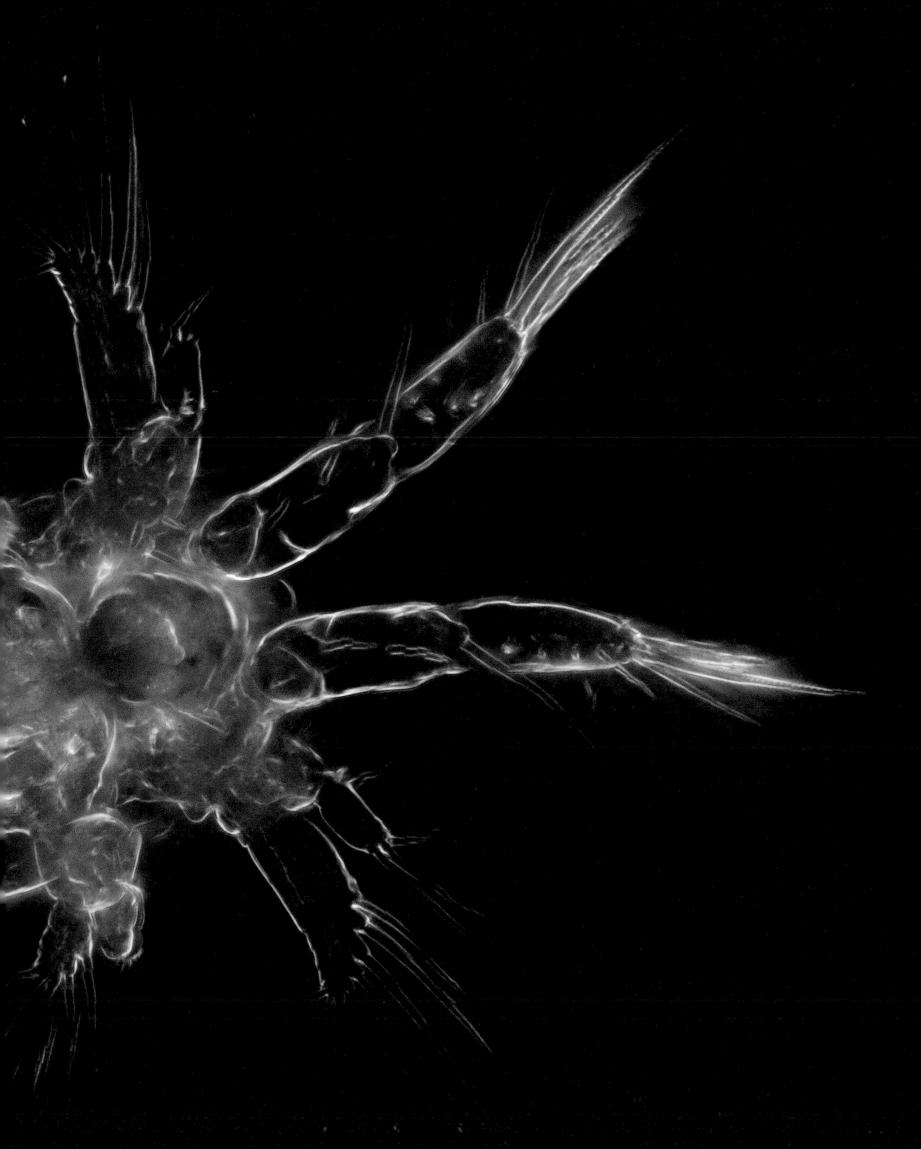

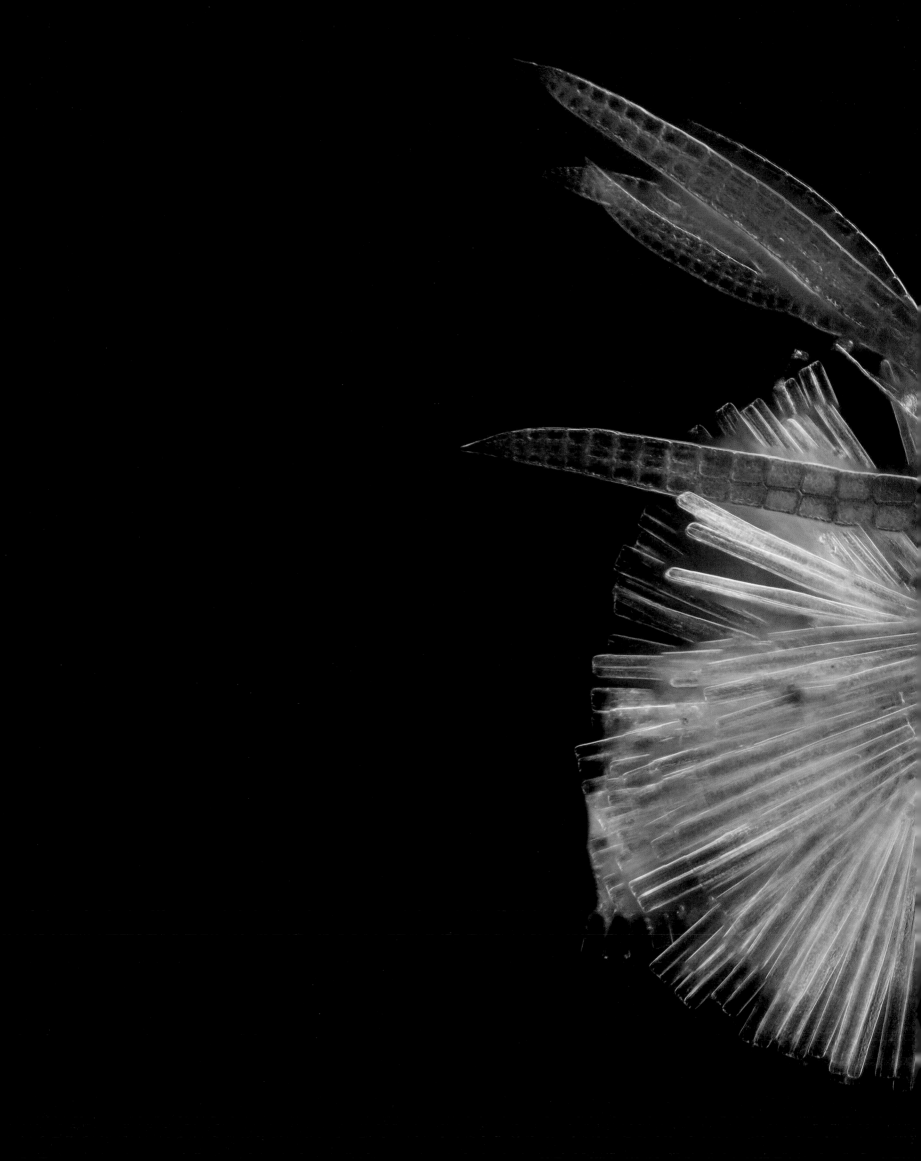

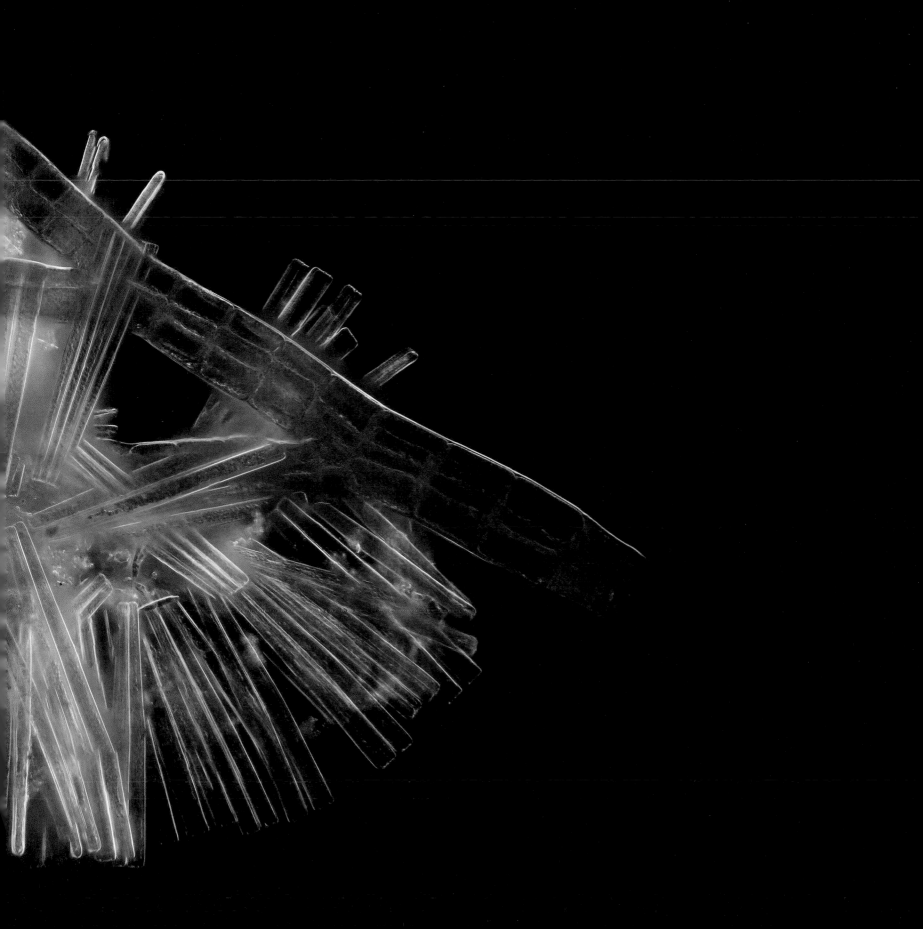

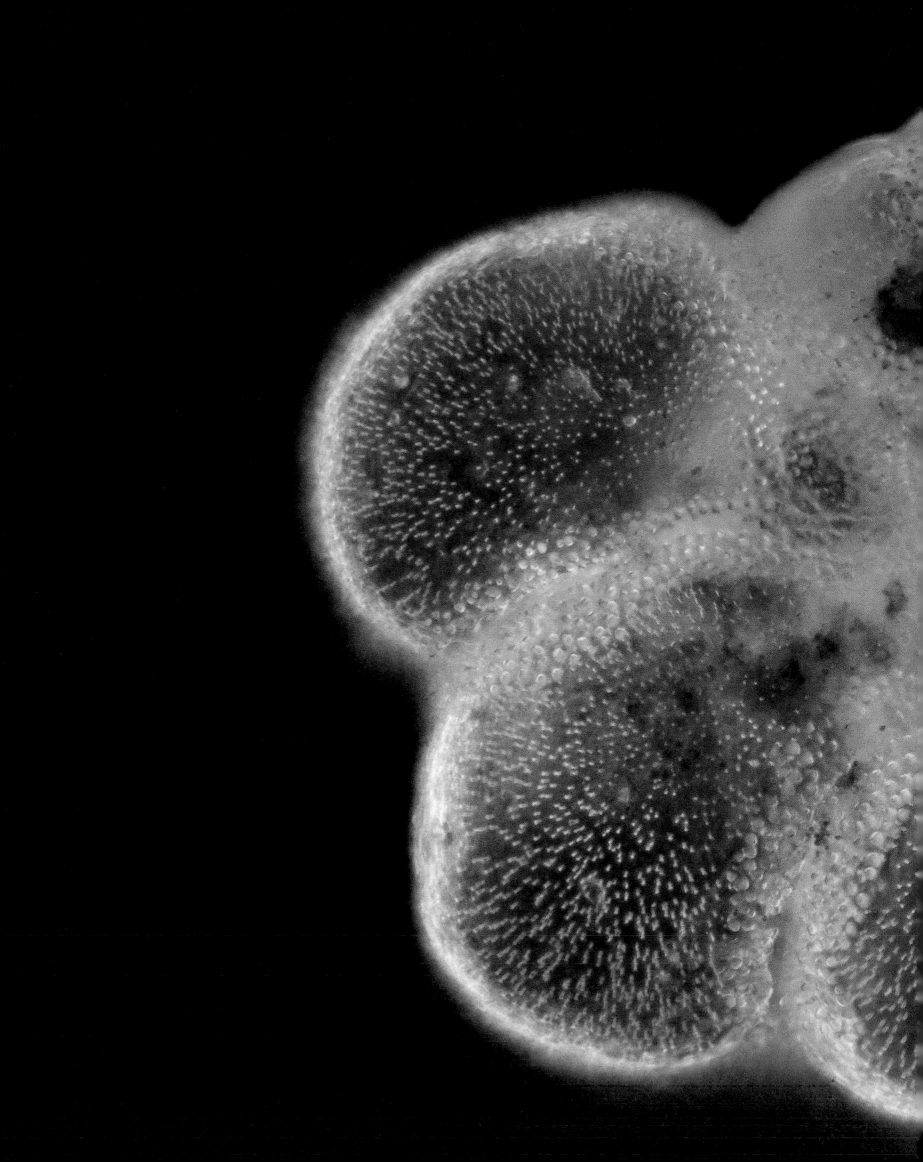

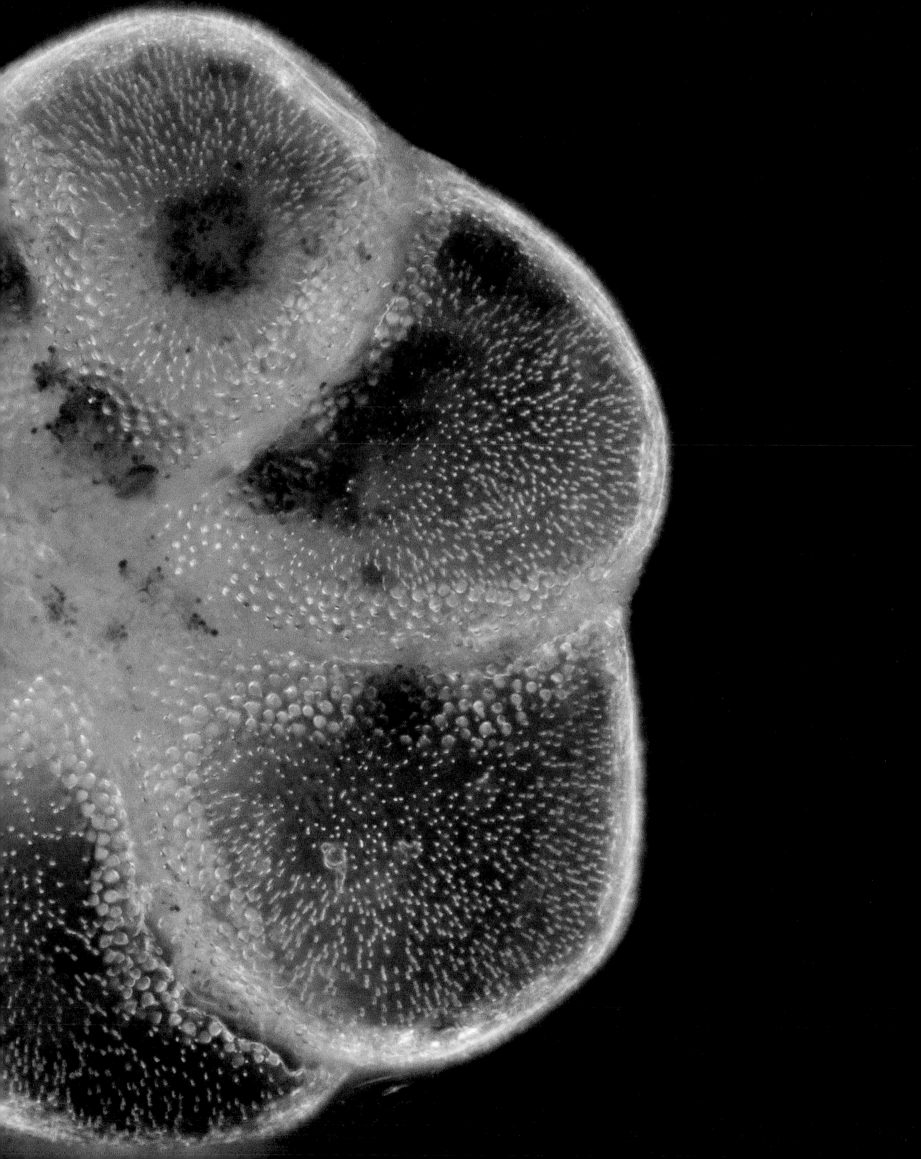

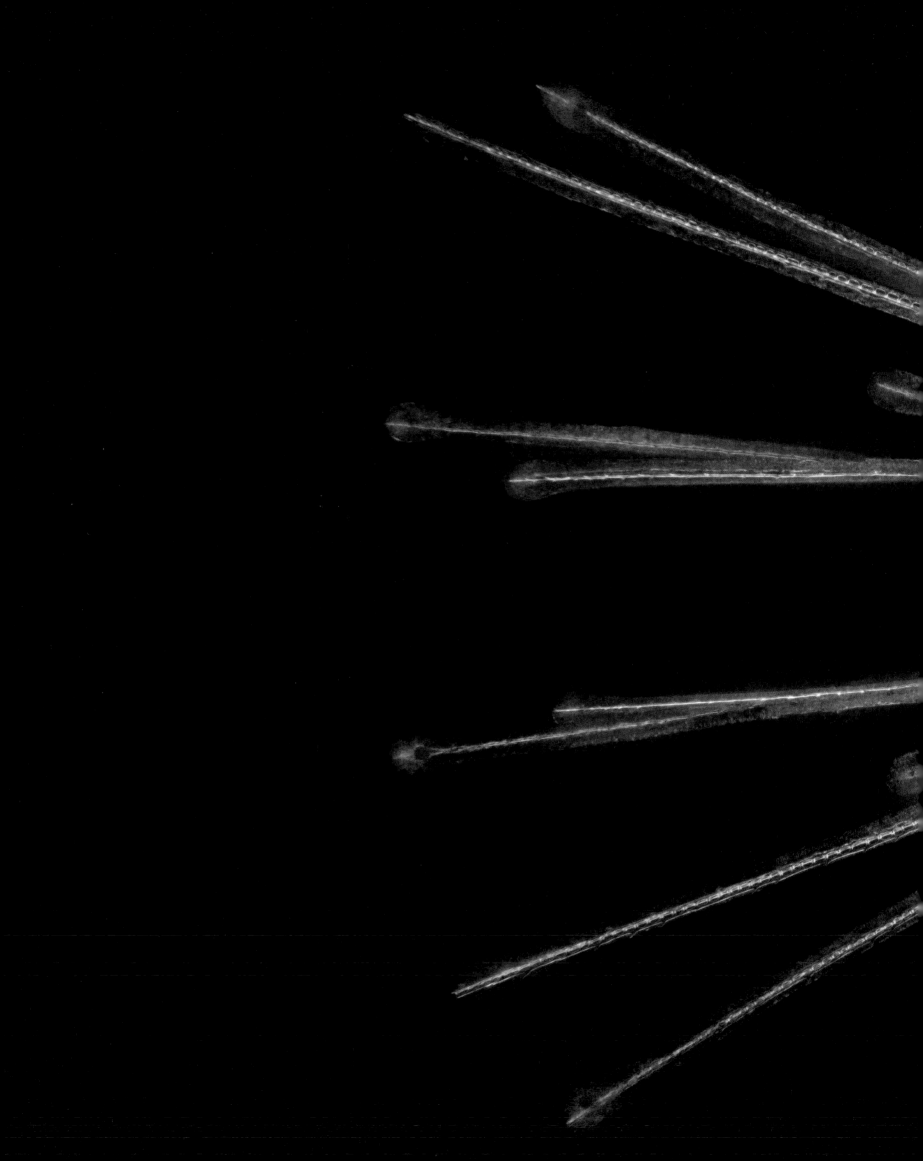

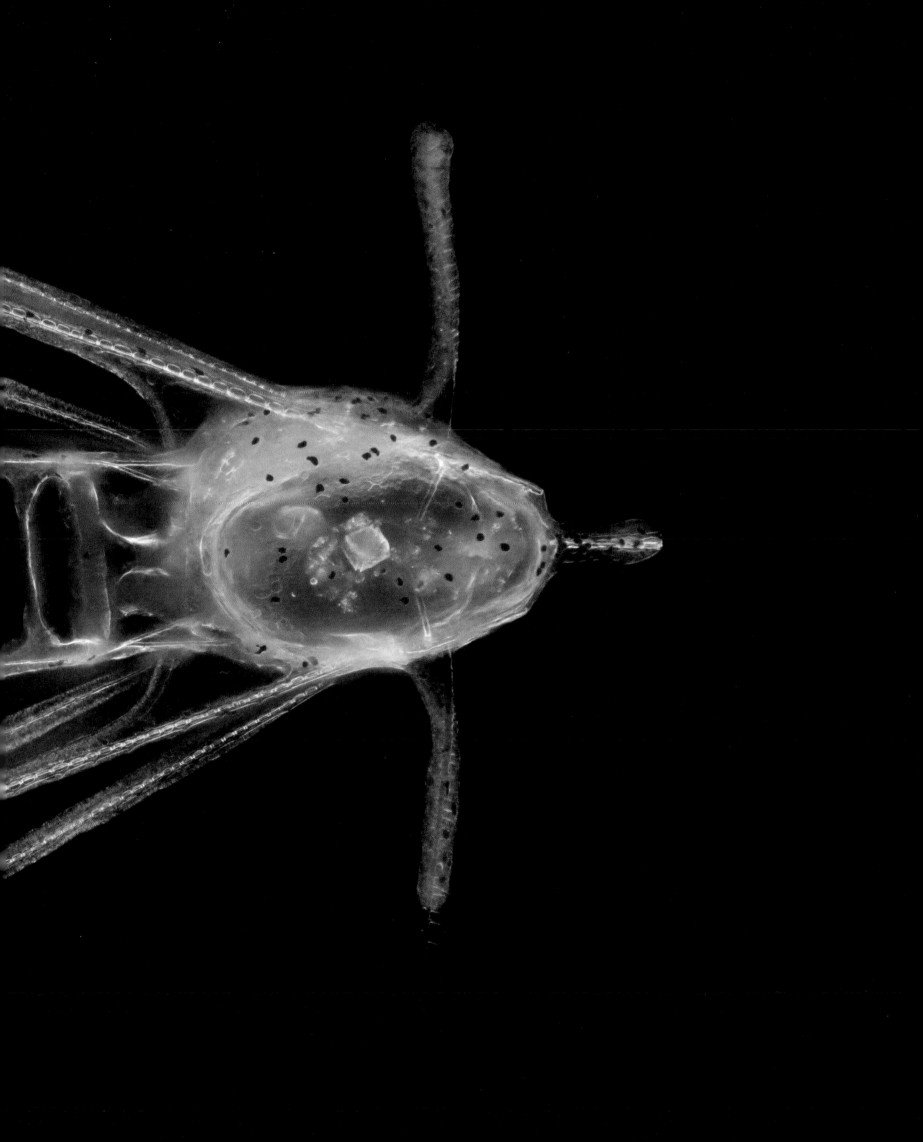

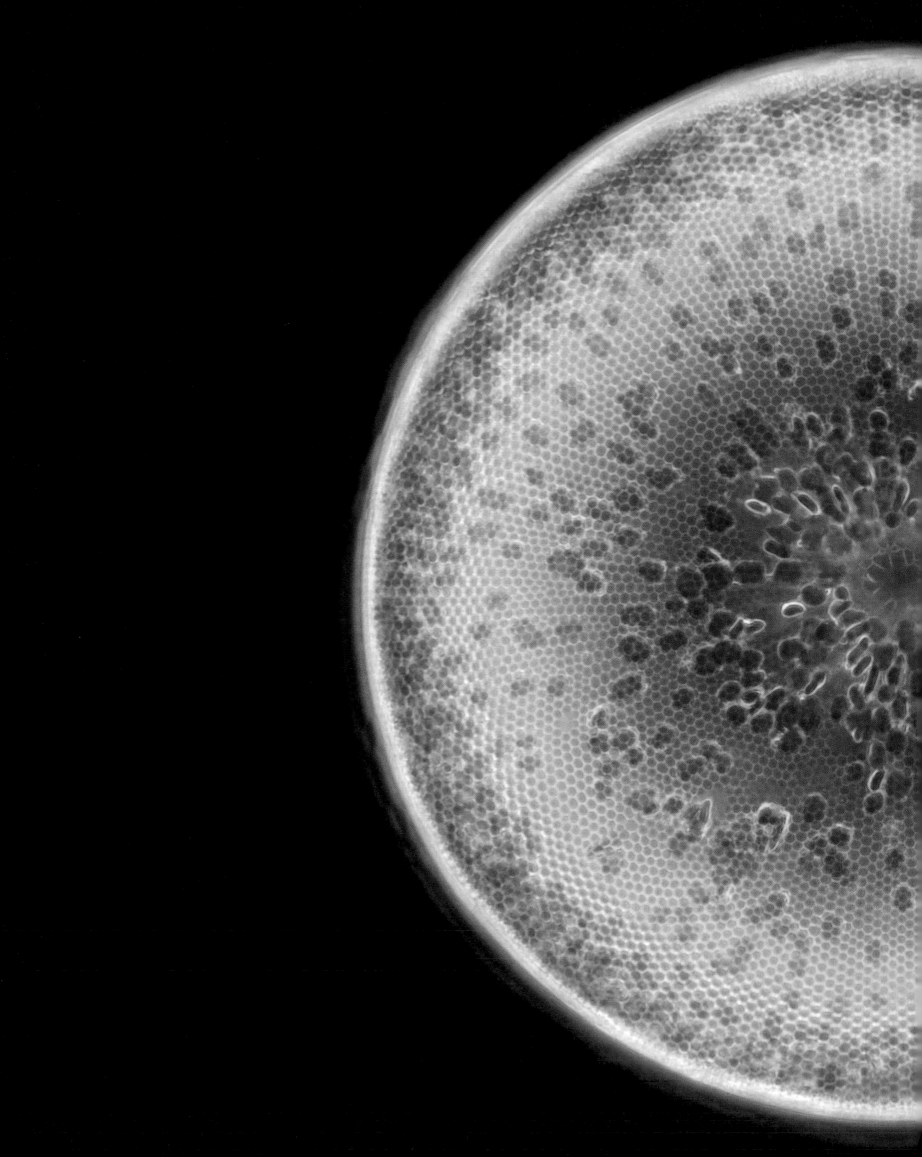

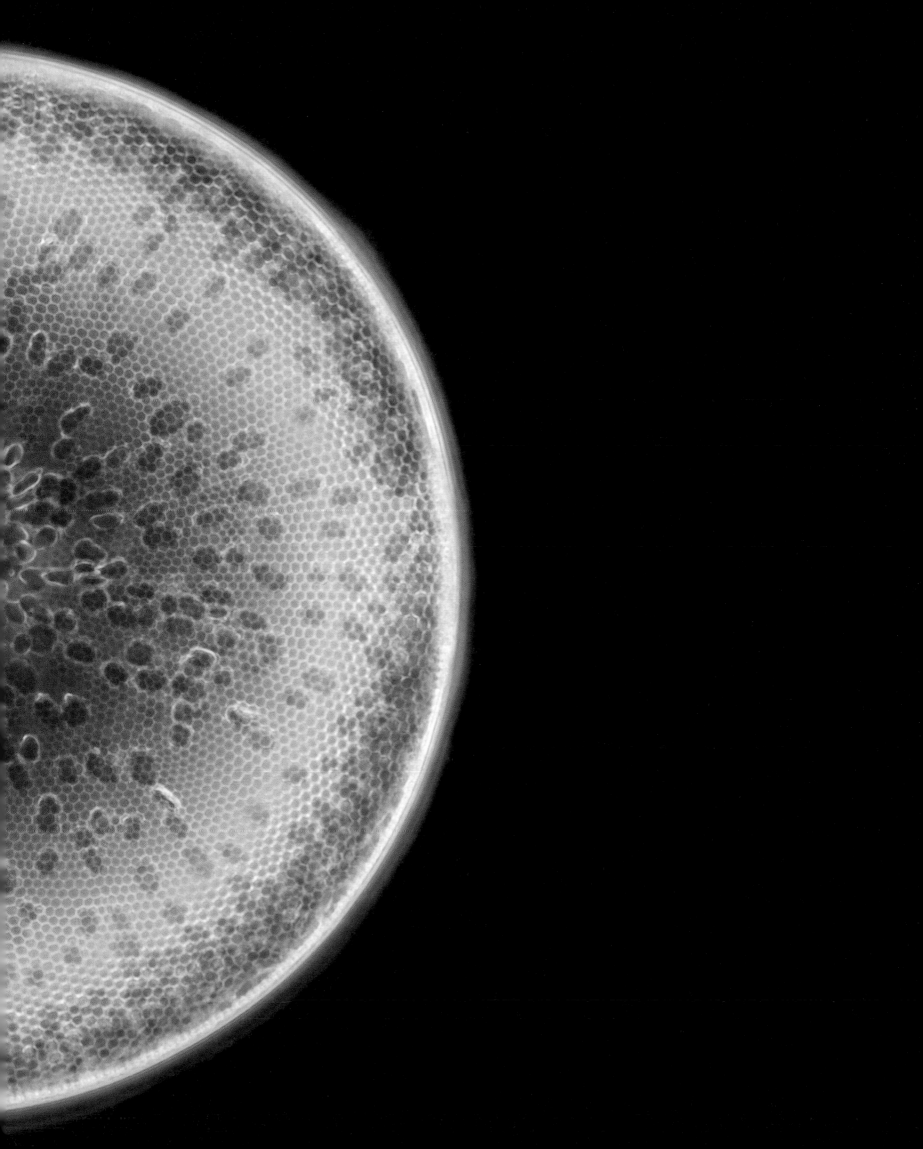

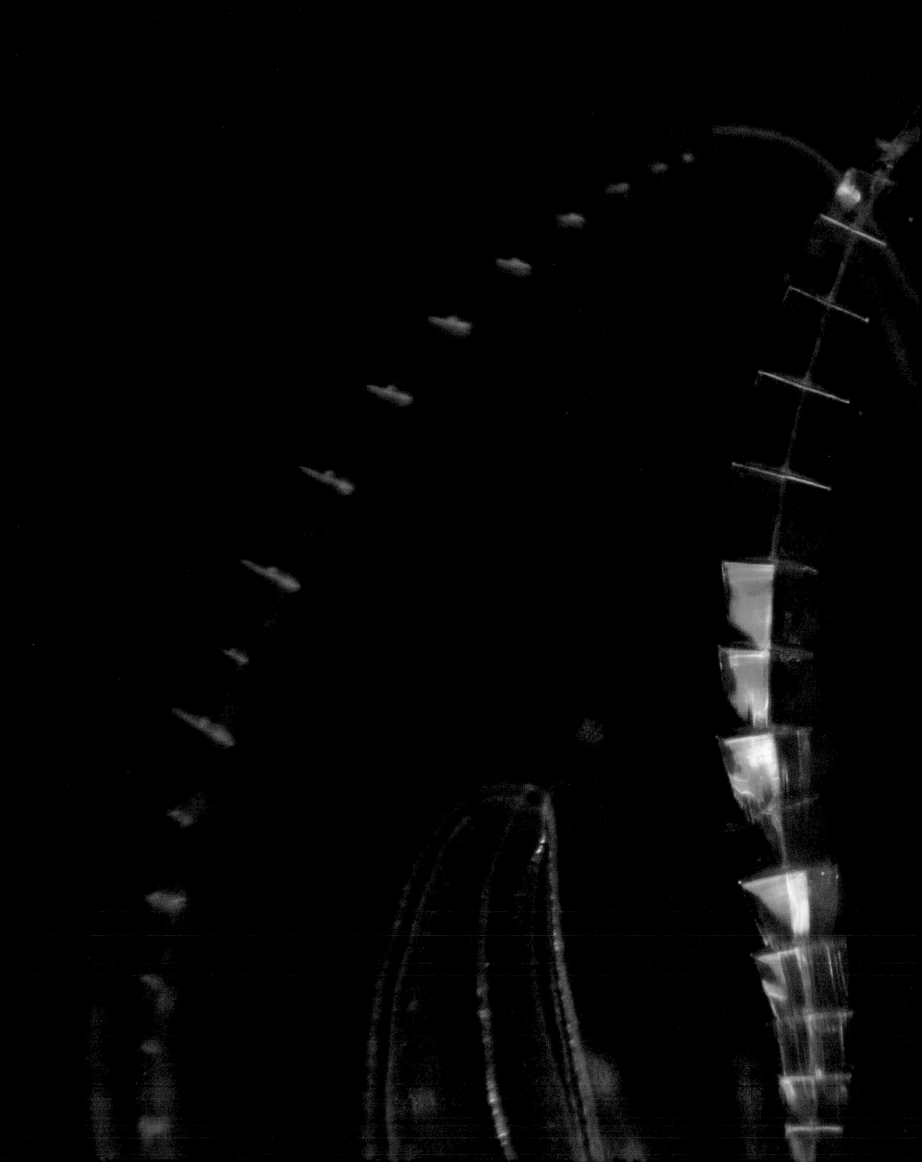

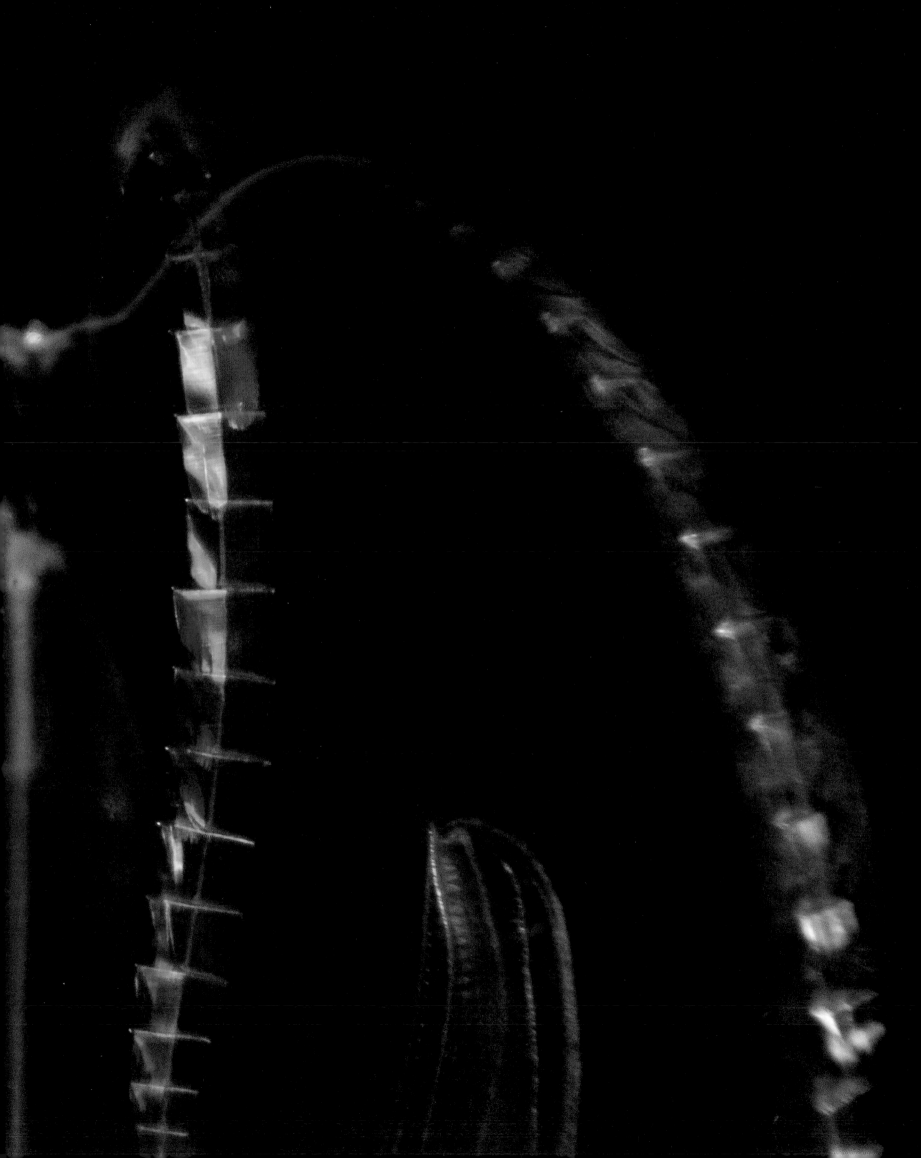

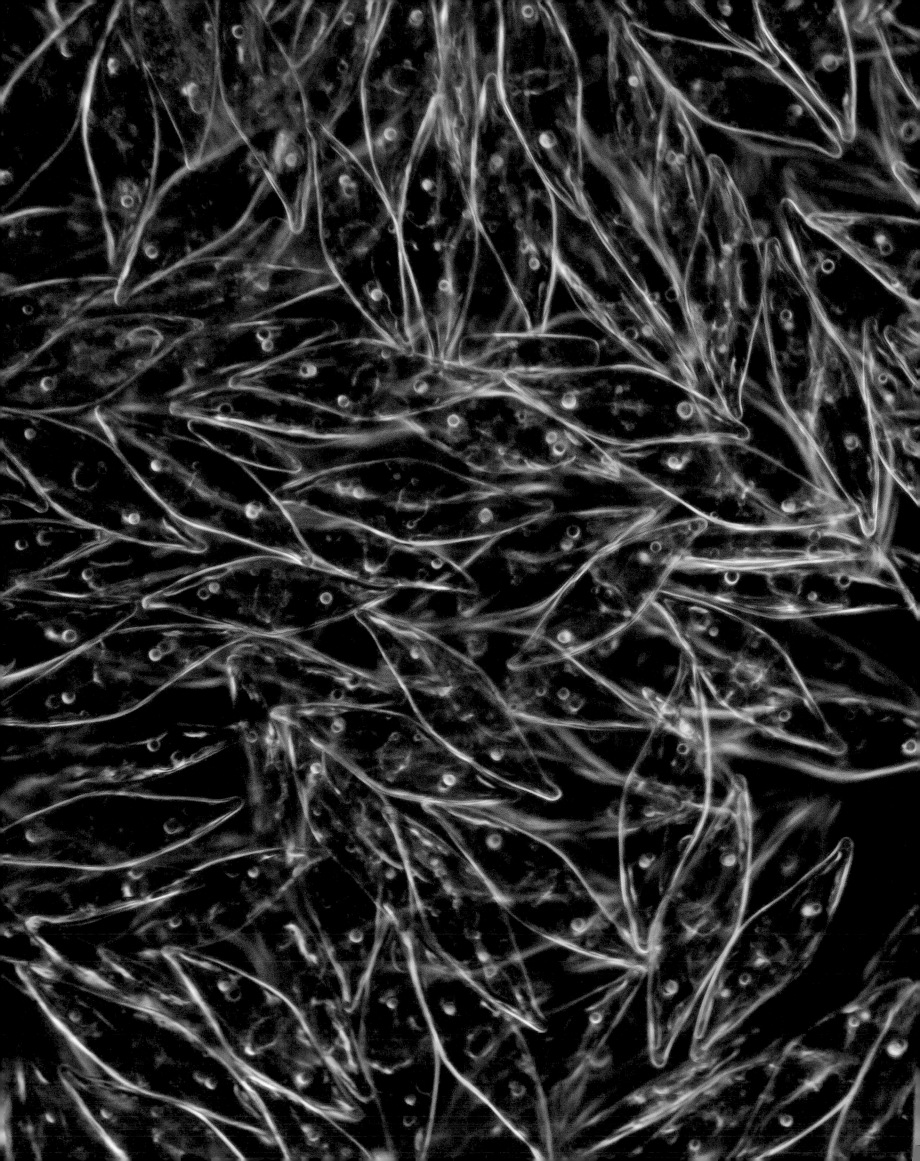

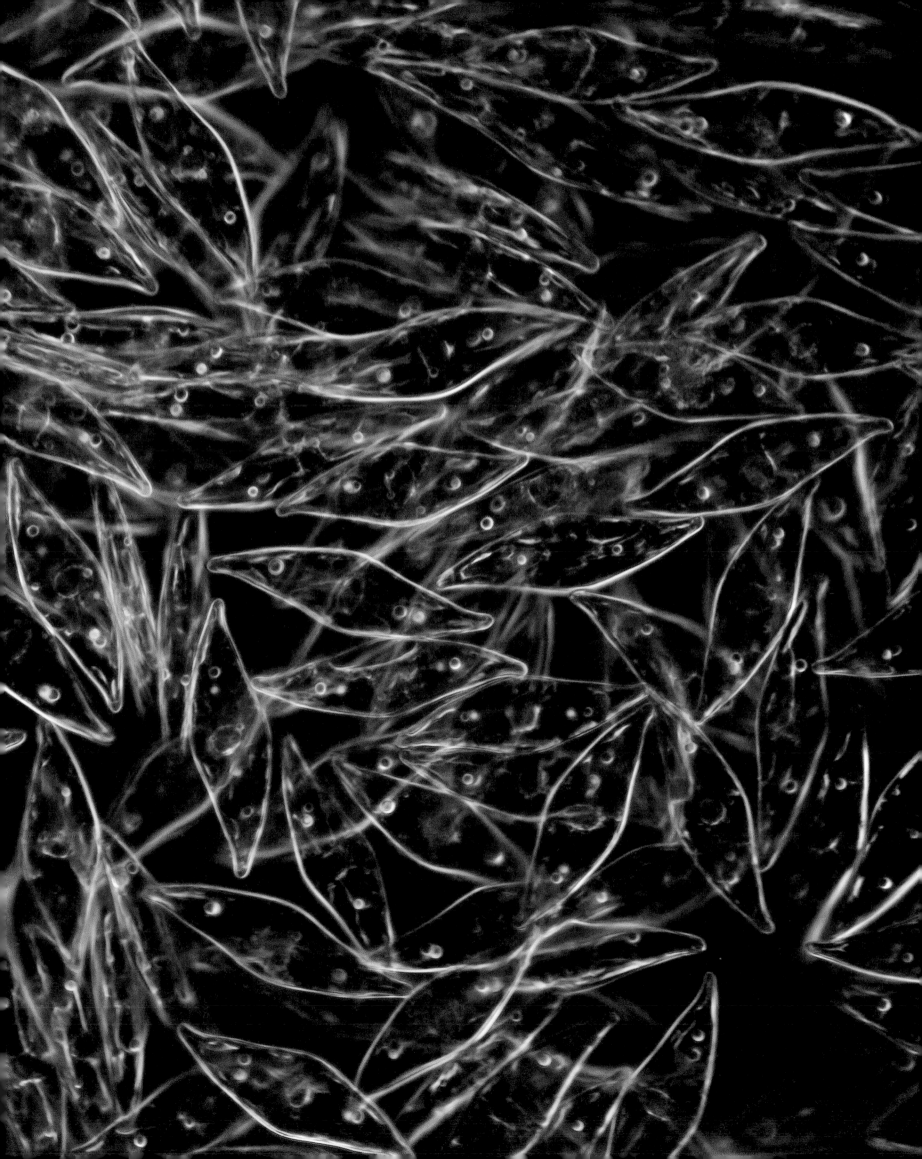

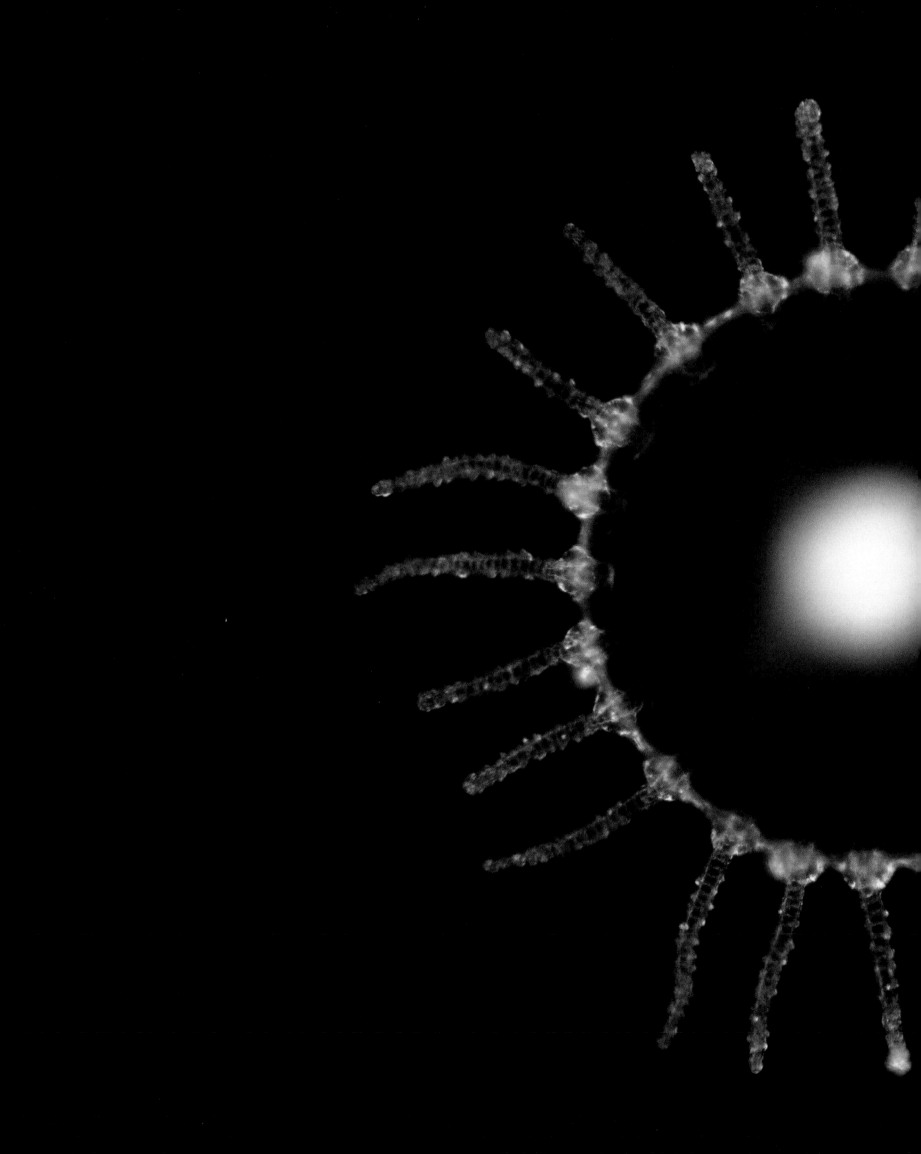

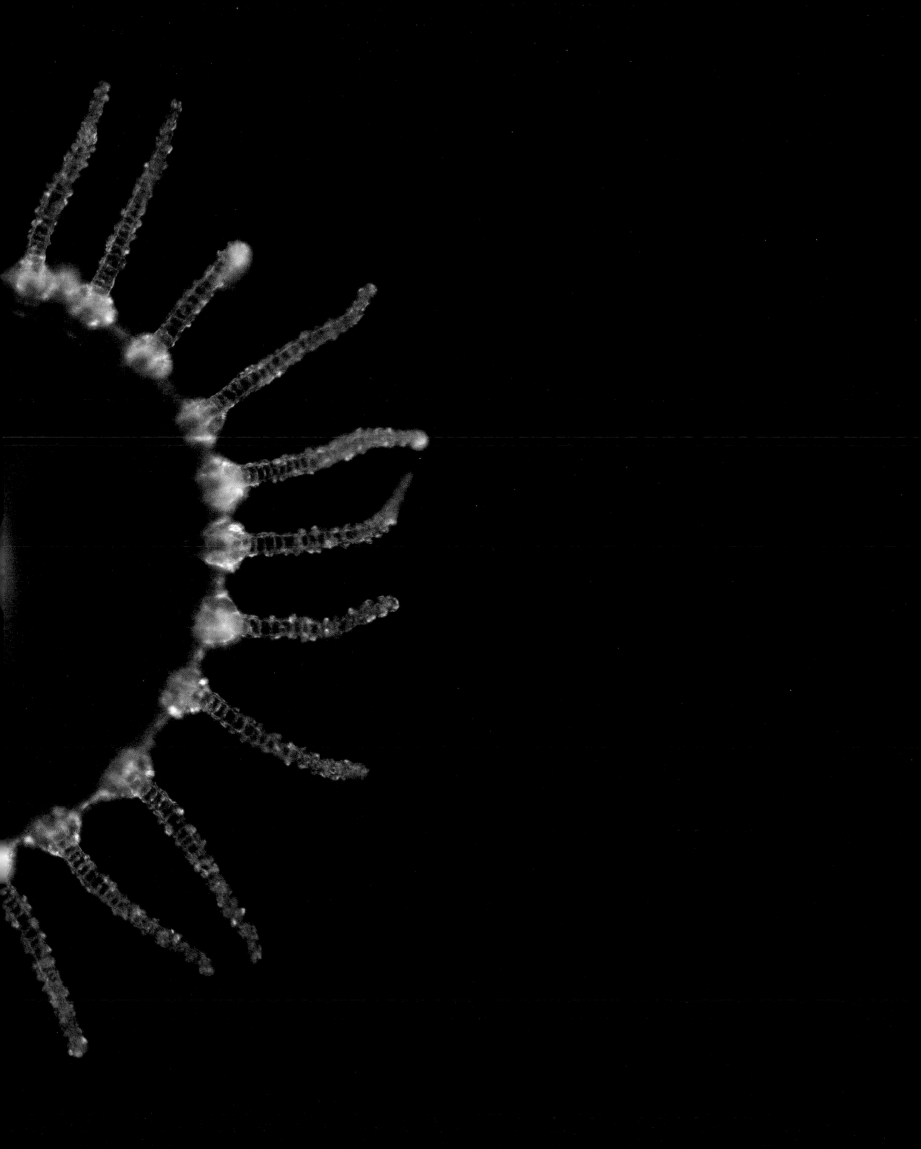

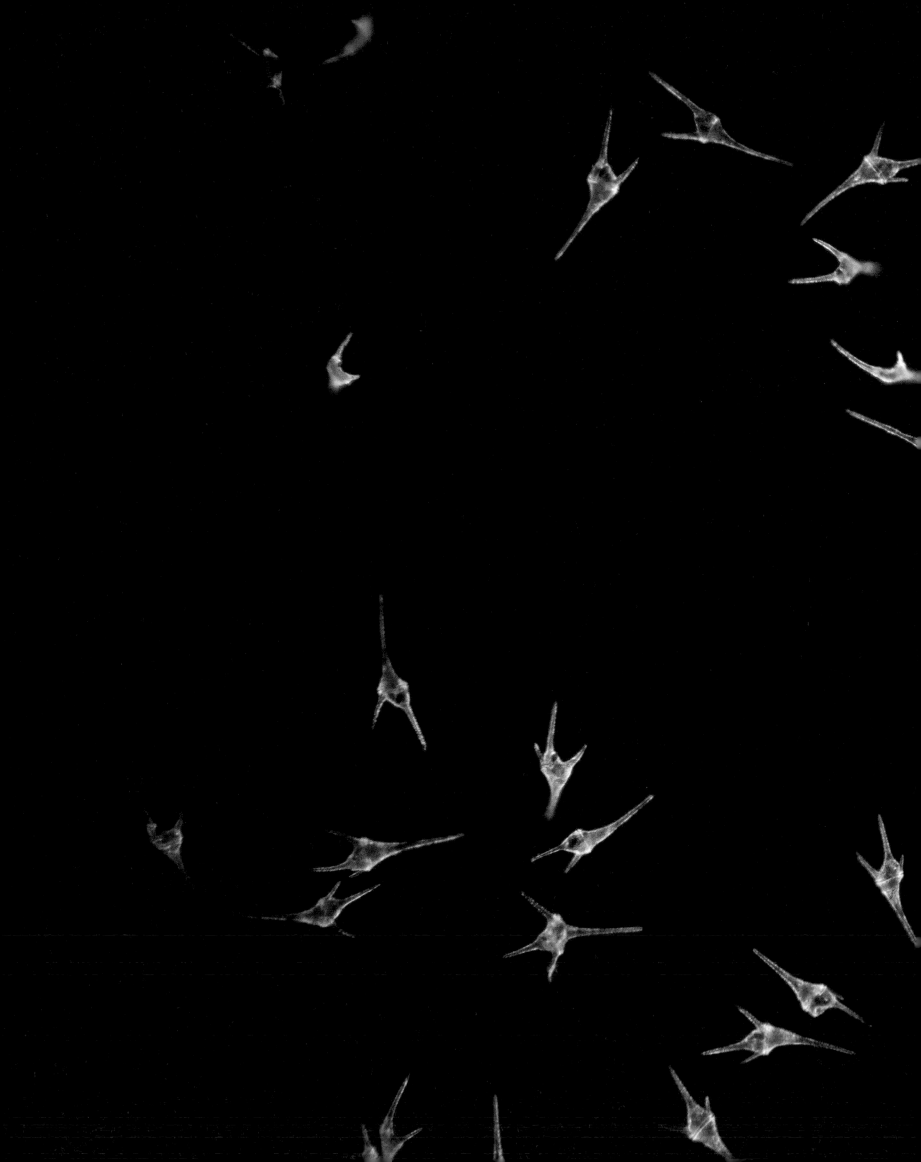

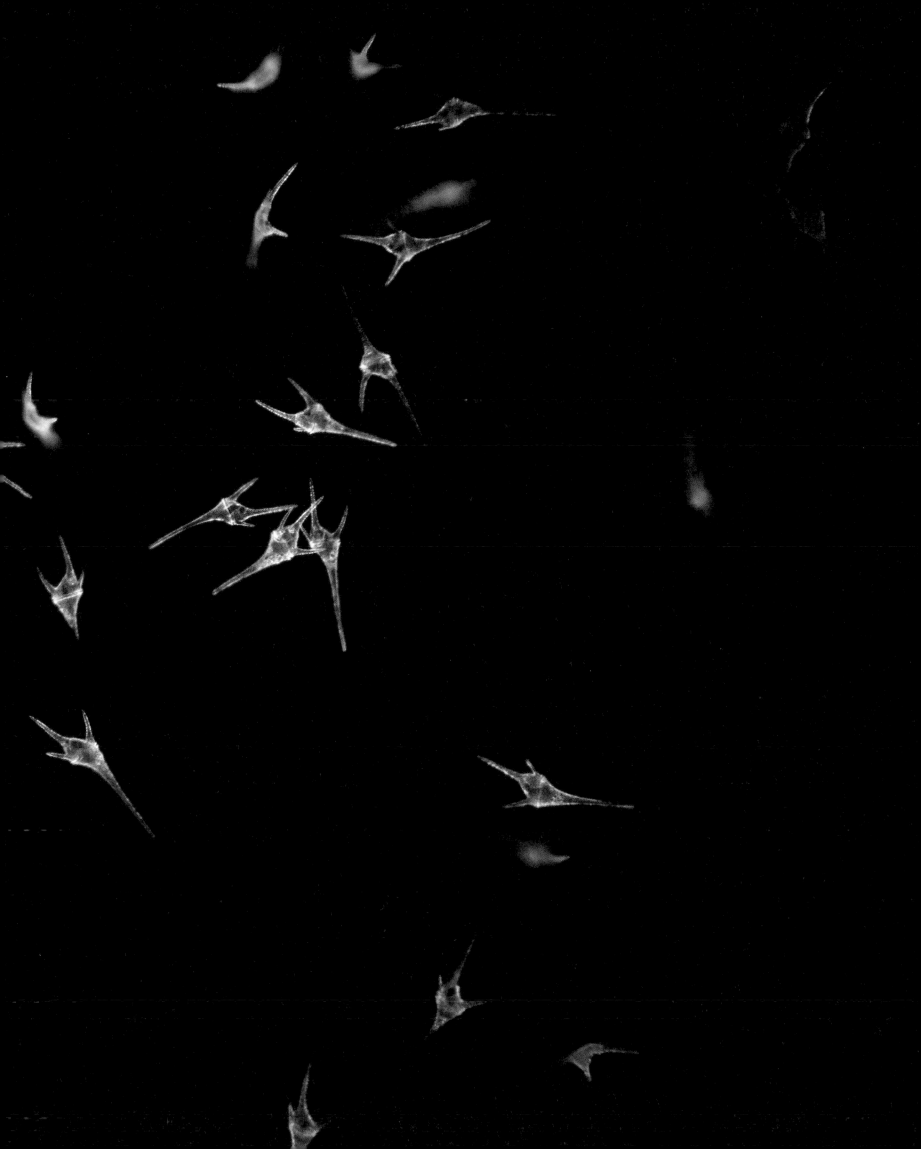

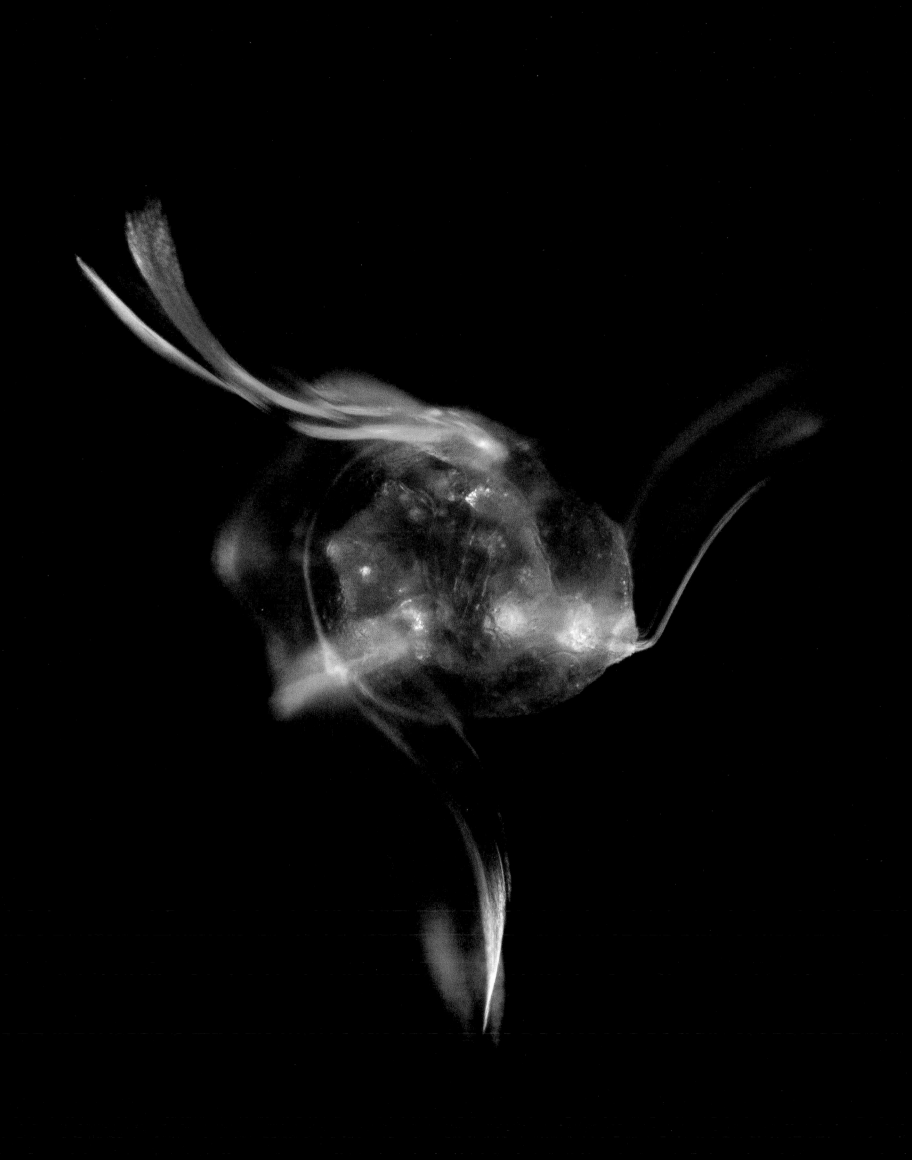

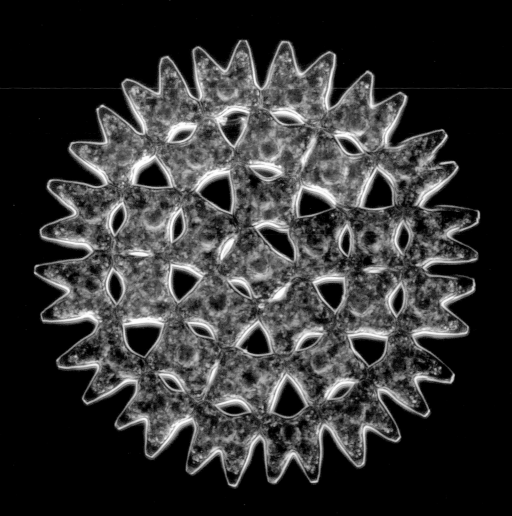

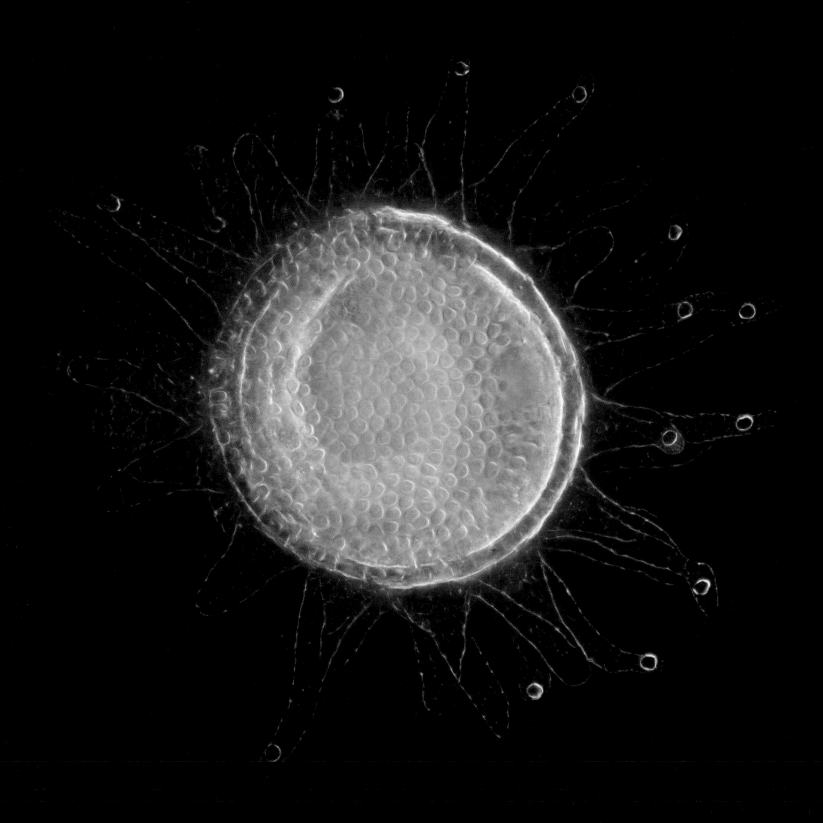

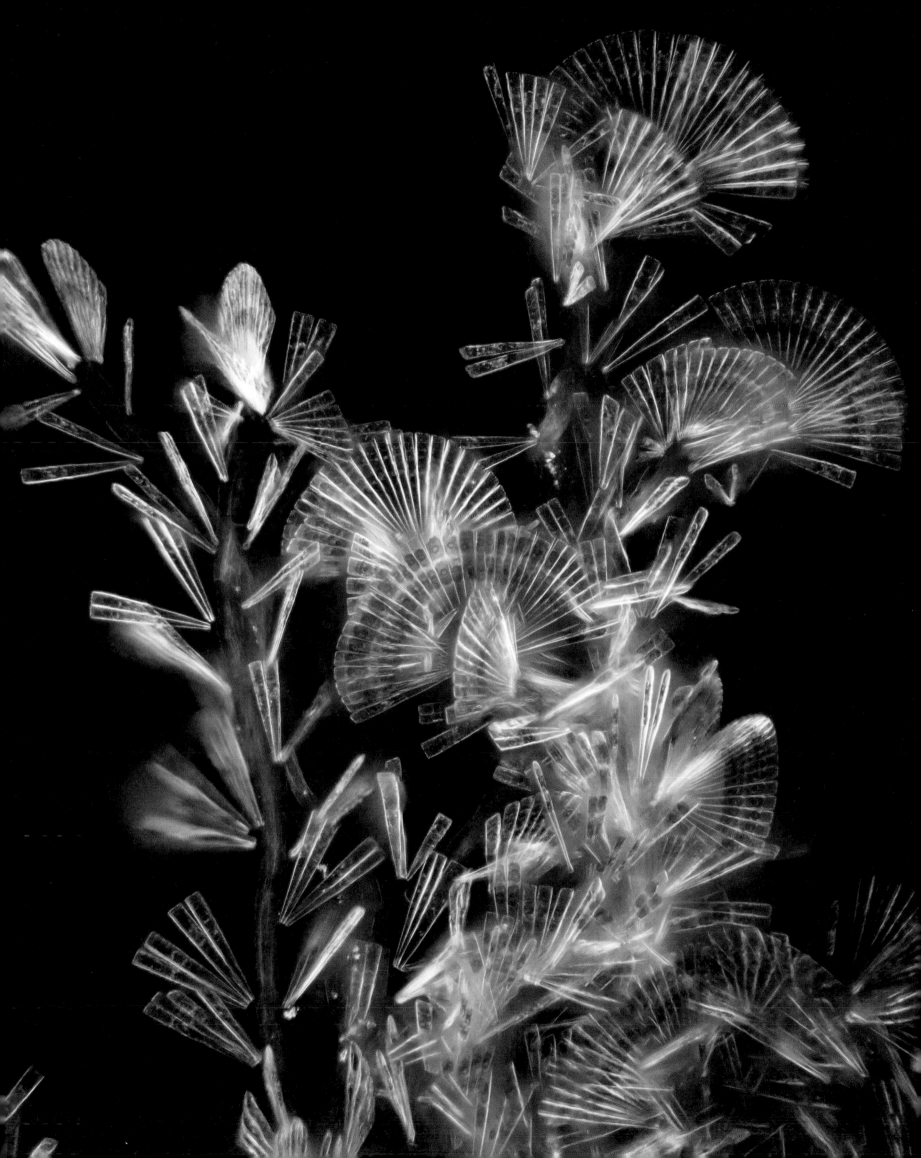

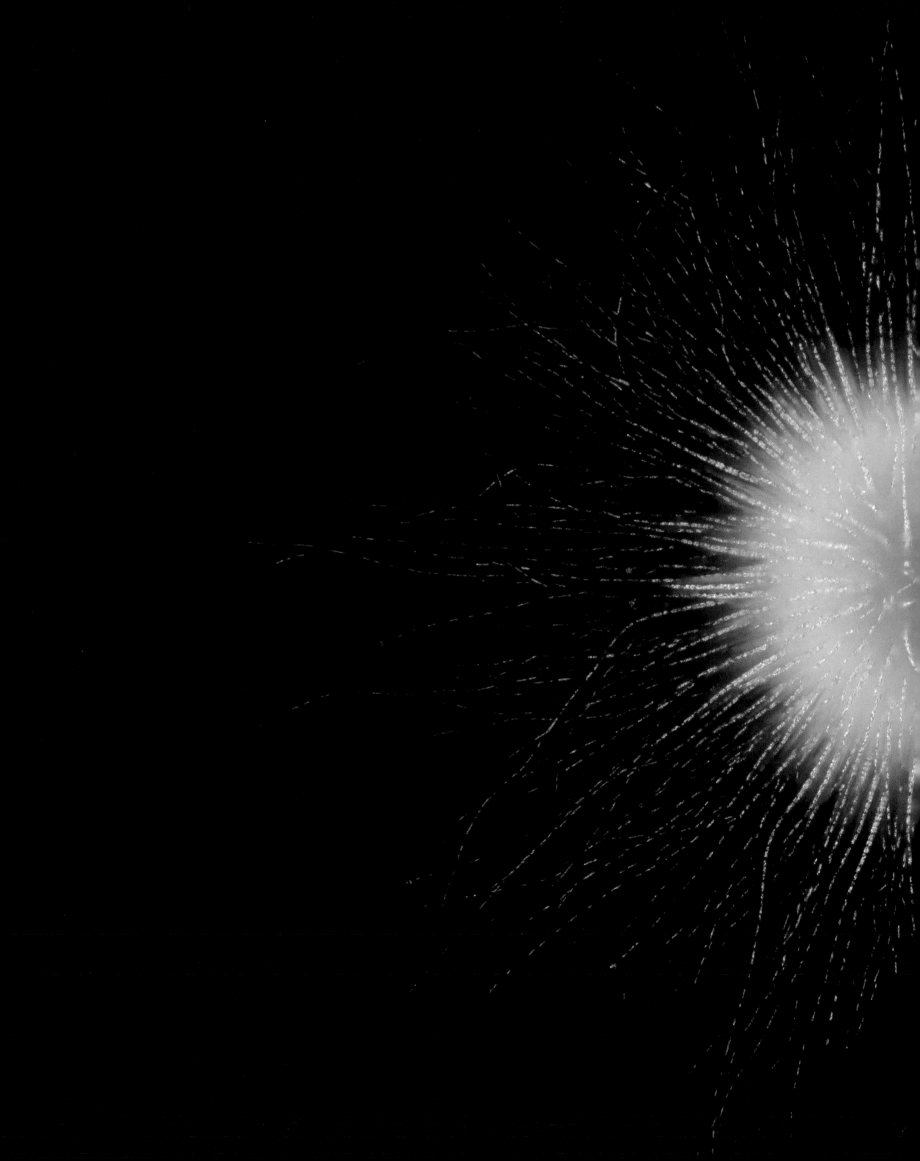

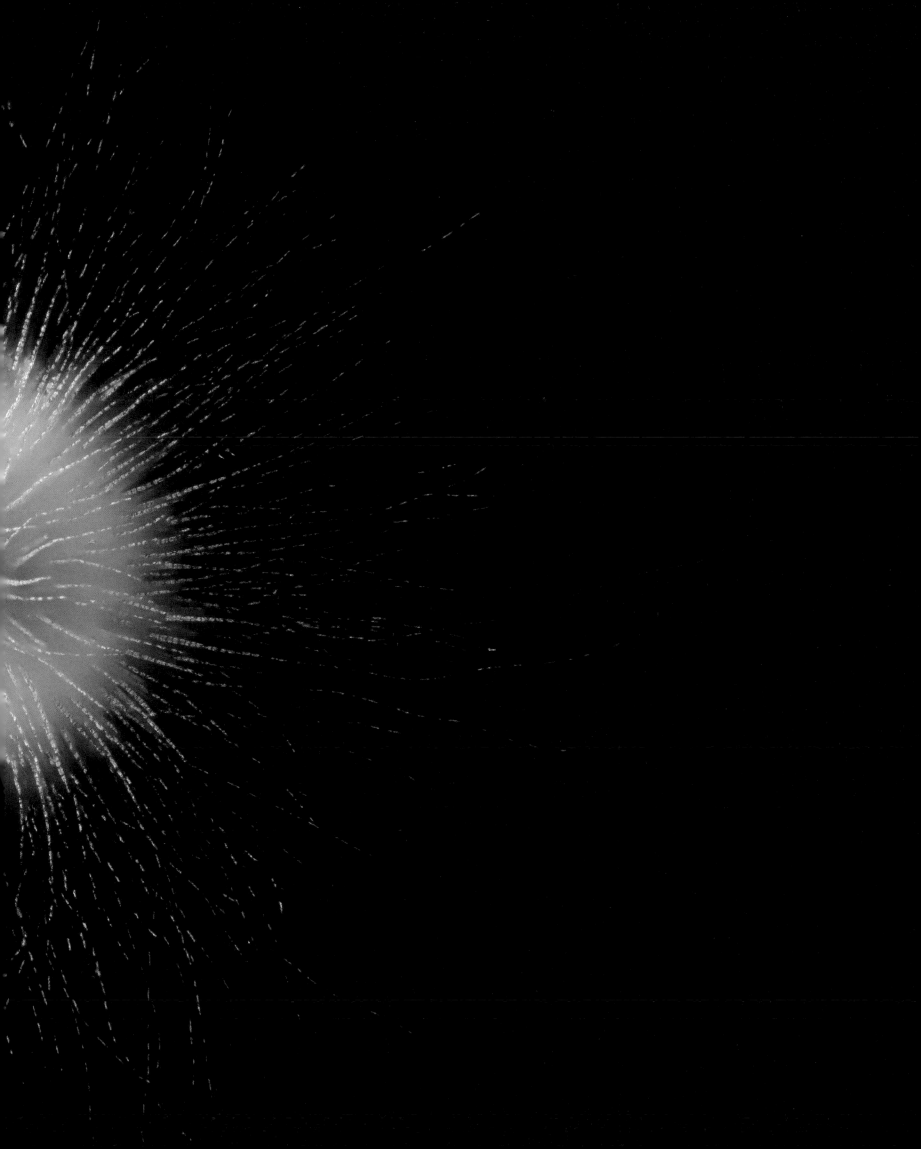

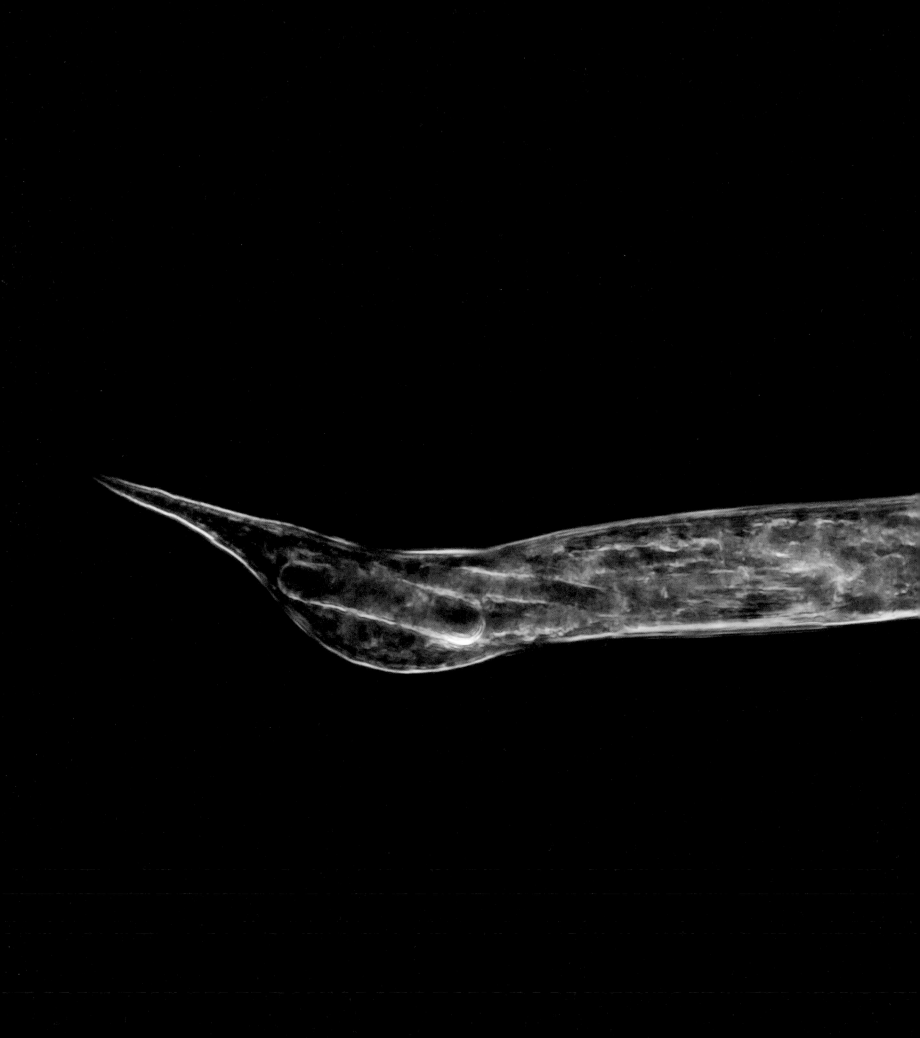

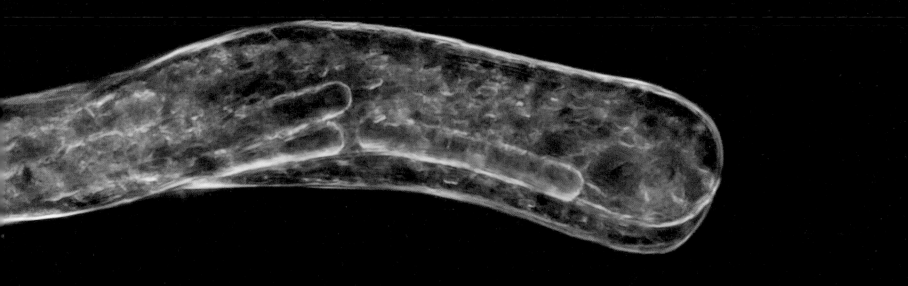

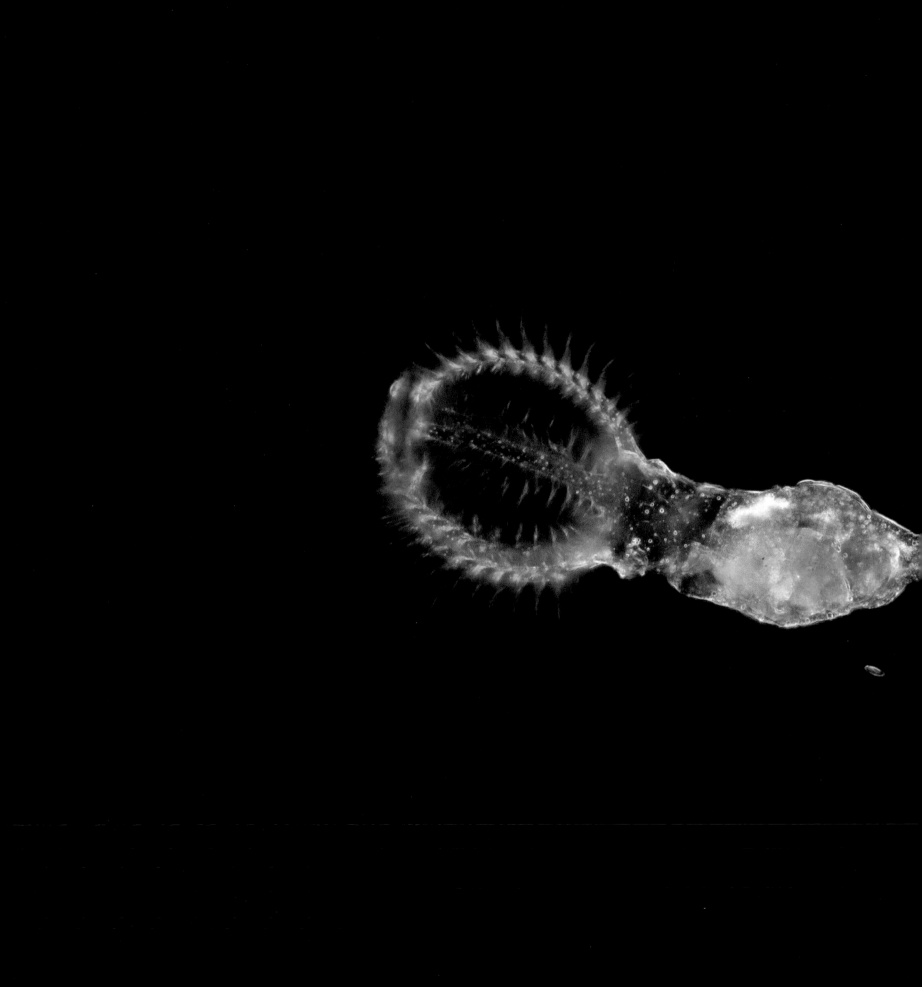

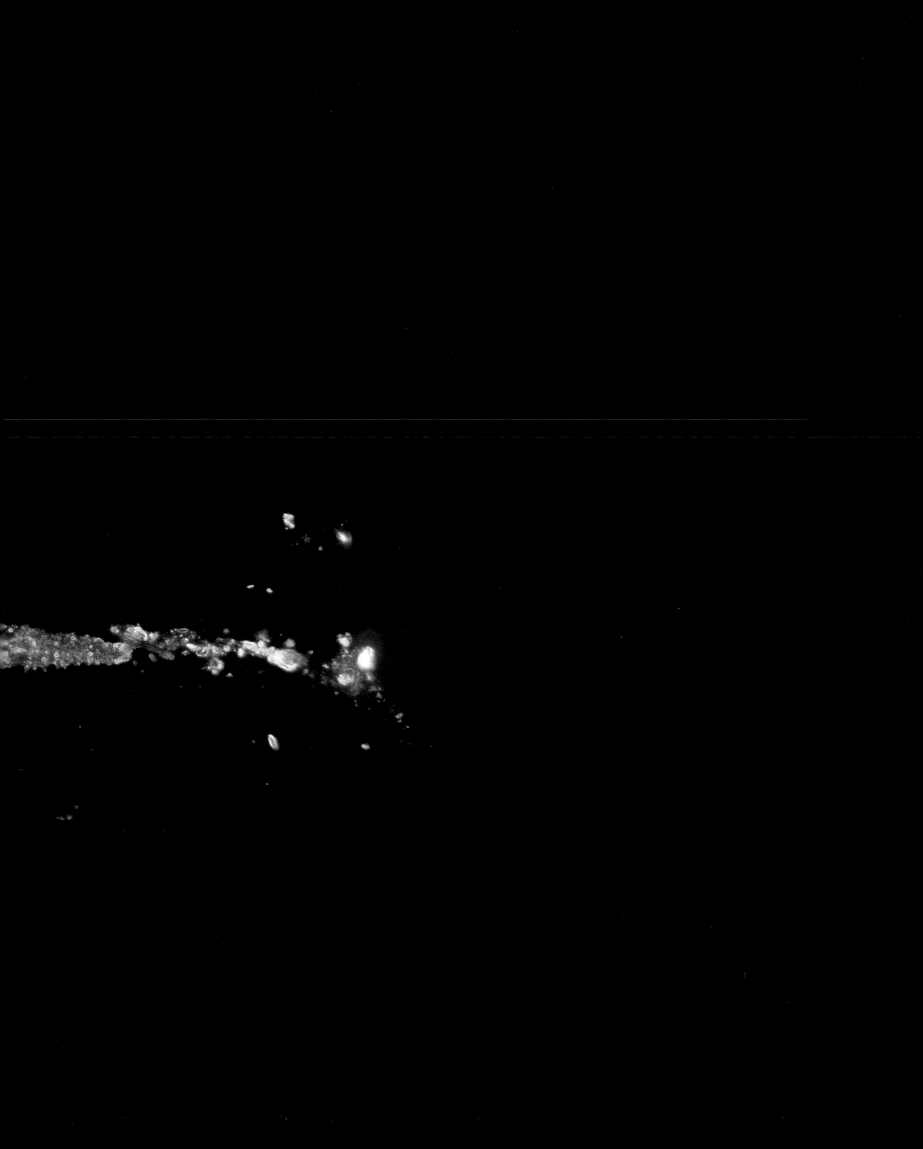

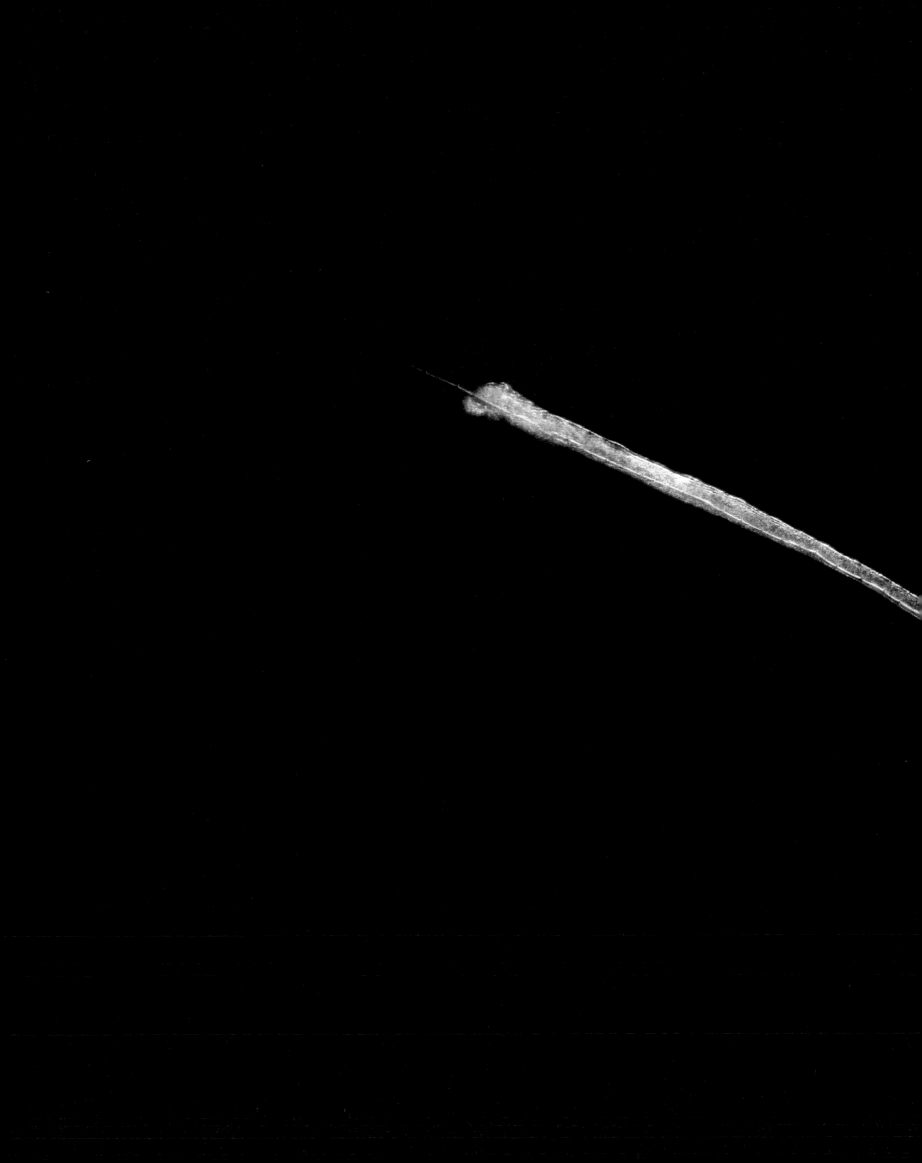

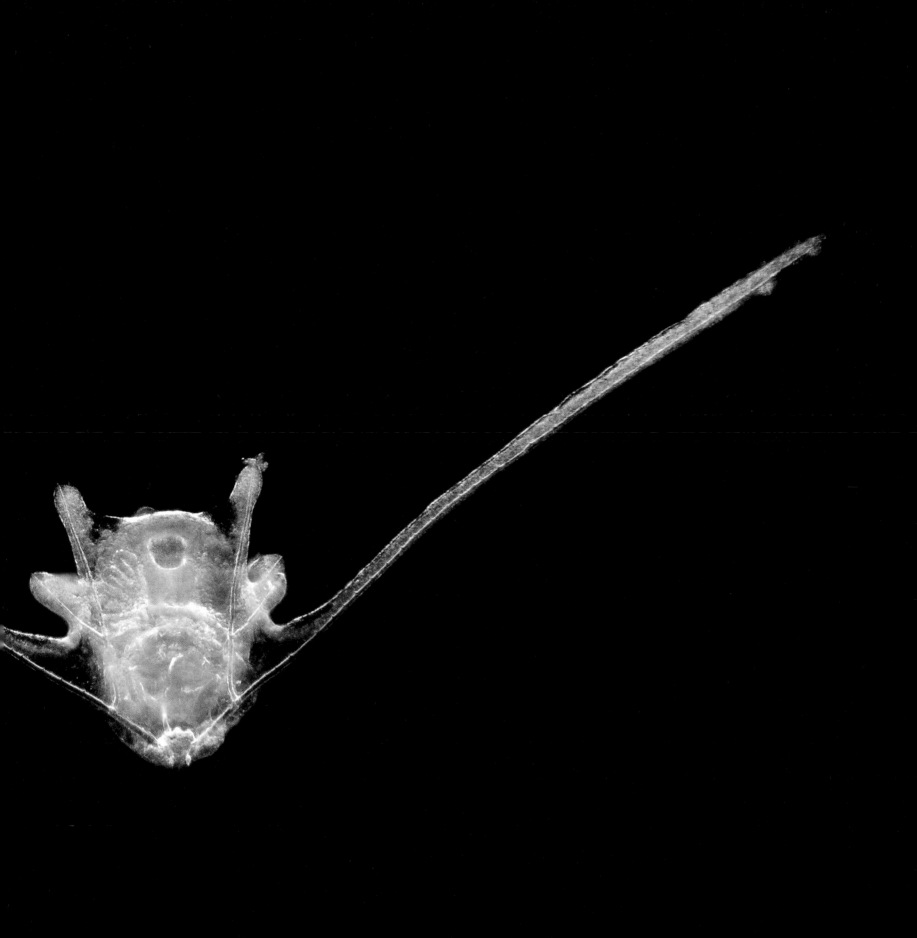

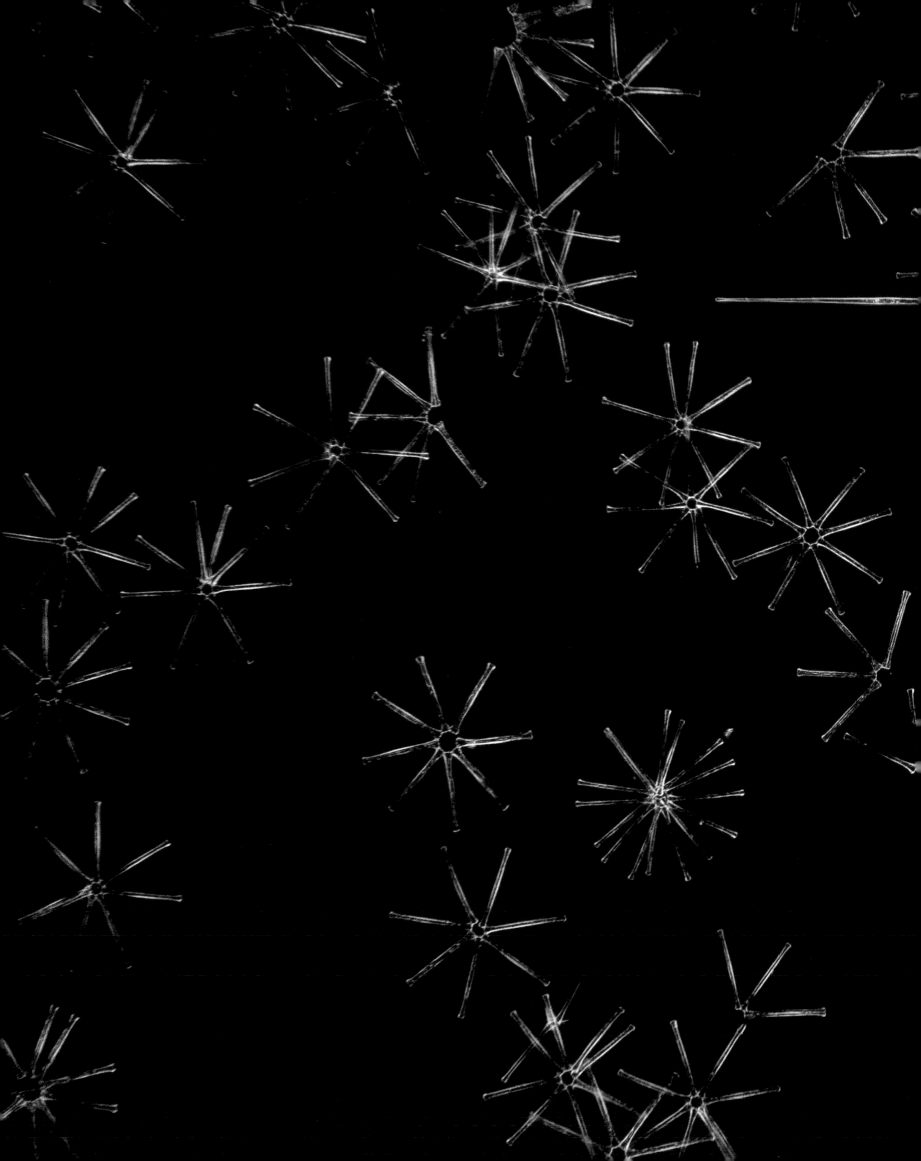

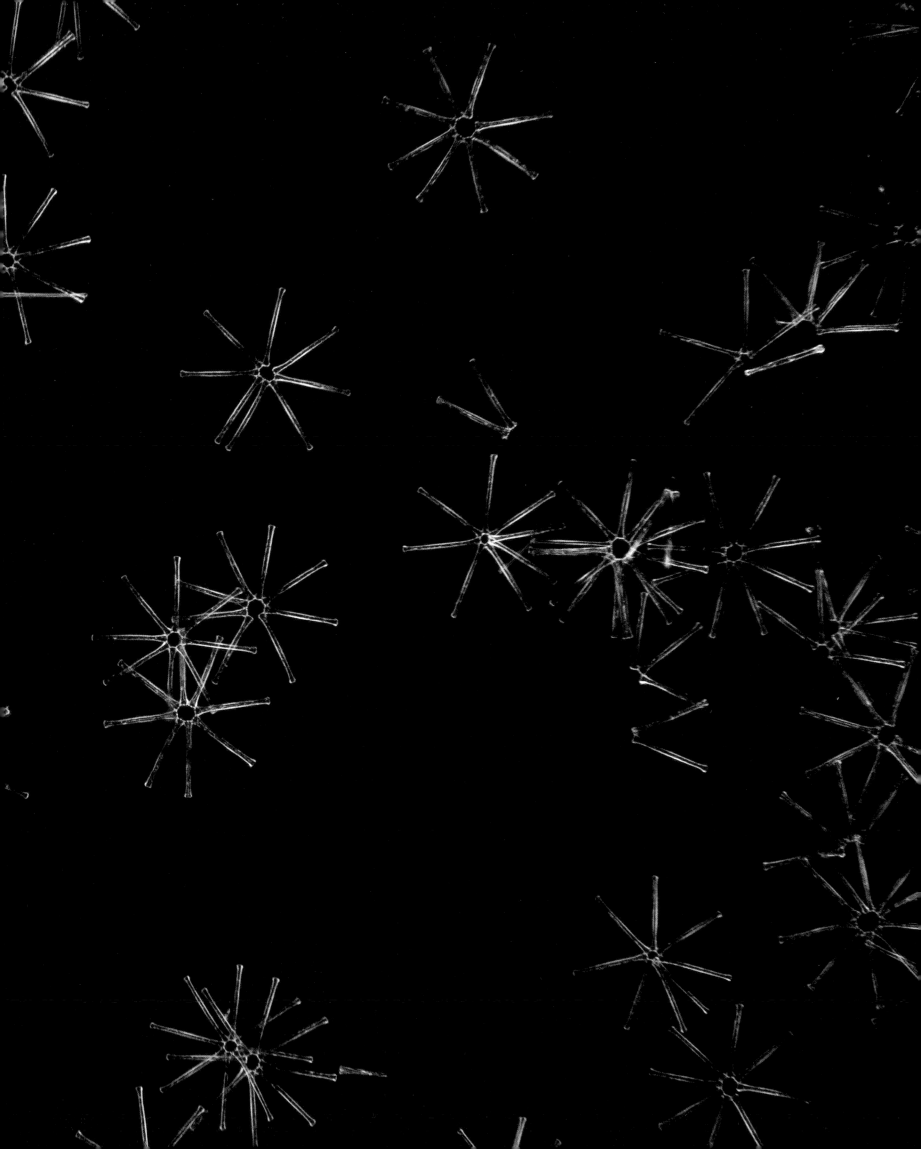

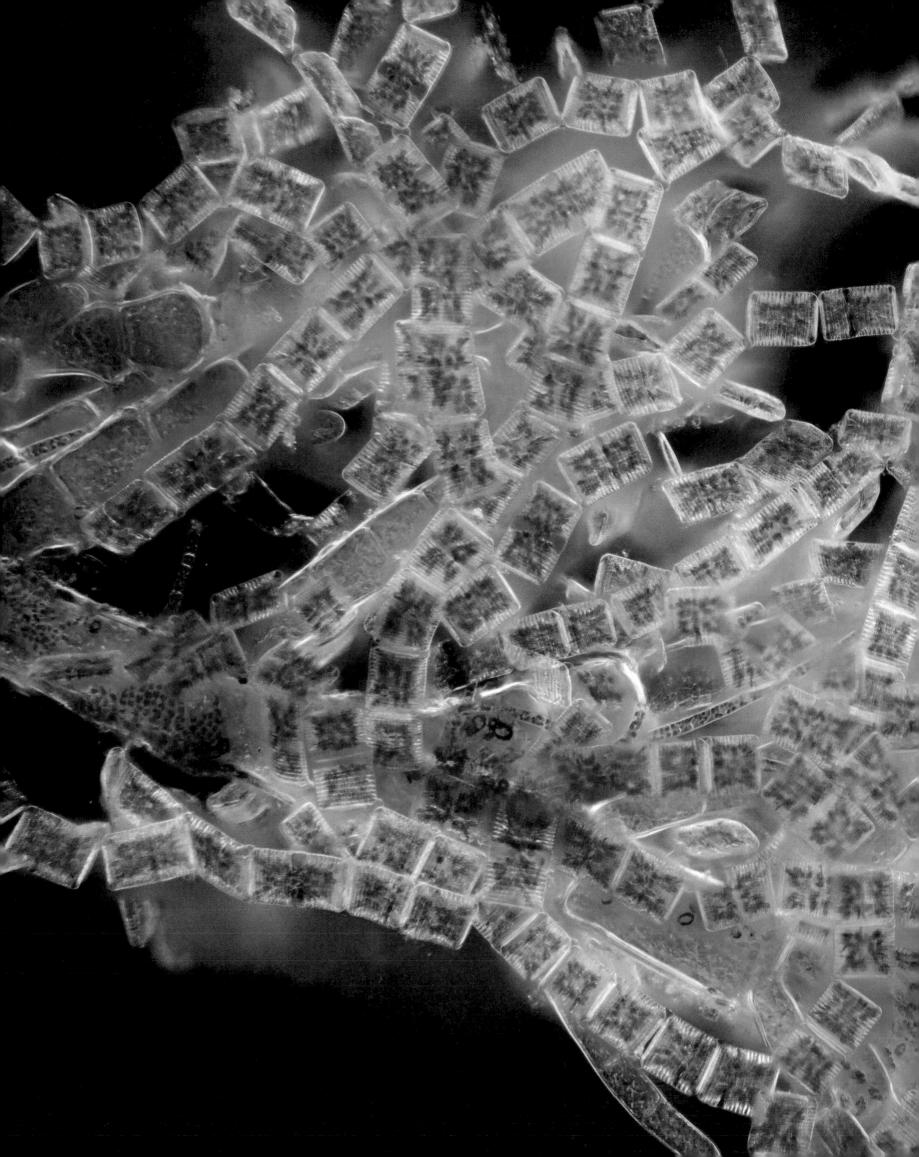

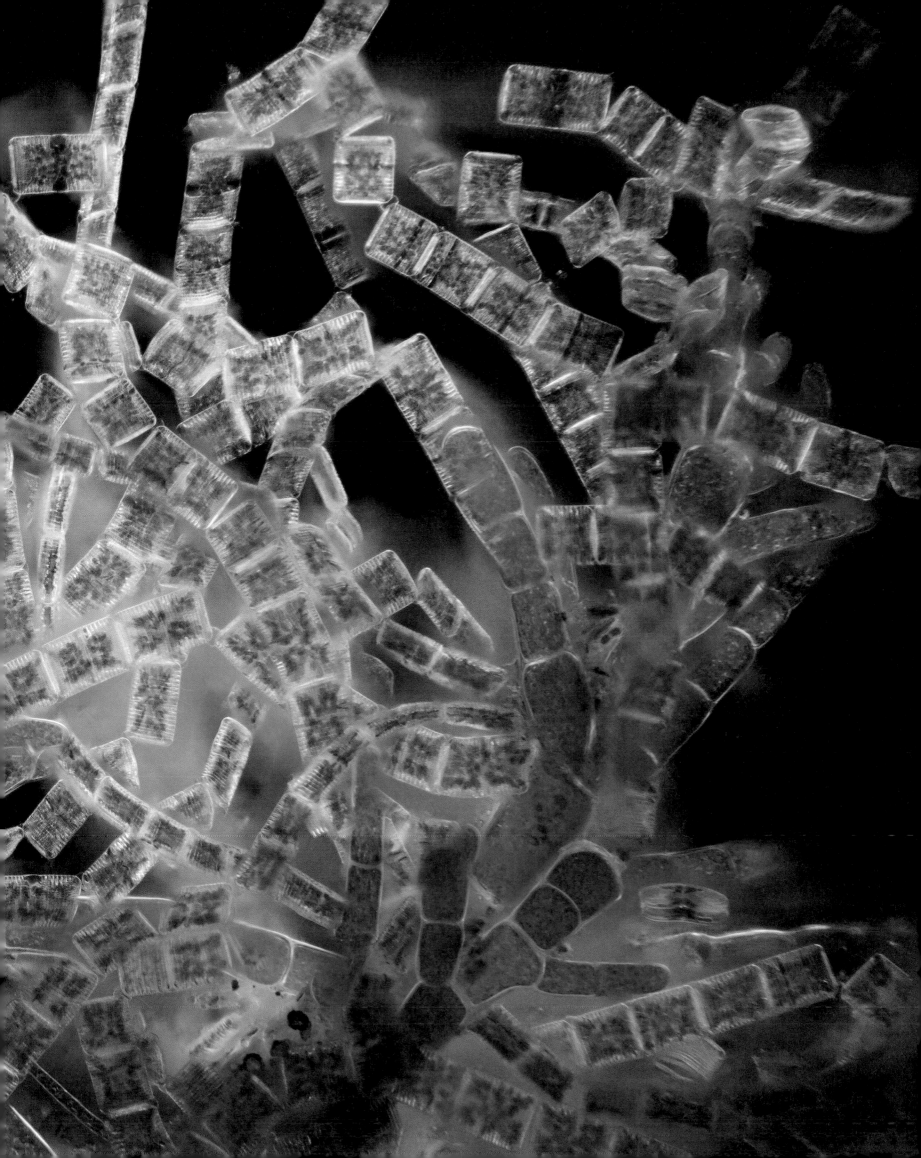

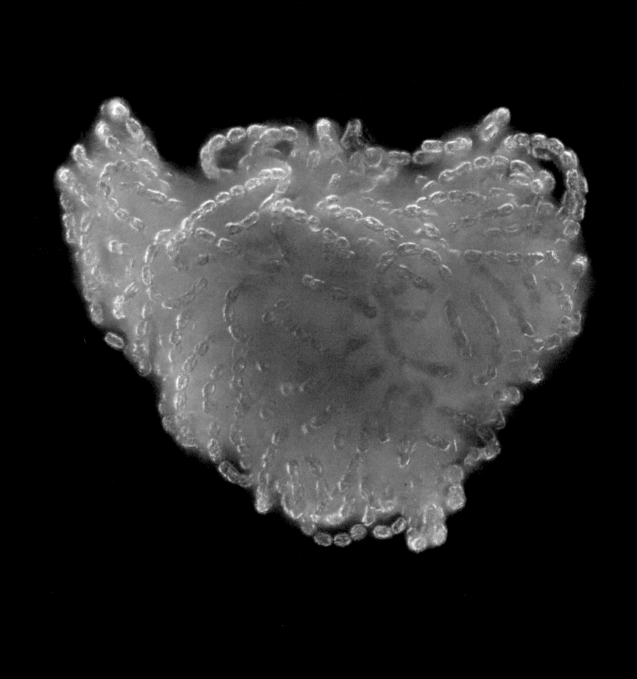

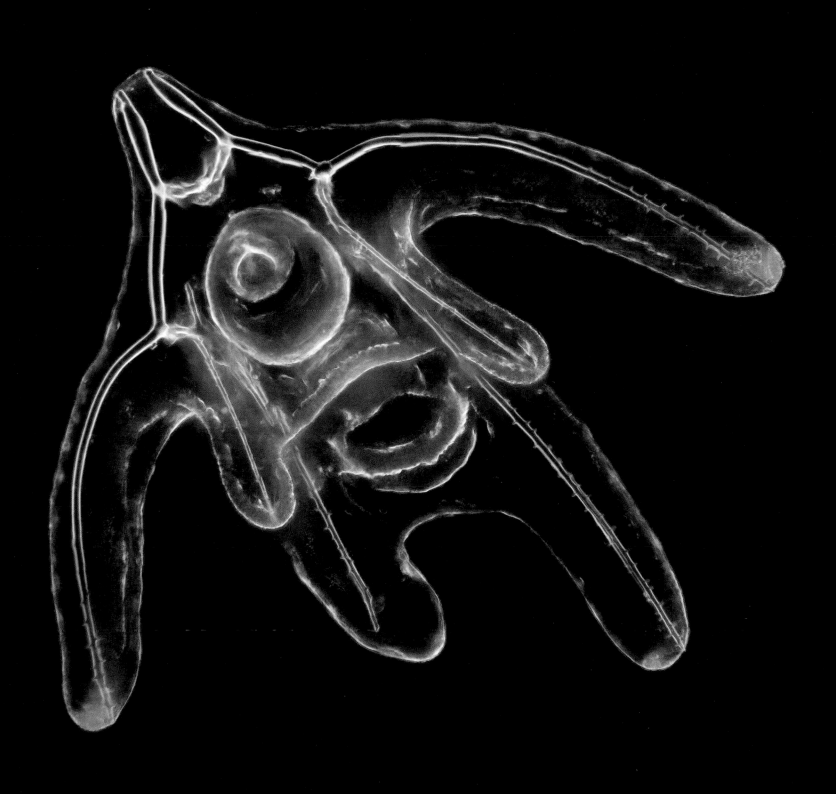

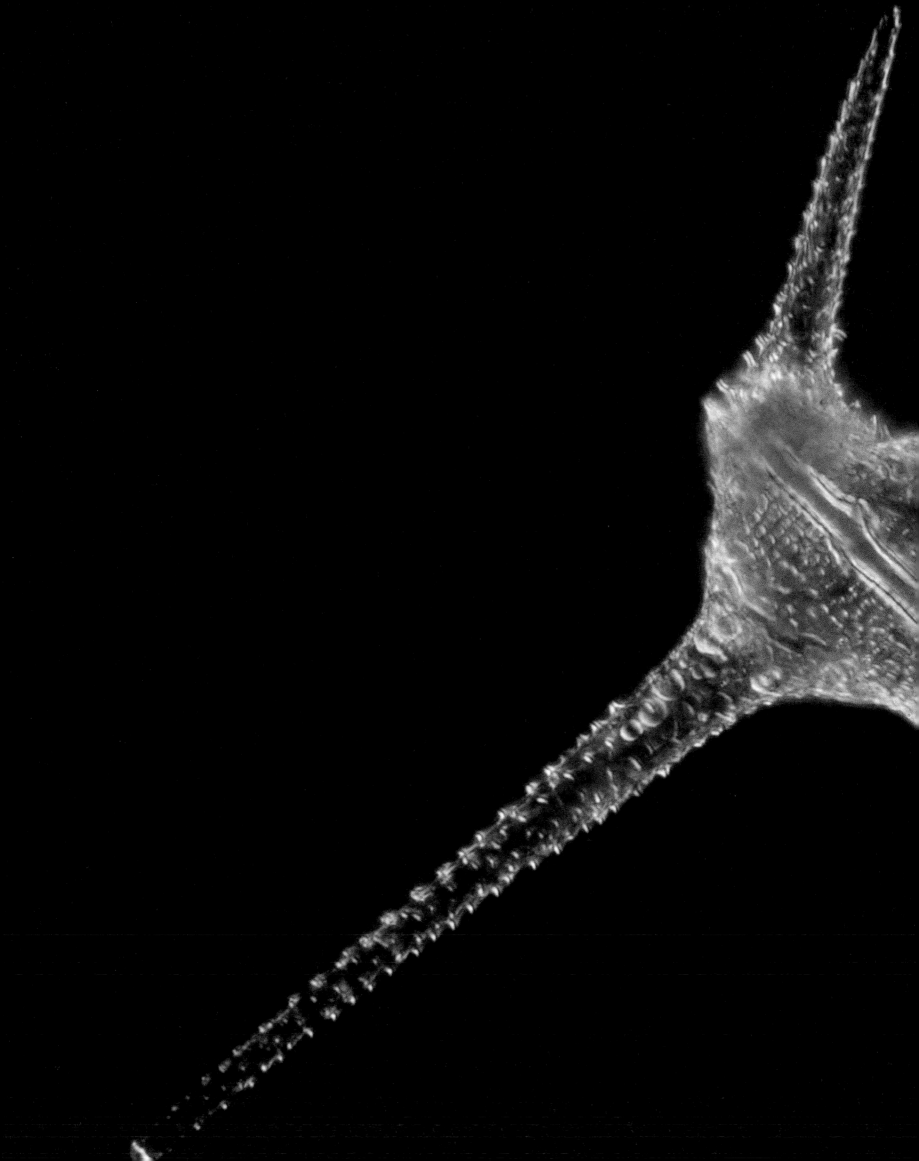

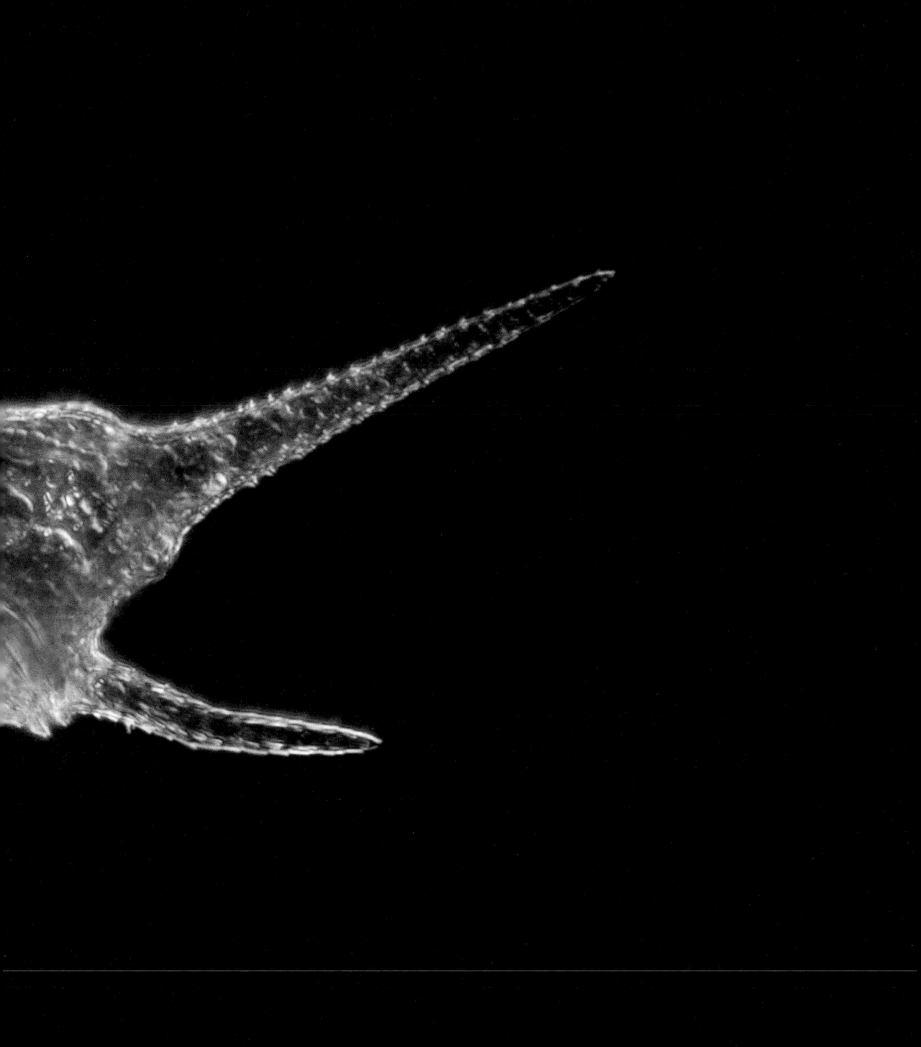

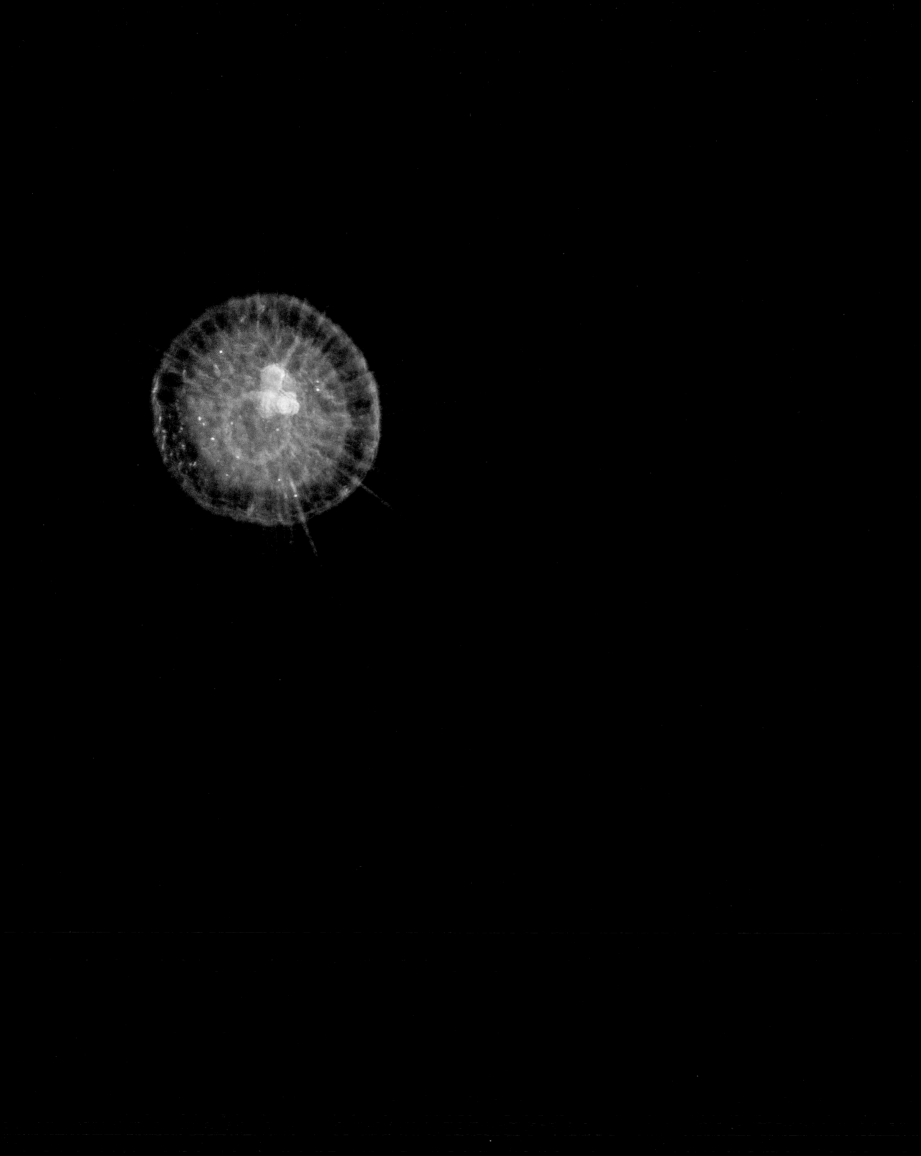

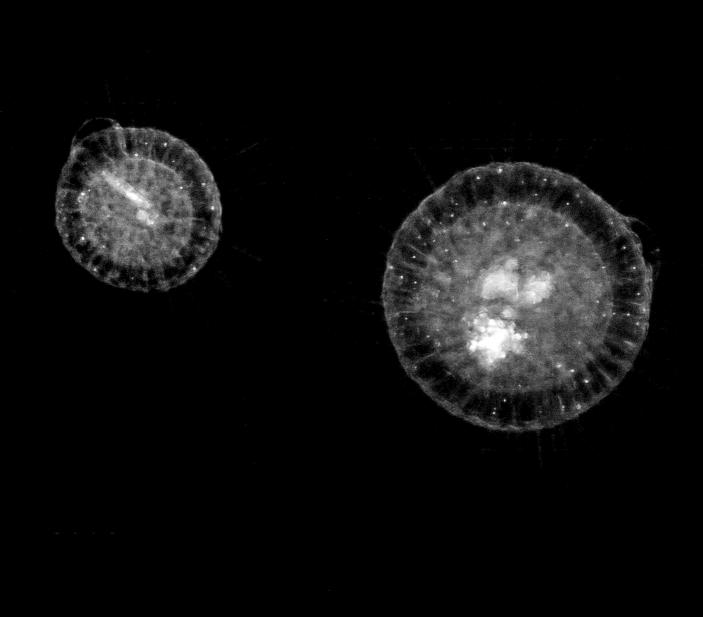

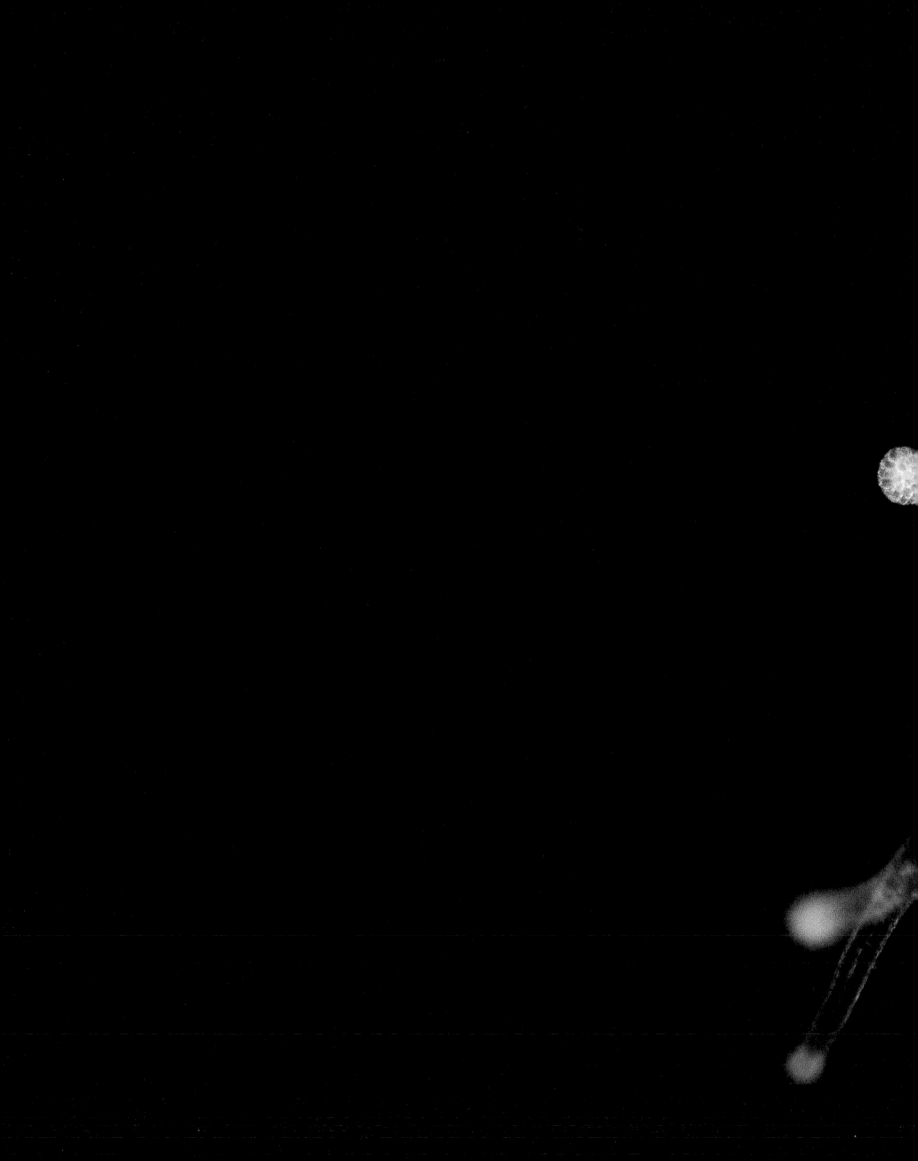

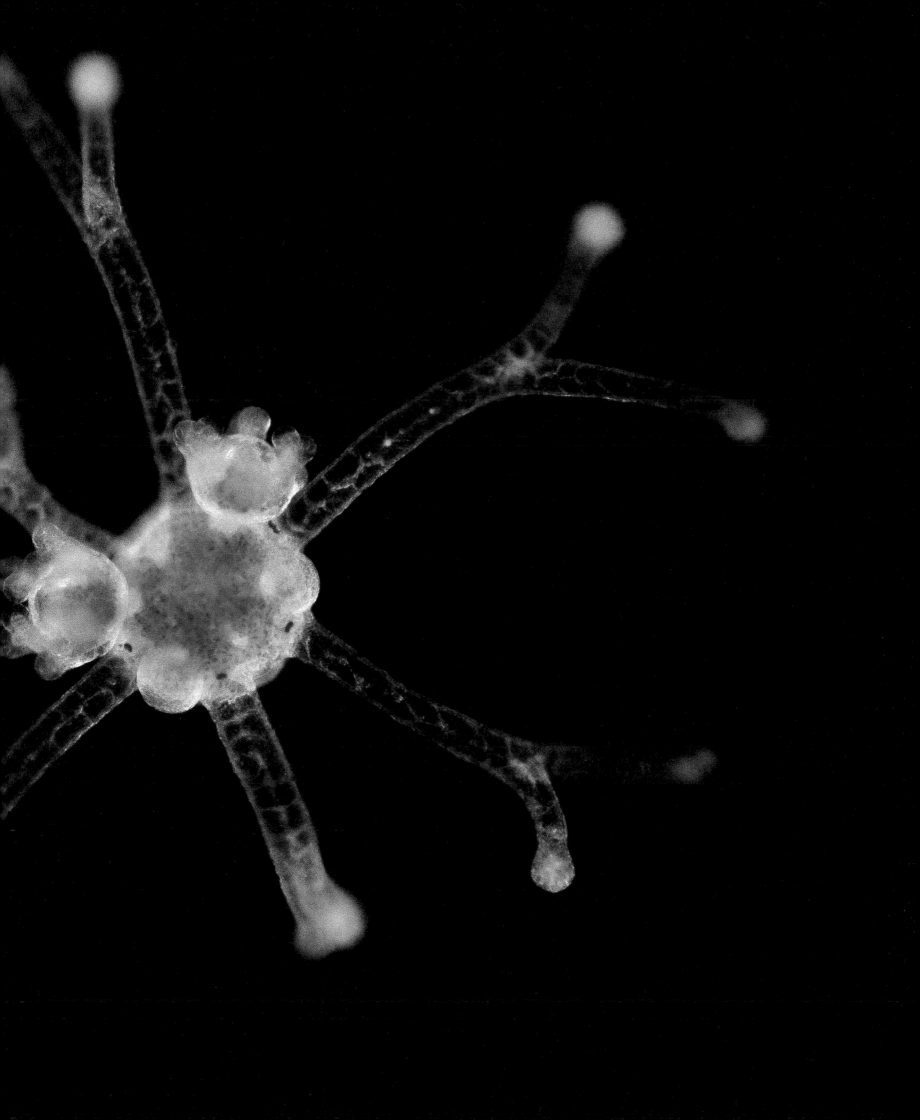

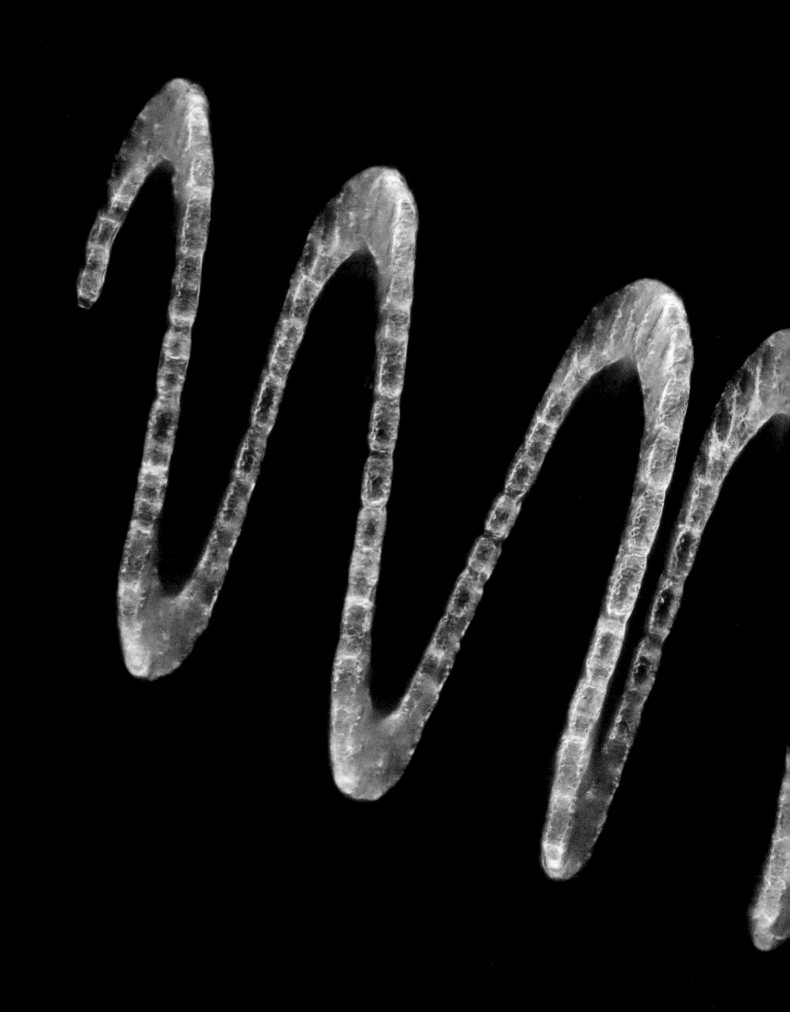

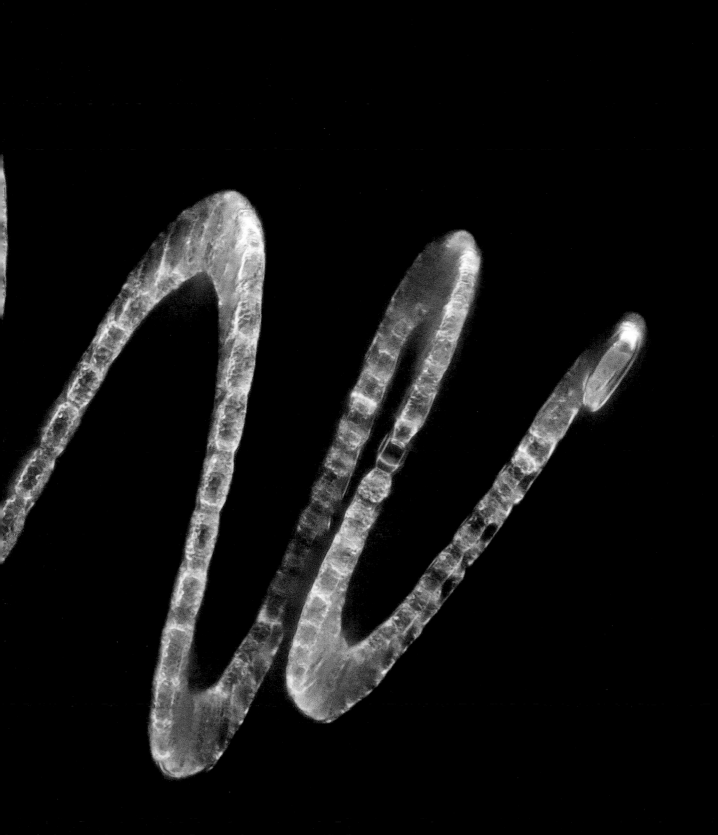

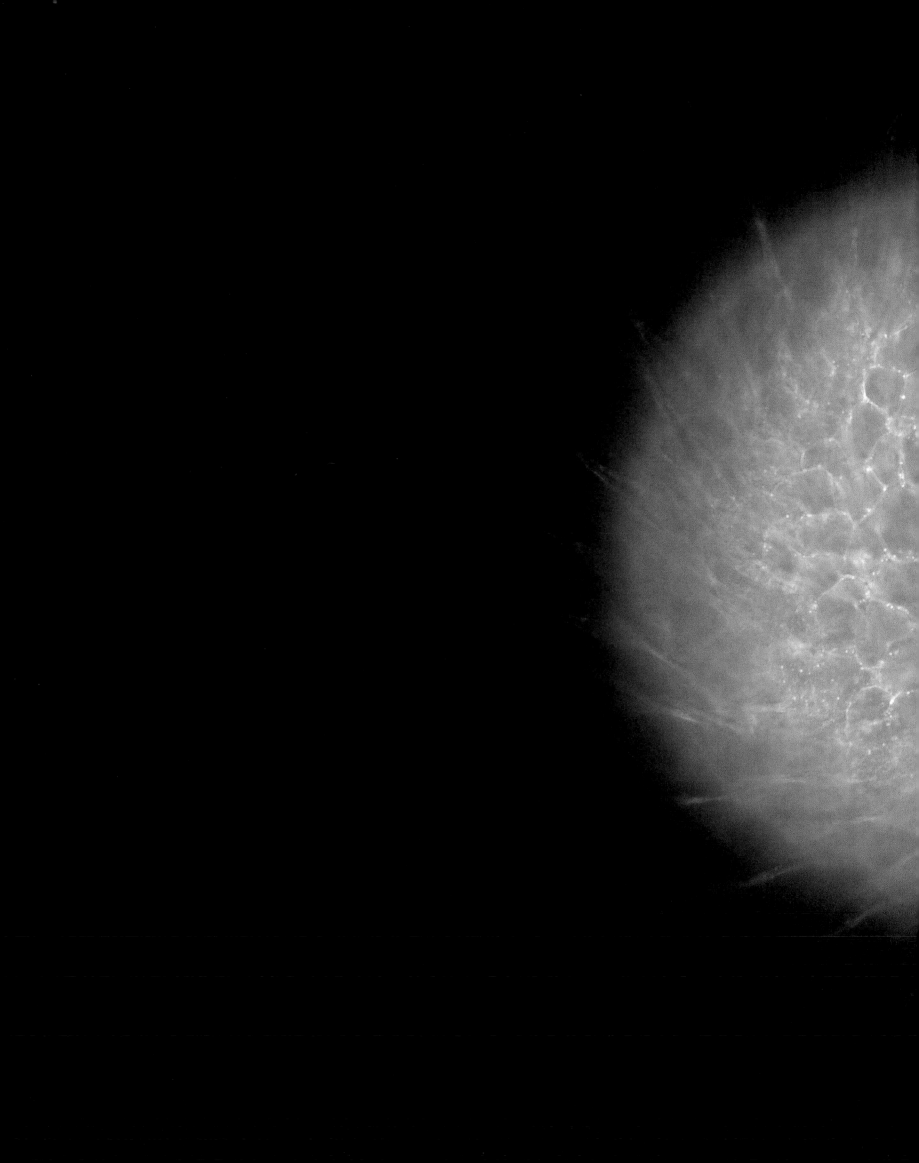

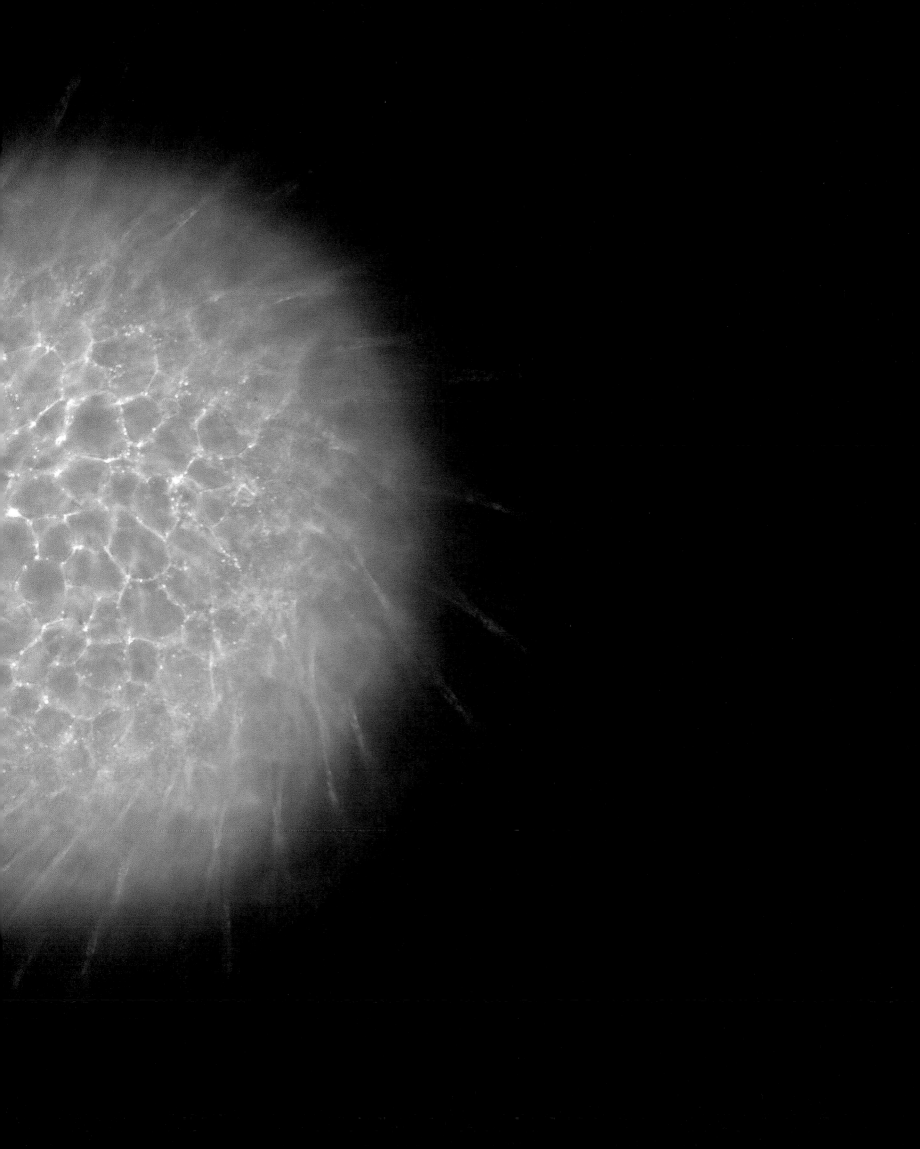

INDEX

Euastrum humerosum
Desmid

Carchesium sp.
Colonial peritrichs

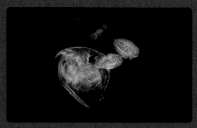

Pleuroxus aduncus
Water flea

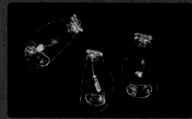

Asplanchna sp.
Rotifers with embryos

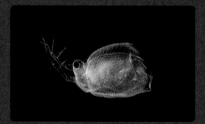

Ceriodaphnia Sp.
Water flea

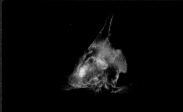

Hexarthra fennica
Rotifer

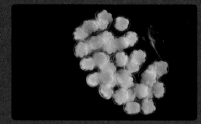

Cluster of eggs of unknown
species

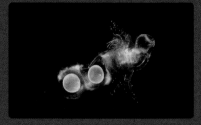

Polyphemus pediculus
Water flea with eggs

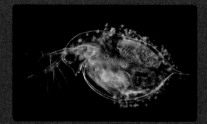

Daphnia pulex. Water flea
carrying embryos and peritrichs

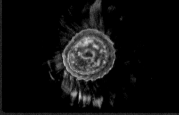

Fragment of comb jelly

Leptodora kindtii
Water flea

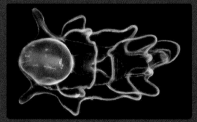

Starfish larva

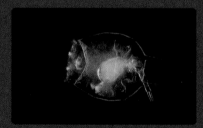

Platyias quadricornis
Rotifer

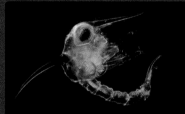

Crab larva

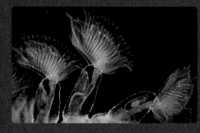

Bryozoan colony

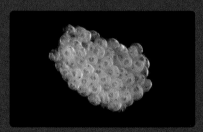

Copepod eggs

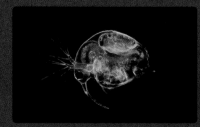

Bosmina sp.
Water flea

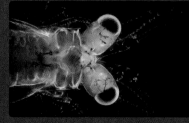

Mysid

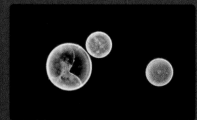

Coscinodiscus sp.
Diatoms

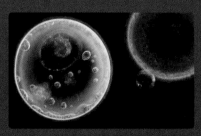

Coscinodiscus sp.
Diatoms

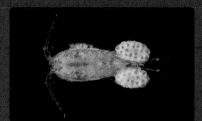

Cyclops
Copepod carrying eggs

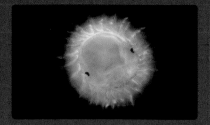

Oikopleura dioica

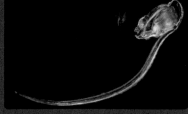

Polychaete worm larva

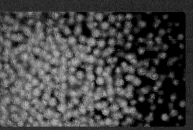

Synura uvella
Golden algae

INDEX

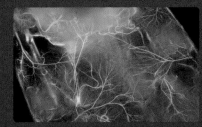
Insect larva

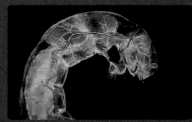
Polyp phase of an Obelia

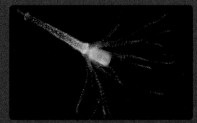
Insect larva

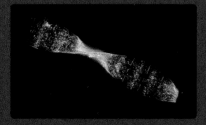
Helicotheca tamesis
Diatom

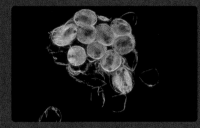
Hatching eggs of a copepod

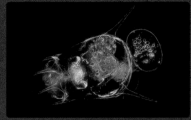
Brachionus sp.
Rotifer

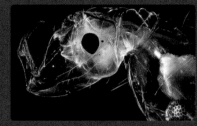
Chaoborus sp.
Phantom midge larva

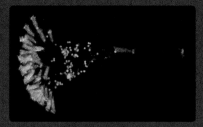
Peritrich ciliates

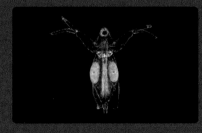
Volvox aureus

Larva of tube-building worm

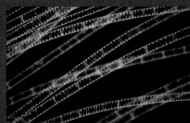
Polyphemus pediculus
water flea carrying embryos

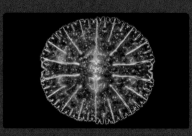
Testate amoeba

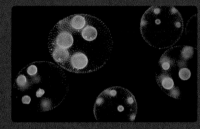
Diaphanosoma sp.
Water flea

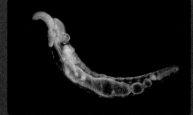
Stentor polymorphus
Ciliate

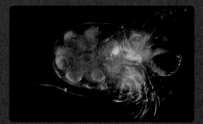
Green algae

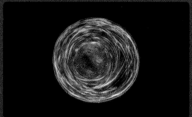
Micrasterias thomasiana sp.
Desmid

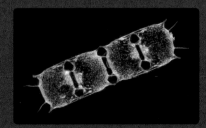
Odontella regia
Diatom

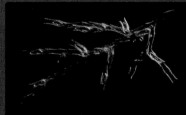
Dinobryon Sp.
Golden algae

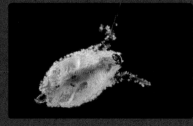
Scapholeberis sp.
Water flea

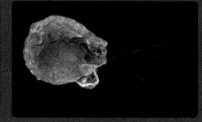
Testate amoeba

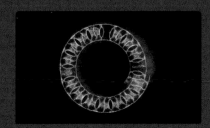
Eucampia zodiacus
Centric diatom

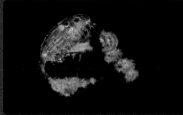
Copepod carrying diatoms

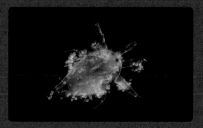
Copepod nauplius

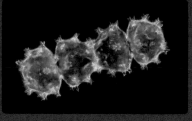
Xanthidium armatum
Desmid

INDEX

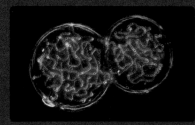

Nostoc Sp.
Cyanobacteria

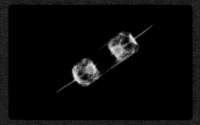

Ditylum brightwelli
Diatom

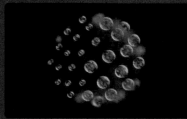

Pleodorina Sp.
Green algae

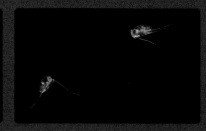

Filinia Longiseta Limnetica
Rotifers

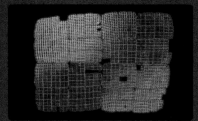

Merismopedia elegans
Cyanobacteria

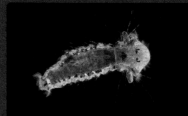

Spionida larva

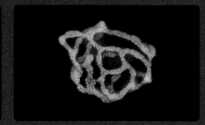

Microcystis flos-aquae

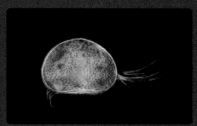

Ostracod
Seed shrimp

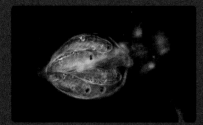

Diaphanosoma sp.
Water flea with embryos

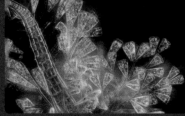

Diatoms on red algae

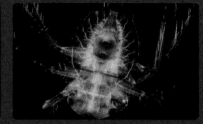

Water boatman larva

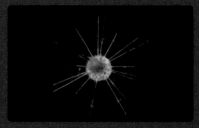

Radiolaria

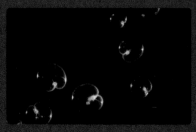

Noctiluca scintillans

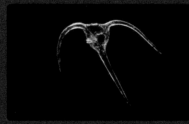

Dinoflagellate

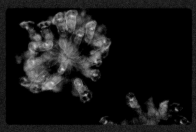

Conochilus unicornis
Rotifers

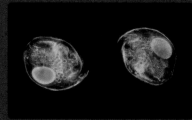

Chydorus sphaericus
Water fleas carrying egg

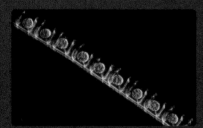

Lithodesmium intricatum
Diatom

Tube-dwelling diatoms

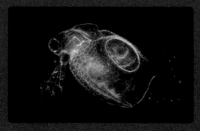

Ceriodaphnia sp.
Waterflea carrying egg

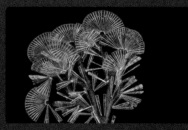

Licmophora flabellata
Colonial diatoms

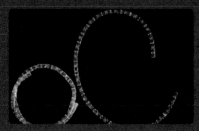

Diatoms

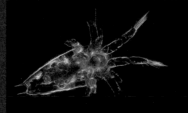

Copepod nauplius

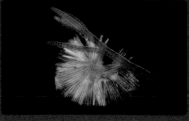

Colonial diatoms, attached
on red algae

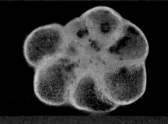

Forminafera

INDEX

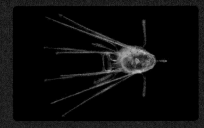

Echinocardium cordatum
Pluteus larva

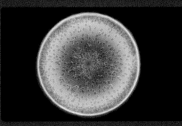

Coscinodiscus Sp.
Diatom

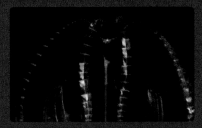

Mnemiopsis leidyi
Comb jelly

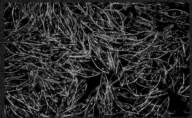

Pleurosigma sp. Diatoms from the mud of the Dutch Wadden Sea

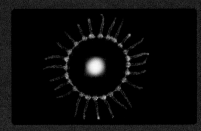

Medusa stage of an Obelia

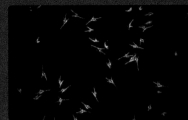

Ceratium hirundinella
Dinoflagellates

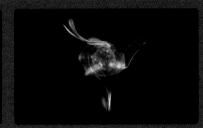

Fragment of comb jelly

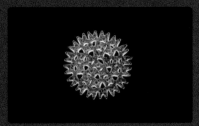

Pediastrum duplex
Desmid

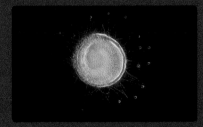

Developing egg of the
tunicate Ciona

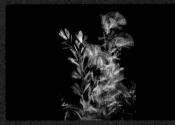

Licmophora flabellata
Colonial diatoms

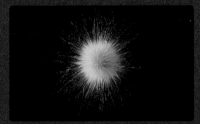

Gloeotrichia Sp.
Cyanobacteria

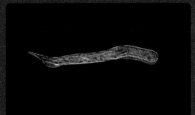

Euglena Sp.

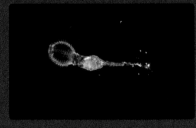

Stephanoceros fimbriatus
Rotifer

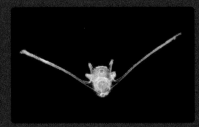

Ophiothrix fragilis
Pluteus larva

Asterionella formosa
Freshwater colonial diatoms

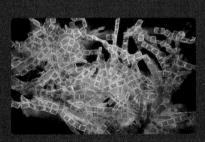

Striatella Sp.
Diatoms, attached on green algae

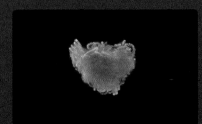

Blue algae

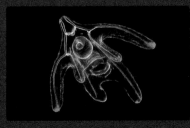

Ophiopluteus larva of a
brittle star

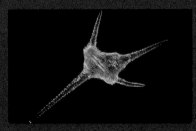

Ceratium hirundinella
Dinoflagellate

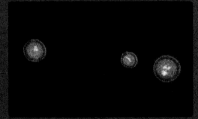

Heliozoa

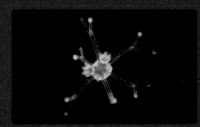

Eleutheria dichotoma
Hydroid

Colonial diatoms

Actinosphaerium sp.
Heliozoa

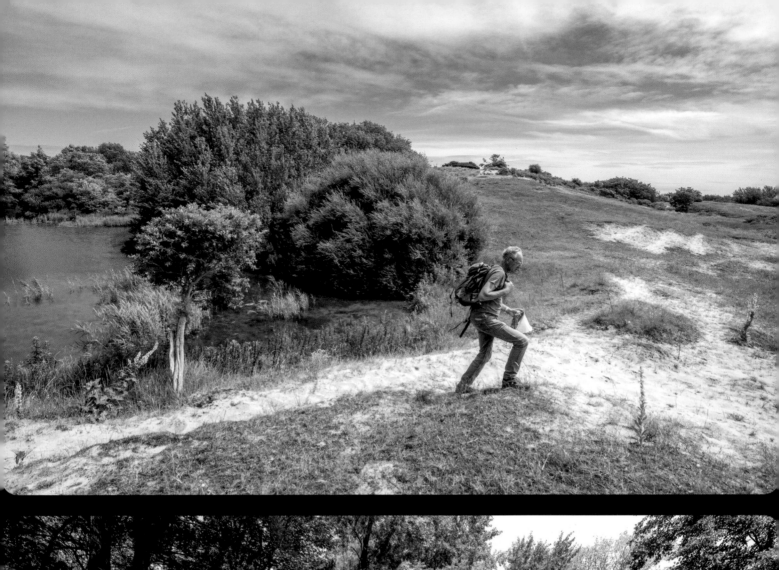
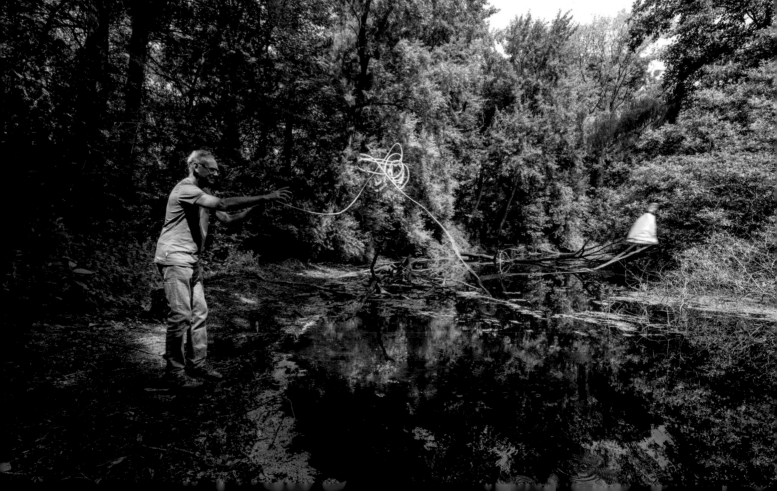

HOW JAN VAN IJKEN CAPTURES THE BEAUTY OF THESE TINY MIRACLES OF LIFE

This book is the result of countless painstaking hours of work by Jan van IJken to capture the stunning beauty and delicate structures of miniscule water-based organisms in the finest detail. But what exactly went into capturing these amazing images? For example, how were the vibrant colours created? "Most people assume that I've used special techniques to add colour effects, but I didn't see the need to; these are the natural colours in all their splendour," says Jan. Here, he reveals more about the processes that resulted in these spectacular photographs.

Given the amount of detail and sheer fascination that radiates from each photograph, it may come as a surprise to learn that Jan van IJken doesn't actually have a scientific background. "No, I'm driven by pure curiosity!" he states. "I started out as a photographer in the mid-1990s, and I later moved into film-making too. I tend to work autonomously on long-term projects. My early work was mainly focused on social documentaries, which helped me to develop a strong eye for composition, detail and lighting – it's all about how to use the light."

As Jan moved onto exploring the relationship between humans and animals, he gradually became more interested in nature. This eventually led him to make a film called *Becoming*, which was his first venture into microscopy. "By filming a transparent salamander egg through a microscope, I made a usually invisible universal process – the very first stages of embryonic development, and therefore the genesis of life – visible in great microscopic detail. While working on this project, I joined a Dutch microscopy club called Nederlands Genootschap voor Microscopie (NGVM), where I met a lot of enthusiastic

microscopists and conquered the basic techniques of microscopy. I can recommend anyone interested in microscopy to become a member, because we learn so much from each other! One day, I saw some pictures of plankton taken through a microscope. I was so captivated by the incredible beauty of this rarely-seen world that I decided to make that my next project," he recalls.

This required Jan to develop various new skills – and not only skills related to microscopy. "The whole process starts with gathering the plankton, of course. So what were the best spots for finding different types of plankton, and how should I collect the water? I bought myself a plankton net online and attached a 100ml jar beneath it. Over the course of three years, I've been on countless field trips: from ponds, ditches and canals, to the Grevelingenmeer (a saltwater lake), lakes in the dunes, and the North Sea. I feel very lucky to have so many varied bodies of water close to where I live."

"When I get home to examine my catch, it's always exciting to see what kind of microorganisms

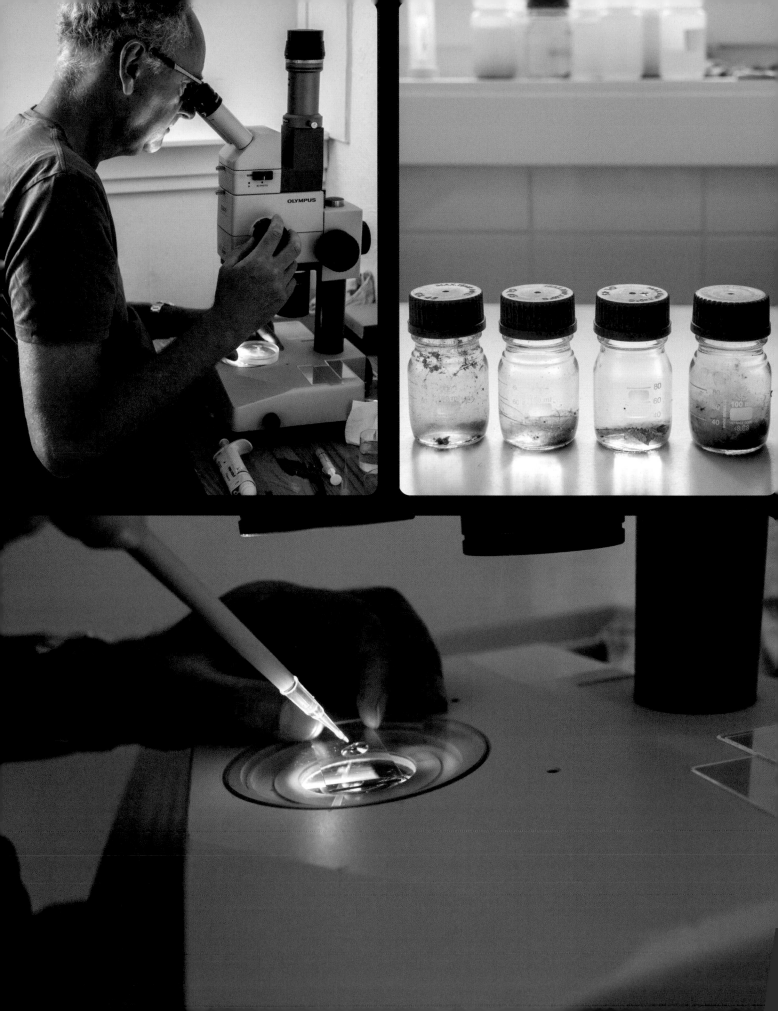

are in the water samples, because you never know what you might find. And even now, after three years, it's still possible to find something new and surprising because there are so many variations. For example, even if I take samples from two neighbouring lakes in the dunes, most times the samples contain very different species," says Jan. To identify what kind of plankton he has caught, he makes a lot of use of reference works, such as the German book called *Das Leben im Wassertropfen* about freshwater organisms. "I also learn a lot by reading other books and simply by talking to people at the microscopy club," he adds.

One of the first challenges is to keep the plankton alive, because they can die pretty quickly if exposed to warmth. "Most people who study plankton mainly work on dead plankton. That makes sense in the context of scientific research, of course. But in order to capture the true beauty of this underwater life, I felt it was really important to use live plankton," comments Jan. He has developed various of ways keeping the plankton cool and therefore alive, such as by storing the samples in the fridge, in the bathroom or out on the balcony.

The next task is to prepare the specimens for a shoot. "Firstly, I examine my catch under a stereo microscope to see what I have brought in. Then I extract the interesting organisms using a pipette and transfer them to microscope slides in a few drops of the original water. It's important to filter the water first so that I can work with a clean sample. Then, I put a cover slip on top of each slide and smear a little petroleum jelly around the edges to create a micro-aquarium. Then comes the most exciting step in the process: filming and/or photographing the live specimen through my Leica light microscope," he explains.

"The fact that they're alive creates an extra challenge; some of the specimens, such as water fleas, have a lot of energy and move very fast, which makes it even harder to get them in focus. Some people use tranquilizers, but I want the photos of the organisms to exude as much life as possible, so it's often just a matter of being patient and waiting until they get tired!"

Once the specimen has been pinpointed under the light microscope, that's when Jan's photography skills come into play. "Filming through a microscope involves various challenges, such as achieving the right sharpness and focus while taking the variation in microscopic lenses into account. It can be tricky to strike the right balance between resolution and depth of field," says Jan. He initially used a Zeiss trinocular microscope but now has a Leica one, which produces even better results. "They are both high-quality microscopes which I bought second-hand after they had been written off by a hospital or professional laboratory. A trinocular microscope means that, in addition to having two tubes you can look down with your eyes, it has a third tube at the top. That's where I set up the camera to 'look' down the tube and through the lens."

He uses small, light-sensitive Sony system cameras which can record film as well as taking photos, including timelapse photos. "Being able to do everything with the same camera made it

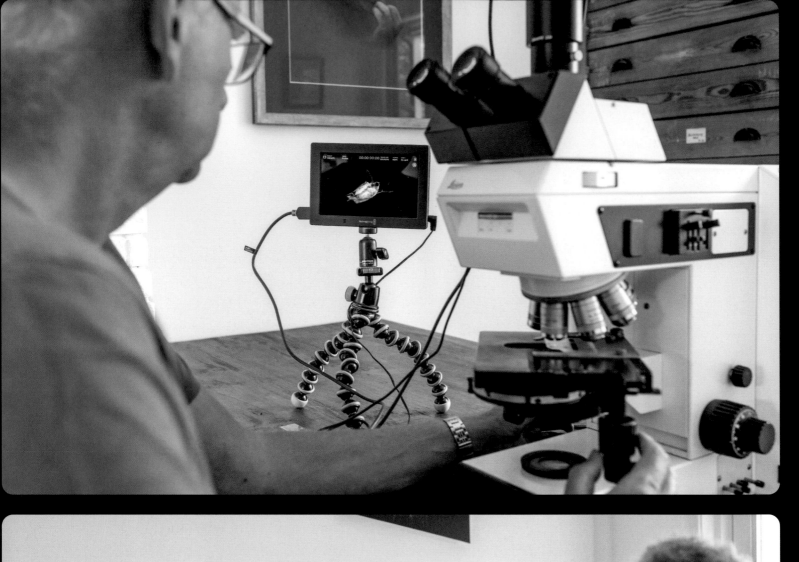
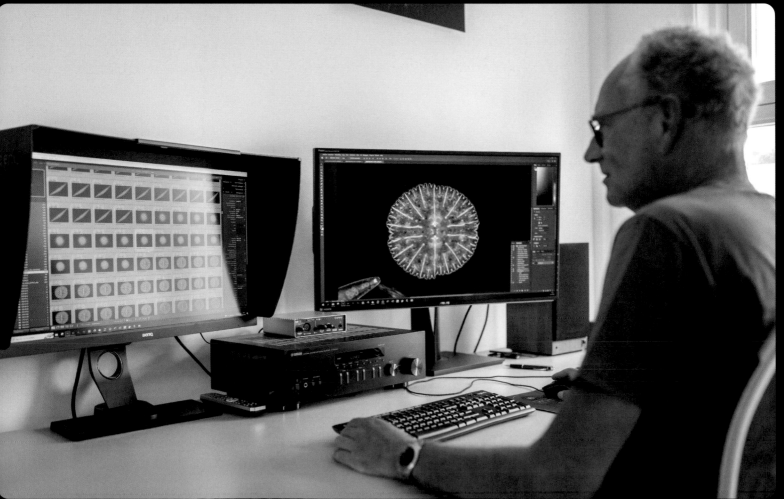

a lot easier for me to experiment and work on a film project in parallel with this book. I was able to keep an open mind about which types of organisms were most suitable for which medium: photo, film or both," states Jan. The resulting 15-minute film is also called *Planktonium* and features a sound composition by renowned Norwegian artist Jana Winderen based on natural underwater sounds. An HDMI cable connects the camera to a monitor, which makes it easy for Jan to adjust focus and keep an eye on the organisms while filming.

The lighting effects play a crucial role in the photos in this book. "While some people assume that I've used special techniques to add effects such as colour, polarization or fluorescence, I didn't see the need to because I believe the organisms are beautiful enough as they are. So these are the natural colours in all their splendour!" What makes those colours come alive is a technique called 'dark field'. "This black background not only increases the contrast and ensures uniformity between all the different images in this book, but for me it also creates a sense of atmosphere – perhaps even a feeling of 'outer space', which I think is very fitting for what, in my opinion, sometimes seems like an alien world," he continues.

Next comes what Jan himself describes as "the tedious part": the production work. "If you only take one shot of an organism, there will be a lack of sharpness because the organism is so small. So instead, I use a technique called 'focus stacking'; I take a lot of photos of each organism and move the focal point each time – starting at the upper point, then moving the fine focus slightly before taking another photo, and so on until I've captured the whole organism. Then I join all the photos together using the software – which in my case is Photoshop, because I want the very best quality and that's the best in my experience." A single photo can contain anything from five to two hundred shots, and around 30 to 40 on average, so the process to stack all the shots can be very time-consuming – especially for a perfectionist like Jan. "I've spent a lot of time improving my techniques and tweaking things, so creating these images has been a very long process involving lots of hard work." All his time and effort certainly seems to have paid off, because six images from this photo series have been nominated in the Photo Story category of the 2022 Wildscreen Panda Awards, the globally acclaimed 'Green Oscars' of the international wildlife film and TV industry.

This is Jan's first book in a while, because he had been too busy with films up until now. "I actually really enjoyed it, although it was far from easy to select which photos to include and which should be left out. As always, it's a matter of 'kill your darlings'; there were far too many to choose from. But I hope that those photos that did make it into this book will cause people to stop and think about the magical and varied world around us. There is a scientific side to plankton; it is crucial for life on Earth. But above all, for me personally working at the intersection of art and science, I hope that people will be inspired by the beauty of these tiny miracles of life," he concludes.

Lynn Radford

ACKNOWLEDGEMENTS

Planktonium has been made possible with generous financial support of Stichting Oog op de Natuur, Gemeente Leiden and Nederlands Film Fonds.

Many thanks for supporting *Planktonium*:
Dunea, Leiden European City of Science 2022, Museum De Lakenhal, Leiden

Wim van Egmond, Tanja Elstgeest, Lucien Geelhoed, Jan Hartholt, Jan-Paul Hendriks, Meta Knol, Rijk van Kooij, Guido Marchena, Metje Postma, Simone de la Rie, Nicole Roepers, Ron Vink, Jana Winderen, José de Winter

My friends of Nederlands Genootschap voor Microscopie (NGVM) and Koninklijk Antwerps Genootschap voor Microscopie (KAGM)

Jan van IJken is a film-maker and photographer from Leiden, the Netherlands, working on the interface of art and science. In his latest works, he reveals secrets in nature like the murmurations of starlings, the genesis of life and the unseen world of microscopic plankton. He is interested in microscopy, nature, biology, evolution, and embryology. In earlier years he published three photobooks on social-documentary subjects like Divinity in Eastern Europe and the relationship of man and animal. He developed a keen eye for light and composition and specializes on autonomous long-term projects. He published 4 photobooks and 5 short films.

His photos have been published in numerous international magazines and newspapers, e.g. *National Geographic Magazine, New Scientist, Oceanographic magazine*, and his short films were screened at many international film festivals.

His work was acquired for the collection of Rijksmuseum Amsterdam NL (photo series *Dierbaar*), and Museum De Lakenhal, Leiden NL (short film *Planktonium*). Several films were awarded, e.g. the Grand Prix for short films of Split Film Festival Croatia *(Facing Animals)* and Best short documentary at Innsbruck Nature Film Festival, Austria *(Becoming)*. The short film *Becoming* went viral on internet with millions of viewers and was nominated for Vimeo Best of 2019 (Top 10 experimental films).

COLOPHON

© 2022
Uitgeverij Terra is part of Uitgeverij
TerraLannoo bv
P.O. Box 23202
1100 DS Amsterdam
The Netherlands
info@terralannoo.nl
terra-publishing.com

f : terrapublishing
: terrapublishing

© 2022 Jan van IJken
janvanijken.com
@janvanijken

Photography: Jan van IJken
Images on pages 184 -191 Ron Vink
Designs cover and interior:
Erik Rikkelman, Studio Rikkelman
Texts: Lynn Radford, Will Ridgeon,
Pauline Terreehorst, Marianne
Wootton
Translation: Kay Dixon
Images on pages 184-191: Ron Vink

Lynn Radford is owner of
Englishproof, providing translating,
copywriting and proof-reading
services.

Will Ridgeon is producer/director
for BBC's *Blue Planet II* and
Planet Earth III

Pauline Terreehorst is a film theorist.
She was a university lecturer,
journalist, consultant and director,
and has published books on film,
photography, new media, fashion and
urban life.

Marianne Wootton is a senior
plankton analyst at the Marine
Biological Association in the
United Kingdom.

Planktonium by Jan van IJken is
also a short film. Watch a trailer and
the full film (15min) here:
https://vimeo.com/ondemand/
planktonium

With special thanks to:

First print, 2022

ISBN 978 90 8989 929 3
NUR 653